Warwickshire County Council

CULTURAL CAPITAL

The Rise and Fall of Creative Britain

Robert Hewison

VERSO

London • New York

For Erica

First published by Verso 2014
© Robert Hewison 2014

1 3 5 7 9 10 8 6 4 2

Verso
UK: 6 Meard Street, London W1F 0EG
US: 20 Jay Street, Suite 1010, Brooklyn, NY 11201
www.versobooks.com

Verso is the imprint of New Left Books

ISBN-13: 978-1-78168-591-4 (PB)
eISBN-13: 978-1-78168-592-1 (US)
eISBN-13: 978-1-78168-751-2 (UK)

British Library Cataloguing in Publication Data
A catalogue record for this book is available from the British Library

Library of Congress Cataloging-in-Publication Data

Hewison, Robert, 1943–
 Cultural capital : the rise and fall of creative Britain /
Robert Hewison.
 pages cm
 Summary: 'What was "Creative Britain"? Was it the
"golden age" that Tony Blair vaunted in 2007, or a
neoliberal nirvana? In the twenty-first century, culture
– the visual and performing arts, museums and
galleries, the creative industries – have become ever
more important to governments, to the economy, and
to how people live. Cultural historian Robert Hewison
shows how, from Cool Britannia and the Millennium
Dome to the Olympics and beyond, Creative Britain
rose from the desert of Thatcherism only to fall into
the slough of New Labour's managerialism' –
Provided by publisher.
 ISBN 978-1-78168-591-4 (paperback)
1. Arts and society – Great Britain – History – 20th
century. 2. Arts and society – Great Britain – History
– 21st century. 3. Great Britain – Civilization – 1945 –
 I. Title.
 NX180.S6H475 2014
 700.1'03094109049 – dc23

 2014026259

Typeset in Adobe Garamond by MJ & N Gavan, Truro, Cornwall
Printed and bound by CPI Group (UK) Ltd, Croydon, CR0 4YY

Contents

Foreword

*C*ultural Capital: The Rise and Fall of Creative Britain* is constructed as a narrative of the period 1997–2012, from the decision to continue with the Millennium Dome to the opening of the 2012 Olympics. The approach is broadly chronological, but each chapter has a governing theme – for instance, the creative industries in Chapter 2 – that is pursued further within the overall time frame. There are also sections where I have gone deeper into the details of a particular project or policy because it serves as a test case. My source material is the aptly named 'grey literature' of policy documents and reports, together with academic commentaries, contemporary journalism and my own observation of events.

No interviews were conducted specifically for research purposes, but I have had many helpful conversations, and several people have commented on versions of the manuscript, while others have answered questions of detail or supplied me with documents. I would like to thank in particular Vivek Bhardway, Stuart Davies, Alan Davey, Christopher Gordon, Andrew Haydon, Stephen Hetherington, Robert Hutchison, Sam Jones, Naseem Khan, Henk van Klaveren, Rónán McDonald, Rachel McGuire, Gareth Maeer, François Matarasso, Irene Morra, Roshi Naidoo, John Newbigin,

Dave O'Brien, Margaret O'Connor, Kate Oakley, Toby Sargent, Sara Selwood, Simon Thurley, Jenny Williams and Karen Wright.

There are three people to whom I owe special thanks: my friend and collaborator John Holden, who has long been a sounding board for this project, and who rightly appears in its pages; my editor, Leo Hollis, who has reminded me what editors are for; and my wife Erica, at whose kitchen table so many interesting debates are to be had.

We can justify the subsidised arts on the grounds of cost effectiveness, or as tourist attractions, or as investments, or as commodities that can be marketed, exploited and profited from, but the arts should make their own argument. They are part of our life, our language, our way of seeing; they are a measure of our civilisation. The arts tell us truths about ourselves and our feelings and our society that reach parts of us that politics and journalism don't. They entertain, they give pleasure, they give hope, they ravish the senses, and above all they help us fit the disparate pieces of the world together; to try and make form out of chaos.

Richard Eyre, *Report on the Future of Lyric Theatre in London*, 1998

Introduction: 'A Golden Age'

In March 2007, three months before he resigned as prime minister, Tony Blair addressed the leaders of Britain's cultural establishment in the Turbine Hall of Tate Modern. He began by reminding them of a promise made before he was elected: that he would make the arts part of the 'core script' of government. He now suggested that the ten years since he had come into office would be looked back on 'as a "golden age" for the arts'.

> Imagine what the world would have been like if we had continued with the funding regime and the policies we inherited. Many of the country's finest regional theatres would have closed, or would exist as shadows of themselves on a diet of light drama. Many orchestras would have gone to the wall. There would be no new programmes for art education. Museums, far from being full, would have gradually diminished in importance as charging reduced the audience to the middle class. I'm not sure there would be a British film industry, or at least not one so healthy, or the same huge success at the National Theatre.[1]

And Blair was right. In 1997 the British cultural world had been in a decayed and fractious state, stale and starved of public funding. By

the time Blair's successor Gordon Brown left office, in May 2010, the scene was transformed. Government spending on the arts had nearly doubled, the removal of entry charges to all national museums and galleries had helped to raise the annual number of visits from 24 million to 40 million. There had been substantial help to regional museums. After years of neglect, the nation's cultural infrastructure had been refurbished and extended, from the Great Court of the British Museum to the Sage Gateshead. The National Lottery had been turned into an engine of urban regeneration. The film industry was flourishing; the BBC's Promenade Concerts were booming; regional theatres, the Royal Shakespeare Company and the National Theatre were adventurous, and their theatres full. Labour's 2010 cultural manifesto, *Creative Britain*, boasted that the 'creative industries' contributed 10 per cent of Gross Domestic Product.

Tate Modern was the obvious venue for Blair's speech. Although the project had started long before Blair came to power, and was made possible by the Conservatives under John Major, who in 1992 recast the funding of culture by launching the National Lottery, the opening of Tate Modern in May 2000 had been appropriated as an emblem of New Labour's success. The conversion of the decommissioned Bankside power station into a cathedral of contemporary art, facing St Paul's across the Thames, symbolized the alchemy that had taken place. Southwark was one of the ten most deprived boroughs in the country, and although Tate Modern 'produced' nothing, turning a derelict power station into a museum of modern art displayed the economic magic that cultural investment could make.

The early years of the twenty-first century seem even more of a golden age because they have been followed by an age of lead – the deepest and longest recession of modern times. The Conservative–Liberal Democratic coalition has vigorously pursued the cultural retrenchment begun in the last New Labour budget. Dominated by the Thatcherite values of the Conservatives, it has used the recession to pursue an alternative experiment in the management of culture. The arts and heritage will have to live with the consequences of that experiment for some time, unless there is a revision as a consequence of the general election in 2015.

Both the Blair boom and the Coalition response to the bust that followed offer lessons about the relationship between culture and society, and specifically about the relationship between culture and the state. It is significant that Blair should make a speech reflecting on the cultural achievements of his government; it is even more significant that this was his only speech on the subject during the ten years he was in power. Golden ages are rarely what they seem.

This is a book about culture in its traditional sense, meaning the arts and heritage, but it is also about the political economy of culture. There is a popular prejudice that politics and the arts should not have too much to do with each other; yet they have important things in common. They are both ways of making meaning. They are concerned with values, engage the emotions, and try to change minds. Above all, politics and the arts have a common interest in shaping a society's wider culture – culture, that is, not just as a way of life, but as a way of organizing life.

In 1997 Blair ended his preface to New Labour's arts manifesto with a paraphrase of William Blake: 'States do not encourage the arts; it is the arts that encourage states.' Politics appeared to be deferring to the arts, and after the neglect they had experienced under the Conservatives, people in the arts welcomed Blair's promise: 'For too long, arts and culture have stood outside the mainstream, their potential unrecognized in government. That has to change, and under Labour it will.'[2] The lesson of this is: be careful what you wish for.

New Labour's intention was to integrate the arts and heritage into a system of government that, for all the rhetoric about a new dawn of national renewal, continued the neoliberal programme established by the Conservatives. The collapse of communism after 1989 had led to talk in the West of the end of history and the end of ideology, but ideology had not disappeared. It was merely that a triumphant neoliberalism had become so all-pervasive and all-encompassing that other ideologies were silenced. It was now no more than common sense that the only way to increase the common good was

by maximizing individual freedom in the market. Since the market was the sole source of profit and progress, its operations should be expanded into all aspects of human life.

Through the unfettered interplay of supply and demand, the market would produce the most efficient distribution of investment, goods and services, and so realize the maximum individual utility. The search for financial profit drove the creativity of enterprises in their investment decisions; the achievement of profit made further investment possible. This thinking did not just apply to private enterprise. The rules of the British Treasury's *Green Book* stated that every government decision must be made on the basis of a cost/benefit analysis, where even those factors that could not be expressed in monetary terms had to be treated as if they *had* monetary value, by finding price proxies for them. The value of culture, however, does not depend on its price.

Because the doctrine of neoliberalism held that the market operated best without interference, governments withdrew from the market by selling off state-owned assets and utilities, and as far as possible creating markets where none had existed, such as within public health. Where government could not withdraw completely, it delegated responsibility to agencies that it expected to behave like private enterprises.

The operators of the market were able to penetrate and privatize so many areas of what had once been considered the public realm because neoliberalism was not just an economic theory. It was an ideology, a system of ideas that achieved cultural change through its appeal to a powerful and specific set of values. They can be encapsulated as individual freedom, creativity, and hedonism. Individuals should be free from the constraints of the collectivism encouraged by the previous social democratic consensus, and must be allowed to maximize their profits in the market, retaining as much of their income as possible for their own benefit. They would be able to do this by being able to exercise their individual entrepreneurial creativity and skills, while the market produced the optimum conditions in which this creativity could flourish. To encourage the circulation of commodities, there should be no constraints on individual

consumption, which would be managed by the law of supply and demand. Consumption encouraged production.

Another way of describing these values is selfishness, the pursuit of redundant novelty, and greed. The acclaimed freedom of individuals to behave unrestrainedly in the market enslaved them to the market, because it is only through the market that individuals can realize their creativity and measure their success. The very identity of individuals becomes a commodity, where the culture of consumption defines them by what they consume. The consumer is self-regarding, makes choices without reference to others, and seeks to maximize personal benefit over and against the common interest. 'Creative workers', especially, are persuaded that they are free because the transformative nature of their work – making the 'new' – appears to give them personal autonomy.

But, as the cultural critic Stuart Hall reminds us: 'Ideology is always contradictory.'[3] The freedom of the individual from the state depends on the state. The same applies to corporations. Both individuals and corporations rely on the state to guarantee private property, law and order, the integrity of money, and the freedom of the market. When New Labour set out to encourage individualism and release a new spirit of entrepreneurialism, it had to use the state to set it free. To achieve this, it had to bring about not just institutional reform, but a *cultural* change.

Culture would be the means to achieve the transformation of Britain: liberated from old bureaucratic procedures, lifestyle would govern a new politics of 'choice' that changed the individual's relation to the state and stimulated permanent innovation. Hence New Labour's rhetoric of 'creativity', and the invention of 'Creative Britain' – a phrase that resonates throughout New Labour's time in office. And who could be against creativity? Creativity is positive and forward-looking – it is *cool*, just as New Labour wished to be.

Creative Britain needed a creative economy in order to ensure the continuous innovation on which growth depended. This would be served by a 'creative class' whose occupation was the production of signs and symbols that could be consumed in commodified form. Creative Britain would be populated by young and eager

people, who, in spite of their techno-savvy, clung to the romantic image of the struggling artist, whose individualism would make the breakthrough that justified their insecurities and self-exploitation. Without the creatives, production and consumption would grind to a halt. They would regenerate the economy with imaginative start-ups, in what New Labour deliberately rebranded as the creative industries.

Britain's accumulated cultural capital would be set to work to drive the engine, not just of urban regeneration, where culture would revive the hollowed-out economies of post-industrial cities, but also of social regeneration. Issues of deprivation, educational dysfunction, community disintegration, and even crime would be magically transformed by the application of culture, both high and low. This social purpose was explicitly instrumental. Cultural production would generate employment; deprived communities would be transformed.

The capital needed to fund the project was cultural; its dividend would be economic. Publicly funded culture, where much of this capital had accumulated, would change from being the needy supplicant for costly subsidy to the grateful recipient of positive investment, and would drive the creative economy. As one of the backroom boys of this project, John Newbigin, special advisor to Blair's first secretary of state for culture, Chris Smith, has written, the arrival of New Labour marked the moment when the arts 'finally came of age as a mainstream concern of government and joined the Darwinian struggle for money and influence in Whitehall'.[4]

Cultural policy became part of economic policy. Culture was an industry, and its products a commodity. But as a means of production it proved difficult to manage. Artistic judgements are not easily made by committee, and creativity does not occur according to a five-year plan. As the architect Richard Rogers has observed, 'Civil servants and politicians in this country will always shy away from any discussion of even the most commonplace aesthetic values. Beauty makes our public servants nervous.'[5] New Labour's answer was to duck the aesthetic questions, and install a regime of targets, funding agreements and measurement intended to make the economic and social outcomes of their cultural investment predictable.

The price of the billions that New Labour directed towards the cultural sector was a Faustian bargain. In exchange for the money they needed, and which, with some exceptions, they used well, the arts and heritage had to submit to regimes of managerialism, instrumentalism, centralization and oversight that had little to do with their core purpose, and which hampered them in achieving it. When an individual or an organization is expected to take the risk of creating something new, there has to be trust in what they are doing. The process of target-setting and audit stifled the independence that was needed to engender the free-ranging creativity that cultural investment was supposed to make possible.

Cultural capital is a form of wealth that is determined by its value in use, not its value in exchange. Its value increases in proportion to its abundance, not its scarcity. It is enjoyed by individuals, but it is a mutual creation that uses the resources of shared traditions and the collective imagination to generate a public, not a private, good. Cultural capitalism seeks to privatize this shared wealth, absorbing it into the circulation of commodities, and putting it to instrumental use.

Contemporary British culture is conditioned by a process that began with the deindustrialization of cities, and the export of their functions and jobs to third world countries. Culture was then summoned up to repurpose those places and their people as contributors to cultural consumption. This started with the invention of the Heritage Industry, and reached its apotheosis with the conversion of an abandoned power station into one of the most visited tourist attractions in the world. The formerly oppositional art of the avant-garde was transmogrified into the fictitious capital that drives the international art market. Government intervened in culture in the hope of turning market failure into market success.

It was an act of cultural capitalism on a grand scale. It was followed by an even purer experiment in neoliberalism, as the Coalition abandoned any expectations of arts-driven social regeneration, and withdrew its support for publicly funded culture

in the hope that the market would provide. It remains to be seen if the market will provide, and whether what it provides has any value. In 2015 there will be an opportunity to pass judgement on both experiments. This book is intended to inform that judgement.

Under New Public Management

It is not part of our culture to think in terms of a cultural policy.
Senior official, Department of National Heritage, 1996

T
he 'golden age' of Creative Britain was presided over by a prime minister who showed little interest in the arts. It is the blunt opinion of the conservative columnist (and cultural politician) Simon Jenkins that Blair 'had no grasp of history, culture or ideas'.[1] At Oxford, Blair had played in a rock band and been a successful actor. He sometimes went to the theatre, but when he became prime minister he displayed overtly demotic tastes calculated by his press secretary Alastair Campbell to appeal to the tabloid newspapers, alarming the increasingly grumpy grandees who sat on the Boards of Britain's cultural institutions.

In 1998 John Tusa was in a unique position to voice the concerns of the arts establishment. A distinguished broadcaster and former head of the BBC World Service, he had become managing director of the Barbican Arts Centre. The Barbican was fully funded by the wealthy Corporation of the City of London, so Tusa was beholden to neither the government nor its agency, the Arts Council. In March 1998 – at a time when New Labour was maintaining the previous Conservative government's constraints on public funding

for the arts – he confessed in an article for *The Times*, 'I'm worried about Tony':

> The arts do not matter to him personally because they are a mar-
> ginal and thinly-rooted side of his own experiences. He is a true
> child of the sixties, the rock and pop world is the one he likes
> instinctively; he is simply not at ease in the arts world. His evident
> lack of esteem for it – as evidenced by the way his government
> treats it – springs from this essential personal discomfort.[2]

Tusa made a larger and more important point about the direc-
tion Blair's government was taking, something that concerned far
more than the cultural establishment: 'In backing "the arts that pay",
and overlooking and undervaluing "the arts that cost", Blair shows
himself to be the true son of Margaret Thatcher.'[3] Though the cre-
ators of 'New' Labour were reluctant to admit it, neoliberal ideas
had become the orthodoxy. The continuities between Blairism and
Thatcherism were such that the political scientist Colin Hay could
write, apparently without irony, that Blair's election was a return
to consensus politics in Britain – the consensus being that there
was 'simply no alternative to neoliberalism in a era of heightened
capital mobility and financial liberalisation – in short, in an era of
globalisation'.[4]

In order to make his party electable, Blair had abandoned the
collectivist values of old Labour and accepted the primacy of individ-
ualism, private enterprise and the market that had been established
under Thatcher. In his 1996 collection of speeches, *New Britain:
My Vision of a Young Country*, he argued: 'There will, inevitably, be
overlap between Left and Right in the politics of the twenty-first
century. The era of the grand ideologies – all-encompassing, all-
pervasive, total in their solutions, and often dangerous – is over. In
particular, the battle between market and public sector is over.'[5] To
borrow Francis Fukuyama's phrase, it was the end of history, and the
market had won. This did not mean the end of the public sector:
like Thatcher, Blair combined neoliberalism with a neoconservative
moralism that called for a strong, if smaller, state. The public sector

would have to conform to the principles of the market, accepting privatization and partnership with private finance. The Bank of England would manage the economy in the market's interests. The market demanded labour flexibility, so although the government signed up to the Social Chapter of the Maastricht Treaty, British trades unions regained few of the privileges they had lost under Thatcher. The government committed itself to tackling child poverty and established a minimum wage, but the welfare state would have to face 'modernization'. Initially New Labour kept to the tight spending plans of the defeated Conservatives – bad news for the cultural sector, which depended on public funding to sustain the activities and institutions that fed the commercially profitable leisure industry.

Although his themes were developed in opposition, it was not until Blair was in power that he found the right label for the new politics that he was practising. The brand he wanted to promote sounded ominously like a New Age management theory: the 'Third Way'. This sought to go, as argued in the title of a book by Blair's policy guru, the director of the London School of Economics, Anthony Giddens, *Beyond Left and Right*. Blair made this clear in a pamphlet for the Fabian Society in 1998: *The Third Way: New Politics for a New Century*: 'It is a third way because it moves decisively beyond an Old Left preoccupied by state control, high taxation and producer interests; and a New Right treating public investment, and often the very notion of "society" and collective endeavour, as evils to be undone.'[6]

Blair explicitly accepted Mrs Thatcher's 'necessary acts of modernization',[7] and declared that the era when big government meant better government was over. Leverage, not size, was what mattered – leverage applied through the market: 'With the right policies, market mechanisms are critical to meeting social objectives, entrepreneurial zeal can promote social justice.'[8] Through an approach that he called 'permanent revisionism', Britain would achieve a 'dynamic knowledge-based economy founded on individual empowerment and opportunity, where governments enable, not command, and the power of the market is harnessed to serve the public interest'.[9]

The ideal of the 'enabling state' presiding over a strong self-governing society implied the decentralization and increased local

autonomy that he had advocated in *New Britain*. As the political scientist Alan Finlayson put it, government became like a head office, franchising out its operations to agencies that were allowed to operate independently, but always subject to rules from above.[10] Blair's pamphlet warned: 'In all areas, monitoring and inspection are playing a key role, as an incentive to higher standards and as a means of determining appropriate levels of intervention.'[11]

Like David Cameron's Big Society, Blair's Third Way did not catch on with the general public, and was treated with considerable scepticism by the press. The critical discourse analyst Norman Fairclough dismissed the government's use of linguistic sleight of hand as 'Thatcherism with a few frills'.[12] The political scientist David Marquand identified the continuities early on:

> Like the Thatcher governments before it, New Labour espouses a version of the entrepreneurial ideal of the early nineteenth century. It disdains traditional elites and glorifies self-made meritocrats, but it sees no reason why successful meritocrats should not enjoy the full fruits of their success: it is for widening opportunity, not for redistributing reward. By the same token, it has no wish to undo the relentless hollowing out of the public domain or to halt the increasing casualisation of labour – white collar as well as blue collar – that marked the Thatcher years.[13]

This did not mean that there was no such thing as society; New Labour's version of neoliberalism was the 'stakeholder society', where the individual earned the right to reward by active participation and investment in the values of 'the community', made possible by the enabling state. According to Blair, this was not socialism but – breaking apart the word that attached his party most firmly to its roots – 'social-ism',[14] which would free Labour from its history. As the political scientist Mark Bevir puts it, 'New Labour's Third Way is one of competitive individualism within a moral framework such that everyone has the chance to compete. It feeds hefty doses of individualism, competition, and materialism into the traditional social democratic ideal of community.'[15]

But in spite of the apparent freedom for individual and collective enterprise offered by the enabling state, and Blair's assertion of the need for devolution and the revival of local government, New Labour was not prepared to release the levers of control, and busily developed new ones. When it came to the relationship between the centre and the periphery, between London and the regions, between national and local government, the centre stayed in charge.

Yet, although London exerted a powerful centripetal force, separate national and regional cultural identities remained strong. Scotland retained its own legal and educational systems; Wales held on to its language; Northern Ireland defined itself by its separation from the mainland and its sectarian divisions. The great nineteenth-century commercial and industrial centres – Belfast, Birmingham, Bristol, Cardiff, Edinburgh, Glasgow, Leeds, Liverpool, Manchester, Newcastle, Sheffield, together with many other towns and cities – had created their own museums and art galleries, orchestras and theatres, that were just as worthy of support as the 'national' cultural facilities in London, and could produce work of as high a standard.

The cultural infrastructure depended on elected local authorities, which varied in size and responsibility from large urban metropolitan authorities to small district councils in rural areas. These owned and supported the majority of the buildings – other than most cinemas and a few theatres – where cultural activity took place, but, with the exception of a legal obligation to provide a public library service, local authorities had complete discretion over cultural spending, and no central government support.[16]

As a result, the financial contribution by local authorities to culture was uneven, and it is emblematic of the fragmented nature of the system that it is very difficult to arrive at an accurate total. In 2009/10, the combined sum for spending by English local authorities on arts, leisure (including sport), heritage, museums and libraries peaked at £3.5 billion. Defined more narrowly, when New Labour came to power the aggregate of local authority revenue spending on activities corresponding to those funded by the Arts Council was

put at £190 million a year.[17] This was marginally more than the Arts Council's contribution, but represented less than 1 per cent of total local authority expenditure.

The nominal parity of local authority and Arts Council funding streams to the same organizations led to an expectation by the Arts Council that it could use its grants to leverage matching local authority funding – but there was a crucial difference in motivations. Ever since its formation in 1945, the Arts Council had supported the arts for what it saw as aesthetic reasons – that is to say, what it believed to be the intrinsic value of the art forms themselves. Local authorities, however, were looking for directly beneficial social and economic outcomes – an instrumentalism that New Labour would adopt and extend.

New Labour's attitude to the dispersal of power away from the centre was contradictory. It granted a form of self-government to Scotland and Wales, and returned it to Northern Ireland; it gave responsibility for London to a directly elected executive mayor. Yet local government was subjected to the same kind of centralizing Treasury control as Whitehall ministries. Local authorities were swamped by zones, pilots and initiatives, and demands for plans and strategies, and subjected to multiplying regimes of inspection. Local government had already lost much of its autonomy under Thatcher, and regardless of New Labour's talk of reviving regionalism, central government was reluctant to surrender the powers it had gained. In spite of the government's 'New Localism', its attempts to decentralize power were limited.

Because New Labour raised spending on public services, local authorities received substantial increases in their budgets, and so appeared to be less oppressed than during the Thatcher years. But only about 20 per cent of their spending was locally financed, making them increasingly dependent on central government. In 1999 the 353 local authorities in England were told to develop local cultural strategies, but there was no move to make their cultural spending statutory. Between 1981 and 1986, as leader of the Greater London Council, the municipal socialist Ken Livingstone had demonstrated the way in which a local authority could use the cultural resources at

its disposal. When he returned as the first elected mayor of London in 2000, he found that the new Greater London Authority was responsible for policing, planning and transport, but had little of the cultural clout of the GLC before its abolition, and an arts budget of less than £250,000 a year.

Within England, New Labour established nine administrative regions, each with a Regional Development Agency (RDA) whose members were appointed by government, and 'supported' by appointed regional chambers made up of local authority members and other interested parties. The intention was to follow these with elected regional assemblies, but after a local referendum rejected proposals for an elected assembly for the north-east region in 2004, New Labour lost interest in regional government. Blair's frustration that Ken Livingstone beat the official Labour candidate to become mayor of London as an independent added to the government's disenchantment with regional democracy. The purpose of the RDAs was economic development: cultural projects, co-funded by the National Lottery, local authorities and the European Union, were given a leading role in urban regeneration schemes.

The overweening urge to centralize policy decisions in Whitehall was yet another manifestation of the theory of government known as the New Public Management, which had developed over the eighteen years of the Thatcher and Major administrations. The idea was to bring greater accountability to the management of public services by establishing measures of performance and contractual relationships between departments and agencies based on the principle of Value for Money, which would be judged by the three 'Es' of Efficiency, Effectiveness and Economy. In 1991 the editor of *Public Administration*, R. A. W. Rhodes, gave a capsule definition of the New Public Management: 'The disaggregation of public bureaucracies into agencies which deal with each other on a user-pay basis, the use of quasi-markets and contracting out to foster competition; cost cutting; and a style of management which emphasises, among other things, output targets, limited term contracts, monetary incentives and freedom to manage.'[18]

In neoliberal fashion, government departments and the 'Next Steps' agencies that increasingly took on their responsibilities were now expected to behave less like disinterested, hierarchically structured bureaucracies, and more like wealth-creating corporations competing in a market for resources. Yet, although the intention was to achieve the freedom of manoeuvre and efficiency attributed to the market, in practice those responsible for delivering public policy became more constrained. Strategic plans had to be prepared, objectives identified, benchmarks set, targets established, measures agreed and impacts assessed.

The master of the system was the Treasury. It decided the spending allocations of the other ministries, and favoured those that achieved their targets. In turn, the ministries were expected to develop their own processes of contract and audit with the agencies they sponsored. All of this called for more and more audited 'evidence' demonstrating that what was supposed to be done was being done, that targets were being met and milestones passed.

The Third Way did not make its mark, but the process that it described – a trade-off between the state and the market that also sought to bring in the voluntary sector (thus anticipating Cameron's Big Society) – became embedded in the process of government. It acquired a less appealing name: 'managerialism'. The New Public Management meant that the discipline and values of the market were applied to the formerly impersonal, politically and socially neutral, world of public service. The whole of government – and especially the welfare state – would be restructured along the lines of business practice.[19]

Yet, although every aspect of government would be focused on achieving maximum efficiency and economic return, the market would be left to its own devices. The control of interest rates was immediately outsourced to an independent committee of the Bank of England; the financial services industry was allowed 'light touch' regulation; and Blair's Svengali Peter Mandelson could declare, with his characteristic mixture of suavity and menace, that New Labour was 'intensely relaxed' about people getting filthy rich – as long as they paid their taxes.[20]

Just over a year after taking office, New Labour completed its first Comprehensive Spending Review, a process of bargaining, arm-twisting and special pleading through which every government department agreed its budget with the Treasury for the next three years. Each ministry signed up to a formal Public Service Agreement (PSA), which set out specific departmental objectives and measurable performance targets. Decisions about policies and programmes would be taken on the basis of a cost/benefit analysis of alternative options – a process codified in the Treasury's regularly updated manual, *The Green Book*.[21]

In March 1999, the ideology of managerialism was given a New Labour spin in the White Paper *Modernizing Government*, which sought to instil 'joined-up government' by encouraging partnership working and 'cross-cutting initiatives'. Making these work, however, called for increased monitoring and target-setting, just as Blair had promised in his *Third Way* pamphlet. In the same month the Treasury set out how it would measure and monitor success against the targets agreed in the 1998 Comprehensive Spending Review.[22] The Treasury wanted to avoid the humiliation it had experienced in 1976, when the International Monetary Fund had moved into Whitehall to rescue the British economy, and was determined to maintain absolute control over the levers of government. The dynamics of New Labour, where Blair ceded so many areas of domestic policy to his possessive rival, the chancellor Gordon Brown, made it even more powerful. Blair's commitment to monitoring and inspection in all areas was one promise that would be kept.

But there was an area of government that was used to a less restricted, indeed neglected, existence. After leaving office, New Labour's first secretary of state for culture, Chris Smith, ruefully admitted that, as far as funding the arts was concerned, the Treasury was not interested in 'the intrinsic merits of nurturing beauty or fostering poetry or even "enhancing the quality of life"'.[23] The department that Smith was put in charge of in 1997 was the newest, and least influential department of state, with a staff of 400 administering a budget of around £1 billion, representing less than half of 1 per cent of total

government expenditure. It had little direct control over what money it did have, because it was obliged to pass on 95 per cent of the funds that it received to be dispensed by the so-called Non-Departmental Public Bodies (NDPBs), such as the national museums and the Arts Council. With the exception of broadcasting and the National Lottery, the writ of the Department for Culture Media and Sport (DCMS) ran only in England. Northern Ireland was managed separately, while Scotland and Wales had enjoyed a form of cultural autonomy, with their own Arts Councils, since 1994. This became complete when Blair fulfilled Labour's manifesto commitment to establish a Scottish parliament and a Welsh assembly with their own cultural ministries.

Before New Labour, 'culture' – even in its more restricted sense as the arts and heritage – had been an uncomfortable word for British legislators. The few politicians who had any interest in the subject remembered Queen Victoria's prime minister, Lord Melbourne, who warned in 1835: 'God help the minister that meddles with art.' Although parliament established the British Museum in 1753, and a Department of Science and Art in 1853, the state only began to fund the performing arts in 1940. The first (very junior) minister for the arts was not appointed until 1964, and the first policy document, *A Policy for the Arts: The First Steps*, appeared in 1965. The indefinite article in its title showed how hesitant these steps were, but they were the beginning of a process that slowly brought cultural issues closer to the heart of government.

Since the financial crises of the mid-1970s, the gradual rise in government spending on the arts and heritage had reached a plateau. Under Thatcher the neoliberal drive to stimulate an 'enterprise culture' encouraged an increase in business sponsorship of the arts, but the only significant new cultural building project of her years was the British Library, which finally opened in 1998, long overdue and far over budget.

In 1992 Thatcher's successor John Major bundled the disparate cultural responsibilities of half a dozen ministries together to form a single government department, the Department of National Heritage, headed for the first time by a minister of cabinet rank. But

the possibility that it would be 'the big beast' that the first secretary of state, David Mellor, had intended it to be was soon dashed, when Mellor was forced to resign over a sex scandal, and his successors – three in five years – had little leverage on the Treasury. Mellor's 'ministry of fun' became the Department of Nothing Happening, but it did establish the National Lottery, which had the potential to transform the cultural landscape – and at a profit rather than a loss to the state, as a new source of tax revenue.

The National Lottery Act was passed in 1993. Its purpose, according to the 1992 Conservative election manifesto, was 'to restore the fabric of our nation'.[24] Management of the Lottery was licensed to a private company, Camelot, which paid out 50 per cent of the stakes to the winners. Once Camelot had covered its costs and taken a 5 per cent profit, and the government had taken its 12 per cent slice in gambling tax, the remaining money was handed over to five non-departmental public bodies to act as distributors. Three existed already: the Arts Council of Great Britain (subsequently separated into the four national Arts Councils); the Sports Council; and the National Heritage Memorial Fund, established in 1980 to protect the built and natural heritage. Two were new creations: the Millennium Commission, intended to have a short life leading up to the close of the millennium celebrations in 2000, and a Charities Board, to give money to voluntary organizations working for the benefit of the community.

This potentially revolutionary instrument was treated timidly. The rules severely hampered the way the distributors to the Lottery's five 'good causes' could operate. They were required to follow the convention that funders did not initiate projects, but merely responded to requests for help. The first set of government policy directions excluded the distributors from devising their own strategies for where the money should go, and they were not allowed to solicit applications for funds. They could only assess whatever bids came in, with the result that national planning was impossible. The millions of pounds that the distributors suddenly had to disburse also put a strain on their internal structures. The National Heritage Memorial Fund grew from an organization of seven to 250, in order to manage the

Heritage Lottery Fund, and the other cultural bureaucracies also burgeoned. The Arts Council's monthly council meetings now took two days, with an extra day for those also serving on the Lottery panel.

The principal drawback, however, was that Lottery money was only available for one-off capital projects – chiefly new buildings or restored old ones. This seemed sensible at the time, because it emphasized that the Lottery was a separate and additional funding stream to the Treasury's grant-in-aid, but as the former director of the National Theatre, Richard Eyre, pointed out, the consequence was that the arts 'appear glutted with cash for substantial capital developments while they are famished for funds to sustain the work for which arts organizations exist. They are the proud tenants of bright shining buildings in danger of becoming as redundant as stainless steel kitchens in a famine.'[25]

For the arts, that famine was becoming real. The lack of government leadership in cultural matters is illustrated by a comment to the *Sunday Times* in 1996 by a senior civil servant at the Department of National Heritage: 'It is not part of our culture to think in terms of a cultural policy.'[26] In this vacuum, day-to-day policy was left to the agencies that operated on the ministry's behalf. In the absence of any overarching vision, decisions about which organizations should get what were based on the passive principle of 'historic funding' – what they had had the year before, plus or minus a few per cent.

Central government was also bound by the 'arm's-length' principle, which was intended to set a prudent distance between politicians and cultural decisions. Although the actual term only came into use in relation to the arts and heritage in the 1970s, the convention that politicians should not meddle with the arts had its origins in a ruling idea with roots in the eighteenth-century Enlightenment. This is the proposition that culture occupies a separate and autonomous sphere, where the universal and eternal values of art transcend those of politics or the market. Although it is true that the arts are generally pursued for other than monetary or directly political reasons, the autonomy of art and its irrelevance to questions of power is a convenient idea if your class or social capital already gives you access to culture.

Until the 1990s, the consensual view was that art should enjoy a conditional autonomy, but the apparent willingness of post-war Western governments disinterestedly to support the arts, even oppositional arts, for their own sake was less innocently benign than it appeared: culture was a key weapon in the Cold War, and it was in the interest of Western governments to afford artists the maximum degree of freedom, as a contrast to the oppression of China and the Soviet Union.[27] With the end of the Cold War, governments needed a new justification for supporting the arts, and the covert instrumentalism of propaganda became the overt instrumentalism of social and economic regeneration.

The arm's-length principle framed the administrative convention that, in the cultural sector, non-departmental public bodies made their operational decisions independently of government, and that government ministers were not answerable in parliament for those decisions. Like most conventions, it required trust and good will to make it work. The Arts Council, for instance, was independent of government by virtue of having been established, not by parliament, but by Royal Charter. The same is true of the BBC. Nonetheless, as with the BBC, the members of the Council who were responsible for its policy, and who appointed the people who executed it, were themselves appointed by the government, which took a close interest in their selection. From the 1940s to the 1970s, there had been an understanding that there were men (and a few women) of experience and social position – 'the Great and the Good' – who could be trusted to run things on the government's behalf without direct interference. This was mainly because, as the cultural critic Raymond Williams observed when he served on the Council, they instinctively knew what the government wanted and could be relied upon to deliver it.[28]

Thatcher's hostility to the traditional establishment caused that comfortable consensus to begin to break down, while the recognition of the economic importance of the arts and their role in urban regeneration gave politicians an instrumental reason for taking a more active role. The creation of the National Lottery led to the establishment in law of 'ministerial directions' that set out the responsibilities

of the Arts Council and other Lottery distributors in terms of the secretary of state's wishes.

In 1995 the Department of National Heritage took a first step towards a more contractual relationship between itself and those it sponsored, by establishing funding agreements that set out in broad terms what the organizations that it funded would do with its money. As with ministerial directions to the distributors of National Lottery funds, this was a shortening of the distance between government and agency – but the politicians and their appointees continued to insist on the sanctity of the arm's-length principle. Under New Labour, its length would become a great deal shorter.

The consensual bargain represented by the arm's-length principle helps to explain a singular contradiction that made state management of the arts and heritage a different proposition to its counterparts anywhere else in government: whereas in other areas of the economy the effect of the post-war welfare state settlement had been to redistribute resources from the rich to the poor and uneducated, in the arts the flow has been in the opposite direction – general taxation was subsidizing the recreations of the educated and the rich. The National Lottery works in a similar way.

The problem was succinctly outlined in an essay published in 1996: 'The consistent theme about Britain's cultural policy not only since 1945, but probably long before, has been its exclusivity: the overwhelming skew of funding to the pleasures of the elite, to London and to traditional art forms, and the deep hostility to any form of democratisation.'[29] Left to its own devices by governments that made a propaganda virtue of artistic freedom, and protected by the arm's-length principle, the arts establishment had been able to define culture in its own terms and direct resources in its own interests. This official support for what became known as the 'cultural sector' was, in effect, the price of the intelligentsia's cooperation with the state. They had filled the policy vacuum, and New Labour would have a hard job changing things. The answer would be to try to co-opt cultural organizations as agents of social control.

The author of the essay, Geoff Mulgan, was an influential thinker who was to become even more influential in the years to come – a member of the growing tribe of 'policy wonks' who would move from think tanks to advisory roles in government and, in some cases – like David and Edward Milliband – to high office. But Mulgan chose to exercise his influence at one remove. A Balliol graduate, he had begun his political life on the far left, but his time studying Buddhism in Sri Lanka appears to have given him a sense of critical distance between the theory and practice of politics. In the 1980s he worked for the radical pop music collective Red Wedge, as a journalist and academic, as a European Community bureaucrat, and for the Cultural Industries Unit of the Greater London Council. His later career would take him to the heart of government, and then out the other side – back into the world of think tanks, where he seemed happiest to operate.

Mulgan's essay bore the marks of his experience with the GLC. He saw that information technologies and a new culture of consumption had changed the terms of the debate: 'by ignoring the dynamics of modern culture, of how it works in an age of mechanical reproduction and electronic transmission', cultural policy had retained only a marginal impact on contemporary culture[30] – culture, that is to say, as it was actually lived by most people, and not 'legitimate' culture as defined by an aristocratic form of patronage that did not have to justify itself to the public. He clearly had in mind the Arts Council's subvention of largely pre-twentieth century art forms.

Because of the left's traditional suspicion of commercial culture, as in the writings of Richard Hoggart and Raymond Williams, there was an innate tendency to support a Reithian view of culture that favoured the high arts, while ignoring the forms of cultural expression with which most people engaged. Mulgan summed this up as a divide 'between a sphere of independent production and ... a tightly controlled, class-based, sphere of public funding, organically linked through boards of the great and the good to the elite of London'.[31]

It was evident to Mulgan, as it was to others, that most of contemporary culture was entirely comfortable in the commercial sphere in which it largely operated, and that many consumers were not too

concerned about the fate of the older forms that the Arts Council preserved – including the idea of the avant-garde. At the same time, however, the breakdown of the post-war consensus under the pressures of neoliberalism and the upsurge of a more democratic – or at least populist – consumer culture had led to a crisis of aesthetic authority for the elite that spoke the language of 'excellence'. Any loss of that authority could lead to questions about how and why public money was being spent.

The collapse of a hierarchical model of culture that placed decisions in the hands of specialist experts had profound implications for the state management of the arts, especially when it was the elite arts that received the overwhelming proportion of its funding. To retain legitimacy, a new reason had to be found for the state to fund the arts and heritage at all. This was a question that Mulgan would try to address when, having managed Gordon Brown's office in the run-up to the 1992 election, in 1993 he became director of a new think tank, Demos – and then, when Labour came to power, moved to the Downing Street Policy Unit.

The accuracy of Mulgan's analysis of the power of the Great and the Good to manage cultural affairs in their own interest was demonstrated within days of New Labour coming into office, when that most elite of cultural institutions, the Royal Opera House (ROH), threatened to go bankrupt.

Ever since 1945, when the economist John Maynard Keynes had secured agreement to the creation of the Arts Council of Great Britain, which he would chair, and the establishment of a new organization funded by the Council to run Britain's premier opera house, the Covent Garden Trust, which he would also chair, there has been an incestuous relationship between the most patrician British arts organization and its principal public funder. It was no surprise to anyone that, as soon as Lottery money became available, one of the Arts Council's first awards should be £78.5 million towards a £213 million redevelopment of the buildings at Covent Garden. The popular press took delight in drawing attention to this generous contribution by working-class punters to the pleasures of the toffs.

It also happened that, in 1996, the chairman of the Arts Council's advisory Lottery panel that had made the award, the public relations magnate Lord Chadlington, brother of a Conservative minister, moved over to become chairman of the Covent Garden Trust. One favour deserves another.

This would not be the only large-scale Lottery project to expose the financial and managerial weaknesses of an indulged organization. In 1997, as it prepared to close for rebuilding, the Royal Opera House was carrying a current account deficit of £4.5 million. It had always relied on the advance sale of tickets for its cash flow, and this income had virtually dried up with the closure of the main house. Having failed to establish an alternative temporary home, its opera and ballet companies were embarking on a precarious nomadic season of performances elsewhere in London. As a peer of the realm and the chairman of Sotheby's, the chairman of the Arts Council, the former Conservative arts minister, Lord Gowrie, was ill-placed to defend handouts for toffs. Nonetheless, in April 1997 he told the *Sunday Times* that the closure plans for Covent Garden were 'a shambles'.[32]

The situation became even more of a shambles on 13 May, when Genista McIntosh, a skilled administrator who had joined the Opera House from the National Theatre only in January, suddenly resigned 'due to ill-health'. She later told the House of Commons Culture Committee that it was because of being extremely unhappy at the infighting and incompetence she had encountered, and that she had been asked to leave. The surprise of her resignation was followed by an even greater one: McIntosh's replacement would be none other than the chief executive of the Arts Council, Mary Allen, who had been through no formal job application or interview process. Lord Gowrie pronounced himself gobsmacked, and this apparent betrayal seems to have contributed to his decision to announce his own resignation, effective from April 1998, two years short of the end of his expected term.

Only four days after becoming secretary of state, Chris Smith had been bounced, establishment fashion, into accepting Allen's appointment, by a Labour-supporting member of the Opera House board, Lord Gavron. Smith's difficulties were exacerbated by a parallel

Lottery-induced crisis at English National Opera (ENO), when in September its general director, Dennis Marks, resigned because of the rejection of his proposal that ENO should leave its home, the Coliseum in St Martin's Lane. In November, faced with a parliamentary enquiry by the House of Commons Culture Committee, Smith launched the suitably New Labour–sounding idea of a 'People's Opera', to be created by having ENO and the Royal Opera House share the facilities of Covent Garden. The former director of the National Theatre, Richard Eyre, was commissioned to conduct a review, but Smith's proposal was a non-starter. By the time Eyre's report appeared, in June 1998, underlining 'the arrogance and presumption' of the Royal Opera House Board,[33] the semi-merger had been abandoned.

Eyre made it clear that the scandal at Covent Garden had brought the whole arts funding system into disrepute. He warned that it might be tempting for the government 'to regard the lack of financial accountability and the failure of control by management and the Arts Council as sufficient evidence that the arts world will mishandle whatever subsidy it gets, and therefore should be saved from its natural profligacy and fecklessness by being made to stand on its own feet, unsupported by state subvention'.[34] New Labour did not take that view, but there were politicians on the right who did.

Mary Allen's diary, *A House Divided*, shows that, while she may have been eager to abandon her 'grindingly impossible job' at the Arts Council,[35] she had transferred to 'an organizational Gormenghast – everything takes place just out of sight'.[36] As the deficit rose to £5.5 million, and the Royal Opera House faced insolvency, Allen and her Board's position was made even less comfortable by the Culture Committee enquiry, chaired by the grandstanding MP Gerald Kaufman. While the Arts Council refused to publish more than a summary of its own internal investigation, which showed that it had kept no proper financial control of the Lottery grant, the conclusions of Kaufman's committee, published in December, were forthright: 'There is no future for the Royal Opera House unless someone accepts responsibility for the sorry train of events.'[37] It would be better to see the Opera House run by a philistine with financial skills than by the opera and ballet lovers who had brought it to its knees.

As was demanded, both the ROH Board and Allen resigned – but Allen's resignation was refused, and she hung on until May 1998. The new chairman, Sir Colin Southgate, head of the music conglomerate EMI, did Covent Garden no favours by a remark at his first press conference about not wishing to go to the opera and sit next to someone in shorts and smelly trainers. But the whole episode showed that there was no way that the government could afford to let the Royal Opera House go bust.

Establishment ties were too strong. Southgate demanded more subsidy, which he got, and the crisis was averted. An American administrator, Michael Kaiser, oversaw the successful reopening of the refurbished Covent Garden at the end of 1999. He too left unexpectedly early in 2001, but the appointment of the former head of BBC News, Tony Hall, as chief executive, followed by that of Antonio Pappano as music director in 2002, opened a much more successful era in terms of management and performance. In 2013, following a crisis of leadership at the BBC, Hall returned to the corporation as director-general.

The scandal of Covent Garden showed that the old ways of doing things would have to change, and although the Royal Opera House has retained its privileged position as the Arts Council's largest client (receiving £26.5 million in 2014), it was forced to adapt to the rhetoric of access promoted by New Labour. Chris Smith came into office promising 'to make things of quality available to the many, not just the few'.[38] But to make that a reality, he had to assert the authority of his department, which in the case of Covent Garden he had not been able to do. He also had to extract more resources from the Treasury.

The question of resources would not be resolved until the 1998 Comprehensive Spending Review ended New Labour's commitment to Conservative spending plans. But before that there was an urgent need to rebrand the department. The change of name from Department of National Heritage to Department *for* Culture, Media and Sport (my italics) was profoundly ideological. The rhetoric of heritage had helped to speed the Thatcherite counter-revolution by wrapping a ruthless programme of deindustrialization in the

comforting notion of a return to Victorian values; but now, as Chris Smith explained, they wanted to demonstrate their modernity by not being afraid 'to use the title culture'.[39]

The proud deployment of the word by the DCMS – an unacknowledged victory for Raymond Williams and other advocates of 'cultural studies' – was so much more democratically embracing than the implicitly elitist term 'the arts', even if this suggested that sport – an important populist signifier in the title – was not also culture. Dropping 'heritage' meant that, throughout the Blair/Brown years, heritage organizations – notably English Heritage – would feel unfairly treated. The word 'media' was not simply a reference to the Department's role as a regulator of broadcasting and the setter of the annual licence fee that paid for the BBC. The economic and technological convergence between culture and media was the driver of what Smith claimed was a 'whole industrial sector that no one hitherto has even conceived of as an "industry"'[40] – the cultural industries.

This freshly named department was expected to write the arts and culture into the 'core script' of government. At Tate Modern in 2007, Blair explained that he had meant that culture 'was no longer on the periphery, an add-on, a valued bit of fun when the serious work of Government was done; but rather it was to be central, an essential part of the narrative about the character of a new, different, changed Britain'.[41]

To conform to this new narrative, after 1997 the previously semi-autonomous field of culture was subjected to two radically different redefinitions. The first was that the arts and heritage were repackaged as part of a new economic phenomenon – the 'cultural and creative industries'. They were commodities whose subsidy was justified because they were the drivers of a much larger process of cultural consumption, initially branded as 'Cool Britannia'. The invisible hand of the market would guide the delivery of culture in the most cost-efficient way, while also delivering dividends to the state.

The second redefinition of the arts and heritage tried to address the awkward fact that not only access to the market, but access to the arts and heritage, was unequal, because of the unequal distribution of social, educational and cultural capital. Although it is rarely

expressed in these terms, culture – formally understood as the arts and heritage – has always had a social purpose that justifies government support and intervention, albeit at arm's length: it is an expression of national identity, a means to achieve social cohesion, and it ultimately carries moral value. This mission was now made explicit: it was to combat a new phenomenon, 'social exclusion'. The arts and heritage were to be put to the purpose of 'delivering key outcomes of lower long-term unemployment, less crime, better health and better qualifications'.[42]

This placed previously unheard-of expectations on the arts and heritage. For the first time under any government since 1940, when the wartime administration's establishment of the Council for the Encouragement of Music and the Arts explicitly recognized a role for culture in public policy, the ministry responsible for delivering the government's cultural objectives could not expect to be treated as a peripheral department, or an occasional contributor at the cabinet table. Culture would be placed at the service of the economy and the government's social agenda, and the backwaters of the arts and heritage would be swept into the mainstream of public policy, with all the turbulence that created.

Cool Britannia

Culture creates wealth.
Creative Nation, 1994

In 1995 Tony Blair flew to Australia to address the top executives of Rupert Murdoch's News Corporation, gathered for their annual conference at the exclusive Queensland resort, Hayman Island. Such was the power of the press over political parties in Britain in the 1990s – and beyond. Blair's appearance, where he assured News Corporation that the battle between the market and the public sector was over,[1] helped to win the Murdoch media's decisive support as he headed towards the general election of 1997. It also had important consequences for New Labour's policy on the arts.

Charged with developing this policy were the opposition spokesman Chris Smith and the shadow arts minister Mark Fisher. Smith, who had a Cambridge doctorate for his work on William Wordsworth, was an unusual politician in that he was an intellectual with a genuine love for the arts, and his enigmatic exterior concealed a determination to change the cultural landscape. He was respected for being the first MP to come out as gay. A Christian Socialist, he was an early supporter of Blair's party leadership bid. Fisher was only one of two sitting Labour MPs who had been to

Eton, and had worked in theatre and film before moving into further education.

The plan had been to launch their policy proposals in September 1995, but during Blair's trip to pay homage to Murdoch he had been shown a report, *Creative Nation*, published by the Australian Labour government the year before. Accustomed to protecting their local industries from overseas competition, the Australians approached the management of culture in the same way, treating it as a matter of industrial policy. While acknowledging the importance of the arts and heritage in terms of national identity and social value, *Creative Nation* declared: 'This cultural policy is also an economic policy. Culture creates wealth.'[2] Blair was impressed, and Smith and Fisher were sent back to the drawing board.

New Labour's cultural manifesto, *Create the Future*, was published in March 1997, just a couple of weeks before the election that put the party into power. *Create the Future* was the product of much discussion in Labour's more cultivated circles. Mark Fisher worked with the Labour-supporting architect Richard Rogers on developing design and urban policy, and another Labour supporter, the film producer David Puttnam, used the resources of his company Enigma Productions to promote policy ideas. He employed John Newbigin, a former speechwriter for Labour's last leader but one, Neil Kinnock, and Ben Evans, son of the future education minister Tessa Blackstone. Evans had worked as a researcher for Mark Fisher and an advisor to the chair of English Heritage, Jocelyn Stevens.

In the autumn of 1995 an informal, self-styled 'Group' began meeting at the houses of Puttnam and Rogers, drawing in the broadcasting figures Melvyn Bragg, Alan Yentob and Michael Grade; the advertising mogul and chair of the Design Council, John Sorrell; the urbanist Sir Peter Hall; the director of the National Theatre, Richard Eyre; and the Conservative advertising guru Maurice Saatchi. Dominated by people in the media, the Group were already key players in a network of commercial – but also cultural – activities that were reconfiguring the relationship between the arts and wider cultural consumption. This is where Creative Britain was conceived.

In the 1930s, the term 'culture industry' had been used pejoratively by the Marxist theorists Theodor Adorno and Max Horkheimer, who saw the commercialization of popular culture as a form of mass deception and exploitation,[3] but in the 1980s writers on the Left began to argue that industrial forms of production now dominated cultural consumption, and that this presented a healthy challenge to traditional, class-bound, hierarchical definitions of culture. The idea of shifting the emphasis from the privileged producers of culture to its consumers was particularly attractive to the intellectuals who gave advice to, and found work with, Ken Livingstone's Greater London Council. A GLC Cultural Industries Unit was set up, and it was here that Geoff Mulgan developed his critique of the elitist distribution of cultural funding. In 1986 he and a colleague in the unit, Ken Worpole, published an unofficial cultural manifesto, *Saturday Night or Sunday Morning?*, arguing that the Labour Party should take advantage of the emergence of this new phenomenon to establish an entirely new approach to culture:

> The phrase 'cultural industries' is not just a fashionable catchword. The forms of culture which the majority of people now use and through which they understand the world – radio, television, video, cable, satellite, records and tapes, books and magazines – are produced by industrial processes no different from any others. What was once thought of as the ideological superstructure has now become a significant part of the economic base.[4]

The idea that culture drove the economy, rather than was driven by it, was fundamental. The GLC's Cultural Industries Unit sought to harness the economic power of cultural consumption, while setting out a materialist challenge to the conventional Arts Council approach to what constituted culture and how it should be managed. Potentially, it was a fresh argument for funding the arts, but the cultural industries argument also meant that the values of high culture were subjected to the low impulses of the market: culture became more 'democratic', but the democracy was the unequal democracy of the marketplace.

Treating culture as a business not only encouraged an undiscriminating populism; it also played into the Thatcherite idea of an 'enterprise culture' that used the arts and heritage as a catalyst for urban regeneration by stimulating domestic and international tourism. The decision to make Glasgow European City of Culture in 1990 – Glasgow being a city that, unlike previous choices such as Paris, was not thought of as a cultural destination – led to a remarkable makeover of the city's image, and set an example for the rebranding of cities through cultural investment.[5]

In 1998 an influential report by the cultural economist John Myerscough, *The Economic Importance of the Arts in Britain*, calculated that the cultural sector had a turnover of £10.5 billion a year, and directly employed almost half a million people. The cultural industries, as Myerscough chose to define them, contributed 1.28 per cent of Gross Domestic Product (GDP), roughly the same as the motor industry.[6] By 1997, not only had traditional manufacturing further declined, information technology had developed to the point where it was possible to talk, as Blair would in his *Third Way* pamphlet, about 'a dynamic knowledge-based economy'[7] – an economy that no longer manufactured things, but depended on the creative manipulation of signs and symbols, images and ideas.

Mulgan's colleague at Demos, the former communist turned management consultant, Charles Leadbeater, celebrated the knowledge economy in a book that began life as a report for Peter Mandelson at the Department of Trade and Industry: 'The generation, application and exploitation of knowledge is driving modern economic growth. Most of us make our money from thin air.'[8] The paperback edition bore an encomium from Blair.

The unintended irony of Leadbeater's phrase would not become apparent until the banking crisis of 2008, but the very rapid growth of the cultural industries seemed to confirm that they were the future. Just as the Heritage Industry had been summoned up in the 1980s to compensate for the pains of deindustrialization, the cultural industries would fill the gaps created by the decline of manufacturing. After all, 'culture creates wealth'. The cultural industries would become part of a modernizing political agenda that detached the

Labour Party from its roots in the industrial working class – a class rapidly disappearing into the thin air of the knowledge economy.

There was another, less cerebral reason for embracing the cultural industries. The British economy was recovering from the sterling crisis and recession of 1992, and commercial culture with it. With recovery came a sense of fresh possibilities that Labour was able to exploit by using the old advertising trick of relabelling its product as 'New'. In contrast to the decadence of the Tories, New Labour projected Blair's 'Young Country' image, promising a renewed national identity: a rejuvenated Labour Party would transform the country into 'Cool Britannia'.

Like other aspects of New Labour, Cool Britannia was a carry-over from the Conservatives. The title of a 1967 pop song by the Bonzo Dog Doodah Band, and the name of a 1996 brand of Ben and Jerry's Ice Cream, the phrase was a nostalgic replay of the excitement that had greeted the emergence of a hedonistic pop culture as 'Swinging London' thirty years before. The Nineties Britpop bands such as Oasis and Blur were hailed as a return to the glory days of the Beatles, and the same ironic use was made of the Union Jack as a pop icon – this time by Spice Girl Geri Halliwell's mini-dress and Noel Gallagher of Oasis's guitar. Gallagher's endorsement of Blair, following his evocation of the Beatles and the Kinks in a speech at the 1996 Brit Awards ceremony, was one of the auguries that encouraged New Labour to appropriate the patriotic colours of Cool Britannia.

In May 1996 the Culture section of the *Sunday Times* celebrated the noticeable increase in cultural consumption with a 'Cool Britannia' cover, and articles on 'Why the arts are on the crest of a new wave': 'We have the makings of a cultural renaissance, based on a new generation of young talent that is being recognised both nationally and internationally. From Britpop to Bryn Terfel, from Stephen Daldry to Damien Hirst, from Jenny Saville to Nicholas Hytner, from Rachel Whiteread to Mark Wigglesworth, there is a renewed vigour and excitement.'[9]

A total of 600,000 people – 2.4 per cent of the working population – were employed in the expanding cultural sector. The

Arts Council claimed that the audience for the arts had grown by 500,000 in the previous two years, meaning that 37 per cent of the adult population now said they went to one or more of seven 'serious' art forms: plays, art galleries and exhibitions, classical music, ballet, opera, jazz, and contemporary dance. The article forbore to point out that this meant that 63 per cent of the adult population showed *no* interest in the high arts, not even once a year, but added that, if the list were broadened to include pop music, dancing and reading, the numbers of culturally active rose to 80 per cent.

As the country headed towards a general election in 1997, both Labour and the Conservatives sought to exploit this feel-good factor. In a press release celebrating the rise in earnings from tourism attributed to 'Cool Britannia', the secretary of state for national heritage, Virginia Bottomley, declared: 'Our fashion, culture, and music scene has made us the envy of our international competitors and has placed "Cool Britannia" firmly on the tourism map.'[10] Cool Britannia was as idealized an image of Britain's future as the Heritage Industry had been of its past, but when New Labour won by a majority of 177 in May 1997, the phrase captured the confident feeling expressed by New Labour's campaign song that things could only get better. Mark Leonard's post-election Demos pamphlet *Britain™: Renewing our Identity* brought the themes together in an optimistic proposal to rebrand Britain as a 'creative island': 'Britain has a new spring in its step. National success in creative industries like music, design and architecture has combined with steady economic growth to dispel much of the introversion and pessimism of recent decades. "Cool Britannia" sets the pace in everything from food to fashion.'[11]

The heady summer of Cool Britannia was duly celebrated at a series of parties at 10 Downing Street, where on 30 July, Blair – whose former membership of the band Ugly Rumours was part of his modernizing image, and who had been seen carrying a Fender guitar into Downing Street – was filmed joshing with Noel Gallagher. On the day 'culture' officially replaced 'heritage', as the Department of National Heritage became the Department for Culture, Media and Sport, Chris Smith declared: 'Cool Britannia is here to stay.'[12]

The *Sensation* show at the Royal Academy in September 1997 was a fitting accompaniment to Blair's first months in power. The highly popular and self-consciously controversial exhibition was the culmination of a miraculous decade for a group of youthful artists that had come together in 1988, under the entrepreneurial curatorship of a canny working-class lad from Leeds, Damien Hirst, to exhibit in converted offices belonging to the London Docklands Development Corporation. Artists of all persuasions had learned to duck and dive if they wanted to prosper in the Thatcher years; now there was an opportunity to cash in. The subversive values of pop, and a new spirit of independence and self-help with a clear eye on the market, invaded the temples of high art.

In spite of its regal foundation in 1768, the Royal Academy received no funding from the government or the Arts Council, and so its complete reliance on commercial sponsorship for its exhibitions programme made it the most modern, as well as the most ancient, of British art institutions. *Sensation*, sponsored by the auction house Christie's, showed works belonging to just one man, Charles Saatchi, brother of Maurice, and regarded as a genius in the advertising world. A deliberately mysterious figure who did not attend his own openings, Saatchi was a new kind of collector. He could make or break reputations by exploiting the commercial possibilities created by his cultural choices, selling as well as buying. In 1993 Saatchi had begun showing the core contributors to *Sensation* at his public gallery in Boundary Road, and, being an ad-man, gave them a marketable identity as 'Young British Artists'. The term began to be applied to a generation that had graduated from mainly London art schools between 1987 and 1993. Footballers and musicians had become working-class heroes in the Sixties; now it was the turn of the upwardly mobile Hirst, who received the establishment's avant-garde accolade – the Tate Gallery's Turner Prize – in 1995. In the same year he made the video for Blur's hit, 'Country House'. Britpop and Britart met.

By the time of the Royal Academy show in 1997, the YBAs were a cultural and commercial spectacle, giving contemporary British art an international status that it had never enjoyed before. *Sensation* moved on to Berlin and New York, where it caused as much offence

to those who wished to be offended as it had in London. It was a clever title, suggesting both scandal and the rush of a drug hit, and encapsulated the hedonistic, nihilistic and individualistic work of this group of Thatcher's children. Its most memorable exhibits, such as Hirst's shark, *The Physical Impossibility of Death in the Mind of Someone Living*, or the Chapman Brothers' multi-orificed, ithyphallic fibreglass children, spoke of death and sex in a way that was both witty and disturbing. Their presence in the Royal Academy challenged the viewer to accept these unusual objects into the canon of high art, but without making difficult critical or intellectual demands: you saw it, you got it, and maybe you thought about it. The work was accessible and classless, in the way that a pop song was classless, and the YBAs enjoyed the celebrity of pop stars, and shared their lifestyles.

But, as the following years were to prove over and over again, celebrity eats itself. New Labour quickly learned that there is nothing so uncool as claiming to be cool. On the one hand, the government laid itself open to charges from the old cultural elite of 'dumbing down'. On the other hand, cool culture was offended by the government's clumsy attempt to appropriate a style whose sub-cultural, resistant motivations it completely misunderstood. This was a lesson brutally taught when the deputy prime minister, John Prescott, the prime minister's wife, Cherie Blair, and Chris Smith attended the Brit Awards on 9 February 1998. Danbert Nobacon, a member of the anarchist pop group Chumbawamba, emptied an ice bucket over Prescott's head.

In March, in response to the planned 'New Deal' changes in the unemployment regulations that made it difficult for would-be musicians and other artists to develop their craft while living on the dole, the *New Musical Express* re-launched itself with an issue claiming betrayal by the New Labour government. A headline made ironic use of Johnny Rotten's comment at the close of his last Sex Pistols concert: 'Ever get the feeling you've been cheated?' In May 1998, at the launch party at the Tate Gallery for his volume of ministerial speeches, *Creative Britain*, Chris Smith conceded: 'I think Cool Britannia will now die.'

* * *

But the conviction that culture could create wealth lived on. New Labour's manifesto *Create the Future* had promised: 'A renamed, reinvigorated Department will be an economic force in the next Labour government, working in partnership with the cultural industries to create wealth and employment.'[13] Commercial success would come from promoting design, fashion, tourism, film, television and the multimedia enterprises that were converging on the 'information superhighway'. Only days into office, Smith set out his stall in a speech at the Royal Academy's Summer Exhibition dinner: 'Central to our aims is the renewal and refreshment of creative industries which generate the rich diversity of British cultures – from Beefeaters to Britpop – and making them accessible and relevant to the many, not just the few.'[14]

The speech signalled a subtle but important shift in terminology, from 'cultural' to 'creative': 'creativity' escaped the snobby associations of 'culture', and gave more substance to the post-industrial economy of signs and symbols – Leadbeater's 'thin air'. It made the idea seem more dynamic, more New Labour. The economic subtext was that culture was a commodity to be made available to the citizen consumer of Cool Britannia. Creative Britain wore a suit (but no tie) to its high-tech office in a converted warehouse; Cool Britannia partied all weekend in the unconverted warehouse across the road.

Smith started preparations for a new National Lottery Act. This would allow the distributors of Lottery funds to be much more proactive and strategic in their policies – though still subject to directions from the secretary of state – and it would create a source of funding for pet government projects, the New Opportunities Fund. It also meant that the government could fulfil a manifesto promise to set up a 'National Trust for talent'. What emerged as the National Endowment for Science, Technology and the Arts (NESTA) was intended to transcend the traditional opposition between the arts and science by promoting cultural and commercial innovation through a single institution.

In a radical and imaginative break with the customary system of annual government grants, NESTA was given an initial endowment from the Lottery of £200 million. It was expected to live off

the income that this generated, plus any money it could raise from the private sector or elsewhere. The now ennobled David Puttnam became chairman, and NESTA began to provide seed money for a range of social, technological, educational and cultural projects. Contrary to the established bureaucratic practice of trusting organizations rather than individuals, it decided to award three-to-five-year fellowships, worth up to £75,000 each, to creative people of all kinds, from the poet Tom Paulin to the performance artist Julia Bardsley and the ceramicist Rob Kesseler, as well as to inventors, educators and thinkers. This was an optimistic investment in the romantic idea of individual creativity, but it turned out to be difficult to demonstrate its economic payback.

An income of between £8 million and £12 million a year was too small for NESTA to change the landscape on its own, and it had difficulty turning good ideas into marketable projects. Puttnam moved on in 2003. Following the appointment of a new chief executive in 2005 with a background in venture capital, the policy of backing individual artists and inventors was abandoned in favour of supporting high-tech start-ups, and working like a think tank with public and private corporations. The buzzword – 'creativity' – boldly defined as 'seeing what no one else has seen, thinking what no one else has thought and doing what no one else has dared', was replaced by the duller – but less alarming to business – 'innovation'. In 2007 the DCMS lost control of what had begun as an imaginative attempt to reconcile culture and commerce, when responsibility for NESTA was transferred to the business-focused Department for Innovation, Universities and Skills.

The DCMS would not be able to launch NESTA until after the passage of the 1998 Lottery Act, but Chris Smith was quick to set up a Creative Industries Task Force. Task forces were a way of getting outside expertise to contribute on policy issues, and by 1999 there were 295 of them working on time-limited projects across government.[15] The membership of the Creative Industries Task Force was announced on 15 July 1997, the day that the Department changed its name and Smith announced: 'Cool Britannia is here to stay.'

Ten ministers, twenty civil servants and special advisors, and nine volunteers described as industry advisors were present when the Task Force met for first time, under Chris Smith's chairmanship, in October 1997. The volunteers were largely drawn from what was informally known as the 'BBC' – Blair's Business Circle of party donors: Lord Puttnam; Richard Branson, boss of Virgin; the soon-to-be-ennobled media tycoon Waheed Alli; the manager of Oasis and Creation Records, Alan McGee; the publisher Gail Rebuck, whose husband was New Labour's pollster, Philip Gould; and the mens-wear designer Paul Smith. This updated version of the Great and the Good was immediately confronted by a practical problem. No one had decided what the creative industries were.

Since creativity occurs in many places outside the arts – notably in science – the question of definition was tricky. Arguably, the idea of a creative industry is oxymoronic, since the object of creativity is to produce something that is unique, and the object of industry is to produce something that is profitably repeatable. Neither the Standard Industrial Classifications of businesses nor the Standard Occupational Classifications for employees with which the Task Force had to work captured the 'creative' element either in enterprises or individual jobs. As many as half the workers in the creative indus-tries were not doing anything creative, and as many creative people worked outside the designated industries as within them. Creativity only acquires economic value – that is to say, exchange value – when its products can be traded as intellectual property, either in the form of copyright or as registered patents and designs.

The Task Force decided to include activities that involved copy-right and some aspects of design, but to exclude patents. Thirteen areas of activity that had not previously been treated as connected were roped together: advertising, architecture, the art and antiques market, crafts, design, designer fashion, film and video, interactive leisure software (meaning videogames), music, the performing arts, publishing, software and computer services, and television and radio (but not newspapers).

This was not an entirely satisfactory selection. Neither individual artists (a creative occupation) nor museums (a cultural enterprise)

appear on this list, although both categories contribute to the creative economy. On the other hand, because its products are copyright, the whole of the computer software business was included. Arguably, most of this involves a technological rather than an imaginatively creative process, but because it was larger than other sectors, and employed more people, the inclusion of all activities connected to software had the advantage of making the creative industries appear much bigger. Together with advertising and design, computer software services accounted for almost half of the total turnover of the thirteen creative industries.[16] When the decision was taken in 2010 to exclude business and domestic software design and computer consultancy from the DCMS's annual economic estimates for the creative industries, there was a significant downward revision of the figures for employment and the Gross Valued Added (GVA) of the sector as a whole.[17]

In 1998 the first *Creative Industries Mapping Document* was released. Following the Task Force's definition, the creative industries now employed 1.4 million people, which was nearly three times the number according to Myerscough's definition in 1988. They generated revenue of £60 billion a year, and accounted for 4 per cent of Gross Domestic Product. A second *Mapping Document*, released in 2001, showed that the sector was growing at twice the rate of the rest of the economy, and that its economic contribution had risen to 5 per cent of GDP, or 7.8 per cent of GVA. Relative to the size of its overall economy, Britain had one of the most important creative industries sectors in the world.

The figures were impressive, but having made a map – in effect, creating the creative industries – the question was what to do with it. Other than regulating broadcasting, where the consequences of the rapidly developing Internet were not yet appreciated, the DCMS ruled over only a small part of this newly charted territory. The charitable and not-for-profit cultural sector that it funded constituted as little as 5 per cent of the creative industries as a whole. Nor did the sector lend itself to large-scale government intervention. Apart from a few big companies and corporations, such as EMI and the BBC, it was made up of small, flexible, indeed ephemeral micro-businesses

that celebrated their creative independence, many of which did not even want to get any bigger. An effective policy would involve issues of education, business regulation, regional development and planning – areas well beyond the remit of the DCMS, and probably beyond the powers of even joined-up government. Although the industries involved certainly made a significant economic contribution, the notion that they constituted a coherent group was a chimera.

Rather than driving the business cycle forward, they were mainly dependent upon it. The bursting of the Dotcom bubble in 2001 knocked back confidence in the digital sector, and ended the spurt of growth that had so encouraged the Creative Industries Task Force. From a peak of 7.8 per cent in 2001, the annual Gross Value Added figure fell back, and, after the exclusion of software from the calculations, it fell even further, to 2.89 per cent by 2009. By the same token, there were no longer 2 million people working in the sector, but 1.5 million. The economic journalists Dan Atkinson and Larry Elliott argued that the size and significance of the creative industries were overestimated, pointing out that there were three times as many people working in domestic service as there were in advertising, TV, videogames, film, the music business and design combined.[18]

The conceptual difficulty of the creative industries went further than issues of statistical definition. The real problem was that it was very difficult to work out the economic gearing between the creative aspects of the sector and the industrial activities that made it commercially profitable. In 2005, having disbanded the Creative Industries Task Force, the government re-launched its attempt to capture the chimera with the appointment of James Purnell as the DCMS's first ever minister for the creative industries, charged with leading a Creative Economy Programme in partnership with the Department of Trade and Industry. Seven business working groups were set up to prepare the way for a green paper – though, curiously, none specifically addressed the question of creativity. The process confirmed the lack of hard evidence to support policy-making, and when Shaun Woodward took over Purnell's post at the DCMS in a reshuffle he sought outside help from the think tank the Work Foundation, who

duly produced *Staying Ahead: The Economic Performance of the UK's Creative Industries* (2007).

In an attempt to understand the gearing between creativity and industry, the Work Foundation produced an elaborate version of what had become the accepted model of how they operated. This was conceived as a series of concentric circles around a creative core: 'the domain of the author, painter, film-maker, dancer, composer, performer and soft-ware writer'.[19] These mainly self-financing content-providers were the producers of 'expressive value', which the businesses in the outer rings then turned into commercial value through the application of capital and technology. Fancifully, the model was imagined as a fountain seen from above, with the creativity that bubbled up at the centre spilling over into the layers below, and thus spreading downwards and outwards – 'spill-overs' being the economists' term for the accidental benefits that one activity can gain from another. The further they were from the source, the more that technological functions became the generator of added value. Thus, in theory, it was possible to demonstrate the link between the solitary, troubled writer of a television soap opera and the prosperous manufacturer of television sets.

To make the model convincing, the Work Foundation was forced to reintroduce the distinction between 'cultural' and 'creative' industries. The 'expressive' core was first of all encircled by the 'cultural industries', which commercialized expressive value by publishing, recording, broadcasting, filming and presenting the work of the core creators. Encircling them were the 'creative industries', where expressive value combined with functional purposes: advertising, architecture, design, fashion, software services. Beyond that came the wider economy, where the manufacturing and service sectors benefited from the existence of expressive outputs. The trouble was: 'Unlike the other parts of the economy, our understanding of the creative industries' linkages is comparatively weak, made worse by poor statistics, or no statistics at all.'[20]

The model was neat, but it could not cope with the complication that the closer one got to the creative source, the more important non-commercial factors became. The reality for creators of expressive

value was that they are not at the core of anything. In Britain they depend on a network that includes the education sector, the subsidized cultural sector, and the all-important publicly funded BBC – as well as purely commercial enterprises, which also often depend on the publicly supported part of the network to generate the content from which they can profit. The Work Foundation concluded that there was a strong case for 'public investment' – meaning subsidy – in creators of expressive value at the core,[21] but this did not carry any weight with the government. The report fell victim to civil service jealousy and departmental rivalry between the DCMS and the DTI, while the White Paper that it was supposed to support was delayed by the change of premiership from Blair to Brown.

When *Creative Britain: New Talents for the New Economy* at last appeared, in February 2008, it turned out to be little more than a cut-and-paste of the rival ministries' individual proposals.[22] Claiming to set out 'a vision of creativity as the engine of economic growth for towns, cities and regions',[23] the title of the report shows that New Labour was still seduced by the language of creativity. But it turned out to be more concerned with aligning different agencies – NESTA, the Arts Council, the Regional Development Agencies, the UK Intellectual Property Office, the Film Council, the Arts and Humanities Research Council – in the direction of a future Creative Britain, rather than with spending any money on getting there. The Arts Council was told, with scant regard for the arm's-length principle, to help to deliver the objectives of the Creative Economy Programme by taking account of its findings in its next corporate plan.[24]

Like Sir George Cox's 2005 report *Creativity in Business*, this latest attempt to capture the elusive spirit of creativity became a dead letter. A 2013 review by NESTA, 'How Creative Britain Lost Its Way', concluded that, by 2008, 'Creative Britain was running out of steam'.[25] The economic crisis of 2008 would deflate it still further.

The real work on developing the creative industries was done by the Regional Development Agencies and local authorities anxious to promote employment. But over and above any economic significance,

the rhetorical power of the creative industries was of vital importance to the DCMS. Besides giving it the appearance of being, in a term of the time, 'cutting edge', it helped to reposition the department. As the media specialist John Hartley has pointed out,

> The 'creative industries' idea brought creativity from the back door of government, where it had sat for decades holding out the tin cup for arts subsidy – miserable, self-loathing and critical (especially of the hand that fed it), but unwilling to change – around to the front door, where it was introduced to the wealth-creating portfolios, the emergent industry departments, and the enterprise support programmes.[26]

The consequence of a move to the front door, however, is that cultural policy becomes an extension of economic policy, and culture is no longer seen as something distinct from the effects of economic life. The citizen becomes a consumer, competing with other individual consumers, rather than sharing common values expressed through a common culture. Social relations are experienced solely through the market, and culture exists only in commodity form. There would be a charge for entering the Treasury by the front door, one that compromised the very creativity that the DCMS claimed to be encouraging. In future, Creative Britain would have to carry a clipboard, and submit to the managerialism that contradicted the very idea of creativity.

By linking private enterprise with public culture, the creative industries became the operational mode of the Third Way. Although the trial run, 'Cool Britannia', turned out to be an embarrassment, the symbolic moment of a new millennium was approaching, and the hope remained that Britain could somehow reinvent itself through enlightened government leadership. For Blair, the response to the millennium should be 'a journey of national renewal which creates a new young Britain – a young, self-confident and successful country which uses all the talents of all its citizens'.[27] Social change would be shaped by cultural change. This called for an attitude to culture that was populist – more *Daily Mail* than *Guardian*. It would be one

that embraced commercial values, and was supported by commercial sponsorship.

Just such a project was already to hand – a celebration of British creativity that would lead the country into the new century: the Millennium Dome. A messianic Blair told a group of leading businessmen assembled in the Royal Festival Hall to be milked for sponsorship on 24 February 1998: 'This is Britain's opportunity to greet the world with a celebration that is so bold, so beautiful, so inspiring that it embodies at once the spirit of confidence and adventure in Britain and the spirit of the future of the world.'[28] The future would turn out quite otherwise, and the habits of government that were rehearsed proved an early warning of decision-making to come.

The Dome was a Conservative project that could have been cancelled but, as in other areas of government, New Labour continued with Conservative plans. The notion that the new millennium (which, mathematically speaking, began on 1 January 2001, not 2000) would be celebrated in some significant way was a given by the time the National Lottery had been set up in 1993, and the Millennium Commission brought into being. The Commission's first chief executive was Jennie Page, an experienced civil servant who also knew the world of business, but who was, according to one of Chris Smith's closest advisors, 'uncomfortable around creative people'. She was certainly tough: her previous job had been as chief executive of English Heritage under the irascible Jocelyn Stevens, who had behaved very much as an executive chairman.

As chief executive, Page reported to a board of Millennium Commissioners, whom she later described as 'a peculiar mix … with no history of common endeavour and no significant future together beyond 2000'.[29] Unlike the other organizations charged with distributing Lottery funds, the Millennium Commission could not even pretend to be an arm's-length body. It was chaired by the secretary of state for national heritage (under Labour, for culture), who was supported by a second government minister. The opposition nominated one commissioner, and the rest were chosen as regional representatives

of the Great and the Good. If the government changed, the balance of political commissioners had to change correspondingly.

The practical effect of this was to insulate Chris Smith from the worst of the Dome debacle. The Millennium Commission became responsible for funding the Dome, but not for making it happen, and a different minister would be answerable. Because of the way the legislation was set up, the commissioners could only invite (with a certain amount of behind-the-scenes encouragement) other organizations to submit proposals for projects that the Millennium Commission might then fund. At first there were no firm plans for a millennium festival or exhibition. Minds were concentrated on twelve *grands projets*, costing £50 million each, such as Tate Modern, and how to deal with a host of local schemes and individual bursaries. But one of the independent commissioners, Simon Jenkins (whose low opinion of Blair opened Chapter 1), had fond memories of the Festival of Britain in 1951, and he found an ally in Michael Heseltine, the Conservative government's second commissioner, who was in the powerful position of deputy prime minister.

Jenkins became chair of a festival sub-committee. One of the many problems the Commission would have to confront was that the millennium was in essence a Christian event, a moment in the Christian calendar – even if largely secular Britain was not interested in that fact. Those who were interested, however, were the competing faiths, Christian and non-Christian, who struggled with each other over the section of the Dome that – after passing through the names 'Spirit Level' and 'Spirit Zone' – finally became the 'Faith Zone', and whose evolution proved a real *via dolorosa* for its architect-designer, Eva Jiřičná. It was all part of the hubris of the project that the sponsors of the Faith Zone were the Indian arms-dealers the Hinduja Brothers. The Hindu millennium was not until 2066, and the connection with the Hindujas was to prove damaging to Peter Mandelson's political career.

The halting progress towards the Dome's opening night on 31 December 1999 is told in enlightening detail in Adam Nicolson's *Regeneration: The Story of the Dome* (1999), but it does not cover the

disastrous denouement. It is a semi-official history, although, as he wryly comments of his many run-ins with Jennie Page over the text, 'the definition of a "fact" is not always as easy as one might imagine'. Among the commissioners, only Jenkins and Heseltine fully cooperated with Nicolson, and he had to cope with a 'fearful, uncooperative and outdated attitude' familiar to others who encountered the bullying and dismissive news managers of New Labour.[30]

The official purpose of what became the Millennium Dome at Greenwich was to 're-energise the Nation',[31] but the real goal was, as Nicolson's title suggests, urban regeneration. It had been a particular passion of Heseltine's, ever since the Liverpool riots of 1981. He invented the Urban Development Corporations and Enterprise Zones that were intended to solve the problems of deindustrialization, including the abandoned acres and miles of water frontage downriver from Tower Bridge that were taken over by the London Docklands Development Corporation.

The Greenwich peninsula had not been part of that scheme, but the fact that the Greenwich meridian line passed through 180 windswept acres of industrial dereliction and deep ground pollution at Greenwich meant that the other potential sites competing for the Millennium Commission's favour – Stratford East, Pride Park in Derby, and the National Exhibition Centre in Birmingham – had no real chance of being chosen. On the other hand, the only convincing scheme for the exhibition itself had been proposed by the design company, Imagination Ltd, which was attached to the Birmingham bid. There was a compromise: in January 1996 Imagination Ltd became the preferred designers, and the following month Greenwich the preferred site.

The owner of the Greenwich site was British Gas, which had appointed the Richard Rogers Partnership as the master-planners for the 294 acres of the Greenwich peninsula that they controlled. The agreement was that British Gas would sell the land required for the exhibition ground to the government's development agency, English Partnerships, for £20 million. English Partnerships would eventually sell the land on for commercial development after 2000. The link to the Richard Rogers Partnership turned out to be one of the few

pieces of luck the project had. Richard Rogers's partner, Mike Davies, quickly appreciated that the temporary pavilions of the Millennium Exhibition, as proposed by Imagination Ltd, would require some kind of umbrella to protect them from the vicious weather of the peninsula. Thus was born the architectural concept of the Dome – a fortuitous echo of the Dome of Discovery, the signature building of the Festival of Britain in 1951.

An ill-assorted and ill-equipped crew of politicians, political advisors, civil servants, consultants and creatives fell over each other trying to fill this magnificently engineered empty space. The overarching problem was how the project was going to be managed and delivered. In 1951 the Labour government had very successfully used a temporary state organization to deploy the recent wartime experience of architects, engineers and designers to deliver the Festival of Britain; New Labour, however, accepted the neoliberal ideology of the 1990s that insisted the Millennium Festival should be a private sector undertaking. The prospect of a significant gain in terms of regenerated land for commercial development was the bait. But, with the projected costs as high as £1 billion, and no clue as to what would actually go on in the Dome, or how many people would come, the private sector wisely decided that it was not worth the risk.

As a result, an extraordinary compromise was reached. It was agreed that a private company would indeed run the Millennium Dome,[32] but the sole shareholder – technically the owner – would be a minister of the Crown. Since this person could not also be a Millennium Commissioner, under the Conservatives the first holder was the obscure chancellor of the Duchy of Lancaster, who was given two shares. He was also made to sign an undated form returning these shares to the government in the event of his death. As Page has explained, this arrangement was arrived at in December 1996 because 'The project was, for the third or fourth time in its life close to death because of the catch-22 effect – no go ahead could be given without worked up plans and at least an embryo management, both acceptable to all parties, but no way existed to get either without the commitment to go ahead.'[33]

The Millennium Commission now had an organization to fund – but there was a price: although a private company, the vehicle for delivering the project would also be treated as a non-departmental public body, with all the public sector constraints that that involved. Page observed that it was hard to convince a wardrobe mistress 'buying materials for eighty-four aerial performers in the central show, that the procurement of fringes for skirts was something on which the Commission should be allowed a view'.[34] Page agreed to transfer from the Millennium Commission to become chief executive of the private company that would deliver the project. A consultant presciently warned her that she was 'likely to end up walking out, sacked, dead or mad'.[35] Heseltine invited a friend of Labour's – the chief executive of British Airways, Bob Ayling – to chair the company.

The involvement of three distinct bodies, three different accounting officers and two ministers exercising three distinct roles was, as a National Audit Office report dryly commented, 'by any standards ... a highly complex structure'.[36] Nicolson, who observed these relationships at close quarters, comments: 'The time pressures of an immovable deadline, the expectations of an acute commercial performance and conformity to the standards of propriety in public life made the Dome company's existence nearly intolerable.'[37] In the quiet understatement of the National Audit Office: 'the parties are not always in agreement as to where in practice the burden of authority has lain.'[38]

On 13 January 1997, in the dying days of the Conservative government, the Millennium Commission accepted a revised budget that reduced the overall outlay to £750 million, but which assumed a considerable contribution from the Commission, including the extension of the Commission's own life beyond 2000, so as to be able to meet the risk of cost overruns or financial losses. This would act indirectly as a government guarantee for the venture, but not count as public expenditure. Being in opposition, Labour was exploiting the bad press resulting from delays and the lack of information about what was going to happen; with a general election approaching, it was essential to have Labour's assent to this deal. Only days away from the last possible moment for ordering the materials necessary

for building the Dome on time, Heseltine swallowed his pride and took the unusual step for a government minister of going to see Blair in the leader of the opposition's office at the House of Commons.

Accounts of Blair's enthusiasm for the project have varied with the fortunes of the Dome. In his memoirs Blair, who mistakes the date of the Festival of Britain and misspells Page's first name, tries to pass the Dome off as an inheritance from the Conservatives that was too expensive to cancel: 'as bad decisions go, it wasn't a frightful one'.[39] But he bore much more responsibility than that. He had been lobbied for support by Bob Ayling and Richard Rogers when he attended a party at Rogers's Chelsea house in October 1996, when the 'Group' was most active, and he could see how the millennium celebrations fitted his 'Young Country' agenda. At the meeting with Heseltine, Blair, on his own authority, agreed to the project, subject to its being 'reviewed' if he won the election.

By 1 May 1997 – election day – the site was ready. A double skin of plastic and stone had been buried to protect the surface from the poisons that lay beneath, although the shallowness of the decontamination was to cause problems with selling the site on afterwards. New Labour's review began, with a four-week deadline. At the Cabinet Office Peter Mandelson, minister without portfolio, took a close interest. The Dome's business plan settled on a target of 12 million paying visitors, although 11 million would balance the budget. (At one time it had been speculated that there might be as many as 30 million.) In spite of this megalomaniac optimism, crucial decisions about actual ticket prices, marketing and contents had still not been taken.

On 10 June a cabinet sub-committee (without Blair) met to consider Chris Smith's noncommittal report on the options of going ahead, stopping, or – his preferred choice – proceeding with a scaled-down version. Other than Jack Straw, the majority were against the scheme, but the decision was postponed by an intervention from Mandelson, who had his reasons to support the project. The following day, both Smith and Mandelson saw a report commissioned by the Millennium Commission from the consultants Deloitte that warned of significant risks, especially that the projected figure of 12

million visitors might be overestimated by as much as 50 per cent. Nonetheless, the Millennium Commissioners approved the company's business plan.

All depended on the outcome of a full cabinet meeting on 19 June. Blair was believed to be wavering, and Simon Jenkins decided to write what became known as the 'Euan letter', in which he urged the prime minister to see the project through the eyes of his eldest son. He concluded: 'Greenwich is a future that will work. It will be Britain's proudest creation and proudest boast in the year 2000.'[40] On the morning of the full cabinet, Blair talked first with Mandelson, and then John Prescott, who thought it would be wrong to throw in the towel. A hostile Gordon Brown wanted to make sure the costs would not fall on the Treasury, and – as he would do with Britain's decision on whether or not to adopt the euro – suggested the project would have to pass five tests before it went ahead. The formal cabinet began at 10.30, but before the Dome was fully discussed Blair had to leave for the blessing of the new parliamentary session at St Margaret's, next door to Westminster Abbey. Prescott took the chair.

Thanks to a 'war of the leaks' between government and opposition in 2000, verbatim notes of the discussion that followed have come into the public domain via the *Mail on Sunday* – the notes that would have formed the basis of the official cabinet record. (Considering how little of Blair's policy-making was minuted, this is a rare document.) The discussion was decidedly negative. Chris Smith called it 'a shambles inherited from the Tories'. Clare Short was 'vehemently opposed'. David Blunkett was 'deeply against'. Gordon Brown warned about the cost, and that 'if anything goes wrong it will come back to us'. But there was no vote and, at the urging of Prescott with the support of Jack Straw and Margaret Beckett – and because Blair had told them before he left that he supported the scheme – the meeting left it to Blair to 'make whatever statement is going to be made'. True to form, Gordon Brown appears to have quietly made off. In spite of the overwhelming opposition to the idea, this exercise in cabinet government left everything in the hands of the prime minister. It was an unfortunate – presidential – precedent. That afternoon Blair and

Mandelson went down to Greenwich to meet the press. Blair told them: 'These plans require a leap of faith.'[41]

Mandelson was alongside Blair because it was decided that he should become the company's only shareholder – owner of the Dome. This was gratifying on two counts: his grandfather, Herbert Morrison, had been the political power behind the Festival of Britain; as a minister without portfolio in the Cabinet Office, he now had a real job to do. His vision of this key New Labour propaganda project, however, was unclear: 'something of a cross between the Science Museum and a hi-tech circus' was the best he could come up with in an interview.[42] His appointment added to the conflicting stresses within the project. In July, Mandelson renamed the organization the New Millennium Experience Company (NMEC): 'new' was de rigueur in government circles; 'experience' promised much, and committed little.

Mandelson's principal contribution, given his position as a lightning rod for hostility to New Labour, was to politicize the project even more than it had been already. After his forced resignation over a scandal over a private loan and mortgage in December 1998, he was replaced as Dome shareholder by Blair's former flatmate, the lawyer Lord Falconer – parachuted into government with a peerage – who was Blair's eyes and ears in the Cabinet Office. The Dome was his first outward-facing responsibility, and he lacked Mandelson's svelte technique for dealing with criticism.

Someone who found Mandelson's influence particularly baleful was the witty and articulate design guru Stephen Bayley, who had been launch director of Terence Conran's Design Museum, and whose consultancy business embodied the image-manipulation that was one of the principal products of the creative industries. In June 1997 he was hired for three days a week on £80,000 a year to act as a consultant 'creative director'. He was supposed to pull together the very disparate ideas of the architects, museum display experts, product launch designers and theatre people who were being asked to design the settings (and sometimes the content) for the emerging 'zones' that were supposed to coalesce around the theme of 'Time to Make a Difference' – a Saatchi-devised slogan.

Bayley appears to have been hired for his reputation: he was not a man for the project's endless meetings; he was not a great collaborator, and did not work at the NMEC's office. Nicolson comments: 'People were offended by his apparent assumption that everyone was stupid.'[43] His idea of excellence was way beyond that of the NMEC, which was determined to avoid the Reithian worthiness of the Festival of Britain but had little idea of what to put in its place.

Bayley was resolutely off-message, and in January 1998 his 'resignation' was announced. This left him free to put his spin on things in an explosive squib, *Labour Camp: The Failure of Style over Substance.* Mandelson, he wrote, 'would do anything in the Dome which he felt would get votes. That's the degree of integrity involved.'[44] He went on to explain how the politicians failed to understand creativity:

A motley of smallish design consultancies, presentation companies and two or three architects of genuine quality [Eva Jiřičná, Zaha Hadid, Nigel Coates, Lisa Fior] were given briefs of baffling vagueness and asked to interpret them. No creative co-ordination was allowed. The problem here is that no designer, no matter how talented, can generate content for an exhibition: that has to be done by curators and academics. It is as absurd as asking the film crew to make a movie without a director and without a script. Hence the tepid vulgarity of some designs and the contentless elegance of others.[45]

Bayley not only pinpointed the flaw in Creative Britain, but was accurately predicting the curiously vapid nature of the 'experience' of visiting the Dome when it opened. It turned out to be a vast but aimless shopping mall, where there was plenty on offer to eat, but nothing useful to buy. The commercial values that drove the project imposed a political correctness that avoided all possibility of controversy or dissent. Simon Thurley, chief executive of English Heritage, has written that the Dome 'bizarrely came to symbolise the nadir of appreciation of Britain's history and heritage. Its zones were free from the accumulated debris of what were seen as colonialism, xenophobia, national triumphalism, oppression and class war.'[46] This

celebration of two thousand years turned out, like New Labour, to have almost no interest in the past.

The spurious nature of the project is illustrated by the mystery of 'Surfball'. As outside pressure mounted to give at least some idea of what was going to happen in the Dome, it was made known that Surfball would be part of the fun. Mandelson told a House of Commons select committee that this previously unheard-of game was 'the sport of the twenty-first century'. Diligent parliamentary questions from the Labour MP Austin Mitchell revealed that Surfball did not exist, and Mandelson was forced later to admit that the idea had been merely 'illustrative'.[47]

After Bayley's departure, coordination was left to a hapless team of 'content editors', guided by a 'Litmus Group' of NMEC directors chaired by the television executive Michael Grade, with others such as Christopher Frayling, Alan Yentob, and the director of the Science Museum, Neil Cossons, who acted as 'godparents' to those responsible for individual zones.

Barred from the Dome until it opened to the public, in January 2000 Bayley gave his verdict in an interview. He blamed the impoverished results on political interference that had stifled creative freedom, to the point of preventing designers talking to each other, in a culture of secrecy that extended to enforcing confidentiality agreements. Mandelson's leadership was 'a paradigm of bad management', and he must accept most of the blame: 'The contents of the Dome were decided on whispers of what Peter would and would not like. He's a very intelligent man, and the world would be a less interesting place without him, but Mandelson lives in a moral and aesthetic vacuum.'[48]

The Dome opened as scheduled on 31 December 1999, but the night was a disaster. The problem was not the Dome; rather, the failure to send out 3,000 tickets in time meant that national newspaper editors, sponsors, VIPs and the Great and the Good had to queue for up to three hours in a freezing cold tube station to pass through security to get there – and, on arrival, they found that the Tesco champagne was no longer being served.[49] The consequences

were serious, the marketing strategy had assumed positive press coverage and good word-of-mouth, and so was under-budgeted. Blair had begun the evening by opening the Millennium Wheel, which did not yet turn, and where he set off a 'river of fire' display that did not appear to work either. His special underground train made it to the Dome, but he lost his temper with Lord Falconer over the stranded VIPs at Stratford, and spent the aerial display worrying that one of the artistes would fall on the Queen.

As with the British economy, the sums for the Dome did not quite add up. In 1999 the projected cost was £758 million, of which £399 million would come from the Millennium Commission, plus a further £50 million to support cash flow that was supposed to be paid back. The rest was expected to come from 12 million visitors paying £20 a head for adults, and commercial sponsorship. But the crowds did not materialize. In January a further advance of £60 million was needed from the Millennium Commission, in May £29 million, and in July a further £43 million – dressed up as an 'advance' on the resale of the site. The July sale was the first of two deals that fell through. Had this been a genuinely commercial operation, the Dome would have had to close, for by September it was clear that it was insolvent. A further £47 million was advanced to avoid closure, bringing the total Lottery commitment to £628 million – an increase of 57 per cent over the planned £399 million.

As the costs rose, the target for visitor numbers fell: 12 million was rapidly reduced to 10 million, then 7 million, and by July the expectation was of 5.5 million. The final tally was just over 6 million, of whom 1 million – sponsors' guests and schoolchildren – had got in free. This was more than the number of visitors to any other attraction in the United Kingdom that year, but the true comparison is with the Festival of Britain, which managed 10 million paying visitors to the six main sites between May and September, or even with the Great Exhibition of 1851, which drew 6 million to Hyde Park between May and October.

Like the Conservatives before them, New Labour had a fatal belief in the virtues of commercial sponsorship. The original projection was that £195 million would be raised, and it was claimed that

£160 million had been achieved – but only six of the twenty-six sponsorship deals had been finalized by January 2000. An audit by Price Waterhouse Coopers in July 2000 showed that the maximum that could be expected was £122.5 million, and the amount actually received by the time of the National Audit Office's report was £118.9 million.

The shortfall was due to the sponsors' dissatisfaction. British Telecom and Ford had decided to design and build their zones – 'Talk' and 'Journey' – themselves; BSkyB hired an existing building, rechristened the 'Baby Dome', which stood outside the main structure. The sponsorship of BSkyB was an important coup for the NMEC, for it was owned by Rupert Murdoch, whose newspapers, especially the *Sun*, had been highly critical. Within days of BSkyB's sponsorship deal, in February 1998, the *Sun*, which had been calling the Dome a white elephant, decided there might be something in it. In spite of a six-to-one ratio between public and private money, there was definitely something in it for the sponsors. The cultural critic Jim McGuigan concludes from his analysis of the 'coincidental' government favours that went to sponsors such as Tesco, Manpower, BAE and Camelot that it can reasonably be inferred that this was more than a simple matter of publicity.[50]

In spite of being minority contributors, the sponsors were deferred to, and the first to feel their wrath was Jennie Page. On 3 February 2000, without a Board meeting, a recalcitrant Page was told by Ayling to resign or be sacked, and other senior managers followed. She was replaced by a young Frenchman, Pierre-Yves Gerbeau, spun by Ayling's PR advisors Brunswick (run by Lord Chadlington, of Royal Opera House fame) as the man who had helped save Euro Disney, though his responsibilities there turned out to be somewhat modest, such as running the car park. Later there was speculation that they had got the wrong Gerbeaux (*sic*), but he made a valiant effort to bring some order to the queues, get displays working properly (Gerald Scarfe's lavatorial sculpture 'British Humour' had exploded and caught fire) and maintain the morale of the 2,000 staff.

On 22 May, with the Dome already effectively insolvent, Ayling, who had lost his job as chief executive of British Airways in April,

was forced to resign by the NMEC's independent directors. Ayling was succeeded by the chair of the British Tourist Authority, David Quarmby. At this point the surviving directors demanded, and were given, a secret personal government indemnity against claims by creditors. Finally, as a result of the total financial crisis in September, Quarmby stood aside in favour of David James, the City's 'Red Adair' of corporate rescues. James, who later admitted that when he took over he had to offer counselling to staff on the verge of nervous breakdowns, did not hide his opinion that the Dome should not have been built in the first place.

At 7 p.m. on New Year's Eve 2000, the Dome went dark after a last-day rush of 27,000 visitors, while its outer spaces were hired out to a rave managed by the Ministry of Sound. The aerial show was performed for the 999th and last time. Earlier in the day Euan Blair, with his mother and siblings, as well as Lord Falconer and Alastair Campbell, made his third and final visit. A year later, on 18 December 2001, the New Millennium Experience Company went into voluntary liquidation. Its commercial income had been £169 million, not the £359 million originally budgeted for; meanwhile, overall expenditure had reached £789 million, with a further £200 million spent by English Partnerships to buy and clean up the land.

After two aborted sales deals, the second of which was soured partially because one of the bidders was a Labour donor, in May 2002 the Dome, together with the land around it that had development potential, was taken over by Meridian Delta Ltd, and then sub-let to the American billionaire property and media tycoon Philip Anschutz. The lease of the site was handed over for nothing, in return for a share of future profits, while the government had to continue to pay £250,000 a month in maintenance costs until a complex deal, including planning permission, was in place.

Anschutz Entertainment Group gutted the Dome, and within its shell built the O2 Arena, opened in 2007 as a venue for rock and other spectaculars. At last the Dome had found some content, and became successful. In 2009 AEG added 'The British Music Experience', a museum of British pop since 1945. Noel Gallagher's

union jack guitar is one of the exhibits in Cool Britannia's mauso-leum. Surveying the half-finished dystopia of development that had accreted around the Dome by 2010, the architectural critic Owen Hatherley concluded: 'A more outstanding failure of vision is diffi-cult to imagine. If there is a vision here, it's of a transplant of America at its worst – gated communities, entertainment hangars and malls criss-crossed by carbon-spewing roads; a vision of a future alienated, blankly consumerist, class-ridden and anomic.'[51]

The Millennium Experience revealed a great deal about New Labour's approach to policy management. Blair's personal insistence that the Dome should be made 'permanent' had added £7 million to the capital costs of roofing the Dome. His call for 1 million free school visits was calculated to have cost £7 million in lost revenue.[52] Once the Dome proved to be the lame duck that it was, he distanced himself from it, and did not return to what he had intended to be the subject of the first sentence of his re-election manifesto until 19 December 2000, to thank the staff. At the end of a disastrous week in September, he appeared on the BBC's *Breakfast with Frost*, and was forced to admit regret, but gave no apology: 'What I am saying is that probably if I knew then what I know now, about governments trying to run a visitor attraction of this sort, it would probably have been too ambitious to have tried to' – a sentiment repeated at the Labour Party Conference on 26 September.

Mandelson had said that the Dome would hold up a mirror to Britain: what it showed was that official Britain had a vastly over-inflated idea of its capabilities. Thinking of the successes of 1851 or 1951, it showed how little sense of history New Labour had, and – when it was unable to manipulate the media – its willingness to blame them for its own failure. It showed the government's over-ambition, and its inability to delegate, or to trust those who knew what they were talking about. Incapable of sound planning or good manage-ment, it was driven by a blind faith in its own rightness, which led it into denying the truth of what was going on and the extent of its egregious failure. The most sinister part of the Dome story, however, was the way in which the cabinet showed no resistance to an 'act of

faith' by the prime minister. It would happen again in 2003, over the far more important question of war with Iraq.

It was unfortunate that Chris Smith should publish his testament to his beliefs, *Creative Britain*, in May 1998, just as Cool Britannia was going cold, and when he had cut the Arts Council's grant-in-aid by £1.5 million. It was also unfortunate, in the light of the Blair government's notorious reputation for spin, that the jacket of *Creative Britain* should be a spin-painting by Damien Hirst. Reviews of the book were hostile, from the playwright David Hare on the left to the Tory intellectual George Walden on the right.

Although it was unusual for a serving minister to publish a book, the ideas in Smith's collection of speeches were unexceptionable. The four pillars of New Labour's cultural policy were *'access, excellence, education* and *economic value'*.[53] It would be astonishing if he had said they were exclusion, banality, ignorance and waste. The difficulty was how to reconcile the unspoken tensions between his laudable objectives. The magic word that would dissolve all contradictions was 'creativity'.

Creativity, Smith argued, led to personal fulfilment, encouraged a sense of communal identity, helped social inclusion, challenged the status quo, and, in the case of the creative industries, produced 'useful beauty'.[54] Over the next twelve years, the word 'creative' became the adjective of choice for cultural policy documents. It is easy to see why it became such a key part of New Labour's rhetoric. Just like Harold Wilson's 'white heat of the technological revolution' in the 1960s, the term suggested transformation without inconvenient specificity. Creativity sounds positive, forward-looking, unbeholden to the past: it has connotations that suggest freedom and personal autonomy. But the creativity that New Labour had in mind was not the individualistic, counter-cultural, playful and potentially disruptive creativity of the artist.

The hope was that creativity would resolve the ancient problem for the left that hierarchies of taste – even when reframed as 'excellence' – are built on unevenly distributed cultural capital, and consequently are reflections of social power. The market would

replace hierarchy with a benign pluralism – according to Smith, 'a profoundly democratic agenda'.[55] By 2001, when the DCMS published a covert pre-election manifesto, disguised as a Green Paper and titled, almost inevitably, *Culture and Creativity*, he had decided: 'Everyone is creative.'[56]

Culture and Creativity carried a foreword from the prime minister, in which he claimed: 'the arts and creativity set us free.'[57] It sounded cool, but the government had no intention of setting the arts and creativity free. The Dome might have failed, but the creative industries that had produced it would continue to serve the economy. The arts would also serve the government's social mission. People working in the arts were happy to make their contribution – until they discovered that the machinery of government installed to achieve these aims threatened to crush the very creativity that it was intended to inspire.

'The Many Not Just the Few'

Trying to use the arts for social instruction … is like playing snooker with a piece of string.

François Matarasso, 'Out of the Labyrinth' (2012)

In 2001 a quality-of-life survey for the *Sunday Times* named West Bromwich as the second-worst place to live in the United Kingdom. In terms of crime, unemployment, housing and schools, only Stoke-on-Trent was worse. Half a dozen miles to the north-west of Birmingham, West Bromwich lacked a future. The population, a fifth defined as 'immigrants', was declining. Wrecked in the 1960s by an uncompleted traffic master-plan, it was a grim place of social and rented housing, empty business properties and discount stores. There was bingo, and betting shops, but no cinema, museum or theatre. The long-established West Bromwich Operatic Society had nowhere to perform in West Bromwich: the Plaza Theatre and the Paradise Street it had stood on were long gone. No new cultural facility had been built since the public library, in 1907. If New Labour was to 'to make things of quality available to the many, not just the few', West Bromwich was the sort of place to start. Where West Bromwich ended up shows how badly they could get things wrong.

The ability of the DCMS to make a difference depended on deci-
sions about economic policy, planning and education that – as in the
case of the creative industries – were beyond the department's remit.
There was also a question of resources. There had to be a favourable
outcome to the Treasury's 1998 Comprehensive Spending Review.
As a tiny department, the DCMS was a minnow negotiating with
a shark. The best tactic was to wait while the big ministries fought
it out, and then try to pick up some of the leftovers by appealing
directly to the prime minister just as the final allocations were made.
Discreetly encouraged by the DCMS, leaders of the cultural estab-
lishment sought a meeting with Blair to put their case for a release of
the tourniquet that had kept them starved of funds for so long. On
29 June 1998, they got their wish.

The seminar at 10 Downing Street was carefully plotted by Dennis
Stevenson, chairman of the Tate Gallery.[1] Stevenson was close to Peter
Mandelson, whom he had once employed at his market research
company SRU. Mandelson acknowledges Stevenson as a mentor:
'Bright, cultured, generous with his time, he gave unfailingly wise
advice on how Labour might modernize its economic policy and
detoxify its image with the business community.'[2] Stevenson set about
detoxifying the arts with New Labour, as he carefully crafted brief
contributions by, among others, John Tusa, Melvyn Bragg, Nicholas
Serota, Genista McIntosh (who had returned to the National
Theatre), the director of the National Gallery, Neil MacGregor, Neil
Cossons of the Science Museum, the conductor Simon Rattle, and
the chief executive of Scottish Opera, Ruth Mackenzie. Mackenzie
knew the funding system inside out, having started her career as an
actress, worked at the Arts Council and run Nottingham Playhouse,
but she would only come into her own when she became Chris
Smith's special advisor, in September 1999.

The seminar did the trick. Three weeks later it was announced
that the Treasury was releasing an extra £290 million to the DCMS
over the next three years, beginning in April 1999. This meant that
by 2001/02 the department's annual spending would pass the £1
billion mark, at £1,038 million. Just as importantly, expenditure
would be planned on a rolling three-year cycle. By 2010 the Arts

Council's grant-in-aid had risen from £186.1 million in 1997 to £449 million – a real-terms increase of 81 per cent.

In parallel with the vital improvement to revenue funding, the passage of the 1998 National Lottery Act untied the hands of the Lottery distributors by allowing them to solicit applications, run joint schemes, delegate funding decisions – for instance, from the Arts Council to the Regional Arts Boards – and shift the emphasis away from purely capital projects. Partly as a result of the jointly funded Awards for All scheme, which gave one-off project grants from £500 to £5,000, the proportion of non-capital awards paid for by the Lottery rose from 2.5 per cent in 1998 to 22 per cent by 2000.[3]

This was offset, however, by the creation of a sixth good cause – the New Opportunities Fund, where the causes in question were the government's own schemes to improve health, education and the environment. In 2004 the New Opportunities Fund, the residue of the Millennium Commission and the Charities Board were merged as the Big Lottery Fund, taking 50 per cent of the funds. The Lottery cake was further sliced in 2005, when London was chosen to host the 2012 Olympic Games. Nonetheless, by 2013 the Lottery had produced £30 billion, more than enough to make the remaking of the cultural landscape possible.

Cities like Birmingham, Liverpool, Sheffield, Manchester, Newcastle and Gateshead had their centres transformed by new arts facilities; smaller places, such as Walsall and Margate, similarly benefited. Lottery money was the catalyst for a national cultural reconstruction that called for government investment through the Regional Development Agencies, by local authorities, and by access to the European Community's regional development funds. As in other developed countries, would-be 'iconic' buildings became tools in a marketing strategy that aimed both to restore local pride and to attract investment. But, as the architectural critic Owen Hatherley has pointed out, the subtext was always 'one of triumphing against the loss of industry, urban transformation from production to consumption'.[4] City centres became leisure centres; further out of town, deep social problems remained.

Every Lottery distributor had its share of embarrassment: the wrong stone was used on the south portico of the British Museum's Great Court as part of its £90 million refurbishment funded by the Heritage Lottery Fund; in 2000 the Arts Council was shamed by the closure of the £15 million National Centre for Popular Music in Sheffield; the £5 million National Faith Centre in Bradford, funded by the Millennium Commission, closed in 2001; the £100 million Earth Centre in Doncaster, also funded by the Millennium Commission, closed in 2004; costed at £200 million, the £798 million new Wembley Stadium opened in 2007 – four years late and without the athletics track specified by the Sports Council's £120 million Lottery award. There were time and cost over-runs: of fifteen large-scale Arts Council projects examined by the National Audit Office, two went bust, four opened over a year late, and thirteen went over budget.[5] There was boosterism, a bonanza for consultants and construction companies, and a general tendency to overestimate the number of people who would turn up – all features of the Millennium Dome experience – but the change was profound. British architects at last found work in Britain. Institutional confidence grew, and the public's appetite for the arts and heritage grew with it.

The fresh resources that came on-stream were delivered by new or reformed agencies closely monitored and directed by the DCMS. In December 1998 Smith published *A New Cultural Framework*[6] – the formal launch of the new, proactive department. He had wanted all publicly funded museums to be managed by a single body, but the national museums insisted on remaining individually funded by the DCMS. Two very different bodies – the Libraries and Information Commission and the Museums and Galleries Commission, which advised the government on non-national museums – were brought together, with additional responsibility for archives, as a new body, the Museums Libraries and Archives Council.

The MLA, as it eventually became known, would have an unhappy life. Its first chairman was the ambitious and self-confident head of the distinguished publishing house Faber and Faber, Matthew Evans. (Faber had published Chris Smith's *Creative Britain*.) His brisk and business-like approach was a cultural shock to the assortment of civil

servants and local government officials, who had enough trouble as it was reconciling their own different bureaucratic habits with the demands of a new organization.

English Heritage, which both advised on planning and looked after the government's heritage estate, absorbed the Royal Commission on Ancient Monuments. In response to Richard Rogers's Urban Task Force report, *Towards an Urban Renaissance* (1999), the Royal Fine Art Commission became part of a new, enhanced organization charged with raising standards of design and planning, the Council for Architecture and the Built Environment (CABE). Responsibility for film was taken away from the Arts Council and given to a United Kingdom Film Council. The Film Council became a distributor of Lottery funds, and its first chairman, the film director Alan Parker, announced a policy of aggressive investment in 'popular' films. The British Film Institute lost its production responsibilities and reverted to being a purely educational and archival organization. In 2002 the Film Council began to set up Regional Screen Agencies in cooperation with the Regional Development Agencies, to act as promoters for the creative industries involved with film and video.

This was the beginning of the 'golden age' that Blair later claimed New Labour had inaugurated. But the free spirit of the arts he had celebrated in *Culture and Creativity* was now contractually bound by Public Service Agreements to deliver government objectives. The noble ideals of *Creative Britain* were reformulated as six lead objectives and twenty-one targets. The DCMS was now required to improve the quality of life for all, to strengthen the creative industries, and to bring 'quality and excellence' to 'the many not the few'.

Of the lead objectives, the first was to 'create an efficient and competitive market by removing obstacles to growth and unnecessary regulation'.[7] Objectives 2 and 3 were to be met by hitting Target 7 – to increase visitor numbers to national museums by completing the programme to establish free entry by 2001. A further six targets aimed at extending 'social inclusiveness' throughout the DCMS domain, and maintaining standards in broadcasting. Targets 12 and 13 were numerical: 200,000 new educational sessions to be undertaken by

arts organizations, and 75 per cent of public libraries to have Internet connections by 2002.

Objectives 4, 5 and 6 were to ensure 'opportunity to achieve excellence' and to 'develop talent, innovation and good design'; to maintain public support for the National Lottery and make sure the money was well spent; and to promote the department's work in urban and rural regeneration. Environmentalism and social engineering were introduced to the regeneration programme by requiring the pursuit of 'sustainability and social inclusion'. Overall, the intention was to 'agree new standards of effectiveness' with funded bodies and to 'streamline policy delivery mechanisms'.

The most managerialist, and the most ominous, was Target 14: 'Funding of NDPBs to be conditional on quantified improvements in outputs, efficiency, access, quality promotion, income generation or private sector funding, monitored by a new independent watchdog.' This was QUEST – the Quality, Efficiency and Standards Team.

QUEST was intended to be a cultural Witchfinder General, rooting out waste and hunting down poor administration. There was something menacing about the way the DCMS now defined its relationship with the cultural organizations that distributed its money:

> QUEST will look at the process through which DCMS allocates funding to its sponsored bodies in return for specified outputs. In particular, it will assess the various measures and targets used to ensure that both the DCMS and its sponsored bodies are meeting the department's wider objectives of access, excellence and education, and propose ways of bringing the measurement of performance closer into line with the government's objectives and the sponsored bodies' strategic ambitions.[8]

QUEST was immediately charged with reviewing the current funding agreements with the department's said sponsored bodies. The intention was to construct a regime for funding agreements that replicated the DCMS's own Public Service Agreement with the

Treasury. This was the start of a 'delivery chain' that reached down to individual funded organizations to ensure they pursued the government's economic and social policy, whether they wanted to or not. QUEST reported that there were approximately 1,200 indicators across the sector, but it was impossible to give an exact number.[9] They were a confusing mixture of numeric outputs, outcomes, milestones and targets. Interpretations of how the agreements were to be met were vague – performance indicators concentrated on numbers, not their impact, and many measures were incompatible with each other. The government and its agencies interpreted their agreements differently, and it could be a stretch reconciling the two, as the government auditors pointed out.[10]

There were similar problems with the DCMS's own targets, where the only clear objectives were numerical or calendrical. Although the DCMS promised to reduce red tape, it declared in the same breath that it would 'ensure that our sponsored bodies set and deliver targets for improving value for money'.[11] Beyond crude quantitative targets such as the number of museum visits, however, there were no effective methodologies for measurement, and no baselines against which to measure them. Sponsored bodies regarded the insistence on gathering quantitative information as an imposition and a potential loss of independence, and complained of 'evaluation fatigue'.[12] Once gathered, information remained confidential, so it was not properly used for planning.

Such managerialism produces a fundamental change in the relationships between the organizations involved. The operational independence guaranteed by the arm's-length principle is exercised within a much more confined context; previously implicit opportunities for coercion by awarding or withholding finance become explicit. A narrow contractual agreement is substituted for professional judgement and expertise. The purposes of the subaltern organization are understood only in terms of the senior, whether that is the DCMS in relation to the Treasury, the Arts Council in relation to the DCMS, or an arts organization in relation to the Arts Council. Autonomy and trust are replaced by surveillance and assessment. Culture and creativity are constrained by contract and coercion. Trust decays.

Chris Smith explained that the idea of QUEST was 'to make the important measurable rather than the measurable important',[13] but did not reveal that its creation was the price that had been extracted by the Treasury for the DCMS's enlarged budget.

The commitment of the DCMS to creating an efficient and competitive market is consistent with the neoliberal approach to culture that New Labour had taken over from the Conservatives; but references to social inclusion showed a parallel expectation that the arts and heritage would also sort out the social problems that arose from economic failure. As the urban policy specialist Jonathan Vickery puts it, 'culture became a kind of fuel to drive the vehicle of social improvement'.[14] This went beyond the simple ambition to increase visitor numbers: these had to be the sort of people untouched by previous policies. An Arts Council report commented, with an air of surprise, that, while increasing access had always been part of its work, 'advocating the role that the arts can play in addressing social exclusion is, however, a new departure'.[15]

Social inclusion implied its other – exclusion. In official documents, the words were used alternatively, without acknowledgement that they frame concepts of both race and class. Difficult to define, and therefore hard to measure, social exclusion was a polite word for poverty, just as 'diversity' became the latest term to tip-toe around the reality of racial discrimination. To demonstrate New Labour's different approach to its Conservative predecessors, in 1997 the new government set up a Social Exclusion Unit within the Cabinet Office, whose purpose was, in circumlocutory manner, its opposite: to include the excluded. It was not to replicate the work of other departments, but, in pursuit of joined-up government, to bring them together to focus on the joined-up causes of social exclusion: unemployment, poor skills, poor housing, high crime levels, poor health and family breakdown.

Yet the recognition that sections of the population were excluded had an exclusionary effect. As the government struggled with the multiple problems of sink estates and deprived neighbourhoods, the more personal and individual aspects of social exclusion, such as

low self-esteem and family breakdown, appeared to shift the term's meaning, taking on the suggestion that the poor had somehow excluded themselves.

Poverty was no longer seen as a structural problem, but became a perverse form of individualism, a parody of neoliberal personal choice. Since taking part in the arts was voluntary, and the poor, the uneducated and ethnic minorities proved resistant to the benign intentions of cultural institutions, self-exclusion could serve as a useful explanation. An Arts Council report asked: 'Insofar as non-engagement with the arts is a matter of life-style choice, or "self-exclusion", should the state still intervene?'[16] The cultural critic Rhian E. Jones sees the idea of self-exclusion as a manifestation of the neoliberal belief in the social neutrality of meritocracy, which ignores the possibility that there are structural disadvantages produced by class, race, gender or sexuality. A lack of social empowerment just means 'you must simply not have tried sufficiently hard or wanted it enough'.[17] Whether those at the bottom of the heap in West Bromwich saw their exclusion as a lifestyle choice is open to doubt.

After the Social Exclusion Unit published *Bringing Britain Together: A National Strategy for Neighbourhood Renewal*, in September 1998, eighteen 'cross-cutting' Policy Action Teams were set up to tackle the problems of the most distressed neighbourhoods in Britain: the relevant indicators were targets for improvements in health, employment, education and crime. Policy Action Team 10 (PAT 10) was to be led by the DCMS, to work out an action plan deploying the arts and sport. The team was assembled from representatives of the DCMS, the Treasury, the Cabinet Office, the Departments of Health, Education and Transport, the Arts Council, Sport England, local authorities, and a handful of practitioners and experts, among them François Matarasso from the organization Comedia.

Comedia had been set up in 1978 by the urban theorist Charles Landry as a cross between a think tank, a consultancy and a publishing house. Landry's concept of the 'creative city' was influential in developing thinking about urban regeneration and the cultural industries, and anticipated the work of the American economist Richard Florida, whose book *The Rise of the Creative Class* (2002)

argued that opportunities for a civilized bohemianism were essential to successful city-making. In 1995 Comedia was commissioned by the Gulbenkian Foundation to conduct the first large-scale study of the social benefits of taking part in the arts, *Use or Ornament? The Social Impact of Participation in the Arts*. Written by Matarasso, it was published in the month New Labour came to power.

It is important to recognize the study's emphasis on *participation*, rather than mere attendance at a performance or visiting a museum. Matarasso was a former community artist, and although he claimed that participation was not a euphemism for community arts, the projects he examined and the arguments he made came out of the community arts movement. This had emerged in the 1960s and 1970s as a radical, politically committed alternative to orthodox arts provision, but in the 1980s was largely co-opted by the Regional Arts Associations and government work-creation schemes. Crucially, community artists were regarded as inferior to 'artists'; real artists would be judged primarily on questions of aesthetic quality, and only secondarily on questions of social purpose.

Use or Ornament? was explicitly presented as a counterweight to Myerscough's *The Economic Importance of the Arts*. The value of the arts was expressed in terms of personal growth and greater social cohesion; participation had environmental and health benefits and – in a nod to the ideology of community artists – contributed to social change. Matarasso did not over-claim for these benefits:

> The current problems of British society will not be solved if we all learn to make large objects out of papier-mâché, play the accordion or sing Gilbert and Sullivan. Nor will British culture be improved by being sold into bonded labour to a social policy master. But a marginal repositioning of social policy priorities could be very significant: a little art can go a very long way.[18]

This modest proposal acquired considerable traction with the New Labour government. Policy Action Team 10 was directed to focus on the benefits of participation, and Matarasso had a hand in drafting the report. Just as Myerscough's report had been challenged on its

economic methodologies, questions were asked as to how Matarasso's social impacts could be measured,[19] but it became an influential document whose arguments for the benefit of participating in the arts were extended to the social benefits of the arts in general. Matarasso has protested subsequently that his work was co-opted into making a case for the instrumental use of all forms of culture: 'I did not then understand how much politicians and planners – Plato's students in so many ways – struggle to distinguish between what is important and what can be controlled. I did not understand that they see culture as a source of social instruction rather than of *self*-development.'[20]

The *Arts and Sport* report produced little hard evidence, but was read as a ringing endorsement of the instrumental approach, and its recommendations imposed a new set of expectations on local authorities, Lottery distributors, and the Arts Council. The Council was told to make sustaining cultural diversity and combating social exclusion fundamental policy aims, and to ensure that the organizations it funded did so too. In language unfamiliar to arts bureaucrats, the Council was instructed to 'tighten the social inclusion objectives and targets given in its funding agreement with DCMS within a year'.[21]

It was unlikely that the Arts Council would appreciate such bald instructions any more than would its clients. In his memoirs, the director of the Bush Theatre in London, Mike Bradwell, describes his frustration with the new vocabulary of art-speak:

> Theatres would now have to prioritise social and sexual inclusion, cultural diversity, education, education, education, disability, outreach and access. They were charged with developing new audiences and embracing multiculturalism. They had to overhaul their artistic programmes to appeal to audiences from a wider spectrum of society and with a wider ethnic balance, while simultaneously offering innovation and excellence. They had to outreach into local communities and schools, and provide value for money for stakeholders. God knows when there would have been any time to put on plays.[22]

But cultural organizations were prepared in good faith to offer the 'outreach' that the access agenda demanded. That the National Lottery was played by the many for what appeared to be the benefit of the few was an incentive to ensure there were wider social benefits to be had. Funders and the organizations they funded had a choice: they could expand their current programmes and adopt new ones aimed at 'outreach', or they could fundamentally change the way they worked. For the most part they preferred the former course, which may explain how limited their success in extending participation in the arts beyond their traditional audience would turn out to be.

The DCMS took the lead. In 1998 a windfall of £5 million allowed it to launch what became a five-year New Audiences programme. This was an early example of using an agency – in this case the Arts Council – to operate a ministry-inspired scheme in a way that no cultural department had done so explicitly before. Although a third of the £20 million that was eventually spent went on general audiences, there was a specific focus on diversity, disability and social inclusion.

More than a thousand awards were made, but it was not just about new activity: as much as a fifth of the money went on research and training. There were new partnerships with the BBC and Channel 4, whose series *Operatunity* featured amateur opera singers, allowing the Arts Council to claim it had reached 7 million viewers. A project with the DIY store Homebase had pegs designed by Antony Gormley and a lamp by Anish Kapoor on general sale.

The social inclusion strand ran on from the PAT 10 *Arts and Sport* report, with £1.5 million going on work with the homeless, people in prisons, and deprived areas. More than half of this money was for research, which uncovered widespread differences of interpretation and confusion about the meaning of 'access' and 'social inclusion', and a reluctance on the part of arts organizations to be seen as agents of social control.[23] The research revealed a growing complaint: the difficulty of demonstrating the 'impact' that cultural projects had. Various claims were made about the 'soft' outcomes of social inclusion programmes, such as improvements in individual confidence

and self-esteem; but it was difficult to provide hard evidence of changes to the conditions that produced social exclusion, and which arts organizations could not address on their own. The evaluators of the New Audiences programme baldly concluded that they were unable to find new evidence to prove the 'hard' impact of the work.[24]

The most obvious route to increased cultural participation ran through an area in which the DCMS had no direct say: education. In response to the 1998 Education Reform Act, which imposed a legal obligation on schools to encourage the cultural development of their pupils, the DCMS and the Department for Education and Employment commissioned a report from the National Advisory Committee on Creative and Cultural Education, *All Our Futures: Creativity, Culture and Education.*

Playing on the rhetoric of Creative Britain, the report argued that creativity was as important as literacy and numeracy, but was being squeezed out of schools by the strictures of the national curriculum. Since this contradicted the government's utilitarian, target-driven educational agenda, publication was delayed; it took the government nine months to give a decidedly equivocal response, and another year to produce proposals for artists to do more in schools.

In the face of the far greater political influence and financial power of the Department for Education, the DCMS set up its own education unit and launched a series of projects with a strong social motivation. Some £30 million of Arts Council Lottery money went to set up the National Foundation for Youth Music in 1999, specifically aimed at disadvantaged children both in and out of schools, where music teaching was in decline. In 2002 the DCMS ventured into new territory with Culture Online, a 'digital bridge' between cultural and educational projects using the Internet and television to meet the interests of children, the elderly, the disabled and ethnic minorities. Culture Online became a statutory corporation, and established an innovative partnership model by which it commissioned projects, acting in an editorial capacity rather than as a direct provider. Twenty-six projects were commissioned, ranging from city heritage guides to a response to public art from mental health patients, with

the unfortunate title MadforArts. During the four years of its exist-
ence, £16 million was invested, but it does not appear to have been
cost-effective, and Culture Online was wound up in 2007.

The most important response to *All Our Futures* was Creative
Partnerships, operated through the Arts Council. This was socially
instrumental in two ways: the intention was not to strengthen teach-
ing about the arts and heritage in schools, but to use projects run
by cultural professionals, including people from the creative indus-
tries such as fashion and media, to encourage the overall intellectual
creativity of both pupils and teachers. Secondly, addressing the social
agenda, the scheme was deliberately targeted at local authority areas
with the most significant social deprivation.

 After a chaotic start, Creative Partnerships grew into a success-
ful programme, as reports by the schools inspectorate showed.[25]
By 2010 there had been over 8,000 projects in more than 2,000
schools, at a cost of £275 million. But these reached only a tenth of
schools in England and Wales, and the scheme had difficulty over-
coming both the resistance of the Education Department and the
suspicions of cultural organizations wary of its instrumentalism, and
what was seen as a dilution of their core purpose. A consultation by
the Cultural Learning Alliance, set up in 2007 by a group of leading
Trusts, Foundations and NDPBs, including the Arts Council and
the MLA, showed that there was still a fundamental lack of empathy
and shared language between the educational and cultural sectors.[26]
This helps to explain why, when Creative Partnerships was renamed
Creativity, Culture and Education in 2009 and hived off from the
Arts Council as an independent organization, the scheme was run
down. Having cost £110 million between 2002 and 2009, Creativity,
Culture and Education briefly became the Council's largest single
client, with £75 million for the next three years, but following the
cuts imposed by the Coalition in 2010 its funding was halved, and
then withdrawn altogether.

The DCMS was equally forthright in declaring its instrumental inten-
tions for the museums and heritage sector. In May 2000 it issued

a policy guidance document, *Centres for Social Change: Museums, Libraries and Archives for All*, that roundly declared: 'If museums, galleries and archives are to make a real difference, their goal should be to act as vehicles for positive social change.'[27] One straightforward way to increase access was to meet a pre-electoral commitment to review entry charges at museums and galleries directly funded by the DCMS. In 1997 museums were divided on the question of ending admission charges. Some, like the Tate and the British Museum, had always resisted charging and were currently free, while others, like the Science Museum and the Victoria and Albert Museum, favoured charging, partly as a way of controlling visitor numbers. The British Museum was in financial trouble, and the trustees were considering charging, while the chair of the Tate, Dennis Stevenson, was convinced that when Tate Modern opened in 2000, it would be obliged to charge. The DCMS set aside £100 million, but it took until 2001 to make it possible for all charging museums to become entirely free – and then only when a complicated wrangle over VAT was resolved in the museums' favour. All entry charges (except to special exhibitions) ended in December 2001. Target 7 was met, just.

In 2005 the no-charging principle was extended to university museums. The policy meant that museum and gallery visits increased substantially, with 40 million visits to national museums in 2012. 'Visits' are not the same as 'visitors', but 48.9 per cent of the adult population of England visited a museum or gallery at least once that year. It was one of Smith's most significant policy successes, and a change that the Coalition government did not dare to touch. But although this was a significant numerical increase, the social profile of museum visitors proved harder to change. When more detailed analysis became possible after the introduction of the government's *Taking Part* survey in 2005, it was discovered that, while overall visits by adults had risen by 51 per cent between 2006/07 and 2010/11, visits by those in lower socioeconomic groups had actually declined by 11 per cent, and were just 8 per cent of the total.

'Heritage' was a sensitive term for New Labour, partly because of its association with the reactionary Heritage Industry that had flourished under Mrs Thatcher, and partly because it did not fit the

government's modernizing agenda. The preferred term was now the blander and intentionally more inclusive 'historic environment', as in *The Historic Environment: A Force for Our Future*, published by the DCMS in 2001. This described the sector as 'a sleeping giant in both cultural and economic terms',[28] and revealed a determination to wake it up: 'Policy-makers need to regard the historic environment as a unique economic asset, a generator of jobs and wealth in both urban and rural areas.'[29] In 2002 it followed up with *People and Places: Social Inclusion Policy for the Built and Historic Environment*, warning that 'engaging with a social inclusion agenda may require substantial cultural change from heritage organizations'.[30]

Of the twenty-four different agencies dealing with aspects of the heritage across the United Kingdom, this warning was aimed most pointedly at the department's lead organization, English Heritage, and at the Heritage Lottery Fund. Both, by their very names, were open to the challenge that, as the Australian cultural critic Emma Waterton has put it, their vision of the past did not 'move much beyond the deceptively sophisticated notion of an elite, and ultimately white, national narrative'.[31]

English Heritage had an awkward mix of roles. It was part property owner, part patron and part policeman, and it also devoted considerable resources to historical research. As owner, it was responsible for some 400 properties, the majority of them ancient monuments that had become part of the government estate. As a patron, it was a source of grants worth around £35 million a year for heritage repairs and to help national amenity societies. As a policeman, it was responsible for running the government's heritage protection schemes and advising on planning and development issues, although the actual decisions were taken by local authorities, or, when disputed, by ministers.

English Heritage did its best to respond to the DCMS's pressure to commercialize its operations, and expanded its membership scheme in imitation of the independent National Trust. But it did not change its idea of itself as a traditional bureaucracy that derived its legitimacy from its own expertise. It kept a firm grip on regional operations, and excluded local opinion from the decision-making

process. Priding itself on its scholarly and expert-led approach, it resisted the government's implicit criticism of its organizational culture in *A Force for Our Future*: 'The historic environment should be seen as something which all sections of the community can identify with and take pride in, rather than something valued only by narrow specialist interests.'[32] As a result, English Heritage was always at the back of the queue for DCMS funding. In 2010 it calculated that it had 'lost' £130 million in funding over the past twelve years. Eventually, English Heritage would be split up.

By contrast, the Heritage Lottery Fund (HLF) underwent a remarkable conversion. The HLF was technically an arm of the National Heritage Memorial Fund (NHMF), established in 1980 with an endowment that was topped up by varying amounts of annual grant-in-aid. The National Lottery transformed the situation, so that the HLF came to dominate its parent. It is claimed that it became a Lottery distributor because of a chance encounter at a country point-to-point race meeting between the wealthy and cultured Lord Rothschild, chairman of the NHMF, and the first permanent secretary at the Department of National Heritage, Hayden Phillips. The regulatory functions and England-only remit of English Heritage made it unsuitable as a Lottery distributor, while the UK-wide remit of the NHMF fitted the bill. Rothschild was also an eloquent advocate for a conservative idea of 'our heritage'.

The HLF had an advantage over other important cultural players in that it had substantial sums of money to give away – as much as £300 million a year – and was not subject to the vicissitudes of Comprehensive Spending Reviews. Unlike the Arts Council or Sport England, it was not intended to have ongoing revenue commitments to the organizations that it funded. It had got off to a very bad start with its first award: £12.5 million for the acquisition from the Churchill family of the post-1945 papers of Winston Churchill, by Churchill College Cambridge. It was the equivalent of the 'dosh for toffs' scandal of the Arts Council and the Royal Opera House, and for a time the patrician values of the National Heritage Memorial Fund – now a 'fund of last resort' – appeared to dominate its offspring. But in 1998 Lord Rothschild was succeeded as chairman by

Eric Anderson, Tony Blair's former housemaster at Fettes. In 2001 he was succeeded by Dame Liz Forgan, a former director of radio for the BBC and a future chairman of the *Guardian*-owning Scott Trust, who had good New Labour connections, and who believed that the National Lottery was there to benefit the nation as a whole.

While maintaining the Heritage Lottery Fund's resistance to spelling out precisely what 'heritage' was – the argument being that it could only be defined in terms of whatever it was from the past that people chose as worth preserving – under the crisply determined Forgan, and successive chief executives Anthea Case and Carole Souter, the HLF began to broaden the idea of heritage into something more inclusive. The board of trustees was significantly reshaped, with a less patrician and more socially representative membership. It responded positively to the government's social inclusion agenda, emphasizing the importance of local heritage, volunteering and local decision-making, and trying to ensure the survival of cultural traditions and non-physical forms of heritage, such as language. Landscape, environment and biodiversity were considered as important as historic buildings, and industrial heritage was as much a concern as churches.

Though unable to shed its predilection for paperwork, the HLF also changed the way it operated, establishing a regional structure with significant decision-making devolved to local committees and offices. Half the annual budget was reserved for projects of less than £1 million – later raised to £2 million – which were decided by the regional committees. In 2002 the HLF conducted a 'cold-spots' review that sought to identify where money had not been awarded, in order to make sure the whole of the United Kingdom was being served. By 2008 every local authority in the UK had received at least one grant; around 40 per cent of funding had gone to the most deprived 25 per cent of local authorities.[33] The HLF awards between 1994 and 2010, worth £4.51 billion, drew in a further £3.3 billion in partnership funding.

In 2006 a DCMS review of English Heritage noted: 'although there is a long way to go, English Heritage is beginning to dispel perceptions

of heritage as a "white, upper-middle class" sector served by a culturally similar organization.'[34] The HLF had achieved even more, but the problem of 'diversity' remained a challenge right across the cultural field. With a 'minority' population in Britain that had grown by 48 per cent between 1991 and 2001, to just over 9 per cent of the population as a whole – many of whom were disproportionately likely to be unemployed, and living in deprived areas – social exclusion was a reality reinforced by cultural differences that went to the heart of white and non-white identity.

Addressing discrimination was not a matter of simple benevolence; it was an obligation under the law. The Race Relations (Amendment) Act of 2000 imposed a duty on the DCMS, the Arts Council, the MLA and sixty-one other cultural bodies to promote racial equality. Discrimination on the grounds of disability was covered by legislation in 1995 and 2005, until the Equality Acts of 2006 and 2010 attempted to draw together legislation against all forms of discrimination, creating the Equality and Human Rights Commission.

As in the wider dialectic of inclusion and exclusion, the problem of difference is that it is thought of as just that – a problem. As the cultural historian Paul Gilroy writes in his study of race politics *There Ain't No Black in the Union Jack*, such a construction of black people defines them 'as forever victims, objects rather than subjects, beings that feel yet lack the ability to think, and remain incapable of considered behaviour in an active mode'.[35] Language itself constructs difference, and the shifting approaches to discrimination can be tracked through the changing terminology used to address it. Since the 1970s, when 'black' was a generic term used to suggest a global solidarity, the word has been modified and hyphenated: 'Black-British', 'Afro-Caribbean', 'British-Asian', 'Black and Minority Ethnic' (BME), 'Asian' – all of which really mean 'not white' – fragmenting the groups they describe at the same time as underlining their difference from the dominant community. By 1998 the Arts Council was defining Black Arts as 'African, Caribbean, Asian and Chinese arts', the Chinese having belatedly achieved independent recognition. The prepositions attached to 'diversity' across the titles of successive Arts Council–commissioned reports, from *Towards*

Cultural Diversity in 1989 to *Beyond Cultural Diversity* in 2010, tell their own story.

As the compiler of the glossary to the Arts Council's 2006 report *Navigating Difference* warns: 'whatever words you use may be open to misunderstanding.' The lack of a clear definition of cultural diversity 'has led to the term being used inaccurately to mean both "ethnic diversity" and the opposite, "culturally specific"'.[36] Culturally specific can be mistaken for self-exclusionary. Though not necessarily interested in 'mainstream' arts activities, many minorities have a strong interest in specific art forms, some of which are not treated as art but as significant expressions of religion or custom, traditions such as dance being passed on to the next generation. It is a mistake, however, to assume that successive generations will share the same views, so there can be intergenerational, as well as intercultural alienation.

Unsurprisingly, minorities are interested in art that reflects their own experience, although Gurpreet Kaur Bhatti's play *Behzti* ('Dishonour'), at the Birmingham Rep in 2004, caused such offence to parts of the Sikh community that an angry crowd closed it down, in spite of the Rep's attempts to prepare the reception of the play. One of the perennial questions is whether the focus should be on the diversity of the work or the diversity of the audience: to target 'Asian' theatre at 'Asian' audiences, for instance, is self-limiting.

The Arts Council had formally recognized its responsibility towards 'ethnic minorities' in 1976. 'Ethnic' was intended to replace the inadequate – and politically charged – descriptor 'black', but had its own problematic overtones of the exotic and the folkloric. Its adoption can be traced to Naseem Khan's campaigning study *The Arts Britain Ignores*. Importantly, Khan included Balkan and Eastern European art forms among the ignored, but in practice 'ethnic minority' became a racial euphemism.

Though now able to access Arts Council funds, minority artists found that the Council had bundled all their activities in with community arts, rather than recognizing that they practised distinctive art forms. As Khan explains, 'the belief was that "ethnic minority arts" were the province of the communities from which they had sprung and not of any wider significance.'[37] The decision to treat

representatives of minorities as community artists rather than simply artists, condemning them to a second-class status, is one reason for the continued failure of diversity policies to help them escape the ghetto of their own institutional definition.

In the same way that the term 'ethnic' ceased to be useful, 'multiculturalism' also fell out of favour. As it emerged in the 1980s, multiculturalism was seen as a way of promoting common principles of respect for difference, equality of opportunity, and freedom of cultural expression and conscience – but it gradually came to be understood in terms of preserving separate, rather than shared, values. Artists such as the Pakistani-born Rasheed Araeen, founder of the journal *Third Text*, argued that their contribution to mainstream modernism was being ignored: 'Black artists have remained invisible or the marginals of this society. And now we are being asked to accept this marginality under the disguise of multiculturalism.'[38]

'Ethnic' had come to mean separate, and sealed off from mainstream opportunity, while the establishment of a distinct strand of funding for minority artists allowed the mainstream to consider itself absolved of responsibility. In 2001, a year after the Parekh report, *The Future of Multi-Ethnic Britain*, had recommended that the government formally declare the United Kingdom 'a multi-racial society',[39] riots in Bradford, Burnley and Oldham dramatized the reality of communities choosing to live separately.

In an attempt to escape the linguistic trap of 'multiculturalism', the Arts Council's Visual Arts Department tried to promote a different term – 'new internationalism' – and set about creating an organization to embody it, the Institute of New International Visual Arts (INIVA), launched in 1992. The idea was that this would avoid the trap of institutional apartheid by having no dedicated space of its own. Having dropped the 'New' in its title, by 1997 INIVA was the largest single organization funded by the Visual Arts Department, and it mounted a series of exhibitions across the country, as well as organizing publications and debates. When Lottery money became available, however, policy was reversed, and INIVA decided to share a new building in Shoreditch with Autograph, the Association of Black Photographers, which opened in 2007 at a cost of £5.9 million.

Critics of the institution argued that this simply set cultural segrega-
tion in bricks and mortar.[40]

The exhaustion of the term 'ethnic' was recognized in 1989, when the
Arts Council's Ethnic Minorities Monitoring Committee published
a report, *Towards Cultural Diversity*, and this expression took over.
The Ethnic Monitoring committee was replaced by an 'Arts Access
Unit' to cover all the 'marginalised areas' – including all women.
This was disbanded in its turn, and the issue lay dormant until the
appointment to the Council in 1996 of a former director of the race
equality think tank, the Runnymede Trust, Usha Prashar. This led to
the creation of a Cultural Diversity Unit to keep an eye on the way
individual departments looked after minority artists, and to support
the work of the isolated diversity officers in the regions.

The unit recognized that diversity was not simply an issue for indi-
vidual artists, but an institutional problem that required investment
in curators and administrators. Possibly shamed by the revelation
in the Parekh report that, of the first £2 billion of Lottery money
distributed to the arts, just 0.2 per cent had gone to black and Asian
artists,[41] the Arts Council earmarked £29 million for black and Asian
projects in its second capital programme.

But while the Arts Council continued to produce conferences,
policies and reports, not all projects prospered. The NIA Cultural
Centre in Manchester closed in 2000. The Drum in Birmingham
struggled to establish itself. Talawa Theatre's attempt to build the first
dedicated black theatre on the site of the demolished Westminster
Theatre in London led to the near destruction of the company in
2005. In 2009 the Council's *Theatre Assessment* acknowledged: 'major
barriers have yet to be breached for practitioners from Black and
minority ethnic and disability backgrounds.'[42]

The most notorious case, however, was that of Rich Mix, the
cultural centre in Tower Hamlets, East London. Neighbouring the
City of London, Tower Hamlets was, and remains, one of the most
deprived boroughs in the country, where a mixed, but Bangladeshi-
dominated, immigrant population rubs shoulders with artists,
creative industries, and financial services businesses looking for space

in the fashionable East End. Rich Mix suffered all the racial, religious, political and cultural stresses that cultural diversity was supposed to resolve. Emblematically, the first film to be shown when its cinema opened in 2006 was *Mission Impossible III*.

Originally proposed in the early 1990s as a challenge to the white-dominated mainstream, Rich Mix was conceived as a multi-cultural centre that would continue the abolished Greater London Council's emphasis on participation and community arts – although this immediately raised the question of which community among the several competing communities in the area would participate. Over this was laid the rhetoric of regeneration, which attracted funds from the local Cityside Regeneration Agency in 1996. The project began to be redrawn as a creative industries scheme that would bring employment to an under-skilled population.

The weight of expectations became even greater when, in 2000, Ken Livingstone, now mayor of London, gave it his London Development Agency's largest grant, and the Millennium Commission bought in. The community scheme had become a prestige project, with New Labour's Lord Waheed Alli as chair. In 2002 the conversion of the building, a former paint factory, was costed at £17 million; by 2006 this had risen to £27 million.

The choice in 2004 of the 'spectacularist' Keith Khan, who had an international reputation as a designer of parades and carnivals, seemed a good one, but the politics were poisonous, and Khan proved unable to overcome the delays. He resigned in 2007, to be replaced by a trouble-shooter who managed to get the complex – with its two cinemas, performance and exhibition space, and commercial creative-industry tenancies – fully open in 2008. But attendances were poor, and, in addition to £3.9 million in Arts Council funding since 2000, Tower Hamlets had to put in an extra £2.5 million in 2010. Rich Mix had set out to be a response to the racial exclusive-ness of the cultural establishment, but its artists were obliged to turn back to the Arts Council to regain both their and the organization's credibility.

* * *

In 2003 the Arts Council announced that diversity would be one of its five core aims. In response to the coming into force in 2002 of the Race Relations (Amendment) Act, it imposed an obligation on all regularly funded organizations to produce Cultural Diversity Action Plans, with the implication that there would be sanctions if they were inadequate. After an embarrassing failure to produce its intended 'Year of Diversity' in 2001, in 2003 it launched a £5 million scheme to help black artists and curators. To its discomfort, a DCMS review reported that the Arts Council's own staff thought it was not leading sufficiently by example: 'particularly that its staff lack diversity at a senior level'.[43] Accordingly it set itself a target of having 15 per cent of its senior staff from black and minority backgrounds.

The term 'cultural diversity' was the next to collapse under the strain of trying to resolve the tension between unity and difference. In a document that still uses the term in its subtitle, *Navigating Difference: Cultural Diversity and Audience Development*, the Arts Council's director of diversity announced that it would drop the 'cultural': 'The phrase "cultural diversity" is not widely used outside the arts and its currency within the arts helps prevent a more mature understanding of the platform on which the essential principles of diversity are built.'[44] The diversity platform was about to get more crowded. While not neglecting race, disability and social inclusion, the Council would do more 'arts-related work on issues such as age, class, faith, gender and sexuality; working with refugees and asylum seekers; and responding to issues around community development such as urban regeneration, anti-poverty initiatives and the whole rural agenda'.[45]

Social inclusion, once considered a new departure for the Arts Council, had become a core concern. Possibly worried that it might have left somebody out, the Diversity Unit turned to the long-term critic of diversity policies, *Third Text*, to suggest ways to 'reframe' diversity and equality policies. The response was *Beyond Cultural Diversity*, which concluded that the term was 'a meaningless tautological expression' that had come 'to supplant its failed antecedent, multiculturalism, and is proving a more intractable stumbling-block'.[46]

The Arts Council's response was yet another document, *What Is the Creative Case for Diversity?* Published in September 2011, it was strong on positive sentiments but weak in detail. It promised a repositioning that would 'bring art back into the centre of the discussion'.[47] 'Art' in this context appears to be a way of saying 'quality' – the word that had been used so often to exclude non-white artists in the past. The policy would be achieved by encouraging leadership, but abandoning quotas and other forms of positive discrimination, while imposing an obligation on all organizations receiving regular Arts Council funding to address diversity in the new Equality Scheme and Action Plans they would have to have in place by April 2013.

The failure to integrate minority artists into the mainstream was matched by a failure to engage minority audiences. In 2001 the Arts Council had agreed a Public Service Agreement target with the DCMS to increase by 2 per cent the number of people from 'priority' groups – disabled, socially excluded, and black and minority ethnic – who participated in arts activity at least twice a year, and to increase by 3 per cent the numbers attending arts events at least twice a year. In 2007, ACE reported that it had failed to meet this modest aim. It was found that there had been no significant change in overall participation since 2001, and a decline in attendance of black and minority ethnic groups.[48] New targets were set for priority groups in 2005–08, to increase arts activity at least twice a year by 2 per cent, and attendance at at least two arts events by 3 per cent.

At the end of the period the only target that had not been missed was for black and minority ethnic attendance, which in 2008 just managed to hit the target figure.[49] The DCMS *Annual Report* for 2009 admitted to having only 'partly met' its targets for attendance and participation by priority groups.[50] After 2008 the system for setting targets was changed, and such explicitly shaming evidence disappeared from both DCMS and Arts Council annual reports – although the *Taking Part* survey, established in 2005, continued to track audiences in general. The *Taking Part* survey for 2012/13 reported that there had been no significant change in black and minority ethnic engagement in the arts since 2005.

In 2012, black and minority ethnic organizations formed 8 per cent of the Arts Council's regularly funded organizations – but, with £10 million between them, accounted for just 3 per cent of the total allocation. The loss of trust that come from the failure to gain support, where arguments about lack of 'quality' or poor training have been used to deny participation, has caused artists from minority backgrounds to try to work entirely independently of the funding system. Excluded, but not self-excluded, they have had no other choice. For the individuals who have been the object of the linguistic definitions and redefinitions observed here, the paradox remains unresolved. The recognition of their membership of an ethnic minority appears to disable them in their identity as artists.

The quality of the work of a number of artists – among them Akram Khan, Steve McQueen, Chris Ofili, Yinka Shonibare and Anish Kapoor – has enabled them to transcend the limitations of ethnic labelling while respecting their personal formation. Ultimately, 'diversity' is not an 'issue of concern', but a resource, and the real problem lies elsewhere. As one of the Arts Council's diversity officers, Hasan Mahamdallie, has put it: 'Diversity exists; it does not have to be created. The issue is inequality within a diverse society.'[51] Paul Gilroy has proposed that, in order to challenge what he calls the 'reification' of race – something unintentionally achieved by the policies discussed here – there needs to be a new principle of 'conviviality': 'I use this to refer to the processes of cohabitation and interaction that have made multiculture an ordinary feature of social life in Britain's urban areas and in postcolonial cities everywhere. I hope an interest in the workings of conviviality will take off from the point where "multiculturalism" broke down.'[52]

The comedic racial interactions in Zadie Smith's first novel, *White Teeth* (2000), suggest the conviviality that Gilroy is evoking, but her second 'London' novel, *NW* (2012), exposes the strains of double identity that a hyphenated existence can bring.

It is evident that the Arts Council took seriously the DCMS's injunction in its PAT 10 report to 'recognise that sustaining cultural diversity and using the arts to combat social exclusion and promote

community development are among its basic policy aims'.[53] But the question remains as to how far the 'creativity' that New Labour also lauded could be subordinated to social and economic ends. In one notorious example, the imperatives of Policy Action Team 10 created a scandal that has joined the Dome in the demonology of public arts policy. The process by which blighted West Bromwich became the home of The Public – the largest community arts building in Europe and the most expensive failure in the Arts Council's Lottery building programme – shows the extent to which the demands of government policy can override good sense.

Unlike Rich Mix, the project had long-term roots in the area, in the shape of Jubilee Arts, which began life in 1974 as a community theatre group, operating out of a double-decker bus. In 1987 the bus's former driver, the charismatic Sylvia King, took over as director, and the group expanded into new fields, including multimedia projects. Their work on HIV/AIDS supplied a case study for François Matarasso's *Use or Ornament?*, and King subsequently served on the 'best practice sub-group' of Policy Action Team 10.

Thanks to the National Lottery, as part of a £250 million regeneration scheme for West Bromwich, Jubilee Arts was able to propose building a mixed-use structure that combined commercial areas, theatre and exhibition spaces, catering, and a high-tech 'interactive' gallery that that would wind through the building. The radical architect Will Alsop, who won the Stirling Prize for architecture for his Peckham Library, was appointed, and a bid was made to the Arts Council's Lottery Panel for £17.5 million. An 'iconic' building would solve the deep structural problems of life in West Bromwich.

The project had insecure foundations. According to a subsequent Arts Council investigation, its Lottery panel 'recommended rejection on the grounds of an unsound cost plan and likely cost overrun, a very high outstanding sum of Partnership funding, the inflexibility of the design, the probable inadequacy of the revenue funding, and the need to scale up the management's capacity'.[54]

Disregarding these explicit warnings, the Arts Council went ahead, and Sandwell Metropolitan Borough Council, the Regional Development Agency Advantage West Midlands, and the European

Community's Regional Development Fund all became contributors. Construction did not begin until 2003, by which time the projected cost had risen from £35 million to £43.8 million.

When The Public finally opened fully, in March 2009, the cost had grown to £52.6 million. The Arts Council had paid out £28.8 million, plus a further £4.1 million in revenue grants. In 2004, partly for other reasons, Alsop went bust, and was taken off the job; in 2006 the company responsible for running the project led by Sylvia King, also went into administration, and she and her team were made redundant. With so much already invested, the local authority took over the scheme. After a partial opening in 2008 – without the interactive technology, which did not work – in 2009 a £3 million hole was discovered in The Public's finances, and the second organization set up to run it also went into administration.

The Arts Council refused further funding, but gave the local authority a final dowry of £3 million. If it did not wish to repay the £8 million contributed by the European Regional Development Fund, Sandwell Metropolitan Borough was expected to keep The Public open for twenty years, and a new Sandwell Arts Trust was put in place, which won a further grant of £600,000 from ACE. Visitor numbers grew from 90,000 in 2010 to 380,000 in 2012, but it was costing the Council £30,000 a week to keep it open. In November 2013 The Public closed, prior to conversion into a sixth-form college.

According to the author of the Arts Council's subsequent report, Anthony Blackstock, a former Arts Council finance director, there had been 'a very strong, even unstoppable, force within the Arts Council to complete the project'.[55] But how was it that, in spite of knowing there was no workable business plan for a building declared not fit for purpose, the Arts Council's board members ignored their advisors and did not challenge its staff, led by chief executive Peter Hewitt? The answer lies in the Arts Council's need to show that it was willing to meet the policy objectives of New Labour. Blackstock cites Policy Action Team 10's report, and comments that the Council 'was seeking too far to fulfil the social agenda of the Government of the day'.[56]

Blackstock's report had an important message for government. The Arts Council's charter 'limits its funding to the creation of arts and their enjoyment. This may lead to meeting wider social and economic goals but that cannot be a primary aim.'[57] In *Use or Ornament?* Matarasso had warned against the arts 'being sold into bonded labour to a social policy master'.[58] The Public proved him right.

FOUR

The Amoeba – and Its Offspring

Too many people are engaged in too many inconclusive meetings from which no action flows.
 Arts Council of England, *Working Together for the Arts* (2001)

As part of the 1999 programme, Modernizing Government, the cabinet secretary, Sir Richard Wilson, decided that individual government departments should be subjected to a peer review – an inspection by a group of senior colleagues who gather evidence and conduct interviews to assess how well an organization is working, decide how far it is meeting its stated aims, and make recommendations for improvements. The peer review, later transformed under Wilson's successor, Sir Gus O'Donnell, into 'Capability Reviews', became part of the armoury of government. Public Service Agreements set the direction for a ministry, and targets measured its progress; a peer review was a much more forensic investigation, revealing internal weaknesses and rivalries, and creating opportunities for those it worked with to air their dissatisfactions.

In the case of the DCMS and its two key cultural agencies, the Museums, Libraries and Archives Council and the Arts Council, their peer reviews revealed serious failings. It was not enough to put

more resources into the arts: the organizations managing them had to be fit for purpose.

The DCMS was the first government department to be peer reviewed. In May 2000 a team of seven – a mixture of civil servants and experienced outsiders – descended for a week on the DCMS at its glossily corporate offices over four floors in Cockspur Street. The result was a forty-three-page internal report that remained confidential until it was released under the Freedom of Information Act in 2010. The review was led by the chairman of the Inland Revenue, Sir Nicholas Montagu, who clearly had a sense of humour. The report was titled *The Pale Yellow Amoeba*:

> Among the questions we asked at the workshops [with staff] and in some interviews were: 'if the DCMS were a colour/animal/ shape, what would it be?' A striking number of replies made the colour pale yellow and either the animal or the shape an amoeba. The traditional psychological associations with yellow – vibrancy, creativity, vigour – are the right ones: only the pallor gives cause for concern.[1]

Despite its kind words about the Department punching above its weight, and its understanding of the secretary of state Chris Smith's vision, associations with shapelessness and a sickly pallor were hardly designed to increase the self-confidence that the review concluded the DCMS lacked.

The report's main focus was on how the arm's-length principle was working, and how relations with the DCMS's sponsored bodies could be improved. The review shows they could hardly have been worse: witnesses spoke of a 'parent–child relationship' and 'management by nagging'.[2] The Department spent far too much time on deciding the 700 or so appointments it made to the Boards of the NDPBs, and collected too many unnecessary statistics, placing too much emphasis on milestones and targets. Over-management of arm's-length organizations was not producing results:

DCMS does not have very robust systems in place to address poor NDPB performance. Performance is largely measured against hard outcomes as set out in the Funding Agreement, but there are a large number of these and they are not consistent across the DCMS family. Outside these mechanical measures (which contribute to the widely-identified micro-management culture) there is little informed assessment of performance. The danger is that such assessments are formed on the basis of vague impressions (or, at worst, gossip).[3]

There was a double level of dysfunction: while the principles of the New Public Management were producing unclear and sometimes strained relations between the Department and the NDPBs, they were not being properly applied; the target-driven culture was not generating any useful information. But then the Department did not seem to be working very well, either. The peer review detected a 'silo mentality' that divided ministers from the senior civil servants on the Department's management board, the management board from the rest of the staff, and the Department from the organizations it was supposed to work with.[4]

Thus the instrument that was expected to deliver the managerialist utopia of modern cultural policy turned out to be pallid, shapeless, and, like its namesake, constantly dividing against itself. The weakness of the DCMS had significant consequences for the organizations for whom it was *in loco parentis*. In theory, the government's policies had to be delivered at arms'-length, but as their parallel stories show, when the MLA was reviewed in 2004, and the Arts Council in 2005, the institutional tools at the DCMS's disposal were found to be in no better shape.

In 1997 people were asking what the Arts Council was for. The veteran arts correspondent Simon Tait wrote: 'The Arts Council is in free fall … It is over-bureaucratic, unfocused, obscurist, confused about its revenue and capital funding responsibilities, obsessed by its shrinking subsidy and very weary.'[5] The playwright David Hare described it as a 'sclerotic embarrassment, engorged with its own bureaucracy

and inflicting the demented horrors of management culture on poor, luckless theatres which are forced to spend more time in form-filling and the corporate nonsense of fund-raising than they do in putting actual plays on the stage'.[6]

Lord Gowrie's unhappy departure as Arts Council chairman in 1998 was an opportunity to make a fresh start. For the first time, the job was fully advertised, a headhunter was engaged, and the process followed the 'Nolan rules' introduced in 1995 to reduce cronyism and promote transparency in public appointments. Nonetheless, the choice fell on Gerry Robinson, a member of Blair's business circle. Though both men happened to be Irish, Robinson's origins as the son of a carpenter could not have been more different from those of poet and hereditary peer Lord Gowrie. A chartered accountant, Robinson had made his fortune by buying out Grand Metropolitan's contract catering operation, and went on to acquire Granada Television, which in turn took over London Weekend Television, thus effectively ending the old regional structure of Britain's independent television network – an exercise he would set out to repeat at the Arts Council. New Labour's commitment to a modernizing managerialism found its perfect expression in the replacement of a patrician poet by a motorway services manager.

Art lovers might have taken comfort from the knowledge that his hobby was painting, but Robinson was a ruthless cost-cutter. In 2003 he made a television series, *I'll Show Them Who's Boss*. At the Arts Council he would need to: 'The most excited voice I heard in the building when I came here was the automated voice in the lift.'[7] In his view, 'the Arts Council was a shambles, and the government wanted it sorted out'.[8] Appointed in January 1998, his first act was to confirm that Peter Hewitt, who had formerly run Northern Arts, would become chief executive. Hewitt had spent the last five years honing his bureaucratic skills as director of corporate affairs at Tees Health Authority, and chose his language accordingly. The Arts Council was 'a very unwell organization'.[9]

Robinson was determined to make the Arts Council business-like, and portrayed Hewitt and himself as slayers of a many-headed monster: 'Peter and I found a Kafkaesque bureaucracy permeating

throughout the whole of the system from Government to Arts Council to Regional Arts Board – a bureaucracy that had become obsessed with heavy handed control; data collection without purpose or outcome; an absurd number of performance indicators; and the proliferation of funding schemes that diverted energy from the arts themselves.'[10]

But the monster proved difficult to slay. Although he reduced membership of the unpaid governing Council to ten, his promise to cut the staff at the offices in Great Peter Street from 322 to 150, saving £2 million a year in running costs, proved harder to fulfil. As the MLA would also discover, the centralizing impulse of London could be thwarted by the cultural cussedness of the regions.

In England the Council's 'national' remit fitted uneasily with the responsibilities of ten Regional Arts Boards (RABs), including one for London. Their quality varied, and each tended to do things a little differently. As a result, there were more than a hundred different funding schemes in operation across the country, with many organizations funded both by the Arts Council and their local RAB. But even though the Arts Council gave the RABs 97.3 per cent of their core income, a strong sense of local identity made them instinctively suspicious of London. They were also partners with local authorities in maintaining the local cultural facilities on which the whole system depended. In Peter Hewitt's view, however, the system led to 'duplication, inconsistency, complexity. Polarization of policy, with regions seen to be concerned about the arts in social contexts, the national about excellence. Disputatious internal workings, budgetary inflexibility.'[11]

Robinson and Hewitt's initial solution was to transfer all but the seven 'national' arts organizations and responsibility for touring to the Regional Arts Boards. But this apparent surrender of power from the centre did not produce the desired economies. Given their increased responsibilities, the RABs created posts equivalent to the ones the Arts Council was shedding. An external analysis of the accounts for 2000/01 showed that, since 1998/89, the number of head office staff had indeed fallen to 200, but at a cost of £1.4 million in redundancies and £5 million in hiring agency staff. At the same time, the total

number of staff at the RABs had increased to 451, producing a net loss of eleven people. Meanwhile, staff salaries at the Council's offices in Great Peter Street had risen by 55 per cent, with a knock-on effect on regional salaries producing a rise throughout the whole system of 26 per cent. Peter Hewitt's salary, excluding pension payments, had risen from £78,500 in 1998 to £141,000 in 2001 – but that was still less than the salary of the new head of arts, Kim Evans, who had joined from the BBC in 1999 on a salary of £145,000 a year.[12]

As the total operating cost of the combined system rose from £31 million in 1997/98 to £36 million in 2000/01, Robinson reversed his position. He would now save between £8 million and £10 million a year by abolishing the Regional Arts Boards: dispersal would be replaced by centralization. It was a simple, business-like proposition. The Arts Council and the RABs would become a single organization, reverting to a pattern that had existed in the 1940s and early 1950s. The only trouble was, the RABs knew nothing about it until 14 March 2001, when the chairs and directors of all ten were informed by Robinson that they had until 30 April to transfer their staff, assets and liabilities to the Arts Council. Robinson told them this was non-negotiable, and that he had a letter from Chris Smith backing him up. In the gentle world of arts administration, this felt like a hostile takeover, even a *coup d'état*. Five days later the DCMS announced that Robinson's appointment as Arts Council chairman had been extended to 2004.

But Robinson had not allowed for the institutional self-respect of the Regional Arts Boards or the claims of localism. The RABs were self-governing charities, and had no direct connection with the DCMS. Robinson's precipitate action broke the Cabinet Office code on the transfer of staff in the public sector, as well as the code of practice on consultation, for there had been none. Handed the document demanding their surrender, *The New Arts Council of England: A Prospectus for Change*, the RABs said no.

It is surprising that Robinson and Hewitt thought they could get away with it. Hewitt, after all, had been director of one of the most self-assured Regional Arts Boards. Now, without any warning, the RABs were being told to wind themselves up. They would be

replaced by 'a range of advisory groups, including strong regional advisory boards', but the national Council would continue to be only ten people, plus the chair, with 'a considerable artist presence', and London would have the final word.[13]

This silencing of local voices alarmed even Chris Smith, whose support turned out to be more equivocal than Robinson had claimed. In a second letter to Robinson he reiterated his wish that regional participation should be genuine, warning that regional directors might become representatives of the centre rather than spokesmen for their region. Previously, these had been independent chief executives reporting to their local Boards, but they would now report to the chief executive of the Arts Council. In order to match the areas defined by the government's Regional Development Agencies, the number of regions would also be reduced to nine, by distributing the area covered by Southern Arts between the South East and South West offices.

Faced with angry and determined opposition, Robinson had to abandon the six-week deadline of 30 April 2001, and a lengthy negotiation began. A shaken Hewitt was sent on a penitential pilgrimage to the regions, where RAB staff greeted him with hostility. But the truth, as Robinson bluntly explained to a meeting of the chairs of the RABs in May 2001, was that, if they did not agree to the creation of a single system, the Arts Council would simply cease to fund them. Having failed to ambush the RABs, Robinson and Hewitt were forced to bring in a team of consultants, led by a wily former Arts Council deputy director, Richard Pulford, who had the necessary skills in political persuasion they lacked. The ten typewritten pages of *A Prospectus for Change* were refashioned into a new public document, the thirty-four pages of *Working Together for the Arts*, released after much behind-the-scenes bargaining in July. Its very title suggested that Robinson and Hewitt had been forced to adopt a more collaborative approach.

Public opinion was hostile. Of the 1,120 responses to the *Prospectus*, the negatives outnumbered the positive by ten-to-one. Opposition from arts organizations to the revised proposals was nearly three-to-one. Sue Robertson, director of the London Arts Board, who

resigned in protest, compared the atmosphere to the poisonous world of *Hamlet*: 'A small and insular world of politics, structures and hierarchies. A world where things are not what they seem and language loses its meaning. Where new is old, where savings equal costs, and consultation means minds made up.'[14]

Working Together for the Arts did, however, make a significant concession. Under the original proposals, interested parties such as arts professionals, local authority members and other volunteers would have had a purely advisory role. Now Regional Councils – the equivalent of the former Boards, would have a powerful say over policy in their areas, and their chairs would all become members of the Arts Council. Not only had Robinson's preferred unit of decision – no more than ten people – had to expand to fifteen; the Regional Councils were now the majority voice on the national Council.

Regional directors would similarly join the senior management of the national operation, while controlling everything that went on in their region, for not even touring was to be a national responsibility. Although there was still a great deal of unhappiness about the manner in which it had been achieved, by March 2002 all the RABs had accepted the creation of a single organization, and in April – a year later than Robinson had demanded – they began transferring their staff and assets.

The cost of the reorganization was £7.5 million. The projected ongoing annual savings of between £8 million and £10 million from 2003/04 became a more modest £5.6 million, forecast to rise to £6.7 million in 2005/06, but the figures were greeted with scepticism. Instead of falling to around eighty, by April 2004 the number of head office staff had increased to 226, and total staff numbers had risen to 707. Whereas the pay of Arts Council staff matched that of the civil service, staff in the RABs had tracked that of (lower-paid) local authority employees – but they now claimed national parity. Since 1997 staff salaries overall had risen by 66 per cent, including the 93 per cent rise for Peter Hewitt.

At the cost of more than a year in which the staff of the RABs and the Arts Council were almost exclusively focused on internal matters rather than the arts, Robinson had achieved his aim of creating a

single organization, symbolized by the reduction of 115 funding schemes to five. He had also been able to get rid of the unpaid art form advisory panels, which had always irked him. But the Regional Councils continued to approve the budgets and other funding decisions for their regions, and their chairs had a majority on the national Council. What had begun as a hostile takeover by London turned out to be a reverse merger by the regions – one that left the centre weaker than it had been before, as events were to prove. But by then Robinson had moved on.

The 'new' Arts Council officially began work in April 2003. To celebrate its fresh identity, the Arts Council of England decided to adopt a new name, and hired a team of designers to create a new logo. The words 'the' and 'of' were dropped, and the new name, 'Arts Council England' – generally referred to, often ironically, as ACE – was arranged in a circle. The cost of deleting two words was £70,000. Christopher Frayling, Gerry Robinson's successor as chairman, liked to compare the new round design to 'the stain left by a coffee-cup'.[15]

For all its complications, the arts funding system was simple in comparison with the museums sector. It was not even possible to say how many museums there were in the United Kingdom, although the best estimate put it at 2,500, of which about half had fewer than 10,000 visits a year. Here was an elaborate tapestry of institutions of national and local importance woven over two hundred years. The 'national' museums were defined as those funded directly by government, of which twelve were funded by the DCMS, and six by the Ministry of Defence, which also supported a further forty regimental museums. Thirteen university museums received their funding through the university funding body, the Arts and Humanities Research Council.

Museums directly funded by the DCMS jealously guarded their status as Non-Departmental Public Bodies, which gave them direct access to ministers, but they did cooperate through the National Museum Directors' Conference (NMDC). This could be a powerful lobbying tool. In January 2001 it had a small but significant victory over Chris Smith, when he was forced to withdraw a proposal that,

in those cases where a museum's chair was not already appointed by the prime minister, national museums should 'consult' the DCMS over their choice of chairman. Independent boards of trustees were not prepared to accept government interference, any more than the NMDC was willing to accept that all museums, national and regional, should be funded through a single body.

Although some had regional outposts, the dominance of national museums was reinforced by their being in London.[16] Once they all accepted the principle of free admissions, the national museums enhanced their status as part of New Labour's flagship policy, gradually increasing their income from special exhibitions, corporate sponsorship, private giving, trading and catering.

This expansion called for a change in the culture and management of museums. Nicholas Serota succeeded in dividing the Tate's overcrowded collections between their original home on Millbank – renamed Tate Britain – and Tate Modern, while keeping firm control of both. Outwardly reserved, but powerfully persuasive, Serota had the political skill to keep contemporary artists and government ministers on side, while raising immense sums from donors and commercial sponsors. Not content with opening Tate Modern and refurbishing Tate Britain, he pushed on with a second phase at Bankside to increase Tate Modern's capacity by 60 per cent.

The British Museum found it harder to change. It had suffered a serious decline in the real value of its grant-in-aid, and had not been modernizing its practices, so that a deficit developed. In 1996 it was discovered that the museum did not employ a single qualified accountant. A £90 million Lottery project to restore and glaze over the building's Great Court, to a design by Norman Foster, stretched the administrative capacities of the staff and, when it opened in 2000, added to running costs. In an effort to impose some rigour on the organization, in April 1999 the DCMS encouraged the appointment of Suzanna Taverne – a former banker and management consultant with no previous experience of the museum sector – as managing director. She was given equal seniority to the director, the scholarly but old-fashioned Dr Robert Anderson. This was the first time such a duumvirate had been tried in a major museum.

It was not a success. Taverne set about modernizing management and cutting staff and costs, and let it be known that she would be happy to succeed Anderson as director when he retired in 2002. But it was she who resigned, in September 2001, having understood that she would not get the job. Her parting shots were directed at 'this priesthood of curators, who look after the relics ... They carry this sacred flame of the institution – the museum.'[17]

Anderson's successor was the young and charismatic director of the National Gallery, Neil MacGregor – a good communicator who exercised his personal charm ruthlessly in the interests of the institution he was leading; he gradually restored the morale and reputation of the museum, but he was obliged to continue to reduce staff numbers as the deficit threatened to rise to over £6 million. The situation did not improve until 2004, when a Comprehensive Spending Review enabled an increase in the museum's funding to nearly £40 million a year.

Because there was no centre to the museum sector, the government's challenge was not how to concentrate its powers, but how to establish a framework that would enable it to exercise them in a meaningful way. Beyond the national museums there was a bewildering range of scale and forms of governance. In England, local authorities directly funded and managed 41 per cent of museums. These were the backbone of the system, dominated by the big civic museums founded in the nineteenth century, but also including many small town and branch collections. Some 39 per cent of museums were run by independent trusts, the majority of them founded during the museum boom of the 1980s. A further 7 per cent were armed forces museums, and 5 per cent belonged to universities. Although the Museums Association, the professional body representing both individuals and institutions, provided a forum for the sector, each type of museum preferred to talk to its own kind, making arriving at a national view difficult. Regional groupings were defined by the seven Area Museum Councils outside London – self-governing membership organizations open to all types of museum, and originally set up piecemeal, like the Regional Arts Associations that had preceded the

Regional Arts Boards. The Museum Councils acted as representatives for their region and as a conduit for funds and professional expertise, making their directors influential players.

The Museums, Libraries and Archives Council was supposed to bring coherence to the sector, but it was hampered by the national museums' retention of their independence, and by the different institutional histories, cultures and practices that it was expected to reconcile. There were fundamental differences between the way regional museums and library authorities operated and how they were funded, while there was only a rudimentary regional structure for archives.[18]

With a publisher's flair, Matthew Evans began his chairmanship by renaming the organization 'Re:source' (*sic*), and making a challenging speech to the Association of Independent Museums. Blithely admitting that he had no experience of museum management, he pointed out that 80 per cent of the population had not visited a museum or gallery in the past three months, and expressed a dim view of museum staff in their outmoded professional silos. The deputy director of the Museums Association, Maurice Davies, countered: 'what the sector is crying out for is clear, simple, coherent guidance and leadership from this new body.'[19] It would not get it.

In 2000 a DCMS review discovered a growing crisis in regional museums, with declining budgets and shrinking audiences. Chris Smith established a new Task Force, chaired by Evans, and including both Nicholas Serota and Neil MacGregor. It confirmed that morale was low, that scholarship and expertise were being lost, and that it was harder and harder to make new acquisitions. The message was simple: 'The regions are culturally rich but financially impoverished.'[20]

The Task Force's answer was significant new investment. This was to be applied through a network model that identified a major museum in each region, which would form a 'hub', working in partnership with two or three smaller museums. At the same time, Area Museum Councils would become the basis of new regional agencies supplying development and training to museums, libraries and archives. If all the proposals for reforming outmoded structures of management and governance, investing in training and new technology, and

changing the internal culture of museums were followed through, regional museums would be transformed, as best practice spread out across the whole sector.

The funds necessary to set up and maintain this network would be administered by the MLA, which meant that, for the first time, central government would be contributing significantly to the costs of regional museums. Part of the argument that the government should do this was that it had been funding the arts in the regions via the Arts Council since the 1940s; but the report was written at a time when the government's rhetoric about regionalism was at its loudest, and by setting up autonomous local bodies the plan fitted with its regionalist intentions. The cost, spread over five years between a start-up in 2002 and 2006/07, was estimated at £267 million. The Task Force report was given the optimistic title, *Renaissance in the Regions*.

The government accepted the report, but the DCMS created difficulties. The expected investment of £267 million over five years was finessed down to £167 million over three years, and when the scheme was due to start in April 2004, only £70 million was made available, so that instead of it being launched in all nine regions it was only possible to fully fund three. In the hope of impressing the Treasury with 'quick wins' that might prove that the idea worked, these were treated as Phase 1 hubs. The others were allotted less money, and did not start to function until April 2005. This time, the underfunding of the scheme was not the result of a Treasury decision, but reflected a choice of priorities by the new secretary of state at the DCMS.

Following the 2001 general election, Chris Smith had been replaced by the arch Blair loyalist, Tessa Jowell. A former psychiatric social worker, Jowell brought her keen sense of mission with her. Brimming with a genuine, but at times overwhelming, sincerity, she could be persuasive enough to convince a reluctant Blair to bid for the Olympic Games. Characteristically, Jowell could not resist diverting funding earmarked for *Renaissance in the Regions* towards the Department's pet social projects, Culture Online and Creative Partnerships. The former director of the East Midlands Museum Service, Adrian Babbidge, protested that the drive to modernize regional museums was being set aside for more immediate ministerial

enthusiasms: 'In doing so there is a high risk that *Renaissance* has been converted into yet another short-term initiative, without reforming the structure and governance of regional museums, thereby seizing defeat from the jaws of victory.'[21]

In February 2003 ACE's chief executive, Peter Hewitt, invited the arts community to join the Council in a 'bold adventure'.[22] With the traumas of 2002 behind it, the Council felt ready to replace all previous policy statements with a manifesto, *Ambitions for the Arts 2003–2006*. This promised a modern, dynamic Arts Council looking for 'a new relationship with arts organizations, based on trust'.[23] Having won a further increase in government funding after the 2002 Comprehensive Spending Review, and with Lottery money significantly moved away from capital projects, ACE was preparing to recast itself as a development agency.

Approximately 75 per cent of ACE's funding would be committed to some 1,300 Regularly Funded Organizations (RFOs), while the rest would be used to support one-off projects by individuals or organizations, touring, capital projects, and a 'stabilization' scheme – essentially a means of rescuing organizations, among them the Royal Shakespeare Company and English National Opera, that had got into difficulties. Loudly echoing the government's agenda, *Ambitions for the Arts* proclaimed: 'As an organization, we will be focused on growth. We will bring the transforming power of the arts to bear on issues of health, crime, education, and inclusion.'[24]

Gerry Robinson stepped down as Arts Council chairman in January 2004. His successor could not have been more different than he had been from Lord Gowrie. Christopher Frayling, knighted in 2001, was a Cambridge-educated intellectual with a serious interest in popular culture, and an expert on vampires and spaghetti westerns. He had started teaching at the Royal College of Art in 1972, became its first professor of cultural history in 1979, and in 1996 was appointed its head as rector and vice-provost. Here was an arts insider, a dedicated committee-man with long experience of the Arts Council. He had joined the visual arts advisory panel in 1983, and served as a Council member between 1987 and 2000, before

becoming chairman of the Design Council. He was also a trustee of the Victoria and Albert Museum, and among his many other public responsibilities he had been 'godparent' to the Faith Zone of the Millennium Dome. He was genial, witty and a quintessential member of the far less patrician arts establishment that was taking over from the Great and the Good.

But that would not guarantee success. After leaving the Arts Council in 2009, he pointed out that, in the official portraits of past Council chairmen, John Maynard Keynes was the only one smiling. That was because Keynes died before ever having to chair a Council meeting.[25]

The trouble began with the 2004 Comprehensive Spending Review. The final objective declared in *Ambitions for the Arts* had been a further significant increase in funding.[26] This was not to be. The biennial interdepartmental jostling had become a familiar ritual, and rival interests had learned to start the bidding process early.

In 2004 the National Museum Directors' Conference took the lead in a concerted effort to improve funding for the museum sector, and decided to play the instrumentalist game. In partnership with the MLA, the Group for Large Local Authority Museums (GLLAM) and the Association of Independent Museums (AIM), they released a *Manifesto for Museums*, backed up by reports making an economic and social case for an extra £115 million a year for the sector. Assuming that all would be well, the Arts Council merely produced a bland pamphlet, *Ambitions into Action*.

By June, however, Tessa Jowell was beginning to manage expectations with signals that the outcome of the spending round would not be generous. It was not until a week before the departmental allocations were due to be announced, in July, that Frayling made public ACE's bid for an extra £20 million on top of an increase to compensate for inflation. Pointing out that 2005 would be an election year, he told the *Stage* that this 'would not be a good time for the arts community to get angry'.[27]

It is unlikely that the Treasury read the *Stage*. Whereas the average increase for most government departments was 4.2 per cent, the increase for the DCMS was only 2.3 per cent, from £1.4 billion in

2004/05 to £1.6 billion in 2006/07. Although the distribution of this sum within the overall DCMS allocation would not be finalized until December, the chancellor Gordon Brown's announcement made it clear that the museum sector had done well. University museums would be able to drop entry charges, and there was enough money to extend the *Renaissance* programme to all nine regions. The final outcome was an increase of 4.4 per cent for the museums and libraries sector and 3.8 per cent for the arts.

Frayling reacted angrily, issuing a press release interpreting the three-year settlement as a £30 million cut. As was customary, the first year's funding had already been announced as the last of the previous three-year tranche, and that was an increase to £410.5 million – in real terms, the largest amount it would ever receive, but it would be frozen at that figure until April 2008. Once inflation was factored in, this became a cut. It was not what the Arts Council had been led to expect a couple of weeks before the announcement, but what annoyed Frayling most was the relative success of the museums sector. He complained of its being 'Buggins' turn': 'This is no way to build our culture and throws into question the place of the arts and museums in the Government's pecking order.'[28]

This angered Jowell, who complained that she had been 'mugged by spin doctors'[29] – a surprising claim for a member of the New Labour government. Deploying Gordon Brown's technique of double counting, she accused the Arts Council of lying, arguing that funding had increased by £45 million, but neglecting to mention this had been announced three years before. The arts need not suffer, she reasoned, because the costs of inflation would be absorbed by efficiencies in administration. Unusually, the lobbying group the National Campaign for the Arts came out in support of Jowell, arguing that the frozen budget was intended to force the Arts Council to cut its own bureaucratic costs, which it had failed to do as agreed after the previous spending review. No further cuts were necessary.[30]

This proved to be the case. A combination of past underspending, administrative savings and a reduction in the Grants to the Arts fund meant that in March 2005 the majority of regularly funded

organizations got an increase of 2.75 per cent. But the situation still rankled with Frayling, who returned to the subject in a lecture at the Royal Society of the Arts in February 2005. His defence of the Arts Council was that it was 'at the same time a funding body, a development agency, a campaigning organization, a mapping unit, an incubator and a think tank. It is not, as some people seem to think, just a letterbox or a cashpoint machine.'[31]

Frayling was defending the independent professionalism of the Arts Council against a threatened takeover by civil servants, as the pale yellow amoeba sought to assert its authority over its offspring. As evidence of this, he cited the customary letter sent by the secretary of state for culture to the chairman of the Arts Council with each renewed funding agreement. In 2000 Chris Smith's letter to Gerry Robinson had been three pages, but in 2004 Jowell's to Frayling ran to seven, stressing government priorities, ring-fencing funding for projects such as Creative Partnerships, and demanding even more administrative efficiencies, which the Council would in turn have to demand from the 'second-tier' organizations it funded:

> Put all these together – plus the fact that the DCMS has developed an alarming tendency to replicate our structures – and there can be little doubt that the Arts Council is increasingly seen as an extension of the DCMS. As a part of government. In other words that in the eye of the government, the National Theatre is an extension – a second-tier extension – of the civil service. When that has happened, the length of the arm has become very short indeed, almost Venus de Milo length.[32]

Frayling had a fair constitutional point, and it showed that the parent–child relationship between the DCMS and ACE was getting worse. But the Arts Council was also having trouble with its own children. This became clear in July 2005 when, after a trial run with the Museums, Libraries and Archives Council, it was ACE's turn to be the subject of a peer review. It was led by Genista McIntosh, who had left the National Theatre and gone to the House of Lords. Its findings were ready by October, but not made public until the report

was quietly put up on the Arts Council's website in the dead week before Christmas.

The Council had cause not to draw attention to the report. McIntosh noted that ACE had been 'upsized, downsized, outsourced and restructured in various ways for various reasons, and has routinely been seen both as the solution to, and the source of, the problems which perpetually beset artists and arts organizations'.[33] The report came down in favour of retaining an arm's-length body, but seriously questioned the effectiveness of ACE's relationship with the DCMS. There had been a breakdown in trust: fearing that the Arts Council would not meet its targets, the DCMS had set up a parallel monitoring system of its own. If relations were to improve, ACE had to restore its credibility – and here the review discovered another problem. The Arts Council had lost touch with its own constituency. The arts community was losing faith in the Council – especially in the professional authority of its officers.[34]

The review was too discreet to offer specific evidence, but the problem was well known. When the conductor Simon Rattle left the City of Birmingham Symphony Orchestra to take over the Berlin Philharmonic in 2001, he was released from the usual circumspection incumbent upon those in receipt of Arts Council funds: 'Shame on the Arts Council for knowing so little, for being such amateurs, for simply turning up with a different group of people every few years with no expertise, no knowledge of history, to whom you have to explain everything, where it came from and why it is there, who don't listen and who don't care. Shame on them!'[35]

McIntosh found that the Arts Council's staff lacked recent experience of working in arts organizations. There was a shortage of intellectual firepower, an inability to communicate the organization's worth, a reluctance to gather and use data, and poor communication across the organization. The decision to disband the art form advisory panels meant there was a lack of engagement with the arts community. This problem went as high as members of the Council itself. They were poorly briefed, and even the staff was confused about the role of Council members in the decision-making process. Although restructuring into a single organization appeared

to have worked, 'some stakeholders and indeed some staff reflected that Arts Council England still looks very hierarchical and process-dominated'.[36] Above all, there had to be a clear and coherent role for the national office. Having spent six years being upsized, downsized, outsourced and restructured, ACE would have to go through the whole process again.

The travails of the Arts Council had their parallels in the equally dys-functional progress of the Museums, Libraries and Archives Council. Created to bring order to a crowded and rivalrous sector, it lacked the material and organizational resources to do so. Its funding never achieved as much as £100 million a year, and its financial reach was never able to match that of the local authorities or, for capital projects, the Heritage Lottery Fund. Although the *Renaissance* pro-gramme accounted for 70 per cent of the MLA's financial activity, it was given fatally low priority.

The organization's problems were compounded by an alarmingly rapid turnover of chief executives: the first had joined from the DCMS on a five-year contract, but left after two years. His place was temporarily taken by his deputy Chris Batt, a former local authority librarian who had originally joined as an IT specialist, until Anna Southall, a conservator and former director of the National Museum of Wales, arrived in September 2002. She declared at her first senior management meeting that she was there to sort out the MLA or close it down, but by the following spring she too had left, and the loyal but cautious Batt was once more temporarily in charge.

After another fruitless executive search, Batt was finally confirmed as CEO in December 2003; he promptly abandoned the name Re:source, adopting the simpler MLA. Batt was therefore in charge when, in July 2004, the DCMS decided it was the turn of its agen-cies to be peer-reviewed. This 'prototype review' confirmed that the MLA had had a difficult birth, and that there were still doubts about its legitimacy.[37] The report highlighted difficulties in the relationship over 'territorial' boundaries between the MLA and the DCMS similar to those experienced by the Arts Council. Nor was it working effec-tively with the regional agencies that were supposed to help deliver

its programmes. The Board was weak, and many of the criticisms made of the inadequacies of the staff of the Arts Council applied to that of the MLA.

The principal challenge, however, was reconciling its three domains. To achieve this, the MLA was in the process of merging the seven existing Area Museum Councils and seven Library Councils into nine regional agencies. About a third of their funding came via the *Renaissance in the Regions* programme, which, to complicate things even further, had its own regional Boards. Local resistance, especially in the London area, meant that it took until 2006 to complete the pattern of regional agencies.

At this point they closely resembled the Regional Arts Boards, in that they were independent organizations but had a policy and funding relationship with the MLA. In April 2006 the 'MLA Partnership' was formally launched, and the chairs of the nine new agencies were invited onto the MLA board. This was a less drastic step than Robinson's attempt to nationalize the RABs, but by attempting to get all the agencies to cooperate within a single framework, the centre was also risking being outvoted by the regions. The result was confusion, as each regional agency behaved differently and the centre struggled to retain control.

Batt took early retirement in the summer of 2007, and was succeeded by the altogether more colourful Roy Clare. Clare had joined the navy as a boy, and rose to the rank of rear admiral before becoming director of the National Maritime Museum in 2000, where he applied the leadership skills learned in the navy to running the museum. But he resigned after falling out with the museum's new chairman, the shipping magnate Lord Sterling, and exchanged his seat on the Board of the MLA for the post of chief executive. By now the MLA was three years on from its peer review, but had still not established its authority. Commenting on Clare's appointment, the editor of the *Museums Journal*, Sharon Heal, asked if the MLA was fit for purpose: 'There is a strong feeling that despite some hard work on behalf of museums that it is an organization mired in bureaucracy and lacking in confidence.'[38]

* * *

In July 2006, Peter Hewitt – still smarting from a public attack on him by Jowell's minister for culture, David Lammy, who had berated him for failing to achieve a democratic settlement between the Council, the government, the arts community and the public[39] – announced a new initiative. Climbing on the 'public value' band-wagon that had been running since 2002, the Arts Council was launching an enquiry into the way people understood and valued the arts. Hewitt acknowledged that the Council had failed to write itself into either the government's or the nation's core script.[40] Accordingly, this would be an open conversation with the public that as yet had never happened.

While this effort was being made to improve external relations, the Council's internal relations worsened as the restructuring of head office went ahead. To cut costs by £1.8 million, thirty-three posts would have to go. Everyone had to reapply for their jobs, and six out of seven departmental heads left, including the head of the arts department, Kim Evans, and the directors of touring, drama, litera-ture, visual art and dance, plus some of their deputies – meaning that even more expertise in these fields was lost. Hewitt also announced that he would be leaving in 2008. The creation of the new man-agement structure occupied most of 2006; when it was completed, Frayling admitted: 'I didn't realise that the changes would be so dra-matic. It might seem like a huge purge. Yes, the council is now a very tense and demoralised place.'[41]

The Council had one piece of luck: the Comprehensive Spending Review expected in 2006 had been postponed until 2007, so restruc-turing could go ahead without that distraction. On the other hand, because spending decisions were taken in three-year cycles, the post-ponement meant ACE had no idea of its funding after April 2008; arts organizations had no idea of theirs either. Normally the Treasury pronounced in July, but in 2007 that was the month when Gordon Brown took over as prime minister, and the spending settlement was not announced until October.

Given the darkening prospects for the economy, the expectation was that the outcome would not be generous to the DCMS. The Arts Council, however, saw this as an opportunity to stop funding some

of the organizations it regularly funded, and to take on others. After two rounds of internal restructuring, the Council wanted to prove that it could take the lead by reshaping its entire portfolio of funded organizations.[42] Accordingly, 2007 was devoted to an 'Investment Strategy'. Planning went ahead on the basis that there would be a cut, or at best a standstill, in its funding.

The plan was agreed in January 2007, and the executive directors of the regional offices given until May to produce a list of winners and losers in their regions. Only the ten organizations receiving more than £5 million a year would be dealt with by the national office. ACE wrote to all organizations in May warning of possible cuts, but in such general terms that little notice was taken. The whole process went ahead in great secrecy. Even when it was known that an organization was to lose its funding, no mention was made at the annual review meeting between the organization and ACE, causing, it was later admitted, 'huge anger and distress'.[43] This was not the 'new, grown up relationship with arts organizations' heralded in *Ambitions for the Arts*. Even those that did well 'were not treated with trust and respect'.[44]

The secrecy extended to the members of the national Council itself, who were kept in the dark as much as possible because of paranoia about leaks to the press. Council members who chaired Regional Councils knew what was going on in their own regions, but the 'artist' members had little idea of what was brewing. The planning process ground on until the Arts Council's funding settlement was at last announced, on 6 October.

To everyone's surprise, the Council got an increase of £50 million, representing 2.7 per cent above inflation. At least some of the planned cuts to organizations would no longer be necessary. But ACE was determined to go ahead anyway. On 12 December letters started arriving at the offices of 990 arts organizations great and small; but, in what looked like deliberate news management, no general announcement was made, so it was only gradually that the full extent of the changes became known.

That did not stop the furore that broke out in the arts world and the press. While eighty-one new organizations were taken on, and

forty-one others got substantial increases, 194 were to lose their funding completely or in part – among them the London Mozart Players, the City of London Sinfonia, Chisenhale Dance, Birmingham Opera Company, the Bush Theatre in London, the Derby Playhouse, the Bristol Old Vic, the Yvonne Arnaud Theatre in Guildford, and the Northcott Theatre in Exeter. Condemned organizations were given four weeks – over the Christmas period – to appeal.

The secretive, and in some cases ill-informed, way it had gone about the business meant the Council faced a rising tide of anger. The *Sunday Times* weighed in with an editorial supporting the threat-ened National Student Drama Festival, which it had sponsored since its inception in 1956. On 9 January 2008 Peter Hewitt faced an angry meeting organized by the actors' union Equity at the Young Vic Theatre, where 500 booing practitioners passed a vote of no con-fidence in the Arts Council. It must have been a relief to him to know that at the end of the month his time there would be over.

On 1 February Hewitt's successor, Alan Davey, announced the national Council's final decisions. Seventeen organizations had suc-cessfully appealed, meaning that 185 would have their funding stopped, and twenty-seven would see it reduced. With eighty-one new organizations taken on, the new arts portfolio stood at 888. The Arts Council had achieved its aim of funding fewer better, but at a terrible cost to its reputation. Davey, who for the previous five years had been director for culture at the DCMS – and so the Arts Council's case officer – once more called on the services of Genista McIntosh, whose review of the Investment Strategy process was pub-lished together with Davey's own review, subtitled *Lessons Learned*. McIntosh was explicit about the loss of respect for ACE as a result of the way in which the process was handled, and the reputational damage that had been done.[45]

The most devastating conclusion was that the 'single organization' that Gerry Robinson had thought he was creating had not come into being. The chairs of Regional Councils knew what was going on in their region, and the nine regional executive directors on the manage-ment board knew what they wanted in each region, but 'this regional autonomy is part of the problem'.[46] Regional decision-making was

slow, and no one had a national overview. The 'artist' members of the national Council, who should have been able to take an independent view, 'appear to have been effectively disenfranchised, since at crucial points they had no access to detailed information from any source.'[47]

In spite of everything that Robinson had put the organization through, ACE still had an 'overly complex structure based on ten separate decision making bodies'.[48] It would be up to Davey, as the new chief executive, and – after she took over from Frayling in February 2009 – Liz Forgan as a new chair, to make one more effort to resolve the perennial tensions between the centre and the periphery, persuade the regions that they had to accept the leadership of the national Council, and restore the organization to a position of trust.

By 2008, the MLA was also in deep trouble, its internal problems compounded by the change in the funding climate. In 2006 its funding agreement with the DCMS had committed it to moving much of its operations out of London to save money; the 2007 Comprehensive Spending Review contained worse news: the money for *Renaissance in the Regions* was insufficient to equalize the funding for all museum hubs, and there would be a cut in the MLA's own funding. Head office was told to reduce its administrative costs by 25 per cent. In February 2008 the MLA Board agreed to wind up all the regional agencies (except London) by March 2009 – a move even more drastic than the Arts Council's absorption of the RABs. Core services would move to Birmingham, and the London office and Board would shrink. In 2009 the new regional structure was led by three 'directors of engagement', while the eight regions outside London each had a manager working from home. Having followed orders, Roy Clare told the *Museums Journal*: 'For the first time, we will have an integrated organization and executive board, operating around a neat central core.'[49]

According to Clare, the MLA had emerged 'leaner, fitter and more agile'.[50] But was it any fitter for purpose? This latest painful and demoralizing restructuring took place just as a review was being conducted of its flagship programme, *Renaissance in the Regions*. It was led by Sara Selwood, professor of cultural policy and management

at City University, and a former member of the MLA Board. Since its launch, the government had committed £300 million to the *Renaissance* programme, but it was not until 2008 that it was decided to examine its working.

The Selwood review showed just how badly the programme had been run. There had been distortion from the beginning, when Tessa Jowell's predilection for promoting education and social cohesion had diverted the programme from its purpose of modernizing the regional museum structure. In spite of accounting for 70 per cent of the MLA's expenditure, the *Renaissance* programme was serviced by less than 10 per cent of its staff. The manager for the scheme was never senior enough to serve on the Executive Board, and responsibility for it shifted between different departments. This may help to explain why, by March 2007, the programme had accumulated an underspend of £7.5 million, hurriedly dispersed the following financial year. Another underspend of £4.8 million was simply handed back to the DCMS in 2010.

The MLA had never specified its measures of success, or even developed a forward plan in response to the original *Renaissance in the Regions* report. There was incomplete documentation, and without a forward plan or an annual review the programme was allowed to drift. Although the money it brought was time-limited and attached to specific streams of activity such as diversity in the workforce, its beneficiaries began to treat it as core funding. Hub museums were not alone in this. The review noted the MLA's 'own opportunism in using *Renaissance* to fund extant and cross-domain programmes'.[51] The hub museums lost trust in the MLA, and there was confusion over the relationship with the regional agencies, which were supposed to be developing the whole sector. *Renaissance* had helped to halt the decline of English regional museums, morale had improved, and visitor numbers had gone up, but the MLA had indeed snatched defeat from the jaws of victory.

The Selwood review was not widely circulated. Although it made recommendations for improvements, its main effect was to seal the fate of the MLA when the Coalition government came to power in 2010. Without any apparent thought as to what would

happen to its responsibilities, the new government announced that the Museums, Libraries and Archives Council would be wound up forthwith.

The institutional weaknesses of three key organizations responsible for delivering government objectives – the DCMS, the Arts Council, and especially the MLA – make it surprising that anything was achieved at all. The crises that afflicted the Arts Council up to 2008, and which led to the demise of the MLA, were the result of poor leadership, but they also demonstrate the difficulty of maintaining an arm's-length relationship with a government department that has to respond to a social and economic agenda that fits uneasily with the creative independence of the arts. It also shows the inherent tension – exacerbated by a determinedly centralizing government – between London and regions that had their own strong local identities and cultural resources.

The tension between the centre and the periphery was not a matter of scale. New Labour's granting of self-governing powers to Scotland and Wales was a dispersal of power from the centre, yet the fate of the Welsh and Scottish Arts Councils illustrates the centralizing tendencies to which national governments are prone. Before devolution, the Scottish and Welsh Arts Councils were left alone by the London government, and by the Arts Council of Great Britain, of which they were technically sub-committees. With the arrival of the Scottish parliament and the Welsh assembly, both found themselves fighting for their very existence. The chair of the Welsh Arts Council, Geraint Talfan Davies, managed to stop the Welsh Arts Council being absorbed by the Cardiff civil service, and lost his chairmanship as a result.[52]

The Scottish Arts Council was faced with a similar takeover: the five 'national' performing arts organizations became the responsibility of the Scottish Executive, and through a merger with Scottish Screen the SAC was remodelled as Creative Scotland in 2010. The new body soon found itself at odds with the Scottish arts community, and the first chief executive resigned after only six months of Creative Scotland's formal existence.

It is ironic that, as a Welsh cultural nationalist, Davies should spend his career resisting 'the endemic centralising trends of all aspects of British life and government and, particularly, the drift of cultural power to London and the south east',[53] and then fall victim to the centralizing impulse of the Welsh government he had fought to bring into being. There can be no clearer example of the true intentions of government. New Labour abandoned the idea of regional government, and the language of localism was contradicted by the way the role of local authorities continued to be hollowed out between 1997 and 2010.

Under the Coalition government that succeeded New Labour the rhetoric of localism was briefly revived, but the financial retrenchment enforced by central government meant that the ability of local authorities to act as cultural providers became even more severely constrained, weakening the whole cultural infrastructure of the country. By 2013 local authority spending in England and Wales on arts services had fallen to £134 million.[54] The willingness to fund culture at all became a bargaining chip between local authority and central government, causing – as in Newcastle, Sheffield, Somerset and Westminster – collateral damage to the arts.

One of the principal means deployed by New Labour to assert its control over local authorities, as with first- and second-tier public bodies, was the use of funding agreements to set targets – targets that were irksome in themselves and which distorted the operations of those on whom they were imposed. The substantial increase in public funding for the arts was welcome, but the organizations that were creating culture, as opposed to making cultural policy, felt an ever greater need to challenge the way this policy was being made.

'To Hell with Targets'

We know what things cost but have no idea what they are worth.
Tony Judt, *Ill Fares the Land* (2010)

In 2003, as a condition of receiving its annual grant from Edinburgh City Council, the Edinburgh International Festival was required to meet seventy-eight performance targets. These could be either 'achieved' or 'not achieved', and the Festival would be given a score based on the percentage of targets met. Each of the seventy-eight targets had equal weight. Most addressed the Council's own policy objectives rather than the Festival's specific purpose, but there was a target 'to present an Edinburgh Festival of 185 events', and another to 'refrain from fly posting'. Between mounting the festival and not despoiling the streets, the Edinburgh Festival secured its funding for the following year.

By 2003, targets had become a target. For the cultural sector they were an emblem of New Labour's instrumentalism: they forced artists and cultural organizations to jump through hoops that were not of their own choosing, in pursuit of goals that were not of their making. Worse, there was little faith in the means used to measure whether the targets were being hit. Yet, after a decade of Conservative parsimony, New Labour was being generous to the arts. If instrumentalism was

misguided, it was up to the cultural sector not only to point this out, but also to find a better way to justify government support for what it did. All too often, arguments about cultural policy merely reworked the old debates about 'access' versus 'excellence', populism versus elitism, the intrinsic value of the arts versus the instrumental benefits that they brought. The dispute about targets was part of a profounder struggle over the value of culture itself.

James Purnell, who briefly succeeded Tessa Jowell as secretary of state for culture in 2007, has commented that, in the early days, the New Labour government 'spread targets on public services like a child sprinkles hundreds and thousands on a cake'.[1] In March 2000 the opposition Liberal Democrat party released a report claiming that New Labour had put in place at least 8,636 targets, of which the DCMS was responsible for 1,117. Among these was the commitment by the National Maritime Museum over three years to reduce by 300 the number of reams of photocopier paper that the museum used.[2]

As noted in Chapter 3, the principle that government departments had to meet Treasury-agreed targets was introduced with the 1998 Comprehensive Spending Review (CSR). Over the course of the successive CSRs of 2000, 2002, 2004 and 2007, some were dropped when met, some were revised, and sometimes brand new ones were set – so it was difficult to know exactly how many were in place at any one time. The Treasury spoke in terms of 'headline performance targets', but numbers were confused by the existence of cross-departmental targets, and composite targets that involved more than one measure. The Liberal Democrats were able to expand the twenty-one targets in the DCMS's 1998 agreement with the Treasury to 1,117 by adding in the details of thirty-three funding agreements with organizations that the DCMS sponsored. In 2000 the extension of Public Service Agreements to local authorities meant that the number of performance targets became almost uncountable.

Purnell's 'hundreds and thousands' were certainly in evidence at the DCMS. In 2000 the department had four 'strategic priorities', six objectives and six targets for the period 2001–04. For the period

2003–06, it was given four strategic priorities and four targets (to which a fifth, delivering the Olympics, was later added), plus seventeen 'indicators', either new or in progress. The period 2005–08 would be covered by four targets and twenty-three indicators. In order to track whether its targets were being met, in 2005 the DCMS launched its *Taking Part* survey – a joint exercise with the Arts Council, the MLA, and the Sports Council, in which a large weighted sample of adults in England were asked about their participation in culture and sport.

After July 2007, when Gordon Brown became prime minister, the whole framework was changed: from April 2008, thirty cross-departmental Public Service Agreements were established for the entire government machine, with various departments leading on some and contributing to others. The DCMS led on only one, PSA 22, covering the Olympics, physical education and school sport, while contributing to six others: these were to raise the productivity of the economy, improve the health and well-being of children and young people, increase the number of children and young people on the path to success, address disadvantage, increase the housing supply, and build more cohesive, empowered and active communities. Nothing about truth, beauty, or the power of the sublime. It also had four Departmental Strategic Objectives for 2008–11: 'Opportunity', 'Excellence', 'Economic Impact' and the Olympics, plus a 'Value for Money' programme that succeeded the efficiency savings policy launched after the Gershon review of public administration in 2003.

When applied to areas such as education or the National Health Service, where numerical targets for examinations passed or waiting times could be measured, targets did seem to drive up standards – although scandals such as the deaths at Stafford hospital between 2005 and 2009 show how badly things could go wrong when meeting targets became more important than meeting real needs. In practice the system turned out to be less rigorous than the precision the term appeared to require. As was clear from analysis of the DCMS's first twenty-one PSA targets, specific numerical targets were outnumbered by commitments simply to do certain things, and not

necessarily by a certain time. When the House of Commons Select Committee on Public Administration examined targets in 2003, it received a memorandum from the chief secretary to the Treasury, Paul Boateng, showing that, of the 252 main targets set by the 1998 CSR, only 194 had been 'assessed', of which 148 had been met and twenty partially met.

There were no penalties for missing a target, as Boateng confirmed: 'the purpose is to focus minds, and get people to work together better.'[3] The DCMS appears to have picked up this hint. Its original target fourteen stated that funding of NDPBs would be 'conditional on quantified improvements in outputs, efficiency, access, quality promotion, income generation or private sector funding', but these conditions were not strictly applied. In 2003 the 'independent watchdog' set up to monitor the results, QUEST, was quietly put to sleep.

Along with QUEST died its ambition to produce consistency in the way the outcomes of cultural initiatives were measured. The problem with imposing targets in the cultural field is the lack of an agreed methodology for assessing their achievement. It is possible to assemble numerical data on museum visits or participation in sport, though even such figures are not necessarily – to use a popular word of the time – 'robust'. In 2007 a review of the DCMS's performance indicator framework for museums revealed widespread inconsistencies in the interpretation of performance indicators. The terminology was ambiguous, and changes to the indicators meant there was no continuity in reporting.[4] It is even more difficult to assess qualitatively what such quantitative figures really mean. It is possible to calculate 'outputs' in numbers, but 'outcomes' – the effects of the actions enumerated – are much harder to measure.

In 2002 the Arts Council published a research report, *Measuring the Economic and Social Impact of the Arts*, surveying the methodologies available to establish evidence for the impact of such outcomes. The report acknowledged that the very term 'impact' was difficult to define. Starting with Myerscough's *The Economic Importance of the Arts*, from 1988, the report examined every significant assessment from that date and, though it listed many potentially useful

methods, was unable to find any consistency between any of them. The report ended with a litany of the faults in current approaches, noting the

> lack of conceptual clarity and narrow conceptualisations of social and economic impact, the use of small samples, the reliance on self-reports with little corroborating evidence of impacts, over reliance on official statistics which presents a partial picture of the arts and creative industries, lack of methodological transparency, especially with regard to sampling frames and methods, sample representativeness, survey response-rates, procedures for applying weightings, multipliers and extrapolating findings, lack of a common framework of research principles, assessment processes and standards for evaluation and impact assessment; simplistic and naïve explanations for attributing positive outcomes to arts projects, which fail to acknowledge the often complex issues associated with changing perceptions and behaviour of individuals and communities, their skills, social networks, economic status and quality of life; and overclaiming in conclusions and recommendations through unfair comparisons of the impacts of products at different stages of their product life cycle, or cultural economies at different stages of maturation. In some cases, there is a lack of baseline data.[5]

The whole project of 'evidence-based policy' was subjected to a devastating critique by Sara Selwood in an article for the journal *Cultural Trends*, 'The Politics of Data Collection'. Selwood, whose humiliating report on the MLA was cited in the previous chapter, exposed the reality behind the myth: 'Data collection and analysis appear to have little to do with directing policy. Funding decisions appear to be made on the basis of expectations rather than "evidence", and, whatever the rhetoric, the blurring of the relationship between advocacy and evidence suggests that the implementation of "evidence-based policy" in the cultural sector is some way off.'[6]

After listing the criticisms that had been made of the methodologies used to calculate the economic importance of the arts, Selwood

turned to the social agenda adopted by New Labour. Having read the available literature on the social impact of cultural projects, her conclusion was that much of the 'evidence' presented was invalid. Cultural organizations were hostile to the gathering of such data; and when it was collected, claims were unsubstantiated, methodologies were weak, and projects too time-limited to demonstrate any effect. Selwood's last word on the subject was that, until both the collection and analysis of evidence improved, 'it could be argued that much data gathering in the cultural sector has been spurious'.[7]

Selwood was an influential voice in the rising chorus of objections to the approach taken by the DCMS. These came both from the cultural left and the cultural right; and sometimes – as in the case of the libertarian Institute of Ideas, which had risen from the ashes of the Revolutionary Communist Party's *Living Marxism* – it was difficult to tell which was which. Several members of this group contributed to *Culture Vultures: Is UK Arts Policy Damaging the Arts?*, published in 2006 by the centre-right think tank Policy Exchange, which had been founded by a future Conservative minister for education, Michael Gove. The question mark in the title was superfluous. The pamphlet was edited by Munira Mirza, who shortly afterwards became cultural advisor to Boris Johnson.

It was not just that so much data was being demanded on the social and economic impact of the arts; the purposes for which it was being gathered related only tangentially to what the organizations involved saw as their core purposes. The managing director of the Barbican Arts Centre, John Tusa, had set out the classic argument against instrumentalism in 1999:

> Mozart is Mozart because of his music and not because he created a tourist industry in Salzburg or gave his name to decadent chocolate and marzipan Salzburger kugel. Picasso is important because he taught a century new ways of looking at objects and not because his paintings in the Bilbao Guggenheim Museum are regenerating an otherwise derelict northern Spanish port. Van Gogh is valued because of the pain or intensity of his images and colours, and not

because he made sunflowers and wooden chairs popular. Absolute quality is paramount in attempting a valuation of the arts; all other factors are interesting, useful but secondary.[8]

Even those responsible for delivering the government's agenda felt uncomfortable: 'Any number of commentators have character-ised us as only interested in the arts as social engineers', the Arts Council's chairman Gerry Robinson remarked defensively in 2000.[9] The following year, the chairman of the MLA, Matthew Evans, char-acteristically went on the attack, protesting that the government's relationship with funded bodies was 'too heavy-handed and there is too much micromanagement ... the demand for accountability has spawned a shifting undergrowth of targets, measures and inspection. Is it not particularly ironic that the sector is grossly over-regulated, inhibiting the very creativity and innovation for which it should be known?'[10]

Fortunately, a new generation of leaders was able to demonstrate creativity and innovation as they took advantage of the increased flow of Lottery and revenue funding to reconstruct their buildings, or in some cases create new institutions. Nicholas Serota established Tate Britain and Tate Modern; Julia Peyton-Jones was making the refurbished Serpentine Gallery a key space for contemporary art; a rebuilt Royal Court Theatre opened in 2000 under Ian Rickson, con-tinuing the work of his predecessor Stephen Daldry; Sadler's Wells, rebuilt in 1998, was establishing a renewed reputation as a centre for dance under its programming director Alistair Spalding, who became chief executive in 2004; Tony Hall and Antonio Pappano were restor-ing the reputation of the Royal Opera House; Neil MacGregor had moved from the National Gallery to the British Museum. In 2000 Anthony Sargent was appointed to lead the team that went on to open the Sage, Gateshead in 2004. After a period of crisis between 1999 and 2002 that led the Royal Shakespeare Company to abandon its London home at the Barbican and brought it close to bankruptcy, the RSC began a new phase with Michael Boyd as artistic direc-tor and Vikki Heywood as executive director. Regional museums were benefiting from *Renaissance in the Regions*; in 2000 the Arts

Council began a programme to pump an extra £25 million a year into regional theatre.

While making nationwide expansion possible, the Lottery programme also exposed the need for improved leadership at all levels. In 2002 the wealthy patroness Dame Vivien Duffield (who had been on the board of the ROH throughout the crisis of 1997–2000), disappointed with the way some of the projects funded by the Clore Duffield Foundation had been managed, decided to invest in training future cultural leaders. The Clore Leadership Programme was launched in 2003, with Chris Smith, former secretary of state for culture, as its first director. Core-funded by the Foundation, but with individual Fellows sponsored by funding bodies such as the Arts Council and the MLA, in 2004 the programme started selecting an annual intake of twenty to thirty promising people from across the cultural sector. Although few in number, the successive annual cohorts began to break down the institutional barriers between art forms, and helped to create a new sense of confidence in the cultural sector.

The need for better training was further recognized in 2006 when, as part of the Treasury's 'Invest to Save' programme, aimed at improving the delivery of public services, Gordon Brown announced that an initial £12 million would be invested in improving the management and leadership of the cultural sector. Bypassing the DCMS, the money went to the Arts Council in partnership with the MLA and the sector's skills council, Creative and Cultural Skills. The Clore Leadership Programme acted as a key provider of short courses.[11]

At the beginning of 2003, a change of leadership at two national institutions created an opportunity to demonstrate the sector's new readiness to stand up for itself. Adrian Ellis – a former Treasury official now running AEA Consulting, an international business specializing in strategic planning for cultural institutions – was advising both the new director of the National Gallery, Charles Saumarez Smith, and the new director of the National Theatre, Nicholas Hytner, who was about to take over from Trevor Nunn. Both the radical Hytner and the more conservative-minded Saumarez Smith were critical of the instrumentalist, target-driven regime of the DCMS. Saumarez Smith

summed up the prevailing complaint of traditional institutions that politicians had 'become indifferent or positively hostile to the idea that culture might be of value for its own sake and not just what it does for education or urban regeneration or cultural tourism or the leisure economy'.[12] Ellis thought it would help to establish his clients in their new positions if they made their views known. Hytner was the first to go public, in an article for the *Observer*, headlined 'To Hell With Targets'. The title, supplied by a subeditor, was misleading but effective. The only targets Hytner mentioned were the 'suffocating requirements of the national curriculum'; his real objection was to the government's instrumentalism:

> It is as restrictive to justify the performing arts purely as an instrument of social engineering as it is to judge them only by their capacity to improve the balance of payments. There's a sentimental notion that it's worth spending money on theatre because it might inspire some disadvantaged teenager to watch *Romeo and Juliet* rather than mug old ladies. Well, it might; but it has to be said that you can watch *Romeo and Juliet* and still mug an old lady on the way home. There's no direct link between the arts and good behaviour. Hitler loved Beethoven.[13]

The article struck a chord with many people in the arts, and especially at the think tank Demos, where the head of culture, John Holden, had begun to discuss with colleagues the need to find a new way of expressing the value of the arts. It was agreed that the National Theatre and the National Gallery would host a conference jointly organized by AEA Consulting and Demos, under the title Valuing Culture, with funding from the Clore Duffield and Jerwood foundations.

The conference was to be held at the National Theatre's studio annexe on 17 June 2003, but as the invitations began to go out to over a hundred performing arts, museum and gallery directors, as well as academics and arts journalists, there was an unexpected development. Because the organizers believed that the cultural sector should speak for itself, it had been decided not to invite contributions from

either the Arts Council or the DCMS. But had they had access to the confidential 2000 DCMS Peer Review, 'The Pale Yellow Amoeba', they would have discovered that the DCMS was itself finding targets irksome, and had unsuccessfully appealed to the Treasury for relief.

Now, in 2003, the new secretary of state, Tessa Jowell, wanted to have another go. She wanted to establish a position in which the DCMS was no longer hemmed in by the economic imperatives of the Treasury, or competing with the Department for Education. Jowell got wind of the Valuing Culture conference, and in April its organizers were invited to a meeting with her special advisor, Bill Bush. The secretary of state's position was explained, and Tessa Jowell was duly invited to speak at the conference.

The conference got two ministers for the price of one. Having gone to war with Iraq in March, Blair was forced to reshuffle his cabinet following the resignations first of Robin Cook, and then of Clare Short. In a further reshuffle in June, Estelle Morris, who had resigned as secretary of state for education the previous October, became minister for the arts. Morris's first day in her new post was 17 June, and, having a clear diary, she accompanied Jowell to the conference. Its topic had a particular piquancy for her: one of the reasons she had given for her earlier resignation from Education was that her ministry had failed to meet all its targets.

Jowell, while insisting on the government's mandate to shape policy, admitted in her speech that the DCMS had been 'far too utilitarian and unimaginative in the way we've sought to establish this accountability for public investment'. A new political discourse was needed that gave people the confidence to talk about culture in more than instrumental terms.[14]

Estelle Morris did not speak at the conference, but her experience at Education informed a speech she gave at the Cheltenham Literature Festival later in the year, clearly designed to send a message to the Treasury:

Target performance indicators, value added, evidence bases are all part of the language we've developed to prove our ability to deliver, to make progress to show a return and justify the public

money that is used ... I know that Arts and Culture make a contribution to health, to education, to crime reduction, to strong communities, to the economy and to the nation's well-being, but I don't always know how to evaluate or describe it.[15]

It was left to a liberated Chris Smith, speaking at the conference in his new capacity as director of the Clore Leadership Programme, to sum up the cultural sector's objections to instrumentalism. The arts 'require no justification other than their innate ability to move us, to excite us, and to enhance our lives'. But, he went on, 'I have to confess that it is easier to say that outside government than it is inside.'[16]

Tessa Jowell followed up her speech at Valuing Culture with an unusual document, *Government and the Value of Culture*. This was published by the DCMS in May 2004, but, in spite of being checked with 10 Downing Street, lest it should be mistaken for government policy, it was billed as 'a personal essay'. Jowell ended it with the key question: 'How, in going beyond targets, can we best capture the value of culture?'[17] With unusual candour for a serving minister, she acknowledged the embarrassment with which politicians approached the arts, 'explaining – or in some instances almost apologising for – our investment in culture only in terms of something else. In political and public discourse we have avoided the more difficult approach of investigating, questioning and celebrating what culture actually does in and of itself.'[18]

Although she tried to reframe the customary distinction between high art and popular culture as the difference between complexity and simplicity, between entertainment and engagement, Jowell's explanation of the intrinsic value of culture was firmly in the tradition that treated the arts as having higher, universal values that were not conditioned by power or status. Everyone should aspire to experiencing 'the transcendent thrill of feeling, through chance exposure or patient study, the power of great art'.[19] Her argument then ran on familiar lines: public subsidy for high art was justified because it ensured that such transformative experiences would

remain available beyond the elite. Indirectly, she was deploying the two standard arguments for funding culture: that it has a moral value as 'some deep landscape of personal resource';[20] that should not be restricted to a minority; and that, because of market failure – 'public subsidy produces what the market may not sustain'[21] – governments have a responsibility to intervene.

Jowell's answer to the 'access versus excellence' conundrum was, predictably, that there should be access *to* excellence. Though careful to avoid the language of high art versus populism, and eschewing the idea that there is a fixed canon of works of art that people should aspire to appreciate, Jowell fell back on the same justification for funding the arts that the first chairman of the Arts Council, John Maynard Keynes, had deployed in 1945. Art was something produced by people with special skills, who set their own standards of excellence; they needed to be supported to do this, and the audience needed to be encouraged to appreciate this excellence, by being given subsidised access to it. And for all of Jowell's attempts to transcend instrumentalism, the purpose of culture continued to be to help the government 'to transform our society into a place of justice, talent and ambition where individuals can fulfil their true potential'.[22]

Jowell's criticism of the crudity of targets has been interpreted as a return to 'art for art's sake', but it is clear that in her eyes culture justified the government's support by having a social purpose that went beyond individual experience and expression, and that her policies were shaped by that idea. Her essay admitted that there was a difficulty, and that targets were a blunt instrument, but there was no change of tack. There was no change to her department's *Strategic Plan 2003–2006* or its targets, published a few weeks before the Valuing Culture conference,[23] and she remained committed to what she and New Labour saw as the social mission of the arts.

The debate about the value of culture was part of a wider debate about how to express the value of government itself. After more than twenty years of neoliberalism and the New Public Management, the ideology of the market had so thoroughly penetrated public discourse that the sole purpose of government appeared to be economic

advantage: the only measure of government success was 'growth'. But governments are not businesses, however much they may be expected to behave like them. Some things that governments do, such as guarantee the peace for civil society, cannot be expressed in monetary terms. They have a value beyond what they provide for any single individual, and indeed can only be generated at a collective level, since too often individual preference contradicts the general good. From this, two key principles can be established: that there are public goods that are not subject to the market because they cannot be bought or sold, and that there is such a thing as public value, which expresses the worth of what cannot be measured in exclusively market terms.

Most contemporary theories of public value are a response to the work of Mark H. Moore, a professor at the Kennedy School of Government at Harvard University. In 1995 he published *Creating Public Value: Strategic Value in Government*, in which he discussed how managers of public services add value to what they provide in the same way that managers of commercial enterprises add value to the goods and services they sell – except that public administrators create, not private profit for shareholders, but public value for society at large.

Moore's ideas remained of mainly academic interest in Britain until 2001, when Geoff Mulgan, who had become director of the Forward Strategy Unit at the Cabinet Office, commissioned a study from two members of his staff. The timing was significant, because resistance to the now less-than-new principles of the New Public Management was growing, and New Labour was having difficulty delivering the public service reform it had promised. Even where services were improving, people did not seem to notice. Mulgan's team produced a discussion paper, released in October 2002, titled *Creating Public Value: An Analytical Framework for Public Service Reform*. As its subtitle suggests, this was a think-piece asking, as Jowell's essay was to ask, how to go beyond targets in capturing the value of government. The document argued that public value 'provides a broader measure than is conventionally used within the new public management literature, covering outcomes, the means used to deliver them as well

as trust and legitimacy. It addresses issues such as equity, ethos and accountability.'[24] The New Public Management was unable to understand or manage such hard-to-measure outcomes as trust, legitimacy and fairness.

The idea that public value was defined by the public themselves suggested a more subtle way of thinking about people as more than merely the inert objects of government performance targets. Citizens participated in the creation of public value not only by being willing to pay taxes to provide public services, but also by accepting the regulatory powers of the state. They themselves created value through volunteering for civic duties. The theory offered a way forward from the market model of public sector organizations, and, by emphasizing the active role of individual citizens, did not revert to the old monolithic, bureaucratic idea of the state as provider of goods and services to a passive population.

The BBC, needing a fresh argument for the renewal of its Royal Charter in January 2007, was quick to seize on the rhetorical possibilities of public value. It was under extreme political pressure because of its coverage of the Iraq War and the Hutton enquiry into the circumstances surrounding the death of government scientist David Kelly. Bullied by New Labour, it was also facing hostility from media rivals including News International, who resented the BBC's dominance and its appetite for expansion into new outlets such as online. Advised by the Work Foundation, in June 2004 the BBC published *Building Public Value*, making the case for the corporation not simply in terms of its function as a public service broadcaster, but as a creator of public value:

> While commercial broadcasters aim to create shareholder value, the BBC exists solely to create public value. The BBC creates public value by serving people both as individuals and as citizens. For people as individuals, the BBC aims to provide a range of programmes that inform, educate and entertain, that people enjoy for what they are. For people in their role as citizens, the BBC seeks to offer additional benefits over and above individual value.

It aims to contribute to the wider well-being of society, through its contribution to the UK's democracy, culture and quality of life.[25]

The BBC's lobbyists did not neglect to add to this succinct articulation of the organization's public value an account of its economic contribution to the creative industries.

The BBC emerged from its negotiations with the government with a renewed charter and a modestly increased licence fee, but at the cost of a significant change in governance. Management and responsibility for overall policy were separated by converting the former Board of Governors into a separate BBC Trust, which would represent the public interest by guaranteeing the independence of the BBC, and making sure that the BBC executive also acted for the public good.

This awkward arrangement avoided bringing the BBC under the direct supervision of the broadcasting regulator, OFCOM, set up by the Communications Act of 2003, although the Corporation still had to abide by OFCOM's broadcast code. The Trust decided that, before agreeing to major proposals from the BBC executive, such as to broadcast in high-definition or start a Gaelic television service, these would be subjected to a public value assessment. This would look at the proposal's effect on the market and the BBC's competitors, and test the potential public value in terms of quality, audience reach and public service broadcasting values.

Cynics who thought the BBC's public value argument was no more than a presentational ploy in the run-up to charter renewal were confounded when the term became part of the policy discourse of the BBC – but it did not reduce the BBC's exposure to political pressure from the government, or hostility from its commercial rivals. In the long run, the division of responsibilities between the BBC's executive board and the BBC Trust proved unwieldy, and even the Trust's second chairman, the Tory grandee Chris Patten, had difficulty in bridging the gap, resigning in May 2014.

The first direct answer to Jowell's question – 'How, in going beyond targets, can we best capture the value of culture?' – came from Demos. As a result of the Valuing Culture conference, the Heritage

Lottery Fund commissioned a team from Demos to analyze the way it evaluated the outcomes of the projects it had funded. Demos took up the public value argument, but suggested the HLF should use a more specific term: 'cultural value'. Drawing on the work of both Mark Moore and the Australian cultural economist David Throsby, the team proposed that the value of the HLF's work could only be understood by giving equal weight to the instrumental value of its projects – the measurable economic and social benefits that they brought – and their intrinsic value, made up of the aesthetic experience they offered, and the historical, social, symbolic and spiritual meaning that people found in them.[26]

The HLF adopted these principles as means of assessing its performance,[27] while Holden followed up with a series of independent Demos pamphlets that developed the idea of cultural value as a conceptual framework applicable to all forms of cultural activity.[28] Fully accepting that governments had an interest in the social and economic benefits produced by cultural activity, he argued that the intrinsic value of culture nonetheless precedes its instrumental value, because in order for it to have a social or economic outcome, it must be valued for itself in the first place. To explain how the relationship worked, he proposed a third term – 'institutional value' – as a way of expressing the public value that cultural organizations generated by making the arts and heritage available to their audiences.

Holden emphasized that cultural value was the sum of its constituent parts: different organizations would concentrate on different elements within the framework. A community arts group would emphasize its social mission; an experimental dance company would focus on developing its aesthetic practice; a museum would emphasize its educational activities. Similarly, artists and the institutions that supported them, their audiences, and the politicians who needed a justification for funding the arts, would emphasize the intrinsic, institutional and instrumental aspects of culture differently – but only a proper balance between all three would maintain the funding system's legitimacy.

'Around 2006, if one were around in the cultural sector, it would suddenly seem as if public value was everywhere', write the authors

of a sceptical account of the public value debate.[29] In 2004 the Jerwood Foundation launched a programme of research and discussion, 'Mission, Models, Money', to promote greater resilience and self-reliance among arts organizations. The HLF used the model incorporating intrinsic, instrumental and institutional value to shape the agenda of an international conference.[30] English Heritage similarly framed its new policy guidance on conservation.[31] The National Trust commissioned the international management consultancy Accenture to adapt the company's 'Public Service Value Model', already applied to policing and schools, to National Trust properties.[32] The Work Foundation assembled an impressive list of sponsors, including the DCMS, the Home Office, the BBC, the Metropolitan Police, OFCOM, the National Health Service Institute and the Royal Opera House, to support a wide-ranging exploration of public value.[33]

The roadblock that confronted all of these independent efforts was that, without a revolution in government thinking, 'value for money' would always trump public value. The ideas launched by Blair's Cabinet Office were ignored by Brown's Treasury, where the rules on decision-making in the *Green Book* remained unchanged. (The DCMS had its own pale imitation, the *White Book*.[34]) In 2003 the government added a new colour to its palette: *The Magenta Book: Guidance Notes for Policy Evaluation and Analysis* set out matching economistic methodologies for assessing whether a policy decision's outcomes had been achieved.

The *Green Book* demanded that monetary values be attributed to all the potential impacts of any proposed policy, as the first step towards an analysis that 'quantifies in monetary terms as many of the costs and benefits of a proposal as feasible, including items for which the market does not provide a satisfactory measure of economic value'.[35] Thus, while acknowledging that there might be aspects of a programme – such as social or environmental benefits, or the influence of good design – that were difficult to price, the key question – 'Do the benefits outweigh the costs?' – had to be answered in financial terms. Similarly, the 'opportunity cost' – the cost of *not* doing something, or of doing something different – had to be represented

by 'the value of the most valuable of alternative uses'.[36] The thought that governments might wish to do something because it was a good idea is overlaid in neoliberal fashion by treating decisions as economic choices made within a perfect and rational market.

The *Green Book* conceded that it was not always possible to establish actual prices – but the answer to that was to pretend there *was* a market, by creating a proxy price through a process called contingent valuation. This means testing a citizen's willingness to pay for something by inferring a price from consumer behaviour, or by asking them to state what they might be willing to pay. The public reveal their preferences through proxies such as house prices as an expression of the perceived quality of the local environment, or by the distance they are prepared to travel and the time and cost involved in visiting an attraction. Stated preferences can be established by asking people what they would be willing to pay for a service – for instance, a public library – that is free at the point of use.

Willingness to pay (WTP) – and its converse, willingness to accept (WTA), where people are asked how much they would expect to be compensated for having a service withdrawn – make the neoliberal assumption that people have perfect knowledge of their options, and that they always make rational choices. In reality, these methods are forms of market research. This can be a poor guide to cultural policy, since market research can reduce the discussion to a plebiscite – a mere aggregation of individual opinions, as opposed to the dialogue of democratic engagement. Creativity is about risk, and the public find it difficult to have opinions on the unknown.

The solution proposed by the Work Foundation was to treat the relationship between the providers of cultural services and their public as a more sophisticated process of 'refining public preferences' – a dialogue between those who understood the problems from a professional point of view and the public, whose interests they were expected to serve. But the experts, be they the architectural historians and planning advisors at English Heritage or the funding decision-makers at the Arts Council, still needed a justification for their role of not just responding to, but guiding cultural demand.

* * *

This was the dilemma the Arts Council faced when, in 2006, it set out to conduct its own public value enquiry. The Council chose to emphasize public value as a new way of explaining what public service organizations did, rather than as a measure of its performance. Its literature review, published before the enquiry began, made no mention of Accenture's performance-measurement-driven approach, or, surprisingly for a cultural organization, of Demos and the HLF's work on cultural value. The review preferred the Work Foundation's treatment of public value as evidence of an organization's responsiveness to public demands, achieved through consultation and engagement.

There was a good reason for this. Public opinion is far from homogeneous, and experts can argue that 'the public' does not always know what it wants. In order to be able to claim that it is making sense of conflicting opinions, it is important for an organization that its experts remain in the driving seat. Heading off any danger that the enquiry would be too democratic, the Arts Council's literature review stated: 'Public managers will still need to take difficult decisions and use their own expertise to act as an arbiter between competing views of what constitutes public value.'[37] If the Arts Council could establish itself as the arbiter of what constituted public value, it would be able to reclaim the initiative from the politicians, and once more hold them at arm's length.

In October 2006, the Arts Council began an elaborate consultation, advertised as 'the arts debate', costing £250,000, and involving workshops, discussion groups, interviews, 'open space' meetings, web discussions, and written and online contributions, which produced 1,700 responses of various kinds. The 'public' was represented by 200 people selected to be as representative as possible of the population as a whole in terms of age, gender, ethnicity and socioeconomic background. This exercise revealed that almost a quarter of those involved were entirely indifferent to the arts. The Council appears to have been surprised to discover not only that some people felt excluded from what others enjoyed, but that others were 'actively "anti-arts" in that a lack of engagement was actually part of their identity'.[38] It was possible to think that people were excluding themselves.

The contribution of the 'public' – critics commented that the sample was too small to be statistically meaningful[39] – was matched by that of eighty artists and arts managers and thirty 'stakeholder' organizations, such as local authorities, charities, commercial sponsors, trusts and foundations. These were also selected to be as representative as possible – but, whatever their status, they were not likely to think that funding the arts was a waste of time, even if some were keen to criticize the Arts Council itself.

Throughout, the emphasis was on qualitative, not quantitative research, and since this was a 'debate', its organizers, having set the agenda, did not merely sit and listen, but actively engaged in the deliberative process. Its conclusion was hardly a surprise: 'The final key point of consensus to emerge during the course of the arts debate was broad support for the principle of public funding for the arts. The arts are seen as important and valuable and therefore an appropriate use of taxpayers' money.'[40] Participants appear to have been impressed when they were told that ACE cost each household 39p a week, and the National Health Service around £80.

The debate made a thorough exploration of the issues; but, while individual opinions expressed may have been very informative, the debate as made public was at such a level of generality that it was difficult to see what influence it might have on the actual workings of ACE. The report ended on a blandly cheerful note, claiming: 'the arts debate is helping the Arts Council to become a more outward looking, listening, responsive organization', and promising to continue this important dialogue.[41]

Yet, even as these words were being written, the Council had been preparing, in conditions of great secrecy, a cull of the organizations it was so committed to being in dialogue with. What the Council had really been up to during 'the arts debate' became known in December, and in January 2008 Peter Hewitt found himself in an angry dialogue with arts practitioners at the Young Vic. At the start of its enquiry, the Council had identified 'three important sources of public value: high quality services, outcomes and trust', later adding that 'even when outcome and service targets are met, a decline in trust levels may destroy the capacity to add

public value'.[42] In 2007 the Arts Council failed its own public value test.

While it did seem as though discussions of public value were 'everywhere', it would take more than pamphlets, reports and conferences to change policy itself. A change of ministers, for instance. On 26 June 2007 Blair stepped down after ten years as prime minister, and Gordon Brown at last got his chance to hold the office he had coveted for so long. This meant the end of Tessa Jowell's time as culture secretary, though she was retained as Olympics minister in the Cabinet Office. Her replacement, James Purnell, had already had a brief stint at the DCMS in 2005/06, as the first ever under secretary of state for the creative industries and tourism.

Purnell was one of the clever young men who, in the mid-1990s, formed the amateur football team that in 1997 took the name 'Demon Eyes' as a derisive response to a Saatchi-devised Conservative election poster depicting Blair as Satan. The team, which contained no fewer than four future cabinet ministers (David Miliband, Ed Balls, Andy Burnham and Purnell), typified the laddish style adopted by New Labour's shock troops, masking fierce ambition with demotic male bonding. Purnell was a Balliol graduate and a former researcher for Blair. In 1994 he joined the Institute for Public Policy Research, where he was credited with the original idea for OFCOM, before moving to the BBC as director of corporate planning. In 1997 he went to Downing Street as a cultural policy advisor, and he became an MP in 2001. Evidently he had been thinking about the rising tide of protest about targets, because within days of his appointment he announced his determination to achieve a shift in policy. In a speech at the National Portrait Gallery on 6 July Purnell offered a 'mea culpa':

Targets were probably necessary in 1997, to force a change of direction in some parts of the arts world. But now, we risk idolising them. Without change, we risk treating culture like it's an old fashioned, unresponsive public service – not a modern, complex network of activity, with plurality of funding, with a sophisticated and complex relationship with its global audience. Without

change, we'll create an overly technocratic approach when we should want a transformational one.[43]

Accordingly, while not relaxing the government's expectations about access, he proposed to take a new interest in what people were being offered access *to*.

In a revealing metaphor, he described cultural policy as 'a pyramid – with participation the foundation, education the way up and excellence the apex'.[44] In this model of culture, one that would be familiar to readers of T. S. Eliot's *Notes on the Definition of Culture* (1948), culture was a hierarchy up which, helped by the cultural capital of education, one climbed towards the pinnacle of 'excellence'. To mark out this path, Purnell announced that he had asked Sir Brian McMaster, the former director of the Edinburgh International Festival, and a member of the Arts Council, to advise him on 'the preconditions for excellence and how my Department can promote this in a rational, non-bureaucratic way'.[45]

McMaster's route-map to the summit, *Supporting Excellence in the Arts: From Measurement to Judgement*, was published in January 2008, just as the Arts Council was facing the uproar caused by its December 2007 funding decisions. A more judicious move would have been to use the policy shift signalled by the report as an excuse to pause the process, but the Council ploughed on. In his introduction to the report, Purnell was clear that he wanted change:

This review will mark a real shift in how we view and talk about the arts in this country. The time has come to reclaim the word 'excellence' from its historic, elitist undertones and to recognise that the very best art and culture is for everyone; that it has the power to change lives, regardless of class, education or ethnicity. It is also time to trust our artists and our organizations to do what they do best – to create the most excellent work they can – and to strive for what is new and exciting, rather than what is safe and comfortable. To do this we must free artists and cultural organizations from outdated structures and burdensome targets, which can act as millstones around the neck of creativity.[46]

Where Jowell had merely worried about targets, Purnell was ready to condemn what he called 'targetolatry' outright.[47] But there was no difference in their position on the relationship between 'access' and 'excellence'. The first would make it possible for 'everyone' to enjoy the second. But 'excellence' is an empty category, meaningless until one thing is compared with another, and consequently judged to be better or worse. Regardless of what it is being applied to, a hierarchy of value is implicit in the word. A document intended to change the way the arts were discussed might have been expected to address this issue, but McMaster's report entirely avoided it. Its subtitle, 'From Measurement to Judgement', implied that concrete evidence of the achievements of cultural organizations (evidence tainted because of the association with targets) was to be replaced by fine discriminations about another ambiguous category: 'quality'.

Thus the chains of instrumentalism would be broken, and artists freed to express themselves – provided, that is, that they were 'excellent'. Yet when McMaster came to offer a definition of excellence, he seemed to be unaware that, by describing excellence in terms of its transformational effects, instrumentalism remained in play: 'The best definition of excellence I have heard is that excellence in culture occurs when an experience affects and changes an individual.'[48]

Presumably, the emphasis on the effect of a cultural experience on an individual was intended to draw a distinction from the collective social or economic benefits that were the object of government targets. The idea of culture as a set of values held in common, and so helping to define a community, is set aside in favour of a narrow individualism. But even in this inadequate definition, the reason for, and the justification of, excellence remained the transformative power of art. However much a performance or a work of art had a value in itself, that value was expressed in terms of how its 'experience affects and changes an individual'. It went without saying that this change would be for the better.

Once it is understood that McMaster saw the purpose of art as the moral transformation of the individual, the rest of his argument falls into place. Those in charge of judging excellence have a guardianship role. His reference to the way 'an excellent theatrical, orchestral or

operatic work can help an individual make sense of the world'[49] –
as could a museum or art gallery – betrays his traditional, high art
tastes, which include a role for the avant-garde: 'It has been argued
that culture does not always need to innovate to be excellent, but if
it is to be truly relevant to our society, it absolutely must. Innovation
is understood to be the introduction of something new, where old
methods and systems are insufficient. Innovation is therefore an inte-
gral part of the search for excellence.'[50] Thus, he writes, ticking the
appropriate boxes, the achievement of excellence involves 'innova-
tion, risk-taking, diversity and internationalism'.[51]

Far from reclaiming the word 'excellence' from its 'historic, elitist
undertones', as Purnell intended, the McMaster report returned
the management of culture firmly into the hands of the expert.
The new framework for assessing the work of cultural organizations
that McMaster recommended turned out to be very like the old
one. 'Judgement' would be predominantly in the hands of artists
and practitioners, backed up by 'funders confident in their judge-
ments'.[52] Funders should only fund what the market could not, and,
although it is difficult to imagine funders setting out deliberately
to fund the mediocre, 'should not spend money on what is not, or
does not have the potential to be, excellent'.[53] Recommendations to
prioritize diversity and invest in cultural education suggest that social
instrumentalism had not been abandoned.

While 'excellence' appeared in almost every paragraph, its dia-
lectical other, 'access', appeared nowhere. For access McMaster
substituted 'engagement'. It is clear that the discovery by the Arts
Council's recent public value enquiry that some people felt excluded
by the arts had been a shock. The circularity of McMaster's argu-
ments about the nature of excellence is revealed by his response: 'The
notion that the arts are not for everyone must be tackled head-on,
since excellent art is by definition for, and relevant to, absolutely
everyone.'[54] This unexamined assumption was to be instrumentally
enforced: 'practitioners must be strongly instructed to engage with
their audiences.'[55]

Ultimately, the significance of the McMaster report lay, not in
its dubious arguments, but in the message that it sent, which was,

in effect: 'to hell with targets'. This was welcome, but the real need, as identified by the Valuing Culture debate, was to find a way to combine the justifiable instrumental aims of public funding with the intrinsic interests of the arts and heritage. That had not been met. As the director of the Rayne Foundation, Tim Joss, wrote in an essay for Mission, Models, Money, published shortly after the McMaster report, the state needed a justification for funding culture. There were still unanswered questions about what it was that the public valued about the arts:

> The lack of adequate answers has plagued arts and cultural policy makers for as long as the state has been asked to invest in the arts. We are back with the false polarity of the arts' intrinsic and instrumental benefits and the problem of the arts world trying to produce evidence retrospectively to engage with the latest social or economic policy agenda.[56]

* * *

The McMaster report was a missed opportunity, and Purnell's time for radical thinking at the DCMS was brief. Within days of its publication in January 2008, he was moved on to the Ministry of Work and Pensions. In June 2009, in an unsuccessful attempt to provoke a leadership challenge, he resigned from the government, saying he could no longer support Gordon Brown. In 2010 he left parliament, eventually returning to the BBC. Andy Burnham, another player for the Demon Eyes team who had worked as an advisor to Chris Smith before entering parliament in 2001, took over the DCMS, but he too was replaced in June 2009, by Ben Bradshaw, who remained in office until New Labour were defeated the following year.

In April 2008 the DCMS was restructured following a Cabinet Office Capability Review. This new form of peer review ranked it tenth out of twelve departments: 'There is a perception that DCMS's role is too much of a funding "post-box" between H.M. Treasury and sponsored bodies. The Department is not regarded as sufficiently connected or influential in its engagement with other government departments.'[57]

This time the criticisms in 'Pale Yellow Amoeba' were acted upon. The individual art form divisions, whose micro-management had so irked the Arts Council by shadowing its own structure, were abolished, and regrouped into three sectors, media, sport and leisure, and culture – with culture smaller, and directed to be more focused on 'understanding' the cultural sector for which it was responsible. Part of that understanding would depend on better research, as evidence from the *Taking Part* survey set up in 2005 began to accumulate.

The restructuring of the DCMS coincided with important changes at the Arts Council. In January 2008 Peter Hewitt retired as chief executive, to be replaced by Alan Davey. Here was a gamekeeper turned poacher. A career civil servant, he had been one of the original designers of the National Lottery at the Department of National Heritage, later returning to the DCMS as head of the arts division between 2001 and 2003, before becoming director for culture in time for the Arts Council's 2005 peer review. His first week at the Council was spent trying to undo some of the damage done by recent decisions, before making his first public appearance on 1 February to announce the final conclusions on the funding allocations for 2008–11. The nearest the arts sector came to a public apology for the mess that had been made was in a speech in November: 'We thought we were taking decisions that supported excellence and increased the reach of the arts in this country … we did so in a way that didn't bring others along with us in the overall approach of our thinking.'[58]

Davey had to revive the authority of the Arts Council, respond to the McMaster report, and fend off further depredations to its funding by the demands of the Olympics while at the same time preparing for a 'Cultural Olympiad' and finalizing the Council's strategic plan for 2008–11. His most pressing problem was that he had to see through yet another reorganization, the fourth since 2000. The 2007 settlement had given the Council an extra £20 million, but the price was a 15 per cent saving in administration costs by the end of March 2011. Since 50 per cent of ACE's overhead was salaries, more jobs would have to go.

The reorganization was an opportunity to break the powers of the regional offices that had created such difficulties for his predecessor. Davey joined the ranks of those who had said that ACE would truly become one organization,[59] and came close to achieving it. Regional offices and advisory councils were grouped under four area executive directors. In an assertion of central power, the national office was renamed 'head office', while it and the regional offices were slimmed down. Always disproportionately favoured in terms of funding, London regained the dominance in decision-making it had had in the 1950s. In a symbolic gesture that had the unintended consequence of making the Arts Council sound like a building society, staff responsible for dealing with funded organizations were renamed 'relationship managers'.

Davey was careful to give a bland response to the McMaster report: 'The death of McMaster would be if it got bureaucratized. And if it were treated like a white paper and every sentence in it had to be analysed and turned into a programme.'[60] Most of McMaster's practical suggestions were ignored, but the new language of 'excellence' and 'engagement' was useful in devising a fresh mission statement for the organization. This was intended to deal with what Davey called 'the historically unresolved tension that is in our DNA'[61] – the tension between London and the regions, and between Keynes's idea of 'the best' and the need to widen access. Claiming to draw on the previous year's arts debate – although a summary document published in March 2008, *What People Want from the Arts*,[62] did not use the term 'public value' once – in September 2008 ACE launched its new big idea: 'great art for everyone'.

The bathos of this phrase could not conceal the significant changes that Davey set about making. In addition to restructuring and shrinking the whole organization, there would be an attempt to reconnect with the arts sector by recruiting 'artistic assessors', practitioners paid to write reports on Council-funded organizations and projects. The former system of Regularly Funded Organizations, with its implicit acceptance that some organizations would be funded forever, was to change. The new status would be that of 'National Portfolio Organization', for which every current recipient of regular funding,

including companies such as the National Theatre and the Royal Opera House, as well as aspiring organizations, would have to apply every three years.

Davey's power to effect change was strengthened in February 2009, when Christopher Frayling retired as chairman to be replaced by Liz Forgan, who moved across from the Heritage Lottery Fund. Forgan brought the confidence and authority that she had exercised at the HLF. She showed her steely side in October 2009, when she objected to the appointment of the former editor of the *Evening Standard*, Veronica Wadley, as chair of the London Arts Council, responsible for the London region. At the *Standard*, Wadley had supported Boris Johnson's successful campaign in 2008 to replace Ken Livingstone as mayor; for historic reasons, the appointment was constitutionally in the mayor's gift, though subject to approval by the secretary of state for culture. The latest secretary of state, Ben Bradshaw, supported Forgan, who took the view that Wadley was not the best candidate for the job. When Johnson indicated he would rerun the selection Bradshaw froze the process, and Wadley had to wait until the Conservatives won power in 2010. At the time of the row, Bradshaw warned that the Conservatives were ready to sack Forgan as chair of the Arts Council if they won the election. In 2012 Forgan was duly sacked.

It took until November 2010 to complete Davey's grand design – a ten-year strategic framework, *Achieving Great Art for Everyone*, agreed after much consultation. Liz Forgan's introduction made a spirited attempt to explain excellence:

> Everyone will have their own sense of what excellence is. But for us it is simply the bravest, most original, most innovative, most perfectly realised work of which people are capable – whether in the creation of art, its performance, its communication or its impact on audiences. It can be found in the classical canon or in wild anarchy, in elegant theatres or railway arches, it can be accessible or obscure, aimed at a tiny audience or millions.[63]

In future, the Arts Council would be defined by five goals:

1. Talent and artistic excellence are thriving and celebrated.
2. More people experience and are inspired by the arts.
3. The arts are sustainable, resilient and innovative.
4. The arts leadership and workforce are diverse and highly skilled.
5. Every child and young person has the opportunity to experience the richness of the arts.[64]

Having, thanks to Purnell's commissioning of the McMaster report, been offered an escape from the tyranny of targets, the Arts Council, led by its ex-DCMS chief executive, was now imposing targets of its own. But the long consultation involved, and the transparent handling of the open application process for National Portfolio Organization status that followed, began to restore the trust that had been so damaged in 2007.

Possibly because the changes turned out to be less radical than feared, there was no general outcry when the successful bids for funding under the new system that would begin in April 2012 were announced, despite the fact that half of the 1,333 organizations that applied received nothing, including 206 formerly regularly funded organizations. But the Council's 'Guidance for Applicants' revealed a significant institutional and linguistic shift. Arts organizations were no longer there to be helped to fulfil their ambitions by the Arts Council; they were there to help the Arts Council achieve its aims: 'You must demonstrate that you contribute to at least two of our goals', they were told. The use of the possessive in the demand to know 'how you plan to use our funding to contribute to our goals and priorities' reveals the extent to which mere makers of art had become the instruments of the experts' institutional objectives.[65]

The final twist was that *Achieving Great Art for Everyone* was launched into a very different world from the one in which the process had begun, in 2008. Alan Davey might claim in the document: 'this year of writing, 2010, is a golden one for the arts',[66] but it appeared two weeks after a Comprehensive Spending Review that cut the DCMS's budget from 2011 by 24 per cent, leading to a 30 per cent cut in the Arts Council's own. The golden age of Creative Britain was about to change to one of a baser and more poisonous metal.

The Age of Lead

I've got a genuine belief that art is a more powerful currency than money – that's the romantic feeling that an artist has. But you start to have this sneaking feeling that money is more powerful.

Damien Hirst, *Observer*, 19 February 2006

In June 2007 Damien Hirst presented a work even more audacious than *The Physical Impossibility of Death in the Mind of Someone Living*, the shark that had made his name. Visitors to White Cube, his dealer Jay Jopling's gallery in St James's, were escorted by lift to a darkened room, where, under conditions of great security, they were allowed a short time to view *For The Love of God*, a spot-lit platinum cast of a late-eighteenth-century male skull encrusted with 8,601 diamonds. Neither the subject (death, a Hirst perennial) nor the conception (he acknowledged the influence of an Aztec skull in the British Museum) was particularly original, but the price was the highest ever demanded for a work by a living artist: £50 million. The title of the show, which also displayed diamond dust–encrusted silkscreen versions of the image at £10,000 each, was *Beyond Belief*.

The audacity of the piece lay not just in the glittering power of the object, a *vanitas* that spoke of luxury and death, but in the game that was being played with the concept of value. The price was as much

a part of the work as the craft of the London jewellers, Bentley and Skinner, who had made it. The cost of production was estimated to be £15 million; the materials alone signalled extreme wealth. But it was the asking price that turned kitsch into art. It was a provocation, an invitation to the rich to show just how rich they had become during the long boom that had set in since New Labour had come to power.

Appropriately, the sale of Hirst's skull – the image was stronger than any title he gave it – was shrouded in mystery. At the end of August it was announced, in the language of commerce rather than connoisseurship, that a group of 'investors' had paid the £50 million. These reportedly included Hirst himself, who was said to have a 24 per cent stake. Whether the work really was sold, and to whom, does not matter. In 1936 Walter Benjamin had argued that, in the age of mechanical reproduction, art had lost its aura. Once again, Hirst showed that it had acquired a new one: the aura of money.

Had their book not been published just before the exhibition opened, the financial journalists Larry Elliott and Dan Atkinson might have cited *For the Love of God* as an example of what they called 'Bullshit Britain': 'We count the money and do the bullshit.'[1] Written after it became known that Blair had decided to step down as prime minister, but published before Gordon Brown succeeded him in July 2007, *Fantasy Island: Waking Up to the Incredible Economic, Political and Social Illusions of the Blair Legacy* was, as its title suggests, a sour assessment. Though the difficulties to come might make the Blair years seem like a golden age, Britain's prosperity was largely illusory, built on a series of fantasies promoted by a prime minister who 'may have been the most spectacular election winner in modern British political history, but … leaves behind him a seedy dream world mired in debt and bankruptcy'.[2]

With remarkable prescience, they warned that a financial crash was imminent. The leading fantasy was that the economy could survive the build-up in public and private debt. Gordon Brown was constantly shifting the marker posts of the fiscal cycle so as to appear not to be borrowing too much, while at the same time he had taken

up the Conservatives' fiscal device, the private finance initiative, with enthusiasm, loading hospitals and other public facilities with future debt. While the public sector was trammelled by targets, audit and inspection, the private sector appeared to run free, encouraging personal indebtedness to bubble.

Atkinson and Elliott urged restraint and caution on the incoming prime minister – qualities that Gordon Brown manifested only by ducking the risk of an immediate general election. In September 2007 the run on the profligate mortgage lender Northern Rock brought home to Britain the growing international banking crisis that climaxed with the collapse of Lehmann Brothers in New York a year later. With exquisite timing, on 15 September 2008 – the day Lehman Brothers went under – Damien Hirst put up 223 works for sale at Sotheby's in London. The star lot was *The Golden Calf*, a white bullock in formaldehyde, with hooves, horns and a solid halo in 18 carat gold. It was fortunate that New York was five hours behind London: a day later, and the sale would not have realized £111 million. God punished the Israelites for making their golden calf; Hirst got £9.2 million for his.

The Hirst sale was significant for more than the perfection of its timing. As visual art developed into the twenty-first century's dominant cultural form, the international art market became a battle-ground between the dealers who traditionally handled contemporary art, and the auction houses Sotheby's and Christie's who, not content with the profits from their fashionable black-tie auctions in London and New York, were expanding their dealing through private sales. With the cockiness that had made him a star of the art world, Hirst decided to bypass his London and New York dealers, Jay Jopling and Larry Gagosian, and send his work directly to Sotheby's, obliging them to support his prices by bidding in the auction.

Sotheby's and Christie's operated a duopoly that accounted for as much as 90 per cent of art sales at auction in the world. No one appeared very concerned when, in 2000, both firms settled lawsuits in Europe and America that showed they had been colluding to set consignors' fees between them. The American chairman of Sotheby's,

Alfred Taubman, was sentenced to a year in prison, but Christie's escaped penalty by cooperating with the authorities. While Christie's remained in private hands, bought for $1 billion in 1998 by the French collector Francois Pinault, who added it to his portfolio of luxury brands such as Gucci and Yves St Laurent, in 2005 Taubman sold his interest in Sotheby's, and it became a public company.

According to the art economist Don Thompson, the estimated value of world contemporary art sales at the time of the Hirst sale was around $18 billion a year.[3] The art market had been generally depressed following the collapse of its Japanese component in 1990, but from 2001 it took off again, especially in London, where the opening of Tate Modern and the success of the Young British Artists (YBAs), created a new sense of confidence. The deregulation of the City of London in 1986, followed by the expansion of financial services, hedge funds and commodity dealers – combined with a favourable tax regime for wealthy foreigners living in Britain – meant that there was a new clientele for the fifty or more leading London art dealers, who were joined by international galleries such as Gagosian, Hauser and Wirth, and Sprüth Magers.

The dealers hit back at the move by Sotheby's and Christie's into private sales by supporting an expansion in the number of international art fairs. In 2003 the success of the first Frieze Art Fair, mounted by the founders of *frieze* art magazine, which had launched on the rising tide of interest in contemporary art in 1991, confirmed London's key position on the art fair circuit. An international caravan of dealers, collectors and hangers-on now rolled from Hong Kong to Dubai, Venice, Basel, Maastricht, London, New York and Miami. In 2005 there were sixty-eight art fairs; in 2011 there were 189. In 2012 Frieze opened a second fair in New York and a 'Masters' fair in London.

In December 2011 the man who had helped to set the whole business in motion, Charles Saatchi, denounced the 'vileness' of the art world:

Being an art buyer these days is comprehensively and indisputably vulgar. It is the sport of Eurotrashy, Hedgefundy, Hamptonites; of

trendy oligarchs and oiligarchs; and of art dealers with masturba-
tory levels of self-regard. They were found nestling together in their
super yachts in Venice for this year's spectacular biennale. Venice
is now firmly on the calendar of this new art world, alongside
St Barts at Christmas and St Tropez in August, in a giddy round
of glamour-filled socializing, from one swanky party to another.
Artistic credentials are au courant in the important business of
being seen as cultured, elegant and of course, stupendously rich.[4]

Saatchi was equally rich, and in 2011 he was still enjoying the cul-
tured elegance of his third marriage, to the celebrity television chef
Nigella Lawson. But whereas he had previously dominated London's
contemporary art world – his only rival in influence, Tate's direc-
tor Nicholas Serota, disdained to acknowledge that there might be
any competition between them – Saatchi was now operating in a
crowded field. An attempt to launch 'New Neurotic Realism' as
a successor movement to the YBAs came to nothing. In 2003 he
moved his gallery from Boundary Road to the former GLC head-
quarters opposite the Houses of Parliament, creating an upstream
rival to Tate Modern; but he fell out with Damien Hirst, who dis-
associated himself from the opening retrospective of his work. The
County Hall arrangement descended into expensive legal disputes
with the Japanese landlords, and in 2008 he reopened at the former
Duke of York's barracks in Chelsea. Efforts to 'give' his collection to
the nation were frustrated. But Saatchi had a point: 'The success of
the uber art dealers is based upon the mystical power that art now
holds over the super-rich. The new collectors, some of whom have
become billionaires many times over through their business nous, are
reduced to jibbering gratitude by their art dealer.'[5]

With a little more historical perspective, however, Saatchi might
have seen that the mystical power of art for millionaires shows the
change in art's role since the collapse of communism and the end
of the Cold War. Not only has that collapse created a new breed of
Russian collectors, headed by Roman Abramovitch and his partner
Dasha Zhukova – in May 2007 Sotheby's added roubles to the cur-
rencies electronically displayed in instant price conversions during

auctions – the capitalization of the Chinese economic system and the rise of the Indian and Asian economies opened up new markets and created new buyers. The decision by Qatar, along with Abu Dhabi, Sharjah and Dubai, to invest in new museums has further increased demand and pushed up prices.

International corporations now pride themselves on their art collections; banks like UBS and Deutsche Bank collect art and sponsor exhibitions and art fairs. Since the opening of its satellite in Bilbao in 1997, the New York Guggenheim museum has transformed itself into an international enterprise, trading in its brand association as a form of cultural collateral. Art is no longer the autonomous emblem of Western freedom, but, as the art historian Julian Stallabrass has argued, a sign of the triumph of globalization:

> Just as global capitalism stepped out from behind the cloak of its defeated opponent after 1989 and, in its rapid transformation, was revealed as the rapacious, inexorable system that it is, so it may be with the art world. The end of its use as a tool in the prosecution of the Cold War has made clear a new role already in development: its core function as a propagandist for neoliberal values.[6]

The free play of the market, across national borders, across currencies, is embodied by the trade in art which is – apart from drugs and human trafficking – one of the least-regulated commercial activities in the world. No qualifications are required to become a trader in this commodity, and most of the rules that govern other forms of business do not seem to apply, other than the emphasis on secrecy. It is a shadow banking system in its own right. Complex ownership deals, such as that for Hirst's skull, price fixing, insider trading, market manipulation and the use of tax havens and offshore accounts, are accepted as commonplace. With the exception of Old Masters, which can be subject to export control, the product is easily moved and can be traded in any currency, making it a perfect vehicle for money laundering.

That does not mean that all forms of art are necessarily a good investment. Insurance, conservation, storage and security costs are

high; dealers take their cut, auction houses take commissions from both sellers and buyers; there are complications over capital gains and VAT. Worst of all, the entire market depends on the whims of fashion and the delicate balance between demand and supply. Even Hirst, after his London coup, found that his next sale, at Sotheby's in New York in November 2008, did not go so well.

In an age of mass production and consumption, Hirst, like the American Jeff Koons and Japanese Takashi Murakami, has established an industrial form of art-manufacture, directing teams of assistants in the assembly of signature creations. Brand names and instantly recognizable products – Hirst's spots, Koons's shiny casts of balloons, Murakami's pullulating patterns and cute but disturbing cartoon figures – synthesize celebrity and accessibility into the ultimate cultural commodity. An elite group of blue-chip artists have sustained their prices – or had them sustained – in spite of recession since 2008. The distance between the few artist-millionaires and the 40,000 other artists living in London mirrors the ever-widening gap between Britain's wealthy elite and the rest of the population, which has seen its standard of living stagnate or fall.

Art has become the ultimate example of what the economic geographer David Harvey, borrowing a phrase from Marx's *Grundrisse*, calls 'fictitious financial capital'.[7] In his analysis of the financial crisis since 2008, Harvey argues that, in order for the global capitalist economy to be able to meet its inexorable need for growth, there must be a steady reinvestment of profits in new production, and the development of new markets, so as to avoid the over-accumulation of capital. By the beginning of the twenty-first century, however, globalization – especially with the entry of China into the world market – meant that there were few new opportunities for expansion, while the holding down of wages, both in Asia and the West, stifled demand.

The result was an imbalance between an excessive accumulation of surplus capital and a lack of consumption to sustain growth. The solution was to stimulate production by offering 'fictitious capital' in the form of credit – hence the development of the sub-prime mortgage market in America that engendered the global crisis, where both

impoverished buyers and speculative developers relied on excessive debt. Although it is logical to borrow in order to invest, there is a strong temptation not to invest in production, but in assets such as stocks and bonds, futures, derivatives and property, where value is generated by competitive demand and governed by sentiment. Profits come out of thin air.

Art, which has almost no material value, is the emblematic capital asset. Its worth lies not in what has been paid for it, but in what people in the future might pay for it. In the case of Old Masters, and by extension all unique cultural objects, the value is locked in: the supply is limited because there can be no more examples of exactly the same thing. With all the advantages of being traded in an unregulated market, art is an ideal means of absorbing surplus capital, bringing as it does opportunities for display and the acquisition of social status.

This explains why, after 2008, although there was a dip, and a decline in volume, the art market rose again at the end of 2009, in spite of the almost global recession. Eleven of the twenty most expensive works ever sold at auction were bought between 2008 and 2012. While the middle range of works fetched lower prices, works by Edvard Munch, Rothko, Jean-Michel Basquiat, Yves Klein and Warhol (all, it should be noted, dead) soared ahead. Following strong sales at the leading art fair, Art Basel, in June 2012, the *Art Newspaper* asked 'How Long Can the Art Market Walk on Water?'.[8] The answer appeared to be: indefinitely.

In January 2013 the ArtTactic US and European Market Confidence survey showed that confidence in the high-end post-war and contemporary art market had increased by 25 per cent, following record sales in New York in November 2012 that topped the previous peak in May 2008 by 15 per cent. It seems that, with interest rates so low, and other forms of capital investment no longer offering sufficient profit, the capital surpluses of the very rich had nowhere else to go.

As the international art market floated free from the rest of the world economy, Western governments faced a grimmer reality when the

credit bubble burst. A year after Blair's 'golden age' speech at Tate Modern, his successor was struggling to prevent the collapse of the international banking system, and stop recession turning into depression. Gordon Brown's Comprehensive Spending Review in October 2007 had been relatively generous to the DCMS, with an overall increase of 6.6 per cent in the three years to 2010/11, rising to £1.6 billion in that year, plus a £2 million capital fund.

By January 2009, however, Purnell's successor at the DCMS, Andy Burnham, was warning that the financial crisis was such that there might have to be cuts within the current three-year settlement. At the Arts Council, Alan Davey warned of a 'perfect storm' as corporate giving, business sponsorship, local authority funding and income from trusts and foundations shrank because of the recession. In April 2009, Alistair Darling's budget trimmed £20 million from the DCMS's 2010/11 allocation, as a first step towards cutting the DCMS back by £168 million by 2012/13 – assuming, that is, that Labour stayed in power. Cultural organizations checked the state of their reserves, froze recruiting, and readied themselves for worse cuts to come.

The Arts Council's response to the recession and to a £4 million cut in its 2010/11 grant-in-aid was to raid its Lottery cash balances to create an emergency £40 million 'Sustain' fund for organizations that were in difficulties because of the drying up of business sponsorship and other sources of income. This was directed at large organizations, with a minimum bid of £75,000 and a maximum of £3 million, and there were complaints about the way it was used to plug deficits rather than deployed strategically. But it prevented large-scale disasters – an extra grant of £1.2 million saved the Institute of Contemporary Arts in London from imminent closure. Having achieved a 15 per cent cut in its running costs by April 2010, ACE also had an extra £6.5 million from its grant-in-aid at its disposal.

The Treasury continued to look for cuts, cancelling a £45 million building project for the British Film Institute on the South Bank and postponing a £25 million visitor centre for Stonehenge (which finally opened in December 2013). Labour's last budget, in March 2010, demanded £60 million in 'efficiency savings'

from the DCMS as part of an attempt to cut £11 billion across government.

The following month, the general election was called. Just five days before voting took place on 6 May, a beleaguered Gordon Brown appeared, with Peter Mandelson at his side, to launch the party's cultural manifesto at a closed event for Labour Party members at the National Glass Centre in Sunderland. He was supposed to promise that the coming decades would be 'as golden for the arts and to those that love them as the last decade'.[9] But a heckler had got in, and started shouting about Brown's overheard comments a few days earlier about a 'bigoted woman' who had tackled him on immigration. The heckler was bundled out – but it was he, and not the arts manifesto, that was reported in the press. The manifesto listed New Labour's many achievements, but had few new proposals to make. Thirteen years after coming to power, the once smoothly operating party machine could come up with no more original title for it than *Creative Britain*. New Labour had run out of ideas.

One achievement that *Creative Britain* might have laid claim to, but did not, was that New Labour had forced the Conservative Party to take culture seriously. The financial crisis played into the hands of those on the right who wished to apply a very different model, and dispense with cultural funding altogether. Policy Exchange's pamphlet *Culture Vultures* was positively benign in comparison with the views of the New Culture Forum, set up in 2006: 'the very idea of a central policy on the development of art should be anathema, both as a matter of personal freedom and in recognition of the many contested visions of artistic value among English citizens.'[10]

In *The Arts Council: Managed to Death*, the journalist Marc Sidwell called for the abolition of the DCMS and the Arts Council, whose responsibilities would be given to the regional councils. The report made hay with the scandals that had beset ACE, but the Council was able to dismiss it by pointing to the inaccuracies in its research. The equally neoliberal Adam Smith Institute followed up with the proposal that, instead of funding the producers of culture, every citizen should simply receive an annual voucher – worth £11 if the

current level of subsidy was to be maintained – to spend on 'approved arts producers'.[11] It was not explained who would approve the producers.

Although they privately shared the Adam Smith Institute's horror at the allegedly wasteful costs of cultural administration, and realized that the financial crisis would provide cover for reducing the size of the state, Conservative Party policy-makers were conscious of the need to reposition themselves as no longer 'the nasty party', and in public steered clear of such radical ideas. Once David Cameron became party leader, in December 2005, a concerted effort was made to woo the cultural sector.

In November 2006 he appointed Ed Vaizey, a personal friend who had entered parliament in 2005, as shadow minister for culture. Vaizey was the son of Marina Vaizey, a former art critic for the *Sunday Times*, and knew the field well. One of his goals was to make sure that 'if the Tories win on a Thursday, there will be fewer people in the arts world waking up in a cold sweat on a Friday'.[12]

In July 2007 Vaizey's boss, the right-wing Hugo Swire, lost his job as shadow secretary of state for culture after he suggested that free entry to national museums should be abandoned. His replacement was another friend and Oxford contemporary of Cameron's, the forty-year-old Jeremy Hunt. Hunt, who had a remarkable capacity for side-stepping scandals, was one of the shadow cabinet's several millionaires. After what had happened to Swire, Hunt was careful to display a friendly face to the arts.

In October 2007, Hunt took delivery of a report commissioned by Vaizey from an independent committee chaired by Sir John Tusa, *A New Landscape for the Arts*, intended to help the Conservatives devise a cultural policy. The report recommended that sport should be removed from the DCMS remit, that the department should directly fund flagship performing arts organizations as well as national museums, and that the Arts Council should concentrate on the regions.

Hunt did not take up these suggestions, but noted complaints about the diversion of Lottery money to fund the Olympics. When he launched the official Conservative cultural strategy in June 2009,

not only did he promise to keep free entry to national museums, he proposed to restore the distribution of money raised by the National Lottery to their original four good causes, claiming that New Labour had diverted £3.5 billion for political purposes. This became an election commitment in 2010 in 'The Future of the Arts with a Conservative Government', a two-page document that promised coherent and sustained support for the arts, the removal of targets, and the addition of a fourth pillar to the mixed economy of culture through the establishment of endowments.[13]

Anxious to reassure the arts world, the Conservative shadow chancellor, George Osborne, who had a genuine interest in culture, made a speech at Tate Modern praising the social contribution of the arts and asserting his party's deep commitment to the cultural sector. Jeremy Hunt talked about laying the foundations for a new golden age, and David Cameron told the *Sun*: 'our culture is second to none.'[14] But as Britain's economic difficulties continued, only the Liberal Democrats went into the election promising to maintain spending on culture at the same level.

The Conservative–Liberal Democrat coalition agreement that emerged from the horse-trading after the inconclusive election result contained twelve bullet points on 'Culture, Olympics, Media and Sport': five referred to sport, three to the media, and two to the Lottery reforms the Conservatives had promised; free entry to national museums would be maintained, and the performance of live music in public premises made easier. There was no coalition partnership at the DCMS: all four ministerial posts went to the Conservatives, with Hunt as secretary of state and Vaizey as minister for culture, communications and the creative industries.

In his first speech as secretary of state, on 19 May, Hunt quoted the Russian poet Osip Mandelstam, praised the Royal Court's production of Jez Butterworth's *Jerusalem*, and assured the arts world that culture would not be singled out as a soft target: 'when I was watching *Jerusalem* I wasn't thinking about creative exports or leveraged investment. I was enjoying artistic excellence. Art for art's sake. This is my starting point as Secretary of State for Culture.'[15]

Five days later, he cut £88 million from the DCMS budget. Non-Departmental Public Bodies lost 3 per cent of their current 2010/11 funding, but, to ACE's chairman Liz Forgan's public disappointment, ACE was cut by 4 per cent, an in-year loss of £11 million, sweetened a little by permission to use some of the Council's £18.4 million reserves. This meant a cut of only 0.5 per cent for regularly funded organizations – but that was just the beginning.

In October the Coalition's first Comprehensive Spending Review reduced the DCMS budget by £400 million by 2014/15. This meant a 29.6 per cent cut for ACE, a fall from £449 million in 2010/11 to £350 million in 2014/15. Hunt imposed special conditions: 'frontline' arts organizations were to lose only 15 per cent and, having ordered the DCMS to halve its administration costs, he told ACE to do the same, on top of the reductions it had just achieved. With no time to take a proper view, the Council responded with an across-the-board cut to organizations of 6.9 per cent for 2011/12. ACE also cut back on 'strategic' activities such as its cultural leadership programme, and decided, by 2012, to cease funding both the creative partnerships organization, Culture, Creativity and Education, and the organization intended to promote commercial sponsorship, Arts and Business.

English Heritage was even harder hit. The Coalition's first thought was to ask if its historic properties could somehow be sold off or given away.[16] It received a 32 per cent cut, whereas national museums and galleries lost just 15 per cent. Local authority–run museums, however, were not so lucky. A 29 per cent cut in central government local authority funding – £6.25 billion by April 2015 – put all local cultural spending on the line, including libraries, but the DCMS declined to intervene.

It did, however, join in enthusiastically with a promised 'bonfire of the quangos' – the abolition or merger of more than 400 public bodies. The dissolution of the Museums, Libraries and Archives Council was announced, although it was not until 2011 that it was agreed that its responsibilities for libraries and museums, including the now reduced *Renaissance in the Regions* funding stream, would be taken over by the Arts Council. Having been told to cut costs, the

Council would have to take on fifty-three extra staff.[17] Responsibility for archives was taken over by the National Archives at Kew. Unlike the MLA, the Film Council had been successful, but it was a New Labour creation, and without consultation the decision was taken to merge it with the British Film Institute, whose existence was protected by its royal charter. The Commission for Architecture and the Built Environment was merged with the similarly protected Design Council. A fourth New Labour creation, NESTA, was allowed to keep its endowment and became an independent charity.

In October 2010 Tate's director, Nicholas Serota, denounced the Coalition's policy as 'a blitzkrieg on the arts' that risked provoking the greatest crisis in the arts and heritage since government funding had begun in 1940.[18] The Coalition's answer to all protests was that everyone must suffer together; but if the object of dismantling New Labour's cultural framework was to save money, the sudden imposition of these changes was not the most cost-effective way to go about it. A report by the House of Commons Culture Committee in March 2011 was scathing about the lack of planning that had gone into them. This was backed up by the National Audit Office, which criticized the undifferentiated top-slicing imposed on NDPBs, which might lead to higher costs in the end. There had been no cost/benefit analysis of the closures and mergers, or any estimate of future savings. Yet again, the DCMS was 'not achieving value for money'.[19]

Possibly seeking distraction from the growing sense of crisis, the audience for the arts showed remarkable resilience as the recession deepened. West End theatre ticket sales and museum visits boomed. The cultural sector also benefited indirectly from an increase in the sale of Lottery tickets. But the economy failed to respond to the Coalition's austerity measures. As government borrowing rose, further cuts became necessary. At the end of 2012 it was decided to cut a further £11.6 million from the DCMS in 2013/14 and 2014/15. With the decimated department unable to absorb any more cuts, in-settlement cuts of 1 per cent and then 2 per cent were passed on directly to national museums and other NDPBs. The Arts Council cut National Portfolio Organizations and Museums by a

total of £3.9 million in 2013/14 and £7.7 million in 2014/15. There was deeper gloom when the Coalition announced it would conduct a further one-year Comprehensive Spending Review in 2013, covering most of the financial year that would be the responsibility of a new parliament, and possibly a new government – 2015/16.

Whatever they may have thought privately about the opportunities created by the economic situation to reduce state funding of culture, Hunt and Vaizey had two answers to the steadily worsening situation – one pragmatic, one ideological.

Although it would be years before the sale of Olympic assets – land and buildings – would (if ever) pay back the £644 million that the national Arts Councils and the Heritage Lottery Fund had contributed from their Lottery allocations, the decision to restore an approximation of the original division of the shares between distributors to good causes was a partial answer to those protesting against the cuts. The Big Lottery Fund's share was reduced to 40 per cent, and the shares of arts, heritage and sport rose to 20 per cent. A change in the way the Lottery was taxed was expected to make an extra £50 million a year available for distribution.

As it turned out, 2012/13 was a boom year for the sale of Lottery tickets: £7 billion in sales produced £2 billion for the good causes, of which £390 million was made available to each of the arts, heritage and sport; but Lottery receipts then fell back. A game of chance could not be a reliable source of funding, and although the Arts Council found itself increasingly doing so, using lottery funds to replace core funding risked breaching the principle of additionality enshrined in the National Lottery Act of 2006. This stated that Lottery money was legally separate and additional to the government's grant-in-aid – funding that the Arts Council and its dependents saw melting away, reduced in absolute terms and further eroded by inflation.

Hunt and Vaizey's ideological solution had its roots in the Thatcher years: if the state stepped back, the gap would be filled by commercial sponsorship and private philanthropy. It was counter-intuitive, however, to expect a burst of private and corporate generosity during what was turning out to be the worst recession of modern times. For all of Cameron's talk of the Big Society, according to which,

either acting on their own behalf or paid by the state, charities were expected to take on more responsibility for the public realm, in the first year of the Coalition the number of registered charities fell by more than 1,600. Between 2008 and 2009 charitable donations by individuals fell by nearly £1 billion. In 2010/11 the total given to charity was £11 billion, of which just 1 per cent went to the arts. The following year, 2011/12, the total was £9.3 billion, which, adjusted for inflation, represented a decline of 20 per cent. Charities that provided services under contract to the government and local authorities also saw that income shrink due to budget cuts. A report by the National Council for Voluntary Organizations pointed out that the DCMS was itself planning a cut of £104.3 million in its spending on the community and voluntary sector between 2010/11 and 2014/15.[20]

It was a further irony that the organization that had been set up to encourage corporate sponsorship, the Association for Business Sponsorship of the Arts, later renamed Arts & Business, was itself going out of business. In the 1980s the Thatcher government directly funded Arts & Business to use public money to leverage commercial sponsorship in a matched-funding scheme, but later it came under the wing of the Arts Council. The matched-funding scheme was stopped in 2008, by which time £90 million of public money had, it was claimed, stimulated £1 billion in corporate funding. Arts & Business's grant was cut from £7 million to £4 million; it had to wind down its training programme for fundraisers and concentrate its efforts on brokering partnerships between the arts and the private sector. Not being a 'frontline' organization, it was a prime target as the Coalition cuts to the Arts Council's grant-in-aid began, and by April 2012 it ceased to be funded altogether. Its long-serving chief executive, Colin Tweedy, stood aside, the staff shrank from one hundred to twenty, and the organization moved under the umbrella of the Prince of Wales's charity, Business in the Community.

Arts & Business continued to monitor private investment in the cultural sector, which it divided between individual giving, the work of trusts and foundations, and what it called 'business investment', a combination of commercial sponsorship and corporate donations.

The news was not good: in 2009/10 total private investment of £658 million represented a fall of 3 per cent, within which business investment had dropped by 12 per cent. In 2010/11 business investment fell by a further 7 per cent, and only managed a 0.2 per cent rise in 2011/12. In spite of the partial recovery in the income of trusts and foundations and modest increases in private giving to the arts, in 2011/12 the total private investment of £660.5 million was only £2.5 million higher than in 2009/10, which with inflation meant that the private sector's contribution to funding the arts had at best stayed flat. Contrary to the predictions of neoliberal theory, it was not filling the looming gap in public funding.

Undaunted by the discouraging economic situation, in December 2010 Jeremy Hunt announced that 2011 would be the 'Year of Corporate Philanthropy', and outlined a scheme to use Lottery and DCMS money to encourage private giving. The chancellor, George Osborne (who had served on the board of Arts & Business), provided some help in his 2011 budget by reducing inheritance tax on those who gave 10 per cent or more of their estate to charity. He also introduced 'lifetime giving' tax relief on those who gave works of art or other cultural items to public collections. This was an extension of the 'acceptance-in-lieu' scheme, whereby dead donors' gifts were set against the tax value of their estate; but only £30 million a year would be available to cover both schemes. Responsibility for running them was another task the Arts Council had to take on following the dissolution of the MLA.

These modest improvements were overshadowed, however, in Osborne's 2012 budget when, in response to an outcry about corporate and individual tax evasion, and without consulting the DCMS, he announced a cap of £50,000 or 25 per cent of income on individual tax relief in any one year. This was not only offensive to honest donors who resented the implication that they were only giving in order to avoid tax, but also upset their careful tax planning. The Arts Council warned that £80 million in regular donations to arts organizations was at risk. The chancellor was obliged to think again.

Six months after the 'Year of Corporate Philanthropy' began, details were at last announced of how such philanthropy was to be

encouraged. This showed the Coalition had no more compunction about raiding the Lottery for pet schemes than had New Labour. A £100 million 'Catalyst' fund, made up of £50 million in Arts Council lottery money, £20 million from the HLF, and £30 million from the DCMS, would be made available over three years. Some of this would be used to train fundraisers, explore new kinds of philanthropy, and reward successful efforts with match-funding, but the cornerstone was a £55 million fund to encourage more experienced organizations to expand, or create, endowment funds.

The scheme would pay out matching sums, pro rata, as organizations worked their way towards meeting the targets they had set themselves. A former head of research at Arts & Business noted wryly that the Catalyst scheme recycled two of the de-funded organization's programmes – training in fundraising, and match-funding. He also pointed out that match-funding was not the answer it appeared to be. It favoured large organizations over small ones, failed to generate genuinely new money, and was expensive to monitor.[21]

The major problem with stimulating private investment, however, was that the great majority of funding was concentrated in London (half the Catalyst endowment schemes were for London-based organizations). In 2011/12, an astonishing 90 per cent of individual giving to the arts took place in London, as opposed to 0.9 per cent in the north-east. Meanwhile, 67.8 per cent of business investment was in London, and only 2.7 per cent in the north-east.

The Coalition's campaign did not impress Nicholas Hytner, whose efforts to raise £50 million to refurbish the National Theatre had been thrown off course by the chancellor's announcement of a cap on tax relief for charitable giving. When Hunt's recent replacement as secretary of state for culture, Maria Miller, unhelpfully suggested that the arts needed to get better at asking, he exploded, dismissing the philanthropy policy as a smokescreen: 'It's easy for the British Museum, the Tate and the National Theatre. We are in London, we are handsomely subsidized: philanthropic money follows public money. So, I would like to nail this kind of wishful thinking. The government has done next to nothing to encourage philanthropy … It really is all talk.'[22] Hytner was not alone in his opinion. According

to an editorial in the trade magazine *Arts Industry* in January 2012, 2011's Year of Corporate Philanthropy had 'disappeared without trace'.

As usual, Hunt appeared blithely unembarrassed. He also survived a reputational wobble when his political advisor Adam Smith was revealed to have had inappropriately cosy communications with a News Corporation lobbyist when his boss was considering Rupert Murdoch's bid for complete control of BSkyB. (The bid was abandoned as a consequence of the phone-hacking scandal and the ensuing Leveson enquiry, launched in July 2011.) Smith took the fall, but Hunt, after a successful Olympics, was promoted to the Department of Health in September 2012.

While Hunt had shown his true colours as a neoliberal cost-cutter once he got into office, his successor Maria Miller showed almost no colour at all. A former advertising executive elected in 2005, her principal qualification for the post appeared to be that she improved the gender balance in the cabinet. The DCMS was added to her responsibilities as minister for women and equalities, where she loyally steered the legislation permitting gay marriage through parliament in the face of right-wing opposition. Much of her time would be spent dealing with the fall-out of the Leveson enquiry and the failure of the government to come up with a reformed system for press regulation. There was also the distraction of deepening concerns about the operation of the BBC Trust.

Miller's appointment did not inspire confidence in the cultural sector. The DCMS had been had moved out of its offices in Cockspur Street to corridors at the back of the Treasury, and as it lost the personnel, expertise and institutional memory required by an independent government department, there were suggestions that it would be abolished altogether. In a speech to an invited audience of cultural leaders at the British Museum in April 2013, Miller sought to 'reframe' the argument about the role that culture played in national life by returning to the Conservative rhetoric of the 1980s: 'when times are tough and money is tight, our focus must be on culture's economic impact.'[23]

Knowing from bitter experience the Treasury's customary response to such claims about the economic impact of the arts, Miller's audience was unimpressed, aware that, in preparation for the Comprehensive Spending Review for 2015/16, the Arts Council had been told to model further cuts of 5, 10 and 15 per cent. Even the *Daily Mail's* parliamentary sketch writer and theatre critic, Quentin Letts, who delighted in provoking the liberal arts establishment, launched an *ad feminam* attack: 'what opacity, what blandness, we have from Mrs Miller. What a milky-blancmange zone of nothingness her department has been under her so-called leadership.'[24]

Facing such ridicule, and aware of the need to prove herself to the cultural sector, Miller made a show of fighting her corner during the Comprehensive Spending Review negotiations in June. Just ahead of a House of Commons debate on the arts called by the opposition – the first to be held in five years – it was announced that the settlement for her department would be more generous than expected: an overall cut of 7 per cent, within which museums and the Arts Council would lose 5 per cent. The announcement spiked the opposition's guns; but, far from Miller having put up a fight, the chancellor, known for his sympathy for the arts, had had to ask her to make a stronger case than the one she had originally proposed.[25] Miller asserted: 'The arts are safe with me',[26] but they were not. In December 2013 the chancellor cut a further £10 million from the DCMS in 2013/14, and £20 million in 2014/15. The cumulative cuts to the DCMS between 2010/11 and 2015/16 were approaching 50 per cent.

The June settlement had already decided the fate of English Heritage. In 2015 it would be split between an independent charity to run its historic properties as a business, and an executive Non-Departmental Public Body, Historic England, to carry out the organization's statutory and grant-making duties. As a sweetener, it would be given £85 million to establish itself as the new charity and to help pay for a backlog of repairs, although it was assumed that a further £83 million would be raised from other sources. There would be no further government funding after 2023, by which time it was expected that the 'National Heritage Collection' would be able to

earn its own keep. This was not the view of the National Trust, which, when informally offered English Heritage's properties by David Cameron at the start of his government, calculated that an endowment of several billion would be needed to justify taking them on.

At the Arts Council the redoubtable Liz Forgan was replaced as chair by the altogether more clubbable former television executive Sir Peter Bazalgette. He was close to Hunt and Vaizey, whom he had advised in opposition, and who rewarded him with a non-executive directorship on the advisory board of the DCMS, and then in 2012 with the chairmanship of the Arts Council. Some questioned whether the showman behind the voyeuristic and exploitative reality show *Big Brother* was quite the right person to take on such a distinguished role, but Bazalgette responded enthusiastically, and worked hard to convince people in the arts that he was on their side. It was a sign of the times, however, that he could call the cuts to the Arts Council as a result of the 2013 spending round a good result. This was before the chancellor's further cuts in December.

These meant that, by 2015/16, the Arts Council's grant would have fallen by a third since 2010/11. But the greatest damage was being done to local authorities. Although spared further cuts in December 2013, their accumulated cut by 2015/16 would be 35 per cent. Within this overall reduction, local authority spending on culture, including libraries and recreation, received the proportionately deepest cut of £100 million.

The understanding between the Arts Council and local authorities that they would try to match each other's funding was broken, leaving it open to the Arts Council to cut regional National Portfolio Organizations, as they would have to do. Conservative-controlled Westminster, as well as Somerset County Council, announced a complete end to arts funding; Labour-controlled Newcastle had to be dissuaded from a similar move, instead hiving off its responsibilities to an independent trust, and halving its culture budget to £600,000. In spite of the statutory obligation to maintain a public library service, local authority libraries continued to close or reduce their service. In November 2013 a report by the Joseph Rowntree Foundation warned that, by 2015, local authorities would have to

withdraw from providing all but the most basic social services.[27] That would mean the end of local authority funding for the arts.

In April 2014 Maria Miller's cabinet career came to a grisly end when her arrogant response to the findings of a long-running enquiry into her parliamentary expenses was deemed an insufficient apology. She was replaced as culture secretary by Sajid Javid, the first Muslim to hold the post. Javid was not known for his love of the arts, but before entering Parliament in 2010 he had made a private fortune – as a banker.

In the seven years since Blair's speech at Tate Modern, the golden age had indeed turned to lead. The gleaming new infrastructure that had been constructed for the public enjoyment of culture was becoming a weight, as public and private support concentrated on the larger institutions in the cities, especially London. The Coalition government deployed the argument for private investment and charitable support for culture, but its response to the economic crisis failed to create the conditions in which this could be expected to take place, and ignored the well-established pattern of private support following public investment in the arts. The recession provided cover for the Conservatives' deep desire to cut state spending. The National Lottery remained an independent, if volatile, source, and calls grew louder for it to be used to close the widening gap in government funding, reducing the responsibilities of an already weakened DCMS even further.

But the economic and social role played by the arts and heritage in national life had grown substantially since the Conservative cutbacks of the 1980s, and those who had enjoyed the benefits of the golden age had not lost their appetite for the arts. Whatever the economic prospects in 2015, the future of culture would be an issue in a way it had not been in 1997. The response to the pleasures of 2012 had made sure of that.

Olympic Rings

We hope … you'll glimpse a single golden thread of purpose – the idea of Jerusalem.

Danny Boyle

Leftie multicultural crap.
Aidan Burley MP

A year after the 2012 Olympic Games, Frank Cottrell Boyce, scriptwriter of the opening ceremony, looked back on what he called the 'temporary Utopia' that he had helped to create that warm July night. A total of 900 million viewers, 25 million of them in Britain, had watched the television broadcast of the event with almost universal rapture. The ceremony's diffident but determined director, Danny Boyle, a republican who made a movie star out of the Queen, was treated as a secular saint. The success of the opening ceremony, and of the Games that followed, created a brief euphoria.

A year on, Boyce was more sceptical: 'Did anything come from *any* of it? Is the East End more prosperous, more connected? Will West Ham make proper use of the stadium? Will the Olympic Park blossom into a glorious public space? Will the nation be any

fitter? And, if not, what was the point?'[1] The point, when the decision to bid for the Games was taken, was to show that, in spite of the fiasco of the Millennium Dome, New Labour could pull off a spectacular international event. Later, it became a way to restore Britain's reputation as the Iraq war went from bad to worse. Finally, it was precisely the circus that was needed as a distraction from the lengthening recession. Even if it had wanted to, the one commitment the Coalition could not undo was to hold the London 2012 Olympic Games.

The Games had been gathering momentum since 2003, rolling up cash, taking on people, and crushing criticism beneath its bureaucratic wheels as it first laid waste to, and then rebuilt, a vast swathe of East London. Whatever the economic circumstances, no government could risk the international humiliation of a failed Games. A mere £27 million was trimmed from the Olympic budget of £9.3 billion – the cost of a plastic 'wrap' round the Olympic stadium. A sponsor was found to pay for it – Dow Chemical, a controversial choice in view of the company's association with the 1984 Bhopal disaster in India. Damien Hirst quietly withdrew from an arrangement for him to decorate the wrap.

The Dome cast a long shadow. Doubters recalled the scandal of Wembley Stadium, still unfinished when the Olympic bid went in, and the decision to withdraw from hosting the 2005 World Athletics Championships because £100 million was needed to build a stadium at Pickett's Lock. When the formal bidding process began, not only was Britain internationally unpopular for being at war in Iraq, the city thought most likely to be chosen was Paris; France had refused to join George W. Bush's 'coalition of the willing'. There was deep public scepticism about Britain's capacity to pull off such an expensive project, and, as with the Dome, there was little support in the cabinet.

Tessa Jowell, however, had witnessed the success of the 2002 Commonwealth Games in Manchester, and convinced Blair to make another big gesture. Announcing the decision to bid in the House of Commons on 15 May 2003, she stated her reasons in classic New Labour terms: 'We want to harness the power of sport to help address

some of the issues that our nation faces – health, social inclusion, educational motivation and fighting crime.'[2]

Culture would also have to play its part. Although the competition for arts medals had been dropped after London had hosted the Games in 1948, it was mandatory in any Olympic bid to have a cultural programme, notionally running for as long as the Olympic Athletes' Village was open. Jowell was far more ambitious: the idea was to spread the anticipated benefits to tourism and business throughout the United Kingdom by mounting a four-year cultural festival between the end of the Beijing Olympics and 2012. The cultural programme would be a hook to catch the International Olympic Committee's attention. Everything New Labour had learned about the importance of dressing up events with opportunities for 'youth' was put into London's pitch.

Like the Dome, the Games were justified as a regeneration project, and like the Dome they were aimed at a deprived and semi-derelict part of East London – this time the Lea Valley. The bid documents stated that 'the legacy of the Olympics will be the regeneration of an entire community for the direct benefit of everyone who lives there'.[3] The then mayor of London, Ken Livingstone, had no interest in sport, but he could see the financial opportunity, and was prepared to put the powers and resources of the London Development Agency behind the project. He was also prepared to raise an extra £625 million from London's council tax payers.

While the £2 billion cost of conducting the Olympic and Paralympic Games would be met by the International Olympic Committee (IOC), funded by such health-promoting sponsors as Coca-Cola and McDonald's, the host country had to supply the venues, the security, and all the associated facilities and events. In 2003 the cost of building the Olympic Park and other facilities was put at £2.375 billion, plus a further £1 billion for 'regeneration', and it was anticipated that a further £700 million would come from the private sector.

There was parliamentary uproar when the final budget, set in March 2007, was almost trebled to £9.3 billion – approximately ten times the cost of the Dome. Of this, £6.2 billion would come from

the government, £0.9 billion from the Greater London Authority and the London Development Agency, and £2.2 billion from the Lottery – 20 per cent of the Lottery money for good causes between 2005 and 2012. Culture would certainly contribute to the Games: £322 million from the combined national Arts Councils, and the same from the Heritage Lottery Fund. The anticipated private sector contribution dropped to £165 million, which may have reflected something that was learned from the Dome; but the most important lesson was the requirement for a massive uncommitted contingency of £2.747 billion – of which 83 per cent was actually used.

As a result, the project came in £476 million under budget, but there were other costs: the London Development Agency spent £766 million on buying land; the 'Legacy' programme, which involved finding buyers and a future use for the Olympic Park and its facilities, cost £826 million; government departments were calculated to have spent £86 million on 'delivering' the Games.[4]

The reason the original Olympic budget was so low was that few people in government, and especially in the Treasury, believed that London would be successful. The reason the eventual cost was so high was that a successful Olympic bid created a government obligation to pay up, at whatever price. The IOC also required a prior commitment of support from the opposition. It was the politics of the Dome in reverse: Boris Johnson took over from Ken Livingstone in 2008, but retained Livingstone's Olympic advisor, Neale Coleman; the Coalition took over from Labour in 2010, but Hugh Robertson, who would become the Coalition's Olympics minister, had been kept fully informed ever since the IOC declared in London's favour.

The surprise and excitement that greeted the news of the successful bid on 6 July 2005 was doused the following day, when fifty-two people, plus four suicide bombers, were killed in attacks on a bus and three Underground trains. The cost of security rose even higher.

The government had learned one thing from the Dome, and that was not to micro-manage the project, and at least to appear to keep out of things. A former Downing Street advisor told the Institute for Government that the specially created Olympic Delivery Authority

(ODA) 'was genuinely going to be at arm's length. Our experience of meddling with Wembley and the Dome had persuaded us that ministers shouldn't be involved in these decisions.'[5]

On the other hand, it was not clear who would be in charge. In a valedictory lecture as chairman of the Arts Council in January 2009, Christopher Frayling complained that 'there are too many front doors', adding: 'If you make an anagram of the initials of all the organizations involved in the Olympics it comes out as "eek comic – so logo mad".'[6] Frayling was playing politics, making a concerted bid for the cultural festival – the Olympiad – to be run by the Arts Council. In November 2008 Alan Davey had protested: 'we are already, in the arts, through National Lottery diversion, contributing enough to the cost of the Games. Not a penny more can we give. To do so would damage our chances of producing a Cultural Olympiad with artistic integrity.'[7]

The Arts Council would have to be content with a partnership role in the alphabet soup of rival organizations. The problem was compounded by the existence of two lead clients with very different institutional cultures. The IOC was a private international company accustomed to being indulged by national governments, and trailed an aroma of corruption. Working with the British Olympic Association and its Paralympic counterparts, the IOC was serviced by the London Organizing Committee of the Olympic and Paralympic Games (LOCOG), which had grown out of the original bid committee, and was chaired by the former Olympic athlete – and former Tory MP – Sebastian Coe, who had received a peerage in 2000. This too was a private company, and swelled to 7,000 employees. It controlled sponsorship deals and ticket sales, and was meant to be self-financing, but nonetheless ended up receiving £1 billion from the DCMS.

The parallel government organization was the Olympic Delivery Authority, an NDPB that was also a planning authority, charged with building the venues and providing security and transport. The ODA was staffed by civil servants and experts from the private sector, ten of whom earned more than £150,000 a year, and some considerably more than those commanding the armed forces. Tessa

Jowell was lead minister until 2010; political responsibility ran from the Government Olympic Executive, based in the DCMS, up to a cabinet sub-committee that eventually led to the formation of an Olympic Secretariat. The upright civil service habits of the ODA and LOCOG's lack of transparency created tensions, particularly when it was time to hand over control of the Olympic Park from the one organization to the other.

There were other players in the field. In addition to the mayor's office and the London Development Agency, there was the Olympic Lottery Distributor, established to pass on £750 million in Lottery funding generated by a dedicated lottery; there was the Legacy Trust, set up to fund sporting and cultural opportunities for young people, which was not to be confused with the London Legacy Development Corporation, created to run the post-Games Olympic Park.

The Olympic Park was the largest development the United Kingdom had ever seen: a 560-acre site on land as polluted as the Greenwich peninsula, in an area containing thirteen of London's most deprived wards. Next to it rose the biggest shopping centre in Western Europe, and the intention was to end up with 11,000 new homes – a target subsequently reduced to 6,800 – by 2030. Zaha Hadid's Olympic swimming pool and Michael Hopkins's Velodrome turned out to be distinguished buildings, but the Olympic Stadium left a Wembley-style puzzle over its future ownership and the cost of remodelling it for football use.

As Anna Minton powerfully argues in her study *Ground Control* (2012), regeneration in twenty-first-century Britain has come to mean privatization. It has produced the inferior architecture described by Owen Hatherley in *A Guide to the New Ruins of Great Britain* (2010) and *A New Kind of Bleak* (2012). Formerly shared public spaces, and new ones created by development, have become subject to regimes of surveillance and private exploitation. The Park would be no exception.

The choice of the Olympic site has its origins in the privatization of British Rail in 1996, which made acres of railway land at Stratford available. A series of property deals left the Australian developer Lend Lease with responsibility for the shopping development, Westfield

Stratford City, with 300 shops, fifty restaurants, three hotels and seventeen cinema screens. Anyone arriving at the Olympic Park by public transport – at least 70 per cent of visitors – had to pass through this commercial portal, the first shopping centre to have built-in sensors for explosives.

Lend Lease was also supposed to use its business skills to develop the Athletes' Village, which would have a commercial afterlife, but proved unable to raise the money, and the public sector had to step in with an extra £350 million, at the same time cutting the number of apartments from 4,000 to 2,800. The ODA had already helped the Westfield development with £200 million for access roads. In 2011 the Village and adjoining land was sold to Qatari sovereign investors, who were unlikely to be generous social landlords. The Queen Elizabeth Olympic Park will not be a royal park, but will be run by a private company, as will the former Olympic buildings within it. The three London boroughs whose borders meet in the Park are excluded, and the area is governed by the mayoral development corporation.

As with the Dome, the private sector did not rise to the occasion: apart from its inability to deliver investment during the construction phase, the two most egregious failures of the Games were by private companies – Ticketmaster over ticket sales, and G4S, whose inability to provide sufficient security personnel led to the armed forces being brought in. With 18,200 troops involved, there were more soldiers in East London during the Games than in Afghanistan. The atmosphere of surveillance was compounded by the placement of rocket batteries on the top of private flats, a warship on the Thames, and Eurofighters in the air.

The little-noticed London Olympic Games Act of 2006 sanctioned the use of force by private companies. The Act could be used to secure the privatization of individual bodies, by preventing visitors wearing clothes displaying the names of brands other than those of Olympic sponsors (Visa, McDonald's, Coca-Cola, Panasonic, Sainsbury, Dow Chemical, Procter and Gamble, Atos). Even language was privatized: link '2012' and 'Games', use 'gold', 'silver', 'bronze', 'London' – even 'summer' – in the wrong way, and you might be in trouble.

Over the Olympic Park loomed Anish Kapoor's ArcelorMittal Orbit, a red steel skeleton that appeared to cross a helter-skelter with a radar tower – at 115 metres, the tallest sculpture in Britain. Some £3 million of the cost came from the London Development Agency, and £20 million from the steel magnate Lakshmi Mittal.

The privatizing tentacles of the Olympics spread out across London, with the institution of VIP traffic lanes for the exclusive use of 4,000 black BMWs to carry 40,000 Olympic officials, sponsors, bureaucrats and government dignitaries. In London's newspaper, the *Evening Standard*, the columnist Sam Leith summed it up as 'a giant bunch of public money spent on restraining trade, shutting down free speech, littering the capital with white elephants, creating a two-tier system in the public roadways and providing a jolly for a cartel of self-important shysters with an institutional history of corruption'.[8]

Leith was not the only naysayer. As the costs started to rise alarmingly in 2006, Simon Jenkins – nursing personal memories of the Dome debacle – argued that 'the one justification would be if the city staged a London Games, not an International Olympic Committee one. That corrupt organization has turned a historic athletics festival into an extravaganza of chauvinist bombast.'[9] Jenkins kept up his campaign for the next six years, although he did ultimately concede that the Games had turned out to provide a Keynesian boost to the economy.[10]

The Hackney resident Iain Sinclair – novelist, essayist and psycho-geographer – was the most eloquent objector. The transformation of an anarchic, semi-derelict, proletarian and historically redolent part of London into a privatized, profit-driven playground was the ideal subject for a writer who had made the device of the Situationist *dérive* – the aleatory amble that reveals the secrets of the city – his principal art form in novels like *Downriver* (1991) and semi-documentaries such as *London Orbital* (2002). His 2011 memoir *Ghost Milk: Calling Time on the Grand Project* loops angrily and despairingly between previous Olympic sites and the blue-fenced exclusion zone at Stratford:

The devastation of the ecology of the Lower Lea Valley, with the loss of allotments, unofficial orchards behind abandoned lock-keepers' cottages, native shrubs, wildlife habitats, disturbed the balance of a substantial chunk of London. The corridor between the Thames and the orbital motorway. The folk memory of a broader and more vigorous tributary. But it was the betrayal of language that caused most pain: every pronouncement meant its opposite. *Improving the image of construction. Creating a place where people want to live.* Promoters spoke of the regeneration of a blasted wilderness, underscored by high-angle views of mud paddocks forested with cranes, but omitted to mention the fact that they had created the mess by demolishing everything that stood within the enclosure of the blue fence. They warned of huge budgets and paranoid security measures required to counter the threat of terrorism: a threat they provoked by infiltrating this GP [*Grand Projet*] park under the smokescreen of a seventeen-day commercial frolic.[11]

The book is a homage to the novels of J. G. Ballard and his urban nightmares made real, twisting between the communist oppression of Beijing and the capitalist oppression of London: 'The fix is in and it goes all the way. Bear witness. Record and remember.'[12]

To general surprise, the Olympic Park was finished early, and under budget. The Olympiad – an unfamiliar word and an unfamiliar concept – did not have such a smooth journey. The closing statistics are undeniably impressive: the final cost of the four years of events was £126.6 million; it produced 177,717 activities – performances, exhibitions, broadcasts, and education and training events. There were 5,370 new works or commissions, involving 40,464 artists. It was calculated that there were 43.4 million 'public engagement experiences', of which 37.4 million were attendances at events or visits, and 5.9 million involved participation, including 45,597 volunteers. Of these 'experiences', 38.5 million were free. The final twelve weeks covered by the London 2012 Festival saw as many events and activities as in the entire four years that culminated in Liverpool's year as European Capital of Culture in 2008.

Yet the Olympiad was very nearly a disaster. LOCOG's habit of doing things in its own way, which grated with other partners, was most sharply exposed when it came to the cultural element. Between the competing interests of the IOC, national governments, sports authorities and sponsors, with battles over branding, publicity, confidentiality clauses and the overwhelming priority of sport, culture was always an afterthought. Few previous Olympiads had been a success, the best in recent years having been Barcelona in 1992 and Sydney in 2000.

Sponsorship requirements caused all sorts of problems for the mixed economy of British culture, where most large organizations had long-standing arrangements that cut across those of the Olympic sponsors. A lecture that was intended to celebrate the high ideals of the founder of the modern Olympics, Pierre de Coubertin, ran into trouble because it was given at the Southbank Centre – which is sponsored by Mastercard, whereas the IOC is sponsored by Visa. Disabled artists and athletes in the Paralympic Games resented having to wear lanyards bearing the name of the sponsor Atos, which was conducting tests on behalf of the government designed to reduce the number of people on disability benefit.

The complicated structure for delivering the Games meant there were organizational rivalries, a lack of trust, and opportunities for political interference, especially from the mayor's office. In April 2006 Tessa Jowell announced the formation of a 'Culture and Creativity Forum' to advise on the Olympiad, but little was heard of this unwieldy, thirty-three-person assembly drawn from the arts establishment after its first meeting in July. The main problem was that nobody could say precisely what an Olympiad was.

The original cultural bid had been prepared by a committee led by the artistic director of the Southbank Centre, Jude Kelly. When LOCOG was formed, Kelly became chair of a Culture and Education Advisory Committee, working with the director of ceremonies, culture, education and live sites. This was Bill Morris, who had been in charge of outside broadcasting for the BBC, and who had higher priorities than the half-dozen in the 'culture team', who were given no specific budget. As an advisor, Kelly did what she could to talk

up the inspirational possibilities of a cultural programme, but was unable to offer decisive leadership.

In April 2007 Keith Khan, putting Rich Mix behind him, was appointed Head of Culture on a six-figure salary. But with no budget, the culture team had to be reactive rather than proactive, with would-be players going their own way. As the Olympiad's own account delicately puts it: 'at this early stage diverse teams created diverse opportunities for cultural and community organizations, but the lack of a single management structure impeded the development and delivery of a single vision … the public struggled with the idea of what a Cultural Olympiad was.'[13]

The initial approach to programming was described as 'open source', which turned out to be a euphemism for 'undirected', with different organizations filling the vacuum by launching their own schemes. The Arts Council significantly increased its investment in 'outdoor arts'. In 2007 there were thirteen organizations working primarily in street theatre, supported by ACE with £1.1 million; by 2011 there were sixty-eight, drawing down £14.8 million. ACE ran a competition for a dozen public art commissions, worth £500,000 each, covering the United Kingdom. The resulting projects for 'Artists Taking the Lead' proved obscure, whimsical or disappointing, and the commission for Liverpool failed to materialize at all.

The Royal Shakespeare Company took charge of producing a World Shakespeare Festival, just one element of which was the production of all of Shakespeare's plays at the Globe in London, presented by thirty-eight different companies, each performing in their own language. Museums were encouraged to involve young people in creating exhibitions under the title 'Stories of the World'. 'Discovering Places' was about exploring the local environment; 'Film Nation' encouraged young filmmakers; the PRS Music Foundation set up 'New Music 20x12' to commission twenty twelve-minute compositions.

One of the most impressive combinations of training and commissions was the £3 million Unlimited programme. This developed the Olympiad's commitment to disabled and deaf artists into a scheme to train forty-four disabled artists, Paralympians and ex-service

personnel in circus skills in order to perform at the Paralympic opening and closing ceremonies. The programme also awarded commissions of between £25,000 and £50,000 for thirty-one productions and events by established creators in the field.

In an attempt to create some kind of identity for so many disparate events, LOCOG created the 'Inspire' mark – a version of the 2012 Games logo that got round the sponsorship problem by omitting the Olympic rings. Some 564 projects, predominantly involving sport, were awarded this approval, but, as the Olympiad account admits: 'the lack of a dedicated central budget meant that funder conditions were not always aligned with the cultural Olympiad core vision and that in many instances, each new idea required dedicated fund raising and funding applications.'[14]

To help with this problem, and to meet objections to the diversion of Lottery money away from the arts and heritage, in 2007 it was decided to set up the Legacy Trust, with a £40 million pot drawn from the residue of the Millennium Commission, plus funding from the Big Lottery and ACE, and funding from the DCMS to support the 'School Games'. Although the Legacy Trust was not allowed to use the Olympic rings either, it was given a nationwide remit to raise sponsorship from local sponsors and local authorities. By the time it was wound up in 2013, it had managed to raise an additional £55.6 million from these sources. In 2009 the Olympic Lottery Distributor came on stream, and the British Council later became involved.

LOCOG's problems with organizing the Olympiad became apparent in May 2008, when Keith Khan stepped down as LOCOG's head of culture, and no replacement was appointed. Khan's proposed 'Festival of Carnivals' was just one of several ideas that failed to happen, including a 'Friend Ship' that had been supposed to sail to Beijing for the Olympic handover. In September 2008 the first annual three-day 'Open Weekend' was held in an attempt to promote Olympiad events, but it was plain that the programme was drifting. In March 2009 the *Guardian* asked: 'Is the Cultural Olympiad a Runner?' The article quoted Nicholas Serota, who was on the Board of the ODA: 'The original bid projects were put together by committee. Some have legs and some, frankly, don't. Is LOCOG the right

body to be organizing the Cultural Olympiad? There is no board member who is interested in culture. It is an organization set up to run a sporting event, and it is not clear it is organized in such a way as to successfully run a cultural event.'[15]

At this point the LOCOG cultural budget was a matter of speculation. The sum of £40 million had been set aside for the all-important opening and closing ceremonies, which were being handled separately, leaving, it was thought, around £8 million for developing the Olympiad. Bill Morris prevaricated: 'We won't know the budget of the Cultural Olympiad until it's over.'[16]

It was plain that, if a Dome-scale disaster was to be avoided, new leadership had to be found. After high-level manoeuvres behind the scenes, the decision was taken to reconstitute Jude Kelly's advisory committee as a Cultural Olympiad Board. Tony Hall, the former BBC executive who had successfully transferred to the Royal Opera House, and who had the necessary authority and diplomatic skill, took over as chair, and the Board brought together those whose organizations had emerged as the major players: the director-general of the BBC, Mark Thompson; Alan Davey of ACE; Vikki Heywood of the RSC; Jude Kelly; Nicholas Serota; the managing director of the Barbican, Nicholas Kenyon; Boris Johnson's cultural advisor, Munira Mirza; and Bill Morris. Further names were added later.

In a diplomatic understatement, Hall said that he hoped this would end the 'procrastination'.[17] What he meant was the appalling indecision that had characterized the programme so far. His appointment coincided with a £16 million boost to the budget from the Olympic Lottery Distributor. At the end of the year the new Board became a formal committee of LOCOG, making it directly accountable as opposed to merely advisory, and culture at last achieved proper representation when Hall joined the main LOCOG Board. The culture team moved from LOCOG's Culture, Ceremonies and Education division into Brand and Marketing, which helped to simplify sponsorship issues. But *Arts Industry* reported in November 2009 that, more than a year after it had officially begun, only 2 per cent of the population knew what the Olympiad was.

It was imperative to find someone who could pull the tangled strands of the Olympiad together – someone who could take decisions, and was willing to carry responsibility. In spite of Hall's stressing the urgency of the matter, an artistic director was not appointed until January 2010, the delay caused by internal politicking in LOCOG and the bureaucratic procedures of the DCMS. The choice was Ruth Mackenzie, Chris Smith's former advisor, who had since jointly run the Chichester Festival Theatre, been general director of the Manchester International Festival, launched in 2007, and then returned to the DCMS as a special advisor, while also contributing to programming the Vienna Festival. Mackenzie's political experience and cultural contacts, energy, and ability to appear unfazed in public would be indispensable.

Mackenzie in turn appointed a team of associates: Sir Brian McMaster; the Manchester International Festival director, Alex Poots; the theatre director Martin Duncan; and Craig Hassall, who had managed the cultural programme for the Sydney Games in 2000. New senior producers were appointed, and designated posts were created at ACE and the mayor's office, which was able to cooperate much more closely with the new team. (The mayor's budget for bunting was usefully repurposed, dangling twisting aerialists rather than flags from prominent buildings.) British Petroleum and BT became dedicated Olympiad sponsors. On 17 March 2010 it was announced that a refocused programme, now named the London 2012 Festival, would run from midsummer's day 2012 to the close of the Paralympic Games on 8 September, with a budget of £75.5 million. Having made almost no impression on the public consciousness for more than three years, the Olympiad would be everywhere.

Although it was named the 'London Festival', the original, nationwide ambitions of the Olympiad were retained. None of the significant opening events happened in London. Instead, a performance at Stirling Castle in Scotland, with Gustavo Dudamel and the Simón Bolívar Symphony Orchestra of Venezuela playing alongside children who were taking part in the 'Big Noise', the Scottish version of Venezuela's Sistema, signalled the inclusive and internationalist

aspirations of the Festival. Yet, in spite of efforts to promote themes such as the Olympic Truce by highlighting Daniel Barenboim's performances with the West-Eastern Divan Orchestra at the Proms, or Deborah Warner and Fiona Shaw's poetic light-and-sound installations, *Peace Camp*, events were too multifarious and widespread to communicate a single concept, beyond the existence of the Festival itself. As the marketing expert Marc Sands commented in an independent assessment invited by the Olympiad, the Festival 'never clearly built a narrative to answer why it existed. It just seemed to be part of the Olympics.'[18]

Given the overwhelming perception of the Olympics as a sporting event, that can be counted an achievement, but the Festival turned out to be a catch-all. Almost half the projects would have gone ahead anyway, and the organizers were opportunistic in 'badging' events, having little to offer them beyond access to its database. Some, such as the David Hockney exhibition at the Royal Academy, which was over before the Festival started, or the Damien Hirst retrospective at Tate Modern, had no real Olympic associations, and it was a stretch to include the BBC Promenade concerts.

There were also real acts of the imagination, such as an unannounced 'pop up' street circus that closed Piccadilly Circus for the first time since 1945, or the Turner Prize–winning conceptual artist Martin Creed's *All the Bells in a Country Rung as Quickly and Loudly as Possible for Three Minutes*, which took place at precisely 8.12 a.m. on the opening day of the Games. It was calculated that 2.9 million people participated in this novel version of the Olympic rings. *All the Bells* exploited the new possibilities of digital technology, with 66,000 people ringing virtual bells on a phone app. *Connecting Light*, along Hadrian's Wall, and *Speed of Light*, involving runners on Arthur's Seat in Edinburgh, combined new technology with the magic of animating open spaces.

At the heart of the London 2012 programme was – to borrow a phrase from the theatre critic Michael Coveney's evaluation – 'an establishment-élitist statement of what constituted the best in contemporary theatre';[19] and not just theatre, for, as in any European avant-garde arts festival, there was also music, dance and visual art.

Shakespeare was an inevitable presence, in many variations, but international modernism was represented by the German Botho Strauss, the Irishman Samuel Beckett, and the Americans Robert Wilson and Philip Glass. Tribute was paid to the late German choreographer Pina Bausch. The ultimate high-cultural event was the world premiere in a disused factory in Birmingham of *Mittwoch aus Licht*, the last opera in Stockhausen's *Licht* cycle, with all six parts performed, and involving two choirs, flying solo instrumentalists, electronic and acoustic instruments, and a string quartet performing synchronously in four helicopters. Industrial dereliction once more met high art. Fortunately, the production was judged a success.

The sheer range and multiplicity of events during the four years of the Olympiad was the fruit of the investment in culture since 1997. Their reception showed the extent to which the public had acquired an appetite for cultural experiences that invited participation and stretched conventions – especially if they were free. As far as future Olympics were concerned, the Olympiad was, as Tony Hall had hoped, 'a game-changer – putting art at the heart of the Games themselves'.[20] Though there was no mention of the contribution made by artists in the closing speeches of either the Olympic or Paralympic Games, culture had become more than a desirable add-on, but supplied some of the defining imagery. In the opening ceremonies of the Olympic and Paralympic Games, it produced some of the defining moments of the Games.

These rituals, along with their corresponding closing ceremonies, are expected to conform to conventions as fixed as those of the theatre of the Ancient Greeks. The opening calls for bands, flags, a horde of performers moving around the Olympic stadium with military precision, the entry of the host head of state, speeches from the president of the IOC and the chair of the host organizing committee, the introduction of the Olympic rings, a seemingly endless parade of athletes, the declaration of the Olympic truce, the entry of the Olympic flag, the singing of the Olympic hymn, the Olympic oath, the lighting of the Olympic flame, the release of doves, the most elaborate firework display possible – all must be contained within a triumphant display

of what the host nation believed to be its most outstanding virtues. There are opportunities for chauvinistic bombast at every turn.

It is no wonder that the director of this mass spectacle should be worried that there would be a repeat of the opening night of the Dome, when things went on for so long that public transport had stopped before people could get home. Whoever was made responsible for the event had to create something that would work in the stadium, and entertain a worldwide television audience at the same time. Beyond the precedents of previous Olympic openings, the event drew on the traditions of pageants and carnival parades, amplified by the modern spectacles of rock concerts, royal weddings and open-air papal masses. Somehow it had to combine high culture with populism, and create the atmosphere, without the jingoism, of the Last Night of the Proms.

But it also had to be different. For one night only, Creative Britain would be on a world stage. This was the moment for designers, engineers, choreographers, lighting designers, costume makers, pyrotechnicians, camera and sound technicians, casting directors, composers, musicians, artists – and 7,500 volunteer performers – to show what the creative industries could do. No expense would be spared. In December 2011, the prime minister, David Cameron, more than doubled the original budget for the ceremonies to £81 million. The final cost for all four would be £110 million.

What stopped the opening being an oppressive stadium spectacle, a militaristic jubilee parade, or simply a Glastonbury without mud, was something that could not be written into a funding agreement, or set as a target: the spirit of subversion. The conventions would be respected, but humour would puncture the pomp and circumstance, sentiment soften the solemnity, and the sheer scale and ambition of the event would be tempered with a touch of irony. The roots of this confident self-deprecation can be found in the cultural formation of the principal minds involved: the artistic director, Danny Boyle, his creative producer, Stephen Daldry, and his scriptwriter, Frank Cottrell Boyce.

Boyle, Daldry and Boyce are typical products of the cultural economy this book describes. They are provincial-born graduates

of state-funded education; they were adolescents when Thatcher came to power in 1979, and learned to duck and dive as they made their way into the arts. Daldry and Boyle started in the subsidized theatre – Daldry as a clown, Boyle in the radical Joint Stock Theatre Company. Both worked as directors at the Royal Court, where Daldry became artistic director in 1992, having already run the London fringe theatre, the Gate. Boyce went from a state secondary school to Oxford, before becoming a television scriptwriter, working on the long-running soap opera, *Coronation Street*, and then moving into writing films.

All three benefited from New Labour's creation of the Lottery-funded Film Council. Boyle and Daldry directed films that helped to define the Thatcher years: Boyle captured their tragic hedonism in his 1996 version of Irvine Welsh's novel *Trainspotting*, and in 2000 Daldry combined in *Billy Elliot* an account of the destruction of pit communities during the miners' strike of 1984/85 with a moving tale of a working-class boy becoming a ballet dancer, which subsequently – more for the latter narrative than the former – became a highly successful musical. Boyce wrote the script for Boyle's 2004 film *Millions*, which he turned into the first of a series of children's novels. The Bollywood ending to Boyle's Oscar-winning film *Slumdog Millionaire* (2008) is credited with prompting Sebastian Coe's decision to offer him the job.

All three held on to the political and social values they grew up with. Boyle and Daldry had made the journey from the fringe to the centre of high culture at the National Theatre, and Boyce had an Oxford doctorate, but the trio's common culture was British pop music. Pop – in this context Hubert Parry's setting of William Blake's 'Jerusalem', and Elgar's 'Nimrod' from the *Enigma Variations* qualify as popular music – supplied the means by which they could magically hold the contradictions of their narrative in suspension. As a highly commercial medium that sustains corporate empires, yet transmits messages of protest and alienation, pop contains its own contradictions. In his programme note for the opening ceremony, Boyce points out that, the more meaningless the lyrics of a pop song are, the more power it can have. He cites the chorus to 'Hey Jude', the

song inevitably chosen to close the show: 'Anyone who has ever stood in a vast crowd and na na na'd along with it, knows that meaning doesn't matter. The important thing is the way that chorus allows us to karaoke ourselves into the moment.'[21] The playfulness and sentimental power of pop generate the shared emotions that make the collective experience possible.

Boyle and his music director, Rick Smith, wove pop into a narrative that sustained the successive sequences – in effect, three 'acts' with filmed interludes to cover scene changes – in an arc that started with Parry and Elgar and ended with the Beatles. Shakespeare, as predictable a reference point as Lennon and McCartney, supplied the ceremony's framing text, Caliban's speech in *The Tempest*: 'Be not afeard: the isle is full of noises.' In keeping with Prospero's sorcery, each act was a moment of transformation. The green and pleasant land of Blake's 'Jerusalem' was violently erased by the satanic mills of the Industrial Revolution; post-war Britain was transformed by the welfare state; the whole world was changed by Tim Berners-Lee's invention of the World Wide Web.

The contrast between the opening bucolic idyll of fields with live farm animals, maypole dancing and a cricket match, and the spectacular forging of the Olympic rings amid the flares and smoke-stacks of the Industrial Revolution, embodied the contradictions held in suspension in the hours that followed. Just as 'Jerusalem' was remade into a nationalist anthem during the First World War, in the stadium a pastoral past that never was and an Industrial Revolution whose brutality had been forgotten occupied the same imaginative space. But this was not an image of Heritage Britain, with historical conflicts dissolved in a nostalgic haze.

Boyle embraced the energies that the Industrial Revolution released. In his commentary on the 'director's cut' of the television recording of the ceremony, Boyle calls it a 'Renaissance', as a thousand costumed volunteers, spurred on by a thousand street drummers, indulged in creative destruction. In his recorded commentary, he says at one point: 'I want everything in this show to feel progressive ... we're OK, we're forging ahead.'[22] Boyle's approach was

not to deny the contradictions he was dealing with, but to hold them in a dynamic balance. The productive energy of industrialization was counter-balanced by reference to the mechanized destruction of war.[23] Jarrow hunger marchers and Suffragettes appeared alongside picturesque Chelsea pensioners and Pearly Kings and Queens.

Audaciously, in the filmed sequence that followed, the (real) Elizabeth II greeted the (fictional) James Bond at Buckingham Palace, before leaving with him in a helicopter for the Games, and appearing to make a parachute jump into the stadium. In real time, the (once more real) Queen then took her seat. Here, the humour supported, rather than subverted, the presence of royalty.

A pairing, rather than a contrast, shaped the – retrospectively most controversial – second act: a joint celebration of Britain's contribution to children's literature and of the creation of the National Health Service – the link being that Great Ormond Street children's hospital was a beneficiary of the estate of the author of *Peter Pan*. The coincidence of the launching of the National Health Service with London's hosting of the Olympics in 1948 was a gift to the ceremony's creators, as was the arrival in the same year of the West Indian immigrant ship, the *Empire Windrush*, whose passengers got a walk-on part. The interwoven evocation of the heroes and monsters of children's literature, and the emotional pull of the performance by hundreds of children and NHS workers, concealed the more political message associated with celebrating the welfare state.

In the third act, a celebration of Britain's public service broadcaster, the BBC, was similarly disguised by quoting television situation comedies; the invention of the World Wide Web led to a multiracial Romeo and Juliet encounter that was also a dance rave. A moment when massed dancers briefly formed the provocative outline of the CND peace symbol spoke for itself, while also becoming a historical reference.

Even Boyle's one acknowledged moment of 'high art', given to the Bengali dancer and choreographer Akram Khan, carried a double weight of meaning. Khan and his dancers evoked a pan-religious spiritual moment, but they performed to a solo rendition of 'Abide With Me' – a hymn with nearly a century of associations with football

grounds. Earlier, the spirit of subversion took over an interlude for Simon Rattle and the London Symphony Orchestra. Ostensibly a tribute to British cinema, the music was from the film *Chariots of Fire*, an ironic reference to Olympic victory that was further subverted by the appearance of Rowan Atkinson as his globally familiar character, Mr Bean.

The Britain that emerged in this selective portrait is cheerful, funny, energetic, pleasure-loving, undeferential, full of fantasy, and given to feeling. It is proud of its folkloric past, nostalgic for the countryside, but intensely urban. The Industrial Revolution may be behind it, but it has embraced the global revolution of the World Wide Web. It is monarchist and yet democratic, traditional in its sports and customs, modern in its enjoyment of new technology. It does not conform, yet works as a team. Class and religion do not matter very much. It has plenty of room for individualism, but appreciates the value of public institutions and joint endeavours. It is open and progressive, but has a social conscience. It is highly diverse, yet is able to share in a collective identity.

The appeal of this portrait helps to explain the almost completely positive response to the event. Typically, Sarah Lyall, in a valedictory article on leaving London after her eighteen years as resident correspondent for the *New York Times*, wrote: 'It was a bold, ecstatic celebration of all sorts of things – individuality, creativity, quirkiness, sense of humour, playfulness, rebelliousness and competence in the face of potential chaos – and more than anything I have seen, it seemed to sum up what was great about Britain.'[24]

Such a portrait also explains why the Conservative MP Aidan Burley should have tweeted: 'the most leftie opening ceremony I have ever seen' and 'leftie multicultural crap'. An online editorial for the *Daily Mail* protested: 'the NHS did not deserve to be so disgracefully glorified in this bonanza of left-wing propaganda.'[25]

Yet, from the opposite direction, the left-wing blogger Richard Seymour poured scorn on members of the 'soft left' who had fallen for the recuperative blandishments of Boyle's ceremony: 'whatever people now do to appropriate elements of this spectacle for their

own agendas, the fact that it's [*sic*] major achievement was to induce people to forget temporarily what a disgrace the Olympics are' – and went on to remind people of the imposition of the Games on the East End.²⁶ Seymour was favourably quoted in a blog by Dave Zirin for the American *Nation*, which condemned 'Danny Boyle's Olympic Minstrel Show' as a failure: 'All this celebration of working-class sacrifice, multiculturalism and the glories of national healthcare was done at the service of an Olympics that deliver the harassment of black and brown Londoners, ballooning deficits, austerity and cuts to the very programs like the NHS that Boyle was choosing to celebrate.'²⁷

There was also division within the musical world. In a web letter to his fan club, Morrissey, former lead singer with The Smiths, attacked the 'blistering jingoism' of the Games and 'the spirit of 1939 Germany that now pervades throughout media-brand Britain'.²⁸ He was reproved by the doyen of left-wing pop patriotism, Red Wedge founder Billy Bragg, who, citing the case of the British-Jamaican athlete Jessica Ennis, argued that, in this context, the people waving flags were 'expressing their pride in the possibility of that diverse open society' that Ennis represented.²⁹

The political skirmishes around the ceremony pointed to a profounder question about what it had said about national identity. Boyle and his team's treatment of British history did not satisfy the cultural critic Irene Morra, because it failed to acknowledge the questionable role of the British Empire. For her, the alignment of Shakespeare with the Beatles, the use of Blake's 'Jerusalem' and the evocation of English myth from Glastonbury Tor to James Bond was a rewriting of the traditional national story that tried to free it from the grasp of the institutions that defined official culture. The ceremony revealed a desire to reinvent British history as 'a continuous national tradition open to "ordinary people"'.³⁰

This alternative story, however, depended on the ability to separate the idea of England from the historical existence of an imperialist Great Britain:

The opening ceremony invoked an implicit folk identity (a benign 'little Britain') characterized by imagination, comedy, the NHS … compassion, and popular music. Nonetheless, in rooting the origins of this emergent people in the Industrial Revolution, it also inevitably invoked a more problematic signifier of British identity. No matter its enabling of popular industry, protest, and feats of engineering, the Industrial Revolution is inextricably bound into the history of the British Empire. Ultimately, Boyle's ceremony underlined the spectre of this legacy by refusing to acknowledge or represent the very fact of Empire.

Boyle's failure to engage with the issues of Britain's imperialist past, Morra argues, suggested 'an attempt to repress this imperial legacy into a radically revisionist – and ultimately inaccurate – rewriting of British national history and contemporary identity'.[31]

Morra points to the 'postcolonial' reading of Caliban's keynote speech, 'Be not afeard', which was written to be spoken, not, as it is in Boyle's production, by the confident Victorian entrepreneur Isambard Brunel, but by a dispossessed indigene, enslaved by Prospero's colonialist magic. But the part played in the ceremony by the *Empire Windrush* – the ship's name carried its own freight of meaning – was a better test case. The ship and its passengers, accompanied by a steel band, appeared in the second act. The Empire had come home, to begin the black contribution to British music that culminated in East End–born Dizzee Rascal's rap in the third act.

Thus, for Boyle, the negative history of imperialism is transformed into the positive narrative of inclusivity. 'This is for everyone' – a reference to Tim Berners-Lee's gift of the World Wide Web – was Boyle's strapline. In his commentary on the 12,800-mile Torch Relay, involving 8,000 volunteers, Boyle innocently repeated the mendacious phrase uttered by the Coalition chancellor of the exchequer, George Osborne: 'We are all in this together.'

As gloom descended on the rest of the British cultural sector, Boyle and his team's romantic vision held out the possibility that Creative Britain might yet turn out to be genuinely imaginative and inventive,

and not the utilitarian, profit-driven mechanism that it had become. It offered an alternative idea of national identity – one that was hungrily seized upon by those who believed that the arts were a collective creation, and that heritage should be held in common. This was precisely Boyle's intention. In his programme introduction, he wrote:

> We hope too that through all the noise and excitement you'll glimpse a single golden thread of purpose – the idea of Jerusalem – of the better world, the world of real freedom and true equality, a world that can be built through the prosperity of industry, through the caring nation that built the welfare state, through the joyous energy of popular culture, through the dream of universal communication. A belief that we can build Jerusalem. And that it will be for everyone.[32]

For that one night, Boyle's imagined Jerusalem was realized. Britannia found her cool. But, as in the lines that were also cited from *The Tempest*, 'this insubstantial pageant' was a dream. The paradise of Blair's golden age, if it had ever been, was by now indubitably lost.

It is too soon to answer Frank Cottrell Boyce's questions about the legacy of the Games. In 2013 the Big Lottery Fund created the 'Spirit of 2012 Fund', in an effort to keep alive the already-waning enthusiasm for participation and volunteering (and indeed for taking exercise) stimulated by the Games. The Fund was created with a notional £40 million from the money expected to be returned to the Lottery distributors from the sale of assets in the privatized Olympic park. The park began to reopen in 2014, but the Olympic Stadium would not be fully functioning until 2016, and the housing schemes would not be finished until the following decade. Do not expect a New Jerusalem to be builded there.

Just the Few, Not the Many

*Fifty per cent of our fellow countrymen and women never ever, in
the course of a year, set foot inside a concert hall, a theatre, an opera
house, or an art gallery. They never go to any arts event.*
Chris Smith, speech at the Royal Society of Arts, 22 July 1999

The opening ceremony of the Olympic Games quickly
became a reference point for all discussions about the impor-
tance of funding the arts. Aspects of every art form had
been on display, demonstrating the value of training the perform-
ers, designers and technicians who brought the show into being, and
the benefits of the experience they had gained from working in the
subsidized sector. If proof was needed of the value of investing in
the arts, the £27 million cost of the opening ceremony was money
well spent.

But there was another side to the New Labour project: this invest-
ment was intended to benefit 'the many, not just the few'. The arts
and heritage would contribute to the economy, but they would also
help to achieve a social transformation. The billions of state and
Lottery funding dispensed up to 2012 undoubtedly benefited the
existing audience for culture, but the question remains as to whether
any wider change took place. As far as the New Labour value, 'access',

was concerned, the project failed. The money went in, but what came out?

Publicly funded theatre is a case in point. When Labour came to power in 1997, British theatre was badly in need of reinvestment. Like the rest of the cultural sector, it was feeling the effects of the gradual attrition of public funding that had been going on for more than a decade. This was partially obscured by the commercial success of the West End, largely driven by spectacular musicals, and the sudden burst of energy that had been released in 1995 by the emergence of what became known as 'in-yer-face theatre', heralded by Sarah Kane's *Blasted*, and followed up by Jez Butterworth's *Mojo* and Mark Ravenhill's *Shopping and Fucking* – all productions by the Royal Court under its artistic director since 1992, Stephen Daldry. Like their contemporaries, the YBAs, the dozen or so writers who contributed to this aggressive, deliberately offensive experiential theatre, had learned to fend for themselves in the Thatcher and Major years. Their political agnosticism and the general world-disgust that they expressed reflected the individualism of the times. As the theatre critic Aleks Sierz writes in his study of the genre: 'While it could be read as an example of the "young country" that New Labour – with its attempts to rebrand Britain – tried to promote, it was much more raw, savage and critical than the platitudinous ideas thrown up by the Cool Britannia phenomenon.'[1] Though not confined to the Royal Court, 'in-yer-face theatre' was largely a metropolitan movement, yet, by the time of Kane's suicide in 1999, was being seen as 'a new orthodoxy'.[2] Having successfully set in train the Lottery-funded reconstruction of the Royal Court, Daldry, the genre's principal impresario, moved on to making films.

By 1999 the British theatrical economy was in serious difficulties. The Royal Shakespeare Company under Adrian Noble was drifting towards bankruptcy; the National Theatre under Trevor Nunn was putting on musicals to balance the books. The real problem, however, was outside London. Here, the network that had grown out of the pre-war repertory and civic theatre movements, made up of fifty Arts Council–funded English regional producing theatres, was

showing increasing signs of strain as deficits mounted and audiences shrank. The reps played a vital role in the country's theatre ecology that fed, and was fed by, the national companies and the West End, with touring companies, the reps' studio theatres, theatre-in-education companies and the fringe forming interdependent parts of the whole.

But help was at hand. The publication in 1998 of *A New Cultural Framework*,[3] followed by the largest increase in funding to the arts for twenty years, encouraged the Arts Council to appoint a consultant, Peter Boyden, to review the part played by the regional producing theatres, as a first step towards a new strategy for the whole of subsidized theatre.

Published in May 2000, Boyden's exemplary report confirmed that, for the previous two decades, these theatres had indeed experienced 'sustained crisis'.[4] Inflation in costs, and shrinkage in both local authority and Arts Council subsidy, had created a downward spiral in which financial and artistic deficits grew, old audiences declined, and new ones failed to develop.

Regional theatres were failing to nurture new writing talent, or directors, or actors, or technicians. The number of 'actor-weeks' – a measure of performers' employment – was in decline. Home-grown productions in the theatres' main houses had fallen from about ten a year to between four and seven. Ensemble companies had virtually disappeared, there were fewer creative people on the payroll, and pay was poor. Morale was low, deficits were rising, and most of the theatres covered were technically insolvent: 'Declines in the real value of funding, increasing fixed costs and smaller audiences have driven a self-fulfilling prophecy in which fewer resources get to the work on the stage, quality suffers and audiences decline still further.'[5]

Theatre was in danger of losing its cultural place: 'For many young people, theatre is no longer a natural part of the process of tribal self-definition and cultural reinforcement which drives leisure choices.'[6] The nearest thing to a national audience survey that existed at the time, the Target Group Index, showed that theatre audiences in general had been declining for several years, and in 1998/99 they fell to their lowest level yet. Not only was the audience shrinking,

its composition was becoming even more skewed towards the better educated and those in higher social groups.

The Arts Council faced a double problem: regional theatre was failing artistically, and New Labour's access agenda was not being met. Without putting a figure on what it would cost, Boyden skilfully laid out the parameters for a new strategy that would challenge the arbitrary funding and structure of regional theatre that had been allowed to develop, and offered a social vision: 'When a theatre building is the central focus for live art provision in a community different generations, social groups and ethnic communities will feel equally at home in all spaces. This will be equally true of creative teams, staff and audiences.'[7]

In response to the report, the Arts Council accepted that the theatre was in crisis;[8] it conducted a review of the £70 million that it and the Regional Arts Boards were spending on theatre, and in 2002 produced a *National Policy for the Theatre in England* that committed an additional £25 million a year for theatre for the next three years, representing a 72 per cent increase in its theatre budget. Between 2003 and 2007, a further £56.4 million went to theatre under the project-based Grants for the Arts scheme, launched in 2003, and twenty-one theatres, notably the RSC, benefited from 'stabilization' funding to address their deficits. Grants for some organizations more than doubled; almost all repertory theatres received increases; 83 per cent of available funds went to producing organizations and companies, 12 per cent to 'presenting' theatres, and 5 per cent to strategic policies such as the Black Regional Initiative in Theatre. In 2007 ACE added a commitment to developing street art and circus.

Although it is worth recalling that the majority of theatre performances in England were *not* funded by the Arts Council, the Boyden report appeared to change the weather. Led by Michael Boyd and Vikki Heywood, the Royal Shakespeare Company turned round its finances, and began the process of changing the way the whole company worked, in order to become a true ensemble.[9]

Led by the formidable partnership of Nicholas Hytner and his executive director, Nick Starr, the National Theatre began to enjoy

its most successful period, artistically and financially. In 2003 Hytner launched his tenure with a production of *Henry V* that was framed by the contemporaneous invasion of Iraq. He also showed that he was not afraid of offending sensibilities by following that with *Jerry Springer: The Opera*. In 2004 he pleased herbivorous tastes with Alan Bennett's *The History Boys*, and in 2007 oversaw the creation of one of the National's most profitable productions ever, *War Horse*.

The National also became a much more porous institution, enjoying artistically productive collaborations with fringe companies such as the Cornish group Kneehigh, and two companies that were developing a new form of 'immersive theatre', Shunt and Punchdrunk. Their shows had the attack and expressiveness of in-yer-face theatre, but also drew on physical theatre and installation art.

By contrast, as though in response to political events that were difficult imaginatively to comprehend – 9/11, Afghanistan, Iraq – the same period saw the expansion of forms of 'verbatim theatre'. This used transcripts of official investigations, interviews and documentary research to create a drama of enquiry that sustained British theatre as a forum for national debate. The genre was most strongly associated with the Tricycle Theatre in North London, where in 1999 Nicholas Kent directed *The Colour of Justice*, a dramatization of the Macpherson enquiry into the murder of the black teenager Stephen Lawrence that left no room for doubt about the existence of institutional racism in the Metropolitan Police.

Both commercial and subsidized theatres were flourishing, but when ACE announced its disastrous funding decisions at the end of 2007, the most vocal protests came from the theatre. The row coincided with the arrival of a new director of theatre strategy, Barbara Matthews. Matthews, who had not been responsible for the decisions, quickly appreciated that the Arts Council was still seen as the theatre's enemy, and decided that the time was right to commission a survey of what had happened since the new funds came on stream in 2003. The consultants Anne Millman and Jodi Myers, who proved as perspicacious as Boyden, carried out their work between June and November 2008 – just as the banking crisis was beginning to cause alarm.

As its title implies, *Theatre Assessment 2009* ranged far wider than Boyden's fifty regional theatres, and its research was backed up by data spanning the period from 2000/01 to 2006/07 from a constant sample of seventy-four theatre organizations. Its conclusions appeared to vindicate Boyden: 'The impacts of the additional £25 million per annum went far beyond the monetary.'[10] Theatres were more confident, optimistic and ambitious. The subsidized sector was now more open and less inward-looking; running a regional theatre had become an attractive career proposition; many new artists and companies had benefited from support for the first time; representatives of black and minority-ethnic-led and disability-led organizations reported increased capacity and profile. Producing theatres had better working conditions. There were more people employed, salaries were higher, production values better, casts larger, rehearsal periods longer; more risks were taken, people were more entrepreneurial and business-like; there was significant growth in support for younger artists, and greater diversity. Only new writing appeared not to have prospered in spite of the increased investment.

But there was one finding that the report did not choose to high-light. Although the Target Group Index survey had shown an increase in the audiences for 'plays', from 24.4 per cent of the adult population in 2001/02 to 30.7 per cent in 2006/07, and it was estimated that the combined 'reach' of theatre and of street and circus arts through attendance and participation was 42 per cent (engaging two out of five adults), these very broad categories, embracing all forms of theatre, did not match the far more precise audience figures produced by the constant sample of seventy-four ACE-funded organizations, according to which total attendances had remained static.[11] In the subsidized sector, there had been more performances, more new commissions, and more new productions – but no more people had been to see them. The audience had simply been spread thinner. Since 2002, over £100 million of extra money had been invested, and the audience at these key, core-funded theatres had not increased.

Although the situation would have been even worse without the Arts Council's intervention, this finding raises serious questions, not just about publicly funded theatre, but about the efficacy of public

funding for the arts and culture in general. In the case of the theatre, one possible explanation is that the failure to increase the audience was an unintended consequence of the Arts Council's own *National Policy for the Theatre in England*, which had placed specific obligations on funded theatres to develop new work. Olivia Turnbull's study, *Bringing Down the House: The Crisis in Britain's Regional Theatres*, closes on the funding allocation scandal of December 2007, not the 2009 theatre assessment, but she comments that the Arts Council's policy stress on access, diversity and new work had obliged theatres to move away from the traditional repertoire of text-based classics and do more consciously experimental work:

> Alliances with street performance, circus arts, multi-media productions and site-specific ventures ticked many of the desired boxes. But for the same reasons, particularly when the educational imperative was added to the mix, the new emphasis was also widely seen in terms of the dumbing down of interpretation and over-intrusive preachy labelling. Under these conditions, retaining the old audience while appealing to the new, advocating creativity while ensuring social inclusion, and juggling the multiple and various demands of the partner funding bodies proved too much for some theatres.[12]

Turnbull describes the problems at Basingstoke, Harrogate, Guildford, Derby and Bristol, where by 2008 the 'old' audience did not appear to have been replaced by the new. But this does not offer a complete explanation.

A larger answer is supplied by a point on which the Boyden report and *Theatre Assessment* agree: the narrow social foundations on which the theatre audience is built. The 2009 *Theatre Assessment* sums it up: 'There was a strong consensus of opinion about a lack of socio-economic diversity in the sector.'[13] Their research confirmed Boyden's finding that those with higher levels of education 'are significantly more likely to attend'.[14] Social status was also a strong predictor, and women were significantly more likely to attend than men, while black and minority ethnic adults were less likely to attend. The likelihood

of attendance increased steadily with age, and Londoners were the most active theatregoers.

The problem is that these factors are in play right across the cultural sector.

Since 1997, knowledge about the size and nature of the audience for culture in Britain has improved significantly. But it is not a happy story. When Boyden wrote his report, the principal source of knowledge was the Target Group Index. This is an annual sampling of 24,000 adults, conducted by the British Market Research Bureau, which asks a long series of questions about household consumption and leisure, including about attendance at eight types of arts events. The Arts Council started subscribing to the survey in 1986, but did not make the findings public – unless there was particularly good news. As New Labour's demand for 'evidence-based policy making' grew, however, from 2000 the Council made a concerted effort to establish a research and information strategy.

It began with a preliminary attitudinal survey, commissioned from the opinion research company MORI, of 1,801 adults in England in May 2000. Since this was conditioned by New Labour's 'access' agenda, it was particularly interested in attendance and participation. Asked, for instance, how often people had been to the theatre or participated in drama in the past twelve months, 36 per cent said they had.[15] Meanwhile, 12 per cent said they had been to a classical music concert. This was followed in 2001 by a much larger survey, jointly commissioned with the MLA from the Office of National Statistics, this time of 6,042 adults, and published in 2002 as *Arts in England: Attendance, Participation and Attitudes*.

The enquiry into attitudes was intended to show that the public supported public funding for the arts, which it duly did. *Arts in England* reported that 27 per cent had been to a play or drama, and 10 per cent to a classical concert, while 45 per cent had visited a library and 35 per cent a museum or art gallery.[16]

The exercise was repeated in 2003, and showed that theatre attendances had dropped to 25 per cent, classical concert attendance remained at 10 per cent, while 22 per cent had gone to a visual arts

show, 20 per cent to a pop concert, 12 per cent to a dance performance, and 26 per cent had seen carnival, street art or circus. Overall, 80 per cent had attended at least one arts event in the previous twelve months, and 87 per cent had participated in an arts activity – which included reading a book for pleasure.[17]

In July 2005, a new and even bigger survey was launched – a joint exercise commissioned by the DCMS in partnership with Arts Council England, Sport England, English Heritage and, until it was abolished, the MLA: *Taking Part: The National Survey of Culture, Leisure and Sport.* The fundamental reason for establishing the survey, however, was not social research: it was to discover whether the DCMS and its agencies were hitting the targets set in their funding agreements and achieving Departmental Strategic Objectives for increasing participation in culture and sport – targets that were apparently not being met. The process involves a face-to-face survey of selected adults over the age of sixteen in England, with a smaller sample of children added from 2006 onwards. A 'statistical release' of the main findings is published every quarter, and the raw material is a rich resource of demographic and social information. But, like nearly all surveys, it has its flaws.

The sample size varies, as do the precise questions asked.[18] Although the sample is taken to be representative, it was not until 2012 that a longitudinal element was introduced, with half the people being questioned on a regular basis. Interviews focus on subject areas defined as arts, museums and galleries, archives, libraries, heritage, and sport. The questions ask about attendance at, and participation in, cultural activities, and the emphasis is on 'live' events. Radio and television are excluded, as are listening to recorded music and most forms of literary activity, except membership of a book club or attendance at a literary event. This narrow focus ignores many aspects of culture that informally make up what Raymond Williams called 'a whole way of life'.[19] For advocates of cultural funding, it also produces some depressing results.

The 'headline figures' are distilled from a mass of questions about behaviours and attitudes. Public opinion on the Olympics was carefully tracked, and attention is paid to digital as well as live

engagement. The figures that follow here are taken from *Taking Part 2012/13 Quarter 4: Statistical Release*,[20] which covers the period up to March 2013, and which will be treated as the end-line for comparisons with the first figures released for 2005/06. This covers the period of the Olympic Games (though the Olympiad is not mentioned), and there is a warning that the figures may have benefited from an Olympic bounce. The report reveals that, of those questioned,

- 73 per cent had visited a heritage site – a 3 per cent increase since 2005/06, which was judged 'significant';
- 53 per cent visited a museum or gallery – a 10 per cent increase on 2005/06;
- 37 per cent had visited a library – an 11 per cent fall since 2005/06;
- 3.7 per cent had visited an archive for pleasure – a 2 per cent fall, also noted as 'significant'.

But the most important figure was the aggregate for those who had 'attended or participated in the arts'. This stood at 76.3 per cent in 2005/06 and, after staying at best flat up to 2011/12, rose to 78.4 per cent in 2012/13 – a 2 per cent increase over the period, which was recorded as significant.

There are two things to be said about this last figure. First, that a variation of 2 per cent does not appear to be particularly great, as opposed to much more impressive figures for museums and galleries, or worrying ones for libraries and archives. Second, in order to contribute to what looks like a remarkably high figure for the adult population, it is only necessary to attend or participate *once a year*. It is unlikely that the English population has quite the number of culture vultures that the figure suggests. This can also lead to over-claiming. The Arts Council's policy document *Great Art for Everyone* could happily assert: 'In 2009/10 76 per cent of the adult population engaged with the arts.'[21] Yet the very same document admits: 'only a minority of the population has much to do with the arts on a regular basis'.[22]

'Regular' is a loose term, but it is reasonable to expect 'engagement' with the arts to mean more than once a year. Fortunately,

Taking Part 2012/13 does contain information on those who had 'engaged' with the arts three or more times in the previous twelve months. This gives a more convincing – and still reassuring – figure of 64.1 per cent, a 'significant increase' on 62.5 per cent in 2005/06, all the more so because of the decline after that date before a recovery in 2011. Applying a tighter definition of what it means to 'take part' also gives a better understanding of other headline figures. The high figure for 'visiting a heritage site' becomes less impressive when it is understood that 'visiting' can include simply being in 'a city or town of historic character'. Just 30 per cent visited a heritage site three or four times a year – a 4 per cent increase on 2005/06. Just 17 per cent visited a museum or gallery three or four times a year.

When the first results of the *Taking Part* survey were released in December 2005, the DCMS proudly claimed that 94 per cent of adults in England had engaged in at least one cultural or sporting activity during the year. But what this figure means, in terms of cultural consumption, cultural identity and, ultimately, the efficacy of cultural funding, is another matter. These questions have been addressed by a team of sociologists and Arts Council researchers who were let loose on the results of the first *Taking Part* survey of 2005/06.

Together, they produced a remarkable report: *From Indifference to Enthusiasm: Patterns of Arts Attendance in England*.[23] Since, with the exception of museum and gallery visits, the annual variations in the figures are relatively small, it is reasonable to apply their conclusions to the period as a whole.

In order better to understand the audience for culture in general, the researchers used a statistical technique known as latent class analysis to identify any particular patterns of consumption, and decided that it was possible to distinguish three levels of activity in the population. These were:

- little if anything
- now and then (meaning no more than once or twice a year)
- enthusiastic (meaning three or more times a year)

Accordingly, they calculated that 57 per cent of the population of England did little if anything, 27 per cent went now and then, and just 12 per cent were enthusiastic consumers of culture. They also grouped patterns of cultural consumption into three domains where a particular form dominated:

• theatre, dance and cinema
• visual arts, museums, festival and street arts
• music

Because participation in one domain does not prevent participation in another, the analysts identified a fourth group of consumers, active in two or more domains, whom they termed 'voracious', and who constituted 4 per cent of the population – roughly 2.25 million out of an English population of 56 million. These are the true beneficiaries of public funding for culture, and proportionately there are not many of them. The flat conclusion of *From Indifference to Enthusiasm* is that the people who really take part in the publicly funded arts constitute 'a small minority'.[24]

Explanations for this awkward truth can be found in a contemporaneous study, *Culture, Class, Distinction* (2009), produced by a team of six cultural sociologists led by Tony Bennett, a British-trained Australian, who at the time was professor of sociology at the Open University. This is also based on a representative survey. The sample is much smaller than that used in *Taking Part*, with 1,529 respondents, but it is supplemented by focus groups and qualitative interviews involving nearly 200 people. Although it excludes some activities, such as photography and gardening, the survey is more closely concentrated on domestic cultural consumption, asking questions about television and reading, as well as being directed towards attendance and participation, like *Taking Part*.

As the third term in its title makes clear, the study is a test of the theories of the French sociologist Pierre Bourdieu, as laid out in *Distinction: A Social Critique of the Judgement of Taste*,[25] among other works. In essence, Bourdieu, who coined the term 'cultural capital',

argued that cultural knowledge and cultural experiences are an asset, and that, like economic capital, cultural capital can be accumulated and inherited. Culture does not exist in a separate and autonomous sphere, but is a shaping force in society and, like economic capital (and indeed social and educational capital), is a form of power. When Bordieu made his study of the distinctly elitist national culture of France in the early 1960s, he concluded that cultural capital was being used to enforce a distinction between an empowered ruling class and a disempowered working class – disempowered by its exclusion from the 'legitimate' culture enjoyed by the ruling class. For Bordieu, possession of cultural capital was a source of competitive advantage.

Not surprisingly, Bennett and his team discovered many differences between pre-1968 France and early-twenty-first-century Britain. Their survey paid much more attention to age, gender and ethnicity than Bourdieu (in France asking questions about ethnicity was illegal). They discovered that the boundaries between cultural forms and cultural tastes were much more fluid than Bourdieu had described, and that those who participated in culture emphasized openness, and deprecated cultural snobbery. Whereas in France the avant-garde had acted as an oppositional force within legitimate culture, in twenty-first-century Britain there no longer appeared to be any kind of struggle between canonical high art forms and the avant-garde. Nor were there any specifically 'elite' positions. The authors of *From Indifference to Enthusiasm* had come to the same conclusion:

> There does not appear to be any evidence of a cultural elite that engages with 'high art' rather than popular culture: the groups that are most active in the more niche arts and cultural activities, such as opera, video art and contemporary dance, are also the most frequent attenders of those activities in the *Taking Part* survey that might be classed as popular culture.[26]

These findings confirmed that there had been a cultural shift in Britain since the Second World War: both studies agreed that the key

distinction was no longer between high culture and low, but between engagement and disengagement in culture at all. The studies also agreed that education was the route to engagement. The higher their level of education, the more likely people were to enjoy the arts.

The Arts Council team claimed not to know precisely what it was about education that encouraged this, but thought it likely that education, and the exposure to the arts that it offered, 'results in an increased ability to interpret and understand arts experiences, which increases a person's motivation to engage'.[27]

There is no doubt that education creates opportunities for aesthetic experiences, and that both science and the humanities teach conceptual and critical skills that can be applied to those experiences. But it is also the case that education performs a much more basic function, which is to enable its possessors to maintain or improve their income, and hence their social position. Since education is both a driver of social mobility and is accessed more easily by the middle classes and above, one can expect to see a correlation between voracity or mere enthusiasm for the arts, and social class.

The studies differ markedly, however, over the part played by class. Since 2000, the social classifications used in market research have been replaced in official statistics by the National Statistics Socio-economic Classification (NS-SEC), which define people by their occupations within a broad social hierarchy of higher, intermediate and lower. The sociologist contributors to *From Indifference to Enthusiasm*, Tak Wing Chan and John Goldthorpe, however, have developed their own scale, based on social *status*, rather than social class. Like the NS-SEC, it is based on occupation, but it seeks to group people by closer affinities, such as friendship, where within these groups people are likely to share a common lifestyle and therefore treat each other as of equal social status.[28] They deploy thirty-one different categories, from 'Higher Professional' to 'General Labourer', which roughly correspond to the hierarchy of class, but because people are grouped by interest and affinity, they suggest this offers a more nuanced understanding.

Whereas *From Indifference to Enthusiasm* uses Goldthorpe and Chan's approach to social status and occupation, *Culture, Class,*

Distinction uses the concept of occupational classes to define a three-tiered structure: working class, intermediate-supervisory, and professional-executive – categories that 'transcend particular occupational positions'.[29] Noting a general reluctance in contemporary Britain to talk about class, the most emphatic statement in the book asserts:

> Class remains a central factor in the structuring of contemporary cultural practice in Britain: class matters. Whatever social advantage might arise from heavy engagement in cultural activities will accrue to those who are highly educated, who occupy higher occupational class positions, and who have backgrounds within higher social classes. Higher social class is associated with regular attendance at the theatre, museums, art galleries, stately homes, opera, cinema, musicals and rock concerts. It is also strongly associated with owning paintings and reading books. Belonging to the lowest social classes tends to be associated with never doing these things.[30]

The striking difference between mid-twentieth-century France and twenty-first-century Britain, however, is that, in spite of the evident links between cultural engagement and class, cultural capital is not being used as a form of social distinction that leads to working-class exclusion. One reason suggested is that, now that the consumption of popular culture has become common to all classes, the working class can no longer be said to have a separate culture of its own. Indeed, members of the working class are not interested in the signifiers of distinction: 'detachment is a better notion than exclusion'.[31] Cultural disengagement does not necessarily mean social disengagement; but, not only is the working class explicitly uninterested in legitimate culture, it is hostile to its being publicly funded. This indifference to legitimate culture is not confined, however, to the working class: 'much of the middle class is not strongly attached to, conversant with, or engaged in the activities that mark legitimate culture'.[32]

From Indifference to Enthusiasm makes the same point, and, like the Arts Council report, Bennett and his team conclude that

those most actively engaged with culture have an appetite for both popular and high culture – the 'omnivores' of sociological jargon who correspond to the 'voracious' in the Arts Council's report. Yet, in spite of being emphatically open-minded and expressly anti-elitist, within this group there are still markers that signal high-cultural preferences.

Musical preferences, followed by taste in visual art, still follow this pattern, though less so among the young. Indeed, it is noticeable that, among the 'voracious', the publicly funded arts – theatre, ballet, opera, classical music, art galleries – are the forms that are also the most popular with the professional-executive class. Although – as the Arts Council report also points out – not everyone in the profes-sional-executive class is familiar with the high art forms of legitimate culture, the fact is that legitimate – or in other words high – culture 'is central to the elite, where it oils the wheels of social connections. Being comfortable with opera and theatre confers social advantage in this quarter at least. The same is true, to a lesser degree of intensity, for others in the professional-executive class.'[33]

Culture, Class, Distinction is critical of several of Bourdieu's propo-sitions, but it does not dispute the ruling idea that cultural capital can be converted into social capital, and also economic capital: 'If no one else does, the powerful seem to believe that command of legiti-mate culture is a worthwhile form of investment.'[34]

The authors of the Arts Council report are less comfortable with this idea. They substitute social status for social class, and discount the influence of income, but this does not get round the fact that social status is hierarchically structured, that education is a marker of social status, and that status is a form of power. Possibly in order to defuse this uncomfortable fact, the report suggests:

Arts attendance seems to be driven by some concept of identity – who we think we are, the type of people we perceive to be our social status equals and the kind of life-style we deem appropriate and relevant for 'people like us'. Gender, ethnicity and age are also important factors. Even when all other factors are held constant, women are more likely to attend arts activities than men, older

people more likely than younger people and white people more likely than Black or Asian people.[35]

Thus, all the conditions that inhibit access 'for the many, not just the few' are still present. It may be, as the cultural critic Terry Eagleton writes, that the correlation between high culture and belonging to the upper classes has been overstated, and times have changed:

> The aristocracy has not been remarkable for its love of Schoenberg. High culture was always the stomping ground of the intelligentsia rather than a narrowly class affair, though the intelligentsia is usually that. Postmodern culture, conversely, is classless in the sense that consumerism is classless, which is to say that it cuts across class divisions while driving a system of production that finds such divisions indispensible. In any case, the consumption of a classless culture is nowadays increasingly the mark of the middle class.[36]

Yet, as *Culture, Class, Distinction* has discovered, being middle class does not guarantee that you are a consumer of culture either. The Arts Council report agrees that the key factors driving an interest in the arts are education and social status, but, significantly, it goes on to say that *income* has very little effect on attendance, and that social *status*, as defined by NS-SEC, has no effect. Even many who can afford to participate are indifferent. Having seen what a small proportion of the population are 'voracious' consumers of the arts, the plain fact is: 'Even if we were able to eliminate all the inequalities in arts attendances associated with education, social status, ethnicity, poor health and so on, a large proportion of the population would still choose not to engage with the arts.'[37]

Thus, although both studies agree there is a correlation between education and an appetite for the arts, nothing seems to guarantee an interest in culture. A significant proportion of highly educated, high status people have almost no interest in the arts.[38] Regardless of class, as another pair of sociologists who have more recently analyzed the *Taking Part* figures baldly state: 'not taking part in highbrow cultural

activities is the norm.'[39] Even though there is not a simple identifi-
cation between 'highbrow cultural activities' and what the publicly
funded cultural sector does, for those who administer public funding
of the arts, this must be a worrying thought. The majority of people
are not taking part.

For all of the optimistic interpretations placed upon them, the overall
findings of the *Taking Part* survey and its predecessors show only a
marginal shift, if that, in the social patterns of cultural consump-
tion since 1997. It is true that there has been growth in the size of
the cultural sector and the importance of the economic role that it
plays, but it may be that those whom the administrators of public
funding for culture serve are principally themselves, since they have
the cultural capital to occupy professional-executive positions, and
are members of the class that is the principal beneficiary of pub-
licly funded culture. It may not be that culture is being intentionally
treated as a means of exclusion; indeed, it is the openness that it
displays – aesthetically and formally promiscuous, socially anti-elitist –
that is its most prominent characteristic. Yet this openness may not
be as open as it appears.

This ruling culture can afford to be open, because there is little
opposition to it, so there is no need for distinction. Popular culture
gives pleasure and sentimental release to anyone who engages with it,
whether it is 'classless' pop music, or the imaginary re-enactment of
class roles in the Heritage Industry. Traditional culture gives reassur-
ance because its enjoyment depends on the knowledge and expertise
acquired through education, which is a form of distinction, even as
its openness is protested. The 'voracious' consumers of culture may
not be called an elite – and hate it when they are – but they do con-
stitute a significant class fraction that operates within the terms of
the prevailing class structure.

Yet, in spite of the apparent closure of a system that leads to such
a narrow audience, openness to experiences and ideas is one of the
ways in which cultural capital is acquired, and is thus a means to
social and economic power. A genuinely open culture allows for the
exploration and dissent that a democratic culture requires in order

to remain creative, and for it to be able to resist the co-option of governments and commodification by commercial culture. In which case, the purpose of publicly funded culture is not to continue 'the reproduction of the privilege of the professional-executive class',[40] as it appears to do, but to open it up to as wide a public as possible – a public that so far declines the access it has been offered. Jerusalem remains on the drawing board.

Conclusion: What Next?

I t is just before 8.30 on a damp Wednesday morning in November 2013. In a small rehearsal room at the Young Vic Theatre in London, people are gathering to discuss the future of the arts in Britain. There are about twenty-five of them: a couple of chief executives of dance and theatre companies, someone from the Museums Association, members of the Cultural Learning Alliance, representatives from arts foundations, Clore Fellows, someone from the Arts Council, individual artists. This is the weekly meeting of What Next?

The session is chaired by the Young Vic's artistic director, David Lan. In March 2011 Lan decided to call a meeting to discuss the worsening situation following the cuts in arts funding that had begun in 2010. Among those present were the artistic director of the RSC, Michael Boyd, Tony Hall from the Royal Opera House, Jude Kelly from the Southbank Centre, Alistair Spalding from Sadler's Wells, and David Whelton from the Philharmonia Orchestra. Lan gave the discussion the title 'What Next?', and the idea grew from there.

A one-off encounter became a weekly meeting that began to be replicated across the country. Similar sessions are held elsewhere in London, as well as in Manchester, Liverpool, Coventry, Cambridge, Cardiff, the north-east and the north-west. In April 2013, 650 people turned up for a conference at the Palace Theatre in London. More

than 150 cultural organizations, and some 3,000 individuals, have so far been involved.

The participants in What Next? stress that it is not a campaign. It is not even an organization: there is no membership and no leadership, and meetings are open to anyone. But What Next? *is* a movement: its aim is not to look inwards, to the problems of cultural organizations and the agencies that fund them, but outwards, towards the audience for the arts, to understand the way they value contemporary culture and to enlist their support. What Next? is about making links, and learning from outside the sector.

The atmosphere at the meeting is brisk and congenial. On the agenda is a brief account of the previous day's launch by the Arts Council of its 'Grand Partnership' with the Royal Society of the Arts, the start of its strategy to influence whatever government emerges after the general election in 2015. A representative from the ailing National Campaign for the Arts presents its latest findings, showing a rise in audiences and declining funding. The announcement of a meeting to launch a What Next? group to focus on diversity leads to a thoughtful discussion about the lack of progress that has been made in the last twenty years.

The exchanges are open and positive; there is no grandstanding, and no deference shown between smaller and larger organizations, between individuals and institutions. The meeting ends promptly at 9.30, and will resume the following week. There seems no end in sight to these discussions: speakers make constant reference to the search for new paradigms, new solutions; but the terms of the What Next? conversation are so open-ended that it may never reach a conclusion. The clue is in the question mark: the process is the paradigm, the conversation is the beginning of a solution. Though wary of ever saying so, the would-be builders of Jerusalem are at work.

The part played by culture as the organizing principle of society is more important than ever before. It has become economically more significant, as are the ways in which it is used to construct our common understanding. But the materials to build Jerusalem

have changed. Even if attendance at certain cultural events is still socially useful to a small elite, the distinction between high and low culture has almost disappeared. All forms of culture are equal before the market. No longer insulated by their status from the instrumental expectations of government, cultural institutions are intimately linked to the wider culture of consumption that drives the economy and shapes our values. At the same time, technological developments are changing the relationship between the producers and consumers of culture.

Culture is a social process, in constant self-generation. This happens independently of the state, but ever since the state became directly involved in regulating and supporting aspects of national culture, the activities it chooses to promote have acquired the authority of being considered 'official' culture. This happened with the art forms that the Arts Council of Great Britain decided to support in 1946; the questions in the *Taking Part* survey are framed by the need to demonstrate that the DCMS and its agencies are meeting officially defined goals. Publicly funded culture – afforded official status by being so funded – has been a preoccupation of this book, because of its connection to government. Creativity happens all the time, but governments help or hinder it. The state has long supported aspects of the arts and heritage for reasons of national prestige, but more recently these have also been expected to produce social and economic outcomes, and this instrumentalism has changed the relationship between culture and the state.

Yet the existence of an official culture does not in itself diminish the intrinsic significance of the artistic practices that the state supports, even if it may influence their reception. Because every society has a need for collective memory (however open to ideological manipulation that might be), much official culture is concerned with the conservation of what are considered high art forms, and the institutions devoted to them. The continuation of performing art practices is just as legitimate as the conservation of material evidence of the past in museums and art galleries. When presented critically and imaginatively, the culture of the past is a source of meaning in the present.

Alongside official culture there exists an informal culture that also expresses the values of society, shapes its identity, and is a source of creativity and pleasure. Culture is by no means the exclusive property of the Arts Council; nor is it limited to what is broadcast on BBC Radio 3. For the great majority of people it comes in the form of recreation, some of it self-generated and non-professional, but chiefly through the market, in forms that need to make themselves as commercially appealing as possible.

The tradition of twentieth-century cultural criticism was to oppose the values and purposes of official and commercial culture. But in the twenty-first century they are interdependent. Commercial culture might appear to undermine the authority of official culture and the language of 'excellence', but under New Labour the invention of the creative industries changed the relationship. Cultural capitalism treated official culture as an economic activity driving innovation, thereby justifying its support on economic grounds. As in other areas of government investment, such as defence, commercial culture looks to official culture to fund the training, research and risks that commerce can later exploit.

Cultural capitalism has ended any lingering opposition between official and commercial culture. Both, however, are having to come to terms with the consequences of technological developments that have made it possible for a third form of culture to assert its influence on the other two. This is what John Holden calls 'homemade culture', which

> extends from the historic objects and activities of folk art, through to the post-modern punk garage band and the YouTube upload. Here the definition of what counts as culture is much broader; it is defined by an informal self-selecting peer group, and the barriers to entry are much lower. Knitting a sweater, inventing a recipe, or writing a song and posting it on YouTube might involve great skill, but can also be done without much difficulty – the decision about the quality of what is produced then lies in the hands of those who see, hear or taste the finished article.[1]

The key to understanding homemade culture is its essentially spontaneous and democratic nature. Official culture depends on the decisions of experts, who act as gatekeepers to the funds that support it. For commercial culture, success is decided by the consumer in the market, but the access of cultural products to the market is controlled by decision-makers even more powerful than the bureaucrats of official culture.

The gatekeepers of official culture determine the supply of certain forms of cultural production by funding people and institutions to create them at the risk – or even in the expectation – that there will be a financial loss. The gatekeepers of commercial culture determine the consumption of culture by investing in only what they hope will make a profit. In contrast, homemade culture is self-starting and self-funded, and depends on a self-appointed network of peers to share enthusiasm and approval for whatever is produced.

Much of this will be trivial and self-referential, but digital technology has not only made it possible for communities of interest to establish themselves through the Internet – it has also made it possible for almost anyone to make work to standards formerly restricted to highly capitalized organizations. Thus technology has allowed consumers to become producers, bypassing the gatekeepers because the cost and difficulty of entry have been significantly reduced. As the cultural economist Hasan Bakhshi writes,

> We see this in all stages of the value chain: in the area of content creation, for example, cheap (and in some cases even free) tools like Audacity (for music editing) Unity 3D (for games) and Blender (for animation) have reduced the costs of professional quality-grade content; in distribution, a myriad websites, services and platforms magnify audience reach and marketing opportunities. Collaboration tools and crowdfunding sites have lowered the costs of finding potential partners.[2]

Nearly all the digital technologies and the forms of social interaction that they make possible were unborn, or in their infancy, in 1997 – the year the United Kingdom acquired only its fifth terrestrial

television channel. YouTube was launched in 2008. By 2012, seventy-two hours of video content were being uploaded every minute worldwide, and the site was receiving 800 million unique visits a month.

Apart from enabling new forms of expressive activity such as the videogame, digital technology has helped to dissolve the barriers between 'professional' and 'amateur' production. François Matarasso cites DCMS figures saying that 15 per cent of the English population is active in amateur arts organizations, promoting 700,000 performances a year, involving 160 million attendances and with an income of £0.5 billion: 'The arts are not divided into two separate and antagonistic worlds: the amateurs and the professionals. It is better understood as a complex ecosystem in which people may play different roles at different times or in different aspects of their career.'[3]

Digital technology has played an important part in blurring boundaries, but it has not removed them altogether, any more than it has eliminated the role of gatekeepers. The Arts Councils of England, Wales, Scotland and Northern Ireland control access to the funding of official culture just as firmly as the Arts Council of Great Britain did in 1946. National and international corporations still control access to capital, and to distribution networks. The creative industries offer opportunities for personal initiative, but they depend on high levels of self-exploitation, and the workforce tends to be socially exclusive, with women, minorities and the working-class significantly under-represented.[4]

The new forms of self-generated culture made possible by digitalization are more communitarian and democratic; but even when consumers become their own producers, they remain consumers, and the gatekeepers of commercial culture are on constant alert, ready to exploit the innovations that informal culture throws up. There is also an assumption that everyone has access to the new digital technologies, and a taste for what is offered. A study for the Arts Council, MLA and Arts & Business in 2010 concluded that there was little evidence that digital technology offered a way to engage people who had little or no current interest in arts and culture.[5] The problems of education, access and exclusion have not been resolved.

Nonetheless, digital technology is changing the social relations upon which the exchange of culture depends, if in paradoxical ways. A network model begins to dissolve hierarchy and to replace the pattern of centre-and-periphery. Opposition and protest can be organized more easily, but the ability to communicate rapidly and conveniently is matched by the opportunities for surveillance. The speed of communications has shortened attention spans and the shelf life of ideas. There is a tension between the need to preserve the rights to intellectual property and the creative possibilities offered by the sharing of ideas through open-source technology. Niche activities can aggregate their influence, but they depend on massive and powerful commercial platforms such as Google, Yahoo and Facebook.

The most positive development made possible by digitalization is the change in the creative relationship between people. As Charles Leadbeater argues,

> If the culture that the web is creating were to be reduced to a single, simple design principle it would be the principle of With. The web invites us to think and act *with* people, rather than for them, on their behalf or even doing things to them. The web is an invitation to connect with other people with whom we can share, exchange and create new knowledge and ideas through a process of structured, lateral, free association of people and ideas.[6]

Consciously or unconsciously, the participants in What Next? have adopted the principles and practices of the 'Art of With', which weakens the power of gatekeepers, leading to the decline of hierarchy and the growth of creative collaboration and co-production.

Julian Stallabrass notes that the change in interpersonal relations affects the property relations involved in digital art. Because Internet art is about the immaterial exchange of ideas and images, rather than the creation of discrete objects, ownership ceases to be significant, and neither public institutions nor private dealers can take possession. When art can neither be 'curated' nor commodified,

democracy is severed from the market, dialogue is rapid, borrow-
ing is frequent, openness is part of the ethos, and there is a blurred
line between makers and viewers. There are the beginnings of a
sacrifice of the sovereign artist and the solitary viewer in favour of
communal participation and – that most necessary and elusive of
cultural qualities – meaningful and effective feedback.[7]

The practice of the 2004 Turner Prize winner Jeremy Deller exem-
plifies the demise of the 'sovereign artist', beginning with his not
having studied at art school, instead graduating in art history. He
sells little of his work, feels no need to paint, and is not particu-
larly interested in making art objects – which he can commission
from others. He recreates past events, works with amateur and pro-
fessional musicians, makes videos, and involves hundreds of people
in ceremonies and parades. Underlying all his work – for instance,
the installation *English Magic* in the British Pavilion for the 2013
Venice Biennale – is a strong theme of social criticism of the rich and
powerful.

The notion that 'anyone can be an artist' is coming closer to reali-
zation. Informally, people have always constructed a *bricolage* of
cultural identity out of their individual taste and experiences, but
this has been a private activity. Digital technology allows those who
choose to, to put these private self-creations into the public arena.
There is a fusion between who is the audience and who is the creator.
In 2009 an unusual actualization of the process took place in Trafalgar
Square in London.

The plinth for a public statue in the north-west corner of the
Square had long stood empty, but in 1999 it began to be used, not
for an official monument, but as the site for the temporary display
of specially commissioned contemporary sculpture. In 2009 Antony
Gormley – whose use of his own body as the basis of figurative casts,
and whose large-scale works, such as *The Angel of the North* (1998),
define him as one of Stallabrass's 'sovereign artists' – stepped down
from that role by using his commission to create *One and Other*.[8]

Over a hundred-day period, 2,400 members of the public, chosen
from 34,250 applicants, were each invited to stand on the plinth

for one hour, and do whatever they liked: address the crowd, dance, sing, strip, mime, show off. Gormley described the project in terms of a gift, and art as a space for exploration in which anyone could participate. The event was free, and available in real time on the Web. This is an extreme example, but it relates to the growth in participative forms of theatre, extending from promenade performances into 'immersive theatre', where members of the audience choose their own route through a theatrical setting, and site-specific work where the division between stage and audience is dissolved by occupation of a common space.

The public's response to these events reveals an appetite for participation that has been stimulated by the possibilities of homemade culture. The thousands of volunteers working alongside the professional artists in the opening ceremony of the 2012 Olympic Games were an example of the synthesis between amateur and professional, between audience participation and performance, between elite and popular art forms. It holds out the possibility that, if Jerusalem were to be built, it might be constructed on a more generous and open conception of culture.

This begins with a reassertion of the value of the public realm. The public realm is an idea, a mental space that allows the free play of the individual and the collective imagination; and it is a physical space: it is the cultural infrastructure that is the true legacy of Creative Britain. These facilities and institutions are collectively owned, and they are a shared responsibility. They are also under threat as a result of the withdrawal of the state from its duty to protect the public's investment.

As a physical and as an imaginative space, the public realm enables individuals to interact with one another to form collectivities and communities. It does not exclude the market, because making, buying, selling and consuming are social interactions. But when all forms of human exchange – loving, family life, charity, self-expression – are reduced to a commodity, their value disappears. The public realm is the field of operations of the 'third' sector, sustained by volunteers who are not looking for a financial return on their time and efforts. Here, too, neoliberal principles are a coercive threat,

as charities are co-opted into working with corporations to deliver social services that have been a government responsibility, but are now outsourced for private profit.

The role of government is not to occupy or dominate the public realm, as in the Stalinist or Maoist model, but to act as the guarantor of its integrity. This should be a place for the circulation of ideas, for creative expression and political argument; but the continued privatization of the public realm, and the withdrawal of the state from support for the arts and cultural education shuts down the possibility of free exchange. The World Wide Web has the potential to act as a virtual form of the public realm, but even this new space is the subject of powerful corporate exploitation, and invasive government surveillance.

To recover the value of the public realm, it is necessary first to recover the idea of the public. Neoliberalism has replaced collective identity with that of the atomized individual – a seeker of maximum utility ruled by economic self-interest. This is a false understanding of human nature that leaves individuals with no meaningful relationships with each other except transactional ones. The autonomy of the individual must be respected, but social questions demand collective responses. As consumers, we act as individuals, and in our private interest; as part of the public, we can think and act for the public good.

Engagement with culture, which is a voluntary activity, is the means to the reconstitution of such a public: the work of an individual artist (who more often than not is working in a team) is realized when it finds an audience, whether experienced privately or in public performance. The individuals who constitute a public audience discover a collective identity through their joint engagement with the work.

As the cultural economist David Throsby points out, this is the root of the difference between economic and cultural value: 'The economic impulse is individualistic, the cultural impulse is collective.'[9] This finds its expression in the arts, which are produced through cooperation, and where for both creators and consumers the value of the whole is greater than the sum of its parts. An encounter with

art is a collective event that overcomes the isolation of individualism, linking performers to audience, and audience members to each other, as the aesthetic experience merges individuals in the shared moment.

In this sense, all cultural activity is an act of co-creation, a collaborative making of meanings, enhanced by the participation of the community. But this will not be a single meaning, any more than the public realm is occupied by a homogeneous group of people. There will be different beliefs and values in the public realm, but because they have to share a common space they cannot be exclusive, any more than minority views can be excluded. In the open space of the public realm, enhanced by the democratic possibilities of digital technology, a plurality of meanings is possible, whose very diversity is the source of further cross-fertilization.

The state has a legitimate interest in this, for just as the collective engagement with culture results in something greater than its individual parts, the state's investment in the arts, heritage and education – as with public health – enriches the whole of society. The state is the guarantor of a free market, but it should also guarantee the freedom of the individual against the exploitation of the market, and against the depredations of the environment that the market engenders. As the guarantor of the public realm, it must protect the right to open information and debate. Above all, the state must revive a public, as opposed to private, property right – the right freely to access the co-created culture that is held as common property in the public realm.

The recognition of a cultural commons, which acknowledges that culture is created out of necessity, calls for institutional change on the part of government, and on the part of cultural agencies and organizations. In 1948, Article 27 of the United Nations Universal Declaration of Human Rights stated: 'Everyone has the right freely to participate in the cultural life of the community, to enjoy the arts, and to share in scientific advancement and knowledge.' Yet how rarely has this right of access to the cultural commons been asserted or reinforced.

Without a firm commitment to culture as a common good, the public realm will continue to be divided and fragmented by privatizing interests that work on the principle of competition, not cooperation. The government has a responsibility to represent the public's cultural interest through legislation or economic intervention. But it needs to define the anticipated outcomes of those interventions differently. Both *The Green Book*, which establishes the principles for government decision-making, and *The Magenta Book*, which shows how the results of those decisions are to be evaluated, acknowledge the existence of use-value and non-quantifiable social benefits. But in cultural policy the insistence on reducing the outcomes of cultural decisions to proxies for economic value is a category mistake.

The right outcome is *cultural value*, which is articulated through qualitative, and not just quantitative evaluation. As an organizing principle, culture is indeed capable of producing social benefits as well as aesthetic pleasures, and it cannot escape the economic context in which it operates. Cultural value recognizes the existence of instrumental outcomes, and is no enemy to quantitative evidence; but the fundamental value of culture lies in its ability to create expressive meaning. That meaning depends on the intrinsic qualities of the forms that convey it. When cultural organizations successfully mediate between the intrinsic purposes of culture and the instrumental outcomes that follow, they generate institutional value in the form of social capital. Social capital, whose principal expression is trust, is essential to the enlargement of the public realm.

A revised approach to government intervention would begin by abandoning the 'deficit model' of market failure that justifies decisions to support the arts and heritage only on the grounds that the market is not providing what the public is judged to need. The input/output mindset that treats culture as a product has to change to one that understands it as a dynamic process. Public funding should be treated as a form of leadership, and defended, not because it gives people privileged access to private pleasures, but because of the possibilities of collective experience it offers, and because it sustains cultural resources and keeps them in the public realm.

* * *

Just as the cultural commons creates a shared space, culture prospers best within a mixed economy. Homemade culture contributes its democratic, self-generated energies; commercial culture brings capital and communicative skills; official culture recognizes the value of tradition, sets standards, and preserves choice.

Public funding is only one part of the mix, but it has a creative role to play, especially in the encouragement of risk. It is accepted that science learns through failure, but cultural organizations are required to operate on far narrower margins than most commercial enterprises. They have the right, but little room, to fail.

Conventionally, the focus of subsidy has been on sustaining a minimum amount of supply; more attention should be paid to distribution. The 'golden age' made progress in that direction by extending the cultural infrastructure and increasing opportunities for participation. It also revealed the problems of demand. There is no lack of appetite for all kinds of cultural consumption, and within the mixed economy commerce meets many needs. But the *Taking Part* survey shows how narrow the audience is for a potentially deeper and more challenging engagement.

The reasons for this, as has been shown, are social and economic. A more equal distribution of wealth would help to address the economic issues associated with social status – essentially, questions of class – but it is clear that education, although in itself a signifier of status, is the most important route to enjoyment of the arts and heritage. The simple fact is that those who are exposed to cultural experience when young are most likely to engage with it later. This has nothing to do with status or class, high art or low – it is a matter of public education. Expand the range of experiences that are offered, and the demand for them will rise.

The cultural sector cannot solve the problems of education on its own; there has to be close cooperation with schools, universities and education authorities. These, however, have come under pressure from the narrow, utilitarian policy pursued by the Coalition's secretary of state for education, Michael Gove, whose insistence on the STEM subjects – science, technology, engineering and maths – has already led to a decline in the take-up of arts subjects – subjects dismissed as 'soft'.

This policy seems calculated to shrink the demand for cultural engagement, and will have long-term effects. There are instrumental benefits to be derived from arts education, in terms of literacy and numeracy, but it develops personal and social skills as well as formal knowledge. Young people have to be encouraged to acquire 'cultural capabilities' that enlarge the imagination, encourage empathy and stimulate cooperation.[10] This is not a question of 'access', but of positive empowerment that enables people to make informed choices, value the outcomes of those choices, and participate in the public realm.

Increased demand will call for better supply: something has to be done about the unequal distribution of cultural assets and funding between London and the south-east, and the rest of the country. With 15 per cent of the population, and a distinctive multicultural identity of its own, London is a region in its own right. An independent report, *Rebalancing Our Cultural Capital*, makes a cogent argument for redressing the significant imbalance between London and the regions. The report's analysis of the Arts Council's use of its Treasury-sourced grant-in-aid for 2012/13 shows that 51 per cent was spent in London. Between 1995 and September 2013, ACE awarded £3.5 billion in Lottery funds, of which 39 per cent went to London. The imbalance is even greater if HLF lottery awards and DCMS direct funding to London museums are included.

More importantly, since 1997 there has also been a greater concentration of cultural power in London. The Arts Council replicated the centralizing impulse of the New Labour government, dissolved the Regional Arts Boards, overcame regional resistance, and established central decision-making. The Coalition's imposition of staff cuts reinforced the position by reducing ACE's nominal regions to four. According to *Rebalancing Our Cultural Capital*, the 'centre' in England takes decisions on 75 per cent of public funding of the arts – a proportion expected to rise as local authority cultural spending falls.[11] The Arts Council's absorption of the former responsibilities of the Museums, Libraries and Archives Council extends its influence over regional museums.

Despite the rhetoric of New Labour and the Coalition, genuine localism is in decline. New Labour made local authorities the subject of targets and audit that limited their powers to act; the Coalition restricted their financial ability to act altogether. Some cities, such as Bristol and Manchester, have maintained their commitment to cultural investment because they can see the social, economic and civic benefits. But the attrition at local level is likely to have the most lasting effects, because the cultural sector is an integrated system that requires feeder routes to ensure a two-way traffic between the centre and the periphery.

The reconstruction of the public realm calls for the revival of the local, the diverse and the different. This extends from distinctive local dialects, customs and cuisines to architecture, where every high street now looks the same. It is essential to encourage local production in the arts, and celebrate the local significance of heritage. The opposite of centralism is subsidiarity, and cultural decisions are best taken at the level closest to those whom they most affect. As the guarantor of the public realm, central government should require local authorities to contribute to the cultural commons, and help them to do so – but not at the price of local autonomy.

This book is written at a time when the future of the government ministry that should bear responsibility for access to culture as a human right – the Department for Media, Culture and Sport – is in doubt. There is a real possibility that its functions will once again be dispersed across an archipelago of ministries and agencies. Its budget has been cut by nearly 50 per cent, and its staff reduced to a rump. Under the Coalition it has resiled from any idea that there might be ancillary social benefits from supporting the arts, although this retreat from New Labour's social instrumentalism has not been matched by a reduction of emphasis on the economic importance of the arts. It has had nothing to say about the decline in cultural funding at the level of local government – even for public libraries, which are its responsibility. Nor has it intervened in the Department for Education's efforts to squeeze the arts out of the national curriculum.

One of the effects of the decimation – and possible demise – of the DCMS has been that responsibility for the management of the cultural commons falls more heavily on intermediate organizations such as the Arts Council, who need to make better arguments to justify their role. That begins with the recovery of the true meaning of the arms'-length principle. This is a metaphor that has been much misinterpreted, ever since Lord Redcliffe-Maud's use of the term in his 1976 Gulbenkian report on the funding of the arts.[12] In theory, the principle keeps a prophylactic distance between the politicians who provide the funds for culture, and those who take the decisions about how they are spent, even though there are often intimate social and cultural links between the two groups. This applies to the Boards of directly funded national museums as well as to the Arts Council, the HLF and other Lottery distributors. As the metaphor is commonly understood, the Arts Council and similar bodies are only the hand that releases the money, while the arm is guided by government policy. Since the 1990s the distance between government and such organizations has shortened considerably.

The true meaning of 'arm's length' is found in its use in law to describe an agreement between two entirely separate parties where neither controls the other, nor ends up with an advantage over the other. It defines a relationship that is based on trust. The conversion of culture into an instrument of social and economic policy has changed what should be an offering into a requirement, and a response into an obligation. But creativity cannot be commanded, any more than its consequences can be predicted. Creativity depends on taking risks; the corollary is that the risk-taker must be trusted to understand the risk being taken. Everything that was done by New Labour to tie the arts and heritage into an instrumental agenda limited the creativity that it sought to encourage.

A relationship that is based on trust is beneficial to both parties – and so it should be with the arts and heritage. The government benefits from the maintenance and enhancement of the cultural commons, with all the social and economic advantages that this brings to society as a whole; the bodies that bear responsibility for the practical decisions are able to direct their energies towards the people

and organizations they exist to serve – not least the individual artists who are in danger of becoming mere cogs in the policy machine, rather than the fundamental imaginative resource that they are.

A relationship based on trust would restore the legitimacy of those who are currently described as gatekeepers. Because the liberation made possible by digital technology is changing the relationship between the producers and consumers of culture, the role of the expert must also change. There can be no monopoly on information, or on decision-making. The question of what – and who – constitutes 'excellence', thanks in part to the 2008 McMaster report, has become an issue upon which the authority of the expert depends. To be trusted, experts must not treat excellence as a codeword for exclusivity; they must acknowledge that it is relative, subjective and, above all, plural – and that pluralism is a key value in the public realm.

Since there needs to be both accountability in the spending of public money and leadership in framing and making choices, the conduct of cultural policy calls for professional expertise. But it is not the moral guardianship of the McMaster report, still less the anti-democratic reliance on the authority of a few decision-makers, that has been the traditional Arts Council approach. It is how expertise is exercised that matters – the ability to comprehend difference, the cultural values that are expressed, and the institutional value that is created by a positive relationship between expert, artist and public. The gatekeeper must become someone who opens windows and doors.

What goes for the 'cultural intermediaries' goes for the public bodies that employ them, and the arts and heritage organizations they support. Constitutionally, most cultural organizations are independent charities, and thus part of the third sector. Like the rest of the third sector, they must resist co-option by state agencies, and reinforce their reluctance to be agents of social control. At the same time, however, they have to understand that engagement means precisely that. Participation has to be more than buying a ticket. The approach taken by the What Next? movement is a belated recognition that cultural organizations are only as strong as the commitment

of their audiences, and that they need to be much more open with the people they wish to engage.

Few organizations would admit to being deliberately exclusive, but the terms of engagement have been changed by the democratization of culture. 'Distinction' may be in decline as a form of social discrimination, but if openness to experiences and ideas is one of the ways in which cultural capital is acquired, and so is a means to social and economic power, then the opportunity to acquire cultural capital must be as open as possible. That is the justification for funding the arts and heritage.

Cultural capital is not an exclusive commodity that can be traded in the market. It is a public good whose value increases when more people possess it, not fewer. The sole purpose of public policy should be to enlarge it, by making it as freely available as possible to as many people as possible. Cultural capital is the knowledge that is gained from engagement with the arts and heritage; it is the emotional as well as intellectual intelligence developed through access to the imaginative world of the arts and the collective memory of a shared heritage; it is the expressive cultural capability that results.

As a constituent element of the cultural commons, cultural capital contributes to the enlargement of social capital, which increases mutual tolerance, encourages cooperation, and engenders trust. The existence of trust is the essential condition for creativity. It liberates the imagination from the distortions of externally imposed expectations; it encourages the imagination to extend itself, because trust offers security in the face of risk. Creativity is the true driver of a fulfilled society, and cultural capital is its key resource: if the ruins of Creative Britain are to be cleared for a New Jerusalem, there has to be a serious investment in both.

Notes

Introduction: 'A Golden Age'

1 Tony Blair, 'Arts and the Creative Industries', press notice text of speech at Tate Modern, 6 March 2007, p. 2.
2 Jack Cunningham and Mark Fisher (1997), *Create the Future: A Strategy for Cultural Policy, Arts and the Creative Economy* (London: Labour Party, 1997), p. 6.
3 Stuart Hall, 'The Neo-Liberal Revolution', *Soundings* 48 (Summer 2011), p. 18.
4 John Newbigin, 'A Golden Age for the Arts?', *Cultural Trends* 20: 3/4 (2011), p. 232.
5 *Independent*, 2 April 2001.

1 Under New Public Management

1 Simon Jenkins, *Thatcher and Sons* (London: Allen Lane, 2006), p. 207.
2 John Tusa, *Art Matters: Reflecting on Culture* (London: Methuen, 1999), pp. 77–8.
3 Ibid., p. 76.
4 Colin Hay, *The Political Economy of New Labour: Labouring under False Pretences?* (Manchester: Manchester University Press, 1999), p. 136.
5 Tony Blair, *New Britain: My Vision of a Young Country* (London: Fourth Estate, 1996), p. 213.
6 Tony Blair, *The Third Way: New Politics for a New Century* (London, Fabian Society, 1998, pamphlet 588), p. 1.
7 Ibid., p. 5.

8 Ibid., p. 4.
9 Ibid., p. 7.
10 Alan Finlayson, 'New Labour: The Culture of Government and the Government of Culture', in Timothy Bewes and Jeremy Gilbert, eds, *Cultural Capitalism: Politics after New Labour* (London: Lawrence & Wishart, 2000), p. 179.
11 Blair, *Third Way*, p. 16.
12 Norman Fairclough, *New Labour, New Language?* (London: Routledge, 2000), p. viii.
13 David Marquand, 'The Blair Paradox', *Prospect* 30 (May 1998), p. 19.
14 Tony Blair, *Socialism*, (London, Fabian Society, 1998, pamphlet 565), p. 4
15 Mark Bevir, *New Labour: A Critique* (London: Routledge, 2005), p. 71.
16 Things were different in Scotland, where since 1982 local authorities had been obliged to make 'adequate cultural provision', although what was provided and what was considered adequate was not defined.
17 Clive Gray, *The Politics of the Arts in Britain* (London: Macmillan, 2000), p. 157.
18 R. A. W. Rhodes, 'Introduction', *New Public Management, Public Administration* 69 (Spring 1991), p. 1.
19 John Clarke and Janet Newman, *The Managerial State: Power, Politics and Ideology in the Remaking of Social Welfare* (London: Sage, 1997), p. 32.
20 Andrew Rawnsley, *Servants of the People* (London: Hamish Hamilton, 2000), p. 213.
21 Treasury, *The Green Book: Appraisal and Evaluation in Central Government*, rev. edn (London: H.M. Treasury, 2011 [2003]).
22 Treasury, *The Government's Measures of Success: Output and Performance Analyses* (London: H.M. Treasury, 1999), p. 2.
23 Chris Smith, 'Valuing Culture', speech at Valuing Culture conference, 17 June 2003.
24 Conservative Central Office, *The Best Future for Britain* (London: CCO, 1992), p. 44.
25 Richard Eyre, *Report on the Future of Lyric Theatre in London* (London: HMSO, 1998), pp. 5–6.
26 *Sunday Times*, 9 June 1996.
27 Kees Vuyk, 'The Arts as an Instrument? Notes on the Controversy Surrounding the Value of Art', *International Journal of Cultural Policy* 16: 2 (2010), pp. 173–83.
28 Raymond Williams, 'Politics and Policies: The Case of the Arts Council', in Raymond Williams, *The Politics of Modernism* (London: Verso, 1989 [1981]).
29 Geoff Mulgan, 'Culture: The Problem With Being Public', in D. Marquand and A. Seldon, eds, *The Ideas that Shaped Post-War Britain* (London: Futura, 1996), p. 196.
30 Ibid., p. 204.
31 Geoff Mulgan and Ken Worple, *Saturday Night or Sunday Morning? From Arts to Industry – New Forms of Cultural Policy* (London: Comedia, 1986), p. 209.
32 *Sunday Times*, 20 April 1997.
33 Eyre, *Report on the Future of Lyric Theatre*, p. 26.
34 Ibid., p. 5.
35 Mary Allen, *A House Divided: The Diary of a Chief Executive of the Royal Opera House* (London: Simon & Schuster, 1998), p. 67.

36 Ibid., p. 19.
37 House of Commons, *The Royal Opera House*, Report of the Culture, Media and Sport Select Committee, 1997, p. xxix.
38 Chris Smith, *Creative Britain* (London: Faber & Faber, 1998), p. 49.
39 Ibid., p. 2.
40 Ibid., p. 26.
41 Tony Blair, 'Arts and the Creative Industries', press notice text of speech at Tate Modern, 6 March 2007, p. 2.
42 DCMS, *Arts & Sport: Policy Action Team 10, a Report to the Social Exclusion Unit* (London: DCMS, 1999), p. 2.

2 Cool Britannia

1 Tony Blair, *New Britain: My Vision of a Young Country* (London: Fourth Estate, 1996), p. 213.
2 Commonwealth of Australia, *Creative Nation* (Canberra: Department of Communications and the Arts, 1994), p. 7.
3 Theodor Adorno, ed. J. Bernstein, *The Culture Industry: Selected Essays on Mass Culture* (London: Routledge, 1991).
4 Geoff Mulgan, and Ken Worpole, *Saturday Night or Sunday Morning? From Arts to Industry – New Forms of Cultural Policy* (London: Comedia, 1986), p. 14.
5 Liverpool's year as European Capital of Culture in 2008 similarly boosted a declining city, though there are questions to be asked about the long-term success of both events. See Dave O'Brien, *Cultural Policy: Management, Value and Modernity in the Creative Industries* (London: Taylor & Francis, 2013).
6 John Myerscough, *The Economic Importance of the Arts in Britain* (London: Policy Studies Institute, 1988), p. 35.
7 Tony Blair, *The Third Way: New Politics for a New Century* (London, Fabian Society, 1998, pamphlet 588), p. 7.
8 Charles Leadbeater, *Living On Thin Air: The New Economy* (London: Penguin, 2000 [1999]), p. ix.
9 *Sunday Times*, 19 May 1996.
10 Department of National Heritage, 'Cool Britannia Rules the Way as 1996 Sees Record Earnings from Overseas Visitors to the UK', press release 69/97, 5 March 1997.
11 Mark Leonard, *Britain™: Renewing Our Identity* (London: Demos, 1997), p. 6.
12 *The Times*, 15 July 1997.
13 Jack Cunningham and Mark Fisher, *Create the Future: A Strategy for Cultural Policy, Arts and the Creative Economy* (London: Labour Party, 1997), p. 10.
14 Chris Smith, 'A Vision for the Arts', speech at Royal Academy, 1997, DNH press release 126/97.
15 Tony Barker, with Iain Byrne and Anjuli Veall, *Ruling By Task Force* (London: Politico's, 1999), pp. 55–65.
16 Work Foundation, *Staying Ahead: The Economic Performance of the UK's Creative Industries* (London: Work Foundation, 2007), p. 96.

17 DCMS, *Creative Industries Economic Estimates: full statistical release* (London: DCMS, 2011) p. 2. Gross Valued Added is the income generated by a business minus the cost of the goods and services required to produce it, and is regarded as a more accurate measure than GDP.

18 Atkinson, Dan, and Larry Elliott, *Fantasy Island: Waking Up to the Incredible Economic, Political and Social Illusions of the Blair Legacy* (London: Constable, 2007), p. 88.

19 Work Foundation, *Staying Ahead*, p. 102.

20 Ibid., p. 106.

21 Ibid., p. 151.

22 P. Schlesinger, 'Creativity and Experts: New Labour, Think Tanks and the Policy Process', *International Journal of Press/Politics* 14: 1 (January 2009), p. 18.

23 DCMS, *Creative Britain: New Talents for the New Economy* (London: DCMS, 2008), p. 6

24 Ibid., p. 42

25 Hasan Bakhshi, Ian Hargreaves, and Juan Mateos-Garcia, *A Manifesto for the Creative Economy* (London: NESTA, 2013), p. 23.

26 John Hartley, ed., *Creative Industries* (Oxford: Blackwell, 2005), p. 19.

27 Blair, *New Britain*, p. 320.

28 Tony Blair, 'Why the Dome is Good for Britain', speech at the People's Palace Restaurant, Royal Festival Hall, 24 February 1998, p. 1.

29 Jennie Page, 'The Millennium Dome', typescript of lecture at Royal Society of Arts, 3 May 2000, p. 1.

30 Adam Nicolson, *Regeneration: The Story of the Dome* (London: HarperCollins, 1999), p. x.

31 Ibid., p. 2.

32 The company's original name was Millennium Central – an inheritance from Imagination Ltd's Birmingham bid, though the designers withdrew from the project.

33 Page, 'Millennium Dome', p. 2.

34 Ibid., p. 5.

35 Ibid., p. 3.

36 National Audit Office, *The Millennium Dome* (London: HMSO, 2000), p. 5.

37 Nicolson, *Regeneration*, pp. 122–3.

38 National Audit Office, *Millennium Dome*, p. 8.

39 Tony Blair, *A Journey* (London: Arrow, 2011 [2010]), with a new introduction, p. 256.

40 Nicolson, *Regeneration*, p. 143.

41 Ibid., p. 147.

42 Steve Richards, 'Interview: Peter Mandelson', *New Statesman*, 4 July 1997, p. 17.

43 Nicolson, *Regeneration*, p. 173.

44 Stephen Bayley, *Labour Camp: The Failure of Style over Substance* (London: B.T. Batsford, 1998), p. 66.

45 Ibid., pp. 68–9.

46 Simon Thurley, *The Men from the Ministry: How Britain Saved its Heritage* (London: Yale University Press, 2013), p. 3.

47 Bayley, *Labour Camp*, pp. 109–10.

48 Fiachra Gibbons, 'Mandelson "Made Dome Second Rate"', *Guardian*, 13 January 2000.

49 Some of the horrors of the night are described in Julia Dawkins's memoir *The Spirit of the Dome* (Bexleyheath: Faygate, 2002).

50 Jim McGuigan, *Rethinking Cultural Policy* (Maidenhead: Open University Press, 2004), p. 85.

51 Owen Hatherley, *A Guide to the New Ruins of Great Britain* (London: Verso, 2010), p. 299.

52 National Audit Office, *Millennium Dome*, p. 5

53 Chris Smith, *Creative Britain* (London: Faber & Faber, 1998), p. 2 (emphasis in original).

54 Ibid., p. 24.

55 Ibid., p. 3.

56 DCMS, *Culture and Creativity: The Next Ten Years* (London: DCMS, 2001), p. 5.

57 Ibid., p. 3.

3 'The Many Not Just the Few'

1 John Tusa, *Art Matters: Reflecting on Culture* (London: Methuen, 1999), pp. 79–92.

2 Peter Mandelson, *The Third Man: Life at the Heart of New Labour* (London: HarperCollins, 2010), p. 128.

3 DCMS, *Culture and Creativity: The Next Ten Years* (London: DCMS, 2001), p. 48.

4 Owen Hatherley, *A Guide to the New Ruins of Great Britain* (London: Verso, 2010), p. 63.

5 National Audit Office, *Progress on 15 major Capital Projects Funded by Arts Council England* (London: HMSO, 2003).

6 DCMS, *A New Cultural Framework* (London: DCMS, 1998).

7 All quotations are from Treasury, *Public Services for the Future: Modernization, Reform, Accountability* (London, H.M. Treasury, 1998), pp. 107–12.

8 DCMS, QUEST press release 277/99, 11 November 1999.

9 QUEST, *Modernizing the Relationship Part One: A New Approach to Funding Agreements* (London: DCMS, 2000), p. 13.

10 Adrian Babbidge, 'Commentary 2: The Only Game in Town', *Cultural Trends* 12: 47 (2002), p. 93.

11 DCMS, *Culture and Creativity*, p. 37.

12 G. Johnson, P. Pfrommer, S. Stewart, P. Glinkowski, C. Fenn, A. Skelton, and A. Jay, *New Audiences for the Arts: The New Audiences Programme 1998–2003* (London: Arts Council England, 2004), p. 218.

13 Chris Smith, 'Government and the Arts', lecture at RSA, 22 July 1999, DCMS press release 200\99.

14 Jonathan Vickery, *The Emergence of Culture-Led Regeneration: A Policy Concept and Its Discontents*, Research Paper No. 9, Centre for Cultural Policy Studies, Warwick University, Warwick, 2007, p. 58.

15 Johnson et al., *New Audiences for the Arts*, p. 163.

16 Catherine Bunting, Tak Wing Chang, John Goldthorpe, Emily Kearney and Anni Oskala, *From Indifference to Enthusiasm: Patterns of Arts Attendance in England* (London: ACE, 2008), p. 68.

17 Rhian E. Jones, *Clampdown: Pop-Cultural Wars on Class and Gender* (Winchester: Zero Books, 2013), p. 52.

18 François Matarasso, *Use or Ornament? The Social Impact of Participation in the Arts* (Stroud: Comedia, 1997), p. 79.

19 Paola Merli, 'Evaluating the Social Impact of Participation in Arts Activities', *International Journal of Cultural Policy* 8: 1 (2002).

20 François Matarasso, *Where We Dream: West Bromwich Operatic Society and the Fine Art of Musical Theatre* (West Bromwich: Multistory, 2012), p. 2.

21 DCMS, *Arts & Sport: Policy Action Team 10, a Report to the Social Exclusion Unit* (London: DCMS, 1999), p. 60.

22 Mike Bradwell, *The Reluctant Escapologist* (London: Nick Hern, 2010), p. 235.

23 Johnson et al., *New Audiences for the Arts*, p. 179.

24 Ibid.

25 OFSTED, *Creative Partnerships: Initiative and Impact* (London: OFSTED, 2006), and *Learning: Creative Approaches that Raise Standards* (London: OFSTED, 2010).

26 Culture and Learning Consortium, *Get It: The Power of Cultural Learning* (London: CLC, 2009), pp. 22–5.

27 DCMS, *Centres for Social Change: Museums, Galleries and Archives for All: Policy Guidance on Social Inclusion for DCMS Funded and Local Authority Museums, Galleries and Archives in England* (London: DCMS, 2000), p. 9.

28 DCMS, *The Historic Environment: A Force for Our Future* (London: DCMS, 2001), p. 4.

29 Ibid., p. 45.

30 DCMS, *People and Places: Social Inclusion Policy for the Built and Historic Environment* (London: DCMS, 2002), p. 12.

31 Emma Waterton, *Politics, Policy and the Discourses of Heritage in Britain* (Basingstoke: Palgrave Macmillan, 2010), p. 109.

32 DCMS, *Historic Environment*, p. 30.

33 Kate Clark and Gareth Maeer 'The Cultural Value of Heritage: Evidence from the Heritage Lottery Fund', *Cultural Trends* 17: 1 (2008), p. 42.

34 English Heritage, *Peer Review of English Heritage: Summary of Findings and Recommendations* (London: English Heritage, 2006), p. 7.

35 Paul Gilroy, *There Ain't No Black in the Union Jack: The Cultural Politics of Race and Nation* (London: Hutchinson Education, 1987), p. 11.

36 Arts Council England, *Navigating Difference: Cultural Diversity and Audience Development* (London: ACE, 2006), p. 222.

37 Ibid., p. 21.

38 Rasheed Araeen, *Making Myself Visible* (London: Kala Press, 1984), p. 105.

39 Runnymede Trust Commission on the Future of Multi-Ethnic Britain, *The Future of Multi-Ethnic Britain: The Parekh Report* (London: Profile, 2000), p. 278.

40 Richard Hylton, *The Nature of the Beast: Cultural Diversity and the Visual Arts* (Bath: Institute of Contemporary Interdisciplinary Arts, 2007), p. 123.

41 Runnymede Trust, *The Future of Multi-Ethnic Britain*, p. 161.

42 Arts Council England, *Theatre Assessment 2009* (London: ACE, 2009), p. 36.

43 Arts Council England, *Arts Council England: Report of the Peer Review* (London: ACE, 2005), p. 13.

44 Arts Council England, *Navigating Difference*, p. 208.

45 Ibid., p. 209.

46 Richard Appignanesi, ed., *Beyond Cultural Diversity: The Case for Creativity* (London: Third Text/ACE, 2010), pp. 5, 9.

47 Arts Council England, *What Is the Creative Case for Diversity?* (London: ACE, 2011), p. 3.

48 Arts Council England, *Annual Review 2007* (London: ACE, 2007), p. 50.

49 Arts Council England, *Annual Review 2009* (London: ACE, 2009), p. 53.

50 DCMS, *Annual Report and Review 2009* (London: DCMS, 2009), pp. 180–3.

51 Appignanesi, *Beyond Cultural Diversity*, p. 108.

52 Paul Gilroy, *After Empire: Melancholia or Convivial Culture* (Abingdon: Routledge, 2004), p. xi.

53 DCMS, *Arts & Sport*, p. 59.

54 Anthony Blackstock, *The Public: Lessons Learned by Arts Council England* (London: Arts Council, 2011), p. 30.

55 Ibid., p. 31.

56 Ibid., p. 27.

57 Ibid., p. 5.

58 François Matarasso, *Use or Ornament?*, p. 79.

4 The Amoeba – and Its Offspring

1 Cabinet Office, 'Pale Yellow Amoeba: A Peer Review of the Department for Culture, Media and Sport', 2000 (internal document), p. 34.

2 Ibid., p. 14.

3 Ibid., p. 17.

4 Ibid., p. 7.

5 *Stage*, 6 November 1997.

6 *Telegraph*, 6 December 1997.

7 *Independent*, 30 July 1999.

8 William Kay, *Lord of the Dance: The Story of Gerry Robinson* (London: Orion Business Books, 1999), p. 200.

9 Ibid., p. 206.

10 Gerry Robinson, 'The Creativity Imperative: Investing in the Arts in the 21st Century', New Statesman Arts Lecture 2000 (London: Arts Council England, 2000), p. 6.

11 Peter Hewitt, *Beyond Boundaries: The Arts after the Events of 2001* (London: Arts Council England, 2002), p. 12.

12 Charles Morgan, 'Reorganising the Arts Funding System Trying to Be Businesslike – Without Really Succeeding', House of Commons Culture, Media and Sport Select Committee, Third Report, 2001–02, 'Arts Development', Appendix 1, 2002

13 Arts Council England, *The New Arts Council of England: A Prospectus for the Arts* (London: ACE, 2001), p. 2.

14 Sue Robertson, 'Sue Takes a Parting Shot at ACE', *Stage*, 27 September 2001.

15 Christopher Frayling, 'Slaying the Sixth Giant: On Being Chair of Arts Council England', lecture, 29 January 2009, p. 3.

16 The exception was the National Museums on Merseyside, a group of Liverpool museums that had been 'nationalized' as a result of the abolition of the large Metropolitan County Councils by Mrs Thatcher in 1986.

17 *Sunday Times*, 10 September 2001.

18 Museums, Libraries and Archives Council, 'Consultation on the Work of the New Museums, Libraries and Archives Council', 2000 (typescript), p. 24.

19 *Guardian*, 19 January 2000.

20 Museums, Libraries and Archives Council (a.k.a. Re:source), *Renaissance in the Regions: A New Vision for England's Museums* (London: MLA, 2001), p. 33.

21 Adrian Babbidge, 'Commentary 2: The Only Game in Town', *Cultural Trends* 12: 47 (2002), p. 95.

22 Arts Council England, *Ambitions for the Arts 2003–2006* (London: ACE, 2003), p. 14.

23 Ibid., p. 5.

24 Ibid., p. 10.

25 Christopher Frayling, 'Slaying the Sixth Giant', p. 8.

26 Arts Council England, *Ambitions for the Arts*, p. 14.

27 *Stage*, 8 July 2004.

28 Arts Council England, '£30 Million Cut to the Arts', press release, 13 December 2004.

29 Tessa Jowell, 'Artists, We Believe in You', *Guardian*, 16 December 2004.

30 National Campaign for the Arts, 'The National Campaign for the Arts Looks at the Facts Behind the Spin', press release, 12 December 2004.

31 Christopher Frayling, *'The Only Trustworthy Book': The Arts and Public Value* (London: Arts Council, 2005), p. 16.

32 Ibid., p. 19.

33 Arts Council England, *Arts Council England: Report of the Peer Review* (London: ACE, 2005), p. v.

34 Ibid., p. vii.

35 Nicholas Kenyon, *Rattle: From Birmingham to Berlin* (London: Faber & Faber, 2001), p. 282.

36 Arts Council England, *Arts Council England: Report of the Peer Review* , p. 25.

37 DCMS, 'The Museums, Libraries and Archives Council: Report of the Prototype Peer Review', 2004 (typescript).

38 *Museums Journal*, August 2007, p. 4.

39 David Lammy, 'Cultural Democracy', speech, 29 March 2006, p. 3.

40 Peter Hewitt, 'Arts in the Core Script: Writing Ourselves In', Smith Institute Arts Lecture, 12 July 2006, p. 6.

41 *Sunday Times*, 15 October 2006.

42 Alan Davey, *Review of Arts Council England's Regularly Funded Organisations Investment Strategy 2007–08 – Lessons Learned* (London: Arts Council England, 2008), p. 20.

43 Ibid., p. 31.

44 Ibid.

45 Ibid., p. 20.

46 Ibid., p. 21.
47 Ibid., p. 23.
48 Ibid., p. 21.
49 *Museums Journal*, July 2008, p. 5.
50 Museums, Libraries and Archives Council (a.k.a. Re:source), *Renaissance in the Regions*, Appendix 12, p. 1.
51 Ibid., Part 7, p. 1.
52 Geraint Talfan Davies, *At Arm's Length: Recollections and Reflections on the Arts, Media and a Young Democracy* (Bridgend: Seren, 2008)
53 Ibid., p. 303.
54 Ed Vaizey, 'Speech by Minister for Culture, Communications and the Creative Industries', Local Government Association conference, 7 March 2013.

5 'To Hell with Targets'

1 James Purnell, 'Politics', *Prospect*, February 2011.
2 Liberal Democrat Research Unit, 'From the Sublime to the Ridiculous: A Critique of Government Target Setting', 2000 (typescript), p. 2.
3 *Times*, 23 July 2002.
4 Morris Hargreaves McIntyre, *Balancing the Scorecard: Review of DCMS Performance Indicator Framework*, Manchester, 2007, p. 15.
5 Michele Reeves, *Measuring the Economic and Social Impact of the Arts* (London: Arts Council, 2002), pp. 102–3.
6 Sara Selwood, 'The Politics of Data Collection: Gathering, Analysing and Using Data about the Subsidised Cultural Sector in England', *Cultural Trends* 12: 47 (2002), p. 15.
7 Ibid., p. 72.
8 John Tusa, *Art Matters: Reflecting on Culture* (London: Methuen, 1999), p. 103.
9 Gerry Robinson, 'The Creativity Imperative: Investing in the Arts in the 21st Century', New Statesman Arts Lecture 2000 (London: Arts Council England, 2000), p. 7.
10 Matthew Evans (Lord Evans of Temple Guiting), 'The Economy of the Imagination', New Statesman Arts Lecture, London, Re:source, 2001, p. 4.
11 The Arts Council scheme ran until 2011, by which time £22 million had been invested, and some 20,000 people had taken part.
12 Charles Saumarez Smith, 'Introductory Overview', Valuing Culture conference, 17 June 2003 (typescript).
13 Nicholas Hytner, 'To Hell with Targets', *Observer*, 12 January 2003.
14 Tessa Jowell, speech at Valuing Culture conference, 17 June 2003.
15 Estelle Morris, speech at Cheltenham Festival of Literature, 16 October 2003.
16 Chris Smith, 'Valuing Culture', speech at Valuing Culture conference, 17 June 2003.
17 Tessa Jowell, *Government and the Value of Culture: A Personal Essay* (London: DCMS, 2004), p. 18.
18 Ibid., p. 8.

19 Ibid., p. 6.
20 Ibid., p. 14.
21 Ibid., p. 16.
22 Ibid., p. 18.
23 DCMS, *Strategic Plan 2003–2006* (London: DCMS, 2003).
24 Gavin Kelly and Stephen Muers, *Creating Public Value: An Analytical Framework for Pubic Service Reform*, London Strategy Unit, Cabinet Office, 2002, p. 3.
25 BBC, *Building Public Value: Renewing the BBC for a digital World* (London: BBC, 2004), p. 29.
26 Robert Hewison and John Holden, *Challenge and Change: HLF and Cultural Value* (London: Demos/HLF, 2004).
27 Kate Clark and Gareth Maeer 'The Cultural Value of Heritage: Evidence from the Heritage Lottery Fund', *Cultural Trends* 17: 1 (2008).
28 John Holden, *Capturing Cultural Value: How Culture Has Become a Tool of Government Policy* (London: Demos, 2004); *Cultural Value and the Crisis of Legitimacy: Why Culture Needs a Democratic Mandate* (London: Demos, 2006); and *Democratic Culture: Opening Up the Arts to Everyone* (London: Demos, 2008).
29 D. J. Lee, K. Oakley and R. Naylor, '"The Public Gets What the Public Wants"? The Uses and Abuses of "Public Value" in Contemporary British Cultural Policy', *International Journal of Cultural Policy* 17: 3 (2011), p. 289.
30 Clark, Kate, *Capturing the Public Value of Heritage: The Proceedings of the London Conference, 25–26 January 2006* (Swindon: English Heritage, 2006).
31 English Heritage, *Conservation Principles, Policies and Guidance* (London: English Heritage, 2008 [2006]).
32 National Trust/Accenture, *Demonstrating the Public Value of Heritage* (London, National Trust, 2006).
33 M. Cowling, *Measuring Public Value: The Economic Theory* (London: Work Foundation, 2006); David Coats and Eleanor Passmore, *Public Value: The Next Steps in Public Service Reform* (London: Work Foundation, 2008).
34 DCMS, *The White Book: DCMS GUIDANCE on Appraisal and Evaluation of Projects, Programmes and Policies* (London: DCMS, 2004).
35 Treasury, *The Green Book: Appraisal and Evaluation in Central Government*, rev. edn (London: H.M. Treasury, 2011 [2003]), p. 101.
36 Ibid., p. 103.
37 Emily Keaney, *Public Value and the Arts: Literature Review* (London: Arts Council England, 2006), p. 25.
38 Catherine Bunting, *Public Value and the Arts in England: Discussion and Conclusions of the Arts Debate* (London: Arts Council England, 2007), p. 9.
39 Clive Gray, 'Arts Council England and Public Value: A Critical Review', *International Journal of Cultural Policy* 14: 2 (2008).
40 Bunting, *Public Value and the Arts*, p. 19.
41 Ibid., p. 28.
42 Keaney, *Public Value and the Arts*, pp. 15, 17.
43 James Purnell, 'World-Class from the Grassroots Up: Culture in the Next Ten Years', speech at National Portrait Gallery, 6 July 2007, p. 6.
44 Ibid., p. 7.
45 Ibid., p. 9.

46 Brian McMaster, *Supporting Excellence in the Arts: From Measurement to Judgement* (London: DCMS, 2008), p. 4.
47 Purnell, 'World-Class from the Grassroots Up', p. 10.
48 McMaster, *Supporting Excellence in the Arts*, p. 9.
49 Ibid., p. 10.
50 Ibid.
51 Ibid., p. 12.
52 Ibid., p. 21.
53 Ibid., p. 16.
54 Ibid., p. 17.
55 Ibid.
56 Tim Joss, 'New Flow: A Better Future for Artists, Citizens and the State' (London: Mission, Models, Money, 2008), pp. 62–3.
57 Cabinet Office, *Capability Review of the Department for Culture, Media and Sport* (London, 2007), p. 18.
58 Alan Davey, 'The Courage of Funders: Risk and Innovation in the Age of Artistic Excellence', lecture at Royal Society of Arts, 3 November 2008.
59 Arts Council England, 'Arts Council Organization Review Briefing Note', London, 2009 (typescript), p. 3.
60 *Stage*, 1 May 2008.
61 Davey, 'Courage of Funders'.
62 Arts Council England, *What People Want from the Arts* (London: ACE, 2008).
63 Arts Council England, 'The National Portfolio Funding Programme: Guidance for Applicants', London, 2010 (typescript), p. 2.
64 Arts Council England, *Achieving Great Art for Everyone: A Strategic Framework for the Arts* (London: ACE, 2010), p. 12.
65 Arts Council England, 'National Portfolio Funding Programme, pp. 9, 7.
66 Arts Council England, *Achieving Great Art for Everyone*, p. 6.

6 The Age of Lead

1 Dan Atkinson and Larry Elliott, *Fantasy Island: Waking Up to the Incredible Economic, Political and Social Illusions of the Blair Legacy* (London: Constable, 2007), p. 72.
2 Ibid., p. vii.
3 Don Thompson, *The $12 Million Stuffed Shark: The Curious Economics of Contemporary Art and Auction Houses* (London: Aurum, 2009), p. 63.
4 Charles Saatchi, 'Vileness of the Art World', *Guardian*, 3 December 2011.
5 Ibid.
6 Julian Stallabrass, *Art Incorporated* (Oxford: Oxford University Press, 2004), p. 72.
7 David Harvey, *The Enigma of Capital and the Crises of Capitalism* (London: Profile, 2010), p. 17.
8 *Art Newspaper*, July/August 2012.
9 Labour Party, 'Labour Party Launches "Creative Britain Manifesto"', press release, 1 May 2010.

10 Marc Sidwell, *The Arts Council: Managed to Death* (London: New Culture Forum/Social Affairs Unit, 2009), p. 40.

11 David Rawcliffe, *Arts Funding: A New Approach* (London: Adam Smith Institute, 2010), p. 5.

12 *Guardian*, 17 June 2009.

13 Conservative Central Office, 'The Future of the Arts with a Conservative Government' (London: CCO, 2010).

14 *Sun*, 2 January 2010.

15 Jeremy Hunt, 'Arts Keynote Speech', Roundhouse, 19 May 2010, DCMS.

16 Simon Thurley, *The Men from the Ministry: How Britain Saved its Heritage* (London: Yale University Press, 2013), p. 4.

17 By July 2013 the total number of ACE staff was stabilized at 442. The cost of this latest restructuring was put at £9.8 million.

18 Nicholas Serota, 'A Blitzkrieg on the Arts', *Guardian*, 5 October 2010.

19 National Audit Office, *DCMS: Financial Management* (London: HMSO, 2011), p. 8.

20 National Council of Voluntary Organizations, *Counting the Cuts* (London: NCVO, 2013), p. 20.

21 Javier Stanziola, 'Good on Paper, Bad in Practice', *Arts Professional* 243 (10 October 2011).

22 *Stage*, 22 November 2012.

23 Maria Miller, 'Testing Times: Fighting Culture's Corner in an Age of Austerity', typescript of speech at British Museum, 24 April 2013.

24 *Daily Mail*, 31 May 2013.

25 *Evening Standard*, 2 July 2013.

26 *Guardian*, 21 June 2013.

27 Annette Hastings, Nick Bailey, Kirstin Besemer, Glen Bramley, Maria Gannnon and David Watkins, *Coping with the Cuts? Local Government and Poorer Communities* (London: Joseph Rowntree Foundation, 2013).

7 Olympic Rings

1 *Observer*, 14 July 2013.

2 Tessa Jowell, Speech on Olympic Bid in House of Commons, 15 May 2003, DCMS Press Release 53/2003.

3 Anna Minton, *Ground Control: Fear and Happiness in the Twenty-First Century City*, rev. edn (London: Penguin, 2012 [2009]), p. xii.

4 Emma Norris, Jill Rutter, and Johnny Medland, *Making the Games: What Government Can Learn from London 2012* (London: Institute of Government, 2013), p. 46.

5 Ibid., p. 69.

6 Christopher Frayling, 'Slaying the Sixth Giant: On Being Chair of Arts Council England', lecture, 29 January 2009, p. 31.

7 Alan Davey, 'The Courage of Funders: Risk and Innovation in the Age of Artistic Excellence', lecture at Royal Society of Arts, 3 November 2008.

8 *Evening Standard*, 30 July 2012.
9 *Guardian*, 24 November 2006.
10 *Guardian*, 28 December 2012.
11 Iain Sinclair, *Ghost Milk: Calling Time on the Grand Project* (London: Hamish Hamilton, 2011), p. 167.
12 Ibid., p. 144.
13 Arts Council England and LOCOG, *Reflections on the Cultural Olympiad and London 2012 Festival* (London: ACE, 2013), p. 27.
14 Ibid., p. 28.
15 *Guardian*, 25 March 2009.
16 Ibid.
17 *Stage*, 23 July 2009.
18 Michael Coveney and Marc Sands, *Independent Evaluations of London 2012 Festival* (London: London 2012 Festival, 2013), p. 12.
19 Ibid., p. 22.
20 Arts Council England/LOCOG, *Reflections on the Cultural Olympiad*, p. 2.
21 LOCOG, *Isles of Wonder: London 2012 Olympic Games Opening Ceremony*, official programme, 2012, p. 26.
22 BBC, *London 2012 Olympic Games*, BBCDVD3745A&B, 2012.
23 The references to war were underplayed in the live transmission of the ceremony, and are more emphasized in the director's cut.
24 *International Herald Tribune*, 19 August 2013.
25 *Daily Mail*, 28 July 2013. The piece drew so much criticism that it was taken down.
26 Richard Seymour, 'Puke Britannia', *Lenin's Tomb* (blog), 29 July 2013, at leninology.com.
27 Dave Zirin, 'Danny Boyle's Olympic Minstrel Show,' *Nation* (blog), 20 July 2012, at thenation.com.
28 *Independent*, 7 August 2012.
29 In Irene Morra, *Britishness, Popular Music, and National Identity: The Making of Modern Britain* (London: Routledge, 2013), p. 27.
30 Ibid., p. 24.
31 Ibid.
32 LOCOG, *Isle of Wonder*, p. 11.

8 Just the Few, Not the Many

1 Aleks Sierz, *In-Yer-Face Theatre: British Drama Today* (London: Faber & Faber, 2001), p. 238.
2 Ibid., p. 248.
3 DCMS, *A New Cultural Framework* (London: DCMS, 1998).
4 Peter Boyden, 'Roles and Functions of the English Regional Producing Theatres' (Bristol: Peter Boyden Associates, 2000), p. 3.
5 Ibid., p. 19.
6 Ibid., p. 17.
7 Ibid., p. 44.

8 Arts Council England, 'The Next Stage: Towards a National Policy for Theatre in England', London, 2000 (typescript), p. 2.

9 Robert Hewison, John Holden and Samuel Jones, *A Creative Approach to Organisational Change* (London: Demos, 2010).

10 Arts Council England, *Theatre Assessment 2009* (London: ACE, 2009), p. 47.

11 Ibid., p. 59.

12 Olivia Turnbull, *Bringing Down the House: The Crisis in Britain's Regional Theatres* (Bristol: Intellect, 2008), pp. 209–10.

13 Arts Council England, *Theatre Assessment 2009*, p. 43.

14 Ibid., p. 60.

15 Arts Council England, *Public Attitudes to the Arts* (London: ACE, 2000).

16 Arts Council England, *Arts in England: Attendance, Participation and Attitudes in 2001* (London: ACE, 2002).

17 Arts Council England, *Arts in England 2003: Attendance, Participation and Attitudes* (London: ACE, 2005).

18 The highest sample in the period up to March 2013 was 29,420, the smallest 9,304.

19 Raymond Williams, *Culture and Society 1780–1950* (London: Penguin, 1962 [1958]).

20 DCMS, *Taking Part 2012/13 Quarter 4: Statistical Release* (London: DCMS, 2013).

21 Arts Council England, *Achieving Great Art for Everyone: A Strategic Framework for the Arts* (London: ACE, 2010), p. 15.

22 Ibid., p. 17.

23 Catherine Bunting, Tak Wing Chang, John Goldthorpe, Emily Kearney and Anni Oskala, *From Indifference to Enthusiasm: Patterns of Arts Attendance in England* (London: Arts Council England, 2008).

24 Ibid., p. 63.

25 Pierre Bourdieu, *Distinction: A Social Critique of the Judgement of Taste* (Cambridge, MA: Harvard University Press, 1984 [French edn, 1979]).

26 Bunting et al., *From Indifference to Enthusiasm*, p. 62.

27 Ibid., p. 63.

28 Tak Wing Chan and John Goldthorpe, 'Is There a Status Order in Contemporary British Society? Evidence from the Occupational Structure of Friendship', *European Sociological Review* 20: 5 (2004), pp. 383–401; 'The Social Stratification of Theatre, Dance and Cinema Attendance', *Cultural Trends* 14: 3 (2005); 'Social Stratification and Cultural Consumption: The Visual Arts in England', *Poetics* 35 (2007), pp. 168–90.

29 T. Bennett, M. Savage, E. Sila, M. Gayo-Cal and D. Wright, *Culture, Class, Distinction* (London: Routledge, 2009), p. 252.

30 Ibid., p. 52.

31 Ibid., p. 212.

32 Ibid., p. 252.

33 Ibid,. p. 253.

34 Ibid., p. 190.

35 Bunting et al., *From Indifference to Enthusiasm*, p. 64.

36 Terry Eagleton, *The Idea of Culture* (Oxford: Blackwell, 2000), p. 125.

37 Bunting et al., *From Indifference to Enthusiasm*, p. 67.

38 Ibid., p. 13.

39 Andrew Miles and Alice Sullivan, 'Understanding Participation in Culture and Sport: Mixing Methods, Reordering Knowledges', *Cultural Trends* 21: 4 (2012), p. 318.
40 Bennett et al., *Culture, Class, Distinction*, p. 259.

Conclusion: What Next?

1 John Holden, *Democratic Culture: Opening Up the Arts to Everyone* (London: Demos, 2008), p. 11.
2 Hasan Bakhshi, Ian Hargreaves and Juan Mateos-Garcia, *A Manifesto for the Creative Economy* (London: NESTA, 2013), p. 37.
3 François Matarasso, *Where We Dream: West Bromwich Operatic Society and the Fine Art of Musical Theatre* (West Bromwich: Multistory, 2012), p. 76.
4 Kate Oakley, 'In Its Own Image: New Labour and the Cultural Workforce', *Cultural Trends* 20: 3/4 (2011).
5 MTM London, *Digital Audiences: Engagement with Arts and Culture Online* (London: MTM, 2010), p. 37.
6 Charles Leadbeater, *The Art of With: An Original Essay for Cornerhouse, Manchester*, published under Creative Commons licence, 2009, p. 5. Available at charlesleadbeater.net.
7 Julian Stallabrass, *Art Incorporated* (Oxford: Oxford University Press, 2004), p. 196.
8 Antony Gormley, *One and Other* (London: Jonathan Cape, 2010).
9 David Throsby, *Economics and Culture* (Cambridge: Cambridge University Press, 2001), p. 13.
10 Samuel Jones, *Culture Shock* (London: Demos, 2010), p. 42.
11 Peter Stark, Christopher Gordon and David Powell, *Rebalancing Our Cultural Capital*, privately printed, 2013, pp. 13–14.
12 Lord Redcliffe-Maud, *Support for the Arts in England and Wales* (London: Calouste Gulbenkian Foundation, 1976).

Bibliography

6, Perri, 'Governing by Cultures', in Geoff Mulgan, ed., *Life After Politics: New Thinking for the Twenty-First Century* (London: Fontana, 1997).

Adorno, Theodor, ed. J. Bernstein, *The Culture Industry: Selected Essays on Mass Culture* (London: Routledge, 1991).

Allen, Mary, *A House Divided: The Diary of a Chief Executive of the Royal Opera House* (London: Simon & Schuster, 1998).

Appignanesi, Richard, ed., *Beyond Cultural Diversity: The Case for Creativity* (London: Third Text/ACE, 2010).

Araeen, Rasheed, *Making Myself Visible* (London: Kala Press, 1984).

Arnold, Matthew, ed. J. Dover Wilson, *Culture and Anarchy* (Cambridge: Cambridge University Press, 1961 [1869]).

Arts Council England, '"The Landscape of Fact": Towards a Policy for Cultural Diversity for the English Funding System', Consultative Green Paper, London, 1997.

——*Public Attitudes to the Arts* (London: ACE, 2000).

——'The Next Stage: Towards a National Policy for Theatre in England', London, 2000 (typescript).

——*Public Attitudes to the Arts* (London: ACE, 2000).

——*The New Arts Council of England: A Prospectus for the Arts* (London: ACE, 2001).

——*Working Together For the Arts* (London: ACE, 2001).

——*Arts in England: Attendance, Participation and Attitudes in 2001* (London: ACE, 2002).

——*Ambitions for the Arts 2003–2006* (London: ACE, 2003).

——*Ambitions into Action* (London: ACE, 2004).

——'£30 Million Cut to the Arts', press release, 13 December 2004.

——*Arts Council England: Report of the Peer Review* (London: ACE, 2005).

——*Arts in England 2003: Attendance, Participation and Attitudes* (London: ACE, 2005).

——*Navigating Difference: Cultural Diversity and Audience Development* (London: ACE, 2006).

——*Annual Review 2007* (London: ACE, 2007).

——*What People Want from the Arts* (London: ACE, 2008).

——*Great Art for Everyone 2008–2011* (London: ACE, 2008).

——'Arts Council Organization Review Briefing Note' (London, 2009 – typescript).

——*Theatre Assessment 2009* (London: ACE, 2009).

——*Annual Review 2009* (London: ACE, 2009).

——*Achieving Great Art for Everyone: A Strategic Framework for the Arts* (London: ACE, 2010).

——'The National Portfolio Funding Programme: Guidance for Applicants', London, 2010 (typescript).

——*What Is the Creative Case for Diversity?* (London: ACE, 2011).

Arts Council England and LOCOG, *Reflections on the Cultural Olympiad and London 2012 Festival* (London: ACE, 2013).

Arts and Humanities Research Council, *Cultural Value Project: Open Funding Call* (Swindon: AHRC, 2013).

Atkinson, Dan, and Larry Elliott, *Fantasy Island: Waking Up to the Incredible Economic, Political and Social Illusions of the Blair Legacy* (London: Constable, 2007).

Babbidge, Adrian, 'Commentary 2: The Only Game in Town', *Cultural Trends* 12: 47 (2002), pp. 91–7.

Bakhshi, Hasan, Ian Hargreaves, and Juan Mateos-Garcia, *A Manifesto for the Creative Economy* (London: NESTA, 2013).

Barker, Tony, with Iain Byrne and Anjuli Veall, *Ruling By Task Force* (London: Politico's, 1999).

Bayley, Stephen, *Labour Camp: The Failure of Style over Substance* (London: B.T. Batsford, 1998).

Bennett, T., M. Savage, E. Sila, M. Gayo-Cal and D. Wright, *Culture, Class, Distinction* (London: Routledge, 2009).

Better Regulation Task Force, *Local Delivery of Central Policy* (London: Cabinet Office, 2002).

Bevir, Mark, *New Labour: A Critique* (London: Routledge, 2005).

Bewes, Timothy, and Jeremy Gilbert, eds, *Cultural Capitalism: Politics after New Labour* (London: Lawrence & Wishart, 2000).

Blackstock, Anthony, *The Public: Lessons Learned by Arts Council England* (London: Arts Council, 2011).

Blair, Tony, *New Britain: My Vision of a Young Country* (London: Fourth Estate, 1996).

——*Socialism* (London, Fabian Society, 1998, pamphlet 565).

——*The Third Way: New Politics for a New Century* (London, Fabian Society, 1998, pamphlet 588).

——'Why the Dome is Good for Britain', speech at the People's Palace Restaurant, Royal Festival Hall, 24 February 1998.

——'Arts and the Creative Industries', press notice text of speech at Tate Modern, 6 March 2007.

——*A Journey* (London: Arrow, 2011 [2010]), with a new introduction.

Bourdieu, Pierre, *Distinction: A Social Critique of the Judgement of Taste*, transl. Richard Nice (London: Routledge, 1984 [1979]).

Boyden, Peter, 'Roles and Functions of the English Regional Producing Theatres' (Bristol: Peter Boyden Associates, 2000).

Bradwell, Mike, *The Reluctant Escapologist* (London: Nick Hern, 2010).

BBC, *Building Public Value: Renewing the BBC for a digital World* (London: BBC, 2004).

——*London 2012 Olympic Games*, BBCDVD3745A&B, 2012.

Bunting, Catherine, *Public Value and the Arts in England: Discussion and Conclusions of the Arts Debate* (London: Arts Council England, 2007).

Bunting, Catherine, Tak Wing Chang, John Goldthorpe, Emily Kearney and Anni Oskala, *From Indifference to Enthusiasm: Patterns of Arts Attendance in England* (London: Arts Council England, 2008).

Cabinet Office, 'Pale Yellow Amoeba: A Peer Review of the Department for Culture, Media and Sport', 2000 (internal document).

——*Capability Review of the Department for Culture, Media and Sport* (London, 2007).

CASE, *Understanding the Drivers, Impact and Value of Engagement in Culture and Sport: An Over-Arching Summary of the Research* (London: DCMS/ACE/English Heritage/MLA/Sport England, 2010).

——*Understanding the Impact of Engagement in Culture and Sport: A Systematic Review of the Learning Impacts for Young People* (London: DCMS/ACE/English Heritage/MLA/Sport England, 2010).

Chan, Tak Wing, and John Goldthorpe, 'Is There a Status Order in Contemporary British Society? Evidence from the Occupational Structure of Friendship', *European Sociological Review* 20: 5 (2004), pp. 383–401.

——'The Social Stratification of Theatre, Dance and Cinema Attendance', *Cultural Trends* 14: 3 (2005), pp. 193–212.

——'Social Stratification and Cultural Consumption: The Visual Arts in England', *Poetics* 35 (2007), pp. 168–90.

Clark, Kate, *Capturing the Public Value of Heritage: The Proceedings of the London Conference, 25–26 January 2006* (Swindon: English Heritage, 2006).

Clark, Kate, and Gareth Maeer 'The Cultural Value of Heritage: Evidence from the Heritage Lottery Fund', *Cultural Trends* 17: 1 (2008), pp. 23–54.

Clarke, John, and Janet Newman, *The Managerial State: Power, Politics and Ideology in the Remaking of Social Welfare* (London: Sage, 1997).

Coats, David, and Eleanor Passmore, *Public Value: The Next Steps in Public Service Reform* (London: Work Foundation, 2008).

Cole, Martin, and Greg Parston, *Unlocking Public Value: A New Model for Unlocking High Performance in Public Service Organisations* (New Jersey: John Wiley, 2006).

Commonwealth of Australia, *Creative Nation* (Canberra: Department of Communications and the Arts, 1994).

Conservative Central Office, *The Best Future for Britain* (London: CCO, 1992).

——'The Future of the Arts with a Conservative Government' (London: CCO, 2010).

Cooper, Adam, 'The Drivers, Impact and Value of CASE: A Short History from the Inside', *Cultural Trends* 21: 4 (2012), pp. 281–9.

Coveney, Michael, and Marc Sands, *Independent Evaluations of London 2012 Festival* (London: London 2012 Festival, 2013).

Cowling, J., ed., *For Art's Sake: Society and the Arts in the 21st Century* (London: IPPR, 2004).

Cowling, M., *Measuring Public Value: The Economic Theory* (London: Work Foundation, 2006).

Coyle, Diane, and Christopher Wollard, *Public Value in Practice: Restoring the ethos of public service* (London: BBC, 2010).

CLC, *Get It: The Power of Cultural Learning* (London: Culture and Learning Consortium, 2009).

Cunningham, Jack, and Mark Fisher, *Create the Future: A Strategy for Cultural Policy, Arts and the Creative Economy* (London: Labour Party, 1997).

Davey, Alan, *Review of Arts Council England's Regularly Funded Organisations Investment Strategy 2007–08 – Lessons Learned* (London: Arts Council England, 2008).

——'The Courage of Funders: Risk and Innovation in the Age of Artistic Excellence', lecture at Royal Society of Arts, 3 November 2008.

Davies, Geraint Talfan, *At Arm's Length: Recollections and Reflections on the Arts, Media and a Young Democracy* (Bridgend: Seren, 2008).

Dawkins, Julia, *Spirit of the Dome* (Bexleyheath: Faygate, 2002).

DCMS, *A New Cultural Framework* (London: DCMS, 1998).

——QUEST press release 277/99, 11 November 1999.

——*Arts & Sport: Policy Action Team 10, a Report to the Social Exclusion Unit* (London: DCMS, 1999).

——*Centres for Social Change: Museums, Galleries and Archives for All: Policy Guidance on Social Inclusion for DCMS Funded and Local Authority Museums, Galleries and Archives in England* (London: DCMS, 2000).

——*Culture and Creativity: The Next Ten Years* (London: DCMS, 2001).

——*The Historic Environment: A Force for Our Future* (London: DCMS, 2001).

——*Annual Report and Review* (London: DCMS, 2002).

——*People and Places: Social Inclusion Policy for the Built and Historic Environment* (London: DCMS, 2002).

——*Strategic Plan 2003–2006* (London: DCMS, 2003).

——'Funding Agreement between Arts Council England and the Department for Culture, Media and Sport, April 2003–March 2006', 2003 (unpaginated typescript).

——'The Museums, Libraries and Archives Council: Report of the Prototype Peer Review', 2004 (typescript).

——*The White Book: DCMS GUIDANCE on Appraisal and Evaluation of Projects, Programmes and Policies* (London: DCMS, 2004).

——*Annual Report and Review 2006* (London: DCMS, 2006).

——*Annual Report and Review 2009* (London: DCMS, 2009).

——*Taking Part 2012/13 Quarter 4: Statistical Release* (London: DCMS, 2013).

DCMS/BERR/DIUS, *Creative Britain: New Talents for the New Economy* (London: DCMS/BERR/DIUS, 2008).

Department of National Heritage, 'Cool Britannia Rules the Way as 1996 Sees Record Earnings from Overseas Visitors to the UK', press release 69/97, 5 March 1997.

Eagleton, Terry, *The Idea of Culture* (Oxford: Blackwell, 2000).

Ellis, Adrian, 'Valuing Culture: A Background Note', AEA Consulting, 2003.

English Heritage, *Peer Review of English Heritage: Summary of Findings and Recommendations* (London: English Heritage, 2006).

——*Conservation Principles, Policies and Guidance* (London: English Heritage, 2008).

Evans, Matthew (Lord Evans of Temple Guiting), 'The Economy of the Imagination', New Statesman Arts Lecture, London, Re:source, 2001.

Eyre, Richard, *Report on the Future of Lyric Theatre in London* (London: HMSO, 1998).

Fairclough, Norman, *New Labour, New Language?* (London: Routledge, 2000).

Finlayson, Alan, 'New Labour: The Culture of Government and the Government of Culture', in Timothy Bewes and Jeremy Gilbert, eds, *Cultural Capitalism: Politics after New Labour* (London: Lawrence & Wishart, 2000).

——*Making Sense of New Labour* (London: Lawrence & Wishart, 2003).

Florida, R., *The Rise of the Creative Class* (New York: Basic Books, 2002).

Fraquelli, Simonetta, and Norman Rosenthal, *Sensation: Young British Artists from the Saatchi Collection* (London: Royal Academy of Arts/ Thames & Hudson, 1997).

Frayling, Christopher, *'The Only Trustworthy Book': The Arts and Public Value* (London: Arts Council, 2005).

——'Slaying the Sixth Giant: On Being Chair of Arts Council England', lecture, 29 January 2009.

Garcia, Beatriz, *London 2012 Cultural Olympiad Evaluation: Final Report*, (Liverpool: Liverpool and John Moores Universities, 2013).

Garnham, Nicholas, *Capitalism and Communication* (London: Sage, 1990).

——'Afterword: The Cultural Commodity and Cultural Policy', in Sara Selwood, ed., *The UK Cultural Sector: Profile and Policy Issues* (London: Policy Studies Institute, 2001).

Gates, Bill, 'A New Approach to Capitalism in the 21st Century', transcript of speech at World Economic Forum, Davos, 24 January 2008.

Gibbons, Fiachra, 'Mandelson "Made Dome Second Rate"', *Guardian*, 13 January 2000.

Giddens, Anthony, *Beyond Left and Right: The Future of Radical Politics* (Cambridge: Polity Press, 1994).

Gilroy, Paul, *There Ain't No Black in the Union Jack: The Cultural Politics of Race and Nation* (London: Hutchinson Education, 1987).

——*After Empire: Melancholia or Convivial Culture* (Abingdon: Routledge, 2004).

Gormley, Antony, *One and Other* (London: Jonathan Cape, 2010).

Gray, Clive, *The Politics of the Arts in Britain* (London: Macmillan, 2000).

——'Arts Council England and Public Value: A Critical Review', *International Journal of Cultural Policy* 14: 2 (2008), pp. 209–14.

Greater London Authority, *Cultural Metropolis: The Mayor's Cultural Strategy – 2012 and Beyond* (London: GLA, 2010).

Hall, Stuart, 'New Labour's Double Shuffle', *Soundings* 24 (Autumn 2003), pp. 10–24.

——'The Neo-Liberal Revolution', *Soundings* 48 (Summer 2011), pp. 9–28.

Hartley, John, ed., *Creative Industries* (Oxford: Blackwell, 2005).

Harvey, David, *A Brief History of Neoliberalism* (Oxford: Oxford University Press, 2007 [2005]).

——*The Enigma of Capital and the Crises of Capitalism* (London: Profile, 2010).

Hastings, Annette, Nick Bailey, Kirstin Besemer, Glen Bramley, Maria Gannnon and David Watkins, *Coping with the Cuts? Local Government and Poorer Communities* (London: Joseph Rowntree Foundation, 2013).

Hatherley, Owen, *A Guide to the New Ruins of Great Britain* (London: Verso, 2010).

——*A New Kind of Bleak: Journeys through Urban Britain* (London: Verso, 2012).

Hay, Colin, *The Political Economy of New Labour: Labouring under False Pretences?* (Manchester: Manchester University Press, 1999).

——*Why We Hate Politics* (Cambridge: Polity Press, 2007).

Hesmondhalgh, David, *The Cultural Industries*, 2nd edn (London: Sage, 2007 [2002]).

Haydon, Andrew, 'British Theatre in the 00s', in Dan Rebellato, ed., *Modern British Playwriting: 2000–20009* (London: Bloomsbury, 2013).

Hetherington, Stephen, 'Culture as Economics in the Rational State: The Role of Cultural Policy in Late 20th Century British Governance', paper for the Midwest Political Science Association National Conference, Chicago April 2010.

Hewison, Robert, *Culture and Consensus: England, Art and Politics since 1940* rev. edn. (London: Methuen, 1997 [1995]).

——*Not A Sideshow: Leadership and Cultural Value* (London: Demos, 2006).

Hewison, Robert, and John Holden, *Challenge and Change: HLF and Cultural Value* (London: Demos/HLF, 2004).

Hewison, Robert, John Holden and Samuel Jones, *All Together: A Creative Approach to Organisational Change* (London: Demos, 2010).

Hewitt, Peter, *Beyond Boundaries: The Arts after the Events of 2001* (London: Arts Council England, 2002).

——*Changing Places: Reflections of an Arts Council Chief Executive* (London: Arts Council England, 2005).

——'Arts in the Core Script: Writing Ourselves In', Smith Institute Arts Lecture, 12 July 2006.

Holden, John, *Capturing Cultural Value: How Culture Has Become a Tool of Government Policy* (London: Demos, 2004).

——*Cultural Value and the Crisis of Legitimacy: Why Culture Needs a Democratic Mandate* (London: Demos, 2006).

——*Democratic Culture: Opening Up the Arts to Everyone* (London: Demos, 2008).

House of Commons, *The Royal Opera House*, Report of the Culture, Media and Sport Select Committee, 1997.

——*Protecting and Preserving Our Heritage*, Report of the Culture, Media and Sport Select Committee, 2006.

Hunt, Jeremy, 'Arts Keynote Speech', Roundhouse, 19 May 2010, DCMS.

Hutchison, Robert, *The Politics of the Arts Council* (London: Sinclair Browne, 1982).

Hylton, Richard, *The Nature of the Beast: Cultural Diversity and the Visual Arts* (Bath: Institute of Contemporary Interdisciplinary Arts, 2007).

Hytner, Nicholas, 'To Hell with Targets', *Observer*, 12 January 2003.

Jenkins, Simon, *Thatcher and Sons* (London: Allen Lane, 2006).

Johnson, G., P. Pfrommer, S. Stewart, P. Glinkowski, C. Fenn, A. Skelton, and A. Jay, *New Audiences for the Arts: The New Audiences Programme 1998–2003* (London: Arts Council England, 2004).

Jones, Rhian E., *Clampdown: Pop-Cultural Wars on Class and Gender* (Winchester: Zero Books, 2013).

Jones, Samuel, *Culture Shock* (London: Demos, 2010).

Joss, Tim, 'New Flow: A Better Future for Artists, Citizens and the State' (London: Mission, Models, Money, 2008).

Jowell, Tessa, speech at Valuing Culture conference, 17 June 2003.

——Speech on Olympic Bid in House of Commons, 15 May 2003, DCMS Press Release 53/2003.

——*Government and the Value of Culture: A Personal Essay* (London: DCMS, 2004).

——'Artists, We Believe in You', *Guardian*, 16 December 2004.

Judt, Tony, *Reappraisals: Reflections on the Forgotten Twentieth Century* (London: Vintage, 2009 [2008]).

——*Ill Fares The Land* (London: Allen Lane, 2010).

Kay, William, *Lord of the Dance: The Story of Gerry Robinson* (London: Orion Business Books, 1999).

Keaney, Emily, *Public Value and the Arts: Literature Review* (London: Arts Council England, 2006).

Kelly, Gavin, and Stephen Muers, *Creating Public Value: An Analytical Framework for Pubic Service Reform*, London Strategy Unit, Cabinet Office, 2002.

Kenyon, Nicholas, *Rattle: From Birmingham to Berlin* (London: Faber & Faber, 2001).

Khan, Naseem, *The Arts Britain Ignores: The Arts of Ethnic Minorities in Britain* (London: ACGB, Gulbenkian Foundation, Community Relations Commission, 1976).

——*Towards a Greater Diversity: Results and Legacy of the Arts Council of England's Cultural Diversity Action Plan* (London: Arts Council England, 2002).

Labour Party, 'Labour Party Launches "Creative Britain Manifesto", press release, 1 May 2010.

——*Creative Britain: Labour's Cultural Manifesto* (London: Labour Party, 2010).

Lammy, David, 'Cultural Democracy', speech, 29 March 2006.

Leadbeater, Charles, *Living On Thin Air: The New Economy* (London: Penguin, 2000 [1999]).

——*Arts Organizations in the Twenty-First Century: Ten Challenges* (London: Arts Council, 2005).

——*The Art of With: An Original Essay for Cornerhouse, Manchester*, published under Creative Commons licence, 2009. Available at charles-leadbeater.net.

Leonard, Mark, *BritainTM: Renewing Our Identity* (London: Demos, 1997).

Lee, D. J., K. Oakley and R. Naylor, '"The Public Gets What the Public Wants"? The Uses and Abuses of "Public Value" in Contemporary British Cultural Policy', *International Journal of Cultural Policy* 17: 3 (2011), pp. 289–300.

Levitas, Ruth, *The Inclusive Society? Social Exclusion and New Labour*, 2nd edn (London: Palgrave Macmillan, 2005 [1998]).

Liberal Democrat Research Unit, 'From the Sublime to the Ridiculous: A Critique of Government Target Setting', 2000 (typescript).

London Organizing Committee Olympic Games, *Unlimited: A London 2012 Festival Book* (London: LOCOG, 2012).

——*Isles of Wonder: London 2012 Olympic Games Opening Ceremony*, official programme, 2012.

Long, J., M. Welch, P. Bramham, J. Butterfield, K. Hylton and E. Lloyd, *Count Me In: The Dimensions of Social Inclusion through Culture, Media and Sport* (London: DCMS, 2002).

McDonald, Rónán, *The Death of the Critic* (London: Continuum, 2007).

McGuigan, Jim, *Rethinking Cultural Policy* (Maidenhead: Open University Press, 2004).

——*Cool Capitalism* (London: Pluto, 2009).

——*Cultural Analysis* (London: Sage, 2010).

McIntosh, Genista, 'The Body Politic', *Stage*, 3 February 2005, p. 24.

——*Review of Arts Council England Investment Process, 2010/11* (London: Arts Council England, 2011).

McMaster, Brian, *Supporting Excellence in the Arts: From Measurement to Judgement* (London: DCMS, 2008).

MTM London, *Digital Audiences: Engagement with Arts and Culture Online* (London: MTM, 2010).

Mandelson, Peter, *The Third Man: Life at the Heart of New Labour* (London: HarperCollins, 2010).

Marquand, David, 'The Blair Paradox', *Prospect* 30 (May 1998), pp. 19–24.

——*Decline of the Public: The Hollowing-Out of Citizenship* (London: Polity, 2004).

Matarasso, François, *Use or Ornament? The Social Impact of Participation in the Arts* (Stroud: Comedia, 1997).

——'Out of the Labyrinth: A Democratic Justification for the Value of Art Outreach Programmes', talk for Pro Helvetia in Basel, Switzerland, 7 November 2012. Available at parliamentofdreams.com.

——*Where We Dream: West Bromwich Operatic Society and the Fine Art of Musical Theatre* (West Bromwich: Multistory, 2012).

Mattinson, Deborah, *Talking to a Brick Wall* (London: Biteback, 2010).

Merli, Paola, 'Evaluating the Social Impact of Participation in Arts Activities', *International Journal of Cultural Policy* 8: 1 (2002), pp. 107–18.

Miles, Andrew, and Alice Sullivan, 'Understanding Participation in Culture and Sport: Mixing Methods, Reordering Knowledges', *Cultural Trends* 21: 4 (2012), pp. 311–24.

Miller, Maria, 'Testing Times: Fighting Culture's Corner in an Age of Austerity', typescript of speech at British Museum, 24 April 2013.

Minton, Anna, *Ground Control: Fear and Happiness in the Twenty-First Century City*, rev. edn (London: Penguin, 2012 [2009]).

Mirza, Munira, ed., *Culture Vultures: Is UK Arts Policy Damaging the Arts?* (London: Policy Exchange, 2006).

——*The Politics of Culture: The Case for Universalism* (Basingstoke: Palgrave Macmillan, 2012).

Morgan, Charles, 'Reorganising the Arts Funding System Trying to Be Businesslike – Without Really Succeeding', House of Commons Culture, Media and Sport Select Committee, Third Report, 2001–02, 'Arts Development', Appendix 1, 2002.

Moore, Mark H., *Creating Public Value: Strategic Value in Government* (Cambridge, MA: Harvard University Press, 1995).

Morra, Irene, *Britishness, Popular Music, and National Identity: The Making of Modern Britain* (London: Routledge, 2013).

Morris, Estelle, speech at Cheltenham Festival of Literature, 16 October 2003.

Morris Hargreaves McIntyre, *Balancing the Scorecard: Review of DCMS Performance Indicator Framework*, Manchester, 2007.

Moulier-Boutang, Yann, *Cognitive Capitalism*, transl. Nigel Thrift (Cambridge: Polity Press, 2011 [2007]).

Mulgan, Geoff, 'Culture: The Problem With Being Public', in D. Marquand and A. Seldon, eds, *The Ideas that Shaped Post-War Britain* (London: Futura, 1996).

Mulgan, Geoff, and Ken Worpole, *Saturday Night or Sunday Morning? From Arts to Industry – New Forms of Cultural Policy* (London: Comedia, 1986).

Museums, Libraries and Archives Council, 'Consultation on the Work of the New Museums, Libraries and Archives Council', 2000 (typescript).

Museums, Libraries and Archives Council (a.k.a. Re:source), *Renaissance in the Regions: A New Vision for England's Museums* (London: MLA, 2001).

Museums, Libraries and Archives Council, *Report of the Prototype Peer Review* (London: MLA, 2004).

——*Renaissance in the Regions: Realising the Vision, Renaissance in the Regions 2001–2008*, review of the Renaissance Review Advisory Group (London: MLA, 2009).

Myerscough, John, *The Economic Importance of the Arts in Britain* (London: Policy Studies Institute, 1988).

National Audit Office, *The Millennium Dome* (London: HMSO, 2000).

——*Progress on 15 major Capital Projects Funded by Arts Council England* (London: HMSO, 2003).

——*DCMS: Financial Management* (London: HMSO, 2011).

National Campaign for the Arts, 'The National Campaign for the Arts Looks at the Facts Behind the Spin', press release, 12 December 2004.

National Council of Voluntary Organizations, *Counting the Cuts* (London: NCVO, 2013).

National Trust and Accenture, *Demonstrating the Public Value of Heritage* (London: Natioinal Trust/Accenture, 2011).

Newbigin, John, 'A Golden Age for the Arts?', *Cultural Trends* 20: 3/4 (2011), pp. 231–4.

Nicolson, Adam, *Regeneration: The Story of the Dome* (London: HarperCollins, 1999).

Norris, Emma, Jill Rutter, and Johnny Medland, *Making the Games: What Government Can Learn from London 2012* (London: Institute of Government, 2013).

Oakley, Kate, 'The Disappearing Art: Creativity and Innovation after the

Creative Industries', *International Journal of Cultural Policy* 15: 4 (2009), pp. 403–13.

——'In Its Own Image: New Labour and the Cultural Workforce', *Cultural Trends* 20: 3/4 (2011), pp. 281–9.

Oakley, Kate, David Hesmondhalgh, David Lee and Melissa Nisbett, 'The National Trust for Talent? NESTA and New Labour's Cultural Policy', *British Politics* 2014 (forthcoming).

O'Brien, Dave, *Cultural Policy: Management, Value and Modernity in the Creative Industries* (London: Taylor & Francis, 2013).

OFSTED, *Creative Partnerships: Initiative and Impact* (London: OFSTED, 2006).

——*Learning: Creative Approaches that Raise Standards* (London: OFSTED, 2010).

Owusu, K., ed., *Black British Culture and Society: A Text Reader* (London: Routledge, 2000).

Page, Jennie, 'The Millennium Dome', typescript of lecture at Royal Society of Arts, 3 May 2000.

Power, Michael, *The Audit Society: Rituals of Verification* (Oxford: Oxford University Press, 1999 [1997]).

Purnell, James, 'World-Class from the Grassroots Up: Culture in the Next Ten Years', speech at National Portrait Gallery, 6 July 2007.

——'Politics', *Prospect*, February 2011, p. 10.

QUEST, *Modernizing the Relationship Part One: A New Approach to Funding Agreements* (London: DCMS, 2000).

Rawcliffe, David, *Arts Funding: A New Approach* (London: Adam Smith Institute, 2010).

Rawnsley, Andrew, *Servants of the People* (London: Hamish Hamilton, 2000).

Redcliffe-Maud, Lord, *Support for the Arts in England and Wales* (London: Calouste Gulbenkian Foundation, 1976).

Reeves, Michele, *Measuring the Economic and Social Impact of the Arts* (London: Arts Council, 2002).

Reid, Benjamin, Alexandra Albert and Laurence Hopkins, *A Creative Block? The Future of the UK Creative Industries* (London: Work Foundation, 2010).

Rhodes, R. A. W., 'Introduction', *New Public Management, Public Administration* 69 (Spring 1991), pp. 1–2.

Richards, Steve, 'Interview: Peter Mandelson', *New Statesman*, 4 July 1997, pp. 16–17.

Rifkin, Jeremy, *The Age of Access: The New Culture of Hypercapitalism, where All of Life Is a Paid-for Experience* (New York: Turcher/Putnam, 2000).

Robertson, Sue, 'Sue Takes a Parting Shot at ACE', *Stage*, 27 September 2001.

Robinson, Gerry, *An Arts Council for the Future* (London: Arts Council England, 1998).

——'The Creativity Imperative: Investing in the Arts in the 21st Century', New Statesman Arts Lecture 2000 (London: Arts Council England, 2000).

Runnymede Trust, *'Education for All': A Summary of the Swann Report* (London: Runnymede Trust, 1985)

Runnymede Trust Commission on the Future of Multi-Ethnic Britain, *The Future of Multi-Ethnic Britain: The Parekh Report* (London: Profile, 2000).

Sainsbury, Lord David, *Progressive Capitalism: How to Achieve Economic Growth, Liberty and Social Justice* (London: Biteback, 2013).

Saatchi, Charles, 'Vileness of the Art World', *Guardian*, 3 December 2011.

Saumarez Smith, Charles, 'Introductory Overview', Valuing Culture conference, 17 June 2003 (typescript).

Scott, Carol A., 'Searching for the "Public" in Public Value: Arts and Cultural Heritage in Australia', *Cultural Trends* 19: 4 (2010), pp. 273–89.

Schlesinger, P., 'Creativity and Experts: New Labour, Think Tanks and the Policy Process', *International Journal of Press/Politics* 14: 1 (January 2009), pp. 3–20.

Seldon, Anthony, and Dennis Kavanagh, eds, *The Blair Effect: 2001–2005* (Cambridge: Cambridge University Press, 2005).

Selwood, Sara, ed., *The UK Cultural Sector: Profile and Policy Issues* (London: Policy Studies Institute, 2001).

——'The Politics of Data Collection: Gathering, Analysing and Using Data about the Subsidised Cultural Sector in England', *Cultural Trends* 12: 47 (2002), pp. 15–84.

Sennett, Richard, *The Culture of the New Capitalism* (London: Yale University Press, 2006).

Serota, Nicholas, 'A Blitzkrieg on the Arts', *Guardian*, 5 October 2010.

Seymour, Richard, 'Puke Britannia', *Lenin's Tomb* (blog), 29 July 2013, at leninology.com.

Sidwell, Marc, *The Arts Council: Managed to Death* (London: New Culture Forum/Social Affairs Unit, 2009).

Sierz, Aleks, *In-Yer-Face Theatre: British Drama Today* (London: Faber & Faber, 2001).

Sinclair, Iain, *Ghost Milk: Calling Time on the Grand Project* (London: Hamish Hamilton, 2011).

Smith, Chris, 'A Vision for the Arts', speech at Royal Academy, 1997, DNH press release 126/97.

——*Creative Britain* (London: Faber & Faber, 1998).

——'Government and the Arts', lecture at RSA, 22 July 1999, DCMS press release 200\99.

——'Valuing Culture', speech at Valuing Culture conference, 17 June 2003.

Smith, Zadie, *White Teeth* (London: Hamish Hamilton, 2000).

——*NW* (London: Hamish Hamilton, 2012).

Stallabrass, Julian, *Art Incorporated* (Oxford: Oxford University Press, 2004).

Stanziola, Javier, 'Good on Paper, Bad in Practice', *Arts Professional* 243 (10 October 2011), p. 12.

Stark, Peter, Christopher Gordon and David Powell, *Rebalancing Our Cultural Capital*, privately printed, 2013.

Thompson, Don, *The $12 Million Stuffed Shark: The Curious Economics of Contemporary Art and Auction Houses* (London: Aurum, 2009).

Throsby, David, *Economics and Culture* (Cambridge: Cambridge University Press, 2001).

Thurley, Simon, *The Men from the Ministry: How Britain Saved its Heritage* (London: Yale University Press, 2013).

Travers, Tony, 'Renewing London', in *Tate Modern: The First Five Years* (London: Tate, 2005).

Treasury, *Public Services for the Future: Modernization, Reform, Accountability* (London, H.M. Treasury, 1998).

——*The Government's Measures of Success: Output and Performance Analyses* (London: H.M. Treasury, 1999).

——*The Green Book: Appraisal and Evaluation in Central Government*, rev. edn (London: H.M. Treasury, 2011 [2003]).

——*The Magenta Book: Guidance for Evaluation*, rev. edn (London: H.M. Treasury, 2011).

——*The Green Book: Appraisal and Evaluation in Central Government* (London, H.M. Treasury, 2013).

Turnbull, Olivia, *Bringing Down the House: The Crisis in Britain's Regional Theatres* (Bristol: Intellect, 2008).

Tusa, John, *Art Matters: Reflecting on Culture* (London: Methuen, 1999).

——*Engaged with the Arts: Writings from the Frontline* (London: I.B. Tauris, 2007).

Vaizey, Ed, 'Speech by Minister for Culture, Communications and the Creative Industries', Local Government Association conference, 7 March 2013.

Vickery, Jonathan, *The Emergence of Culture-Led Regeneration: A Policy Concept and Its Discontents*, Research Paper No. 9, Centre for Cultural Policy Studies, Warwick University, Warwick, 2007.

Vuyk, Kees, 'The Arts as an Instrument? Notes on the Controversy Surrounding the Value of Art', *International Journal of Cultural Policy* 16: 2 (2010), pp. 173–83.

Walmsley, Ben, 'Towards a Balanced Scorecard: A Critical Analysis of the Culture and Sport Evidence (CASE) Programme', *Cultural Trends* 21: 4 (2012), pp. 325–34.

Waterton, Emma, *Politics, Policy and the Discourses of Heritage in Britain* (Basingstoke: Palgrave Macmillan, 2010).

Williams, Raymond, *Culture and Society 1780–1950* (London: Penguin, 1962 [1958]).

——'Politics and Policies: The Case of the Arts Council', in Raymond Williams, *The Politics of Modernism* (London: Verso, 1989 [1981]).

Work Foundation, *Staying Ahead: The Economic Performance of the UK's Creative Industries* (London: Work Foundation, 2007).

Zirin, Dave, 'Danny Boyle's Olympic Minstrel Show,' *Nation* (blog), 20 July 2012, at thenation.com.

Index